Pacific Arcadia

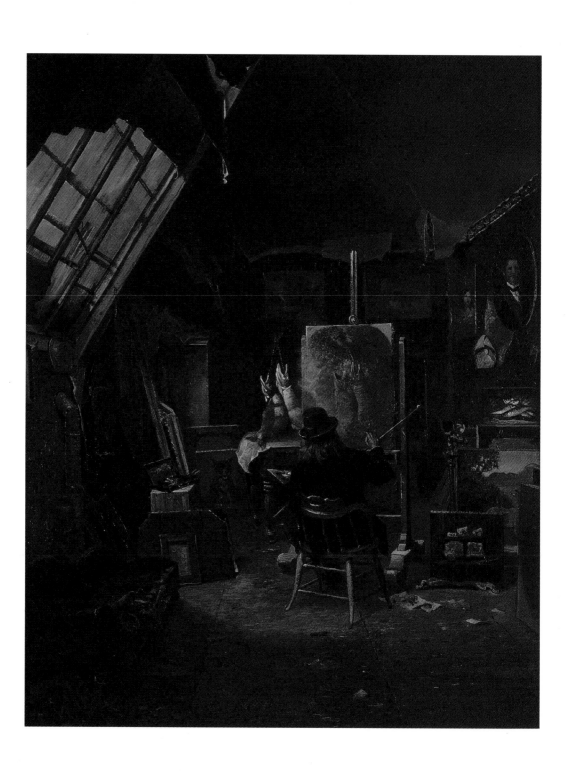

Pacific Arcadia:

Images of California, 1600–1915

Claire Perry

NEW YORK ∞ OXFORD
OXFORD UNIVERSITY PRESS

IRIS & B. GERALD CANTOR
CENTER for VISUAL ARTS
STANFORD UNIVERSITY

1999

Oxford University Press

Oxford New York

Athens Auckland Bangkok Bogotá Buenos Aires Calcutta
Cape Town Chennai Dar es Salaam Delhi Florence Hong Kong Istanbul
Karachi Kuala Lumpur Madrid Melbourne Mexico City Mumbai
Nairobi Paris São Paulo Singapore Taipei Tokyo Toronto Warsaw

and associated companies in

Berlin Ibadan

Published by Oxford University Press, Inc.
198 Madison Avenue, New York, New York 10016

Oxford is a registered trademark of Oxford University Press

Library of Congress Cataloging-in-Publication Data
Perry, Claire.
Pacific Arcadia : images of California, 1600-1915 / by Claire Perry.
p. cm.
Catalog of an exhibition opening April 21, 1999 at the Iris & B. Gerald Cantor Center for Visual Arts at Stanford University.
Includes bibliographical references and index.
ISBN 0-19-510936-8 (cloth : alk. paper). — ISBN 0-19-510937-6 (paper : alk. paper)
1. California—In art—Exhibitions. 2. Art, American—California—Exhibitions.
3. Art—Exhibitions. I. Iris and B. Gerald Cantor Center for Visual Arts. II. Title.
N8214.5.U6P473 1999
760'.04499794'07479473—dc21 98-3382

This book has been published in conjunction with the exhibition, *Pacific Arcadia: Images of California, 1600–1915,*
which was organized by the Iris & B. Gerald Cantor Center for Visual Arts at Stanford University.

We gratefully acknowledge the support of Ford Motor Company, The Honorable Laurence W. Lane, Dr. A. Jess Shenson,
and The Bernard Osher Foundation.

Exhibition itinerary:

Iris & B. Gerald Cantor Center for Visual Arts at Stanford University, Palo Alto, California
 April 21–June 27, 1999

San Diego Museum of Art
 October 30, 1999–January 9, 2000

Joslyn Art Museum, Omaha, Nebraska
 February 19–April 30, 2000

Copyeditor: Fronia Simpson
Production Editor: Ron Reeves
Design and composition: Adam B. Bohannon

Frontispiece: Edwin Deakin. *Samuel Marsden Brookes in His Studio,* 1876. Oil on canvas, 36 x 28 in. Private collection.

9 8 7 6 5 4 3 2 1

Printed in Hong Kong
on acid-free paper

CONTENTS

The Leland Stanford Jr. Museum, now expanded and known as the Iris & B. Gerald Cantor Center for Visual Arts at Stanford University, opened its doors at the end of the last century, looking to the East Coast and to Europe as its source of inspiration. Now, at the end of another century, it is an appropriate time to turn our attention to the art and history of California, the land that nurtured Jane and Leland Stanford's dreams of a prominent museum on their Palo Alto farm. Of course, the local environment also resisted the Stanfords' attempts to develop an institution that would rival the distinguished galleries of New York, Paris, and Berlin. The earthquake of 1906 destroyed over half of the museum building and, more recently, the tremor that shook the Bay Area in 1989 forced the museum to close for ten years. These tectonic nudges, however painful, have served as but one reminder of our inextricable connection to the local environment. It is with this perspective that we present *Pacific Arcadia: Images of California, 1600–1915*. The exhibition focuses exclusively on California, taking as its subject the images produced by early visitors and residents confronted by the peculiarities of California's landscape, the abundance of its natural resources, and the omnipresence of the vast Pacific. In ways that recall the circumstances of the founding of the Leland Stanford Junior Museum, *Pacific Arcadia* examines the relationship between art and ambition, and the

cultural devices that newcomers used to impose structure and meaning on undeveloped territory.

The exhibition lays aside traditional concerns with hierarchies of artistic value, drawing instead from a wide range of sources, including art history, cartography, economic history, anthropology, and literature, to frame certain questions about the role of representation in the development of California. *Pacific Arcadia* demonstrates the rich material awaiting those willing to prospect in local territory and introduces California as a subject for the stimulating interdisciplinary analysis that has characterized American cultural studies in recent years.

In organizing *Pacific Arcadia* we have been supported by the generosity of numerous institutions and friends. We are indebted to the many individuals who generously shared important works from their collections by agreeing to include them in this exhibition and we are very grateful for their contribution. We are equally grateful to the museums, historical organizations, and libraries that allowed us to borrow paintings, drawings, photographs, and other materials so necessary to realize the exhibition.

The exhibition originated from Claire Perry's doctoral work at Stanford University under the guidance of Wanda Corn. Claire has taken her doctoral thesis and turned it into this splendid catalogue and exhibition. She has been assisted by our staff in all aspects of the project. Special thanks go to Diana Strazdes, former Curator of American Art, who worked closely with Claire to refine the catalogue and exhibition. All other members of the staff have made important contributions, and I wish to thank them for their excellent efforts.

We are delighted that the exhibition will also be shown at the San Diego Museum of Art and the Joslyn Art Museum and wish to thank our colleagues for their participation and interest in hosting the exhibition.

Oxford University Press has done a marvelous job as our co-publisher and we are grateful to Joyce Berry and her talented staff. Fronia W. Simpson served as editor and brought her considerable talents to this volume, making it richer and more focused.

No exhibition of the complexity of *Pacific Arcadia* would be possible without substantive financial support. We have been very fortunate that early in the development of the exhibition we received generous support from the Honorable Laurence W. Lane, Dr. A. Jess Shenson and his late brother, Dr. Ben Shenson, and from the Bernard Osher Foundation. Major support allowing for the realization of the exhibit, catalogue, and the tour of the exhibition has come from the Ford Motor Company.

Without the generosity of all of these supporters and contributors, our plans for *Pacific Arcadia* would never have emerged from that state of hopeful reverie, the "California Dream" long associated with this alluring and complex land on the edge of the Pacific. I thank you all.

Thomas K. Seligman
The John and Jill Freidenrich Director

ACKNOWLEDGMENTS

In a happy correspondence with the images of abundance that fill this book, my work on *Pacific Arcadia* has been sustained by a plentiful measure of support and goodwill. Diana Strazdes labored deep in the administrative mines, bringing up shovelful after shovelful of organization and direction until a solid foundation was established. Noreen Ong and Susan Roberts-Manganelli diverted an avalanche of loan forms into a tidy row of files in the back office. Troubleshooters Mona Duggan and Bernard Barryte made sure the footings were straight, and Tom Seligman gave the buck a place to stop. When momentum stalled, Billie Holladay took the time to show a rookie the ropes, and Peter Seligman helped locate pay dirt. I am grateful to them all.

I would also like to recognize the many individuals and organizations who consented to loan works of art, making it possible to assemble the grand cornucopia of paintings, drawings, prints, and photographs offered in *Pacific Arcadia*. The magnanimity of these lenders provided the spark that allowed this exhibition to be realized.

Finally, I would like to thank those who provide an environment conducive to my work. In our little Arcadia on the hill, my children—Beau, Byron, Somerset, Sebastian, and Winslow—open my eyes to wonders long forgotten, and my husband, Noel, restores me with his bountiful affection. In this way, through my family, I have been blessed to learn the true meaning of abundance.

INTRODUCTION

The climate is better
The ocean is wetter
The mountains are higher
The deserts are drier
The hills have more splendor
The girls have more gender
Ca-li-for-ni-ay![1]

This book studies the imagery of the California Dream. Using paintings, drawings, maps, photographs, newspaper and book illustrations, and printed ephemera dating from the seventeenth century to 1915, it examines the role played by images in the creation and development of the idea of the Golden State. Since the arrival of Spanish explorers in the sixteenth century, California has been thought of as a land of promise and opportunity. At first it was appreciated for its strategic location in relation to trade with Asia, its rich soil, and its rumored mineral wealth. With the discovery of gold in the Sierra Nevada in 1848, general predictions about the potential of the region seemed to have become a sudden reality. However, though California was admitted into the union in 1850 and was increasingly populated by Americans from the East, the appropriation of California, and its incorporation into the economic and social systems of the rest of the country, was far from complete. Its geographic isolation, its Spanish history and perceived connection with the Old World, and its arid climate made the region seem exotic and forbidding. In addition, unlike the majority of other western territories, which had been settled relatively slowly by farmers migrating from states nearby, California experienced its first influx of non-Indian population as a result of the discovery of gold. Those who flocked to the territory during this period were not Jeffersonian yeomen, but prospectors, urban merchants, and real-estate speculators.

Through the notoriety of the gold rush, California came to represent cultural values at odds with the ideals of hard work, community solidarity, and religious observance on which the nation had been founded. As a result, for many years after California was made a state, it was considered unfit for permanent settlement. Most of those who came to California during the gold rush intended to stay only long enough to make their "pile," then return to their homes and families in the eastern and midwestern United States. Nevertheless, despite the overwhelming problems that accompanied its early development, California's population grew from a few thousand in 1848 to over five hundred thousand in 1870. By the turn of the century, the number had risen to one and a half million, and California had changed from a chaotic mining frontier to a state in the mainstream of national economic and political affairs.

What was the role of pictorial representation in the dramatic transformation of California in the second half of the century? For large numbers of Anglo-Americans to be willing to make their home in the Golden State, its nature had to be defined according to certain prototypes, and its past and future revised and invented by those who stood to benefit from an increased population. In this book, I argue that a body of carefully constructed images of California was used by a core of middle-class and newly wealthy residents to create a recognizable framework for the new order they hoped to establish on the Pacific, and to set forth a range of attractive social and economic options for prospective settlers. These early developers used representations of idealized aspects of life in California to provide a sense of harmony of interests and the notion of a shared history among Anglo-American newcomers, as well as to identify and isolate "outsiders," such as Native and Hispanic Americans and Asian immigrants.

In their campaign to market California to those in the East, local business leaders drew on themes introduced in the earliest maps of the region made by sixteenth- and seventeenth-century Europeans and developed further in the images and writings of Spanish, French, and English explorers in the Pacific. The idea of a Pacific paradise that was established by these sources provided American promoters with a paradigm through which they could formulate their development strategies. During the second half of the nineteenth century, when faced with the seemingly insurmountable obstacles of the state's remoteness, its anarchic society, its need for extensive irrigation, and the largest foreign population of any state in the union, the state's business elite would fall back on the idyllic vision of California that had originated with their predecessors. Though it was often unclear how the specific details of development would be resolved, promoters presented California as a place where economic bliss could be attained in a spectacular natural setting.

Representations of California tend to fall into certain thematic categories. These categories help us to understand how pictures were used by early developers to promote cohesion, predictability, and trust in a community dedicated to speculation and exploitative opportunism. Images that promoted traditional American values—while identifying them with California's untapped natural wealth, commercial possibilities, liberal society, and magnificent scenery—presented the state as the ultimate fulfillment of the American dream. Paintings, photographs, popular prints, and drawings that depicted California as a promised land for the American Everyman revealed a place where hard work, decency, and enterprise were rewarded, as in the "old" states, but sooner, and in greater measure. In turn, the hoped-for immigration that would be encouraged by such

imagery was expected to result in substantial economic benefits for Californian real-estate owners, railroad companies, merchants, lawyers, and financiers, whose livelihoods depended on a growing population of local consumers and on the integration of state markets with those of the nation.

Those responsible for the dissemination of a certain image of California represented all sectors of the economy, from largest industries and state agencies to small businesses and individual households. Newspaper editors and guidebook authors often included promotional pictures in their publications, while grocers, bankers, and homemakers bought idealized prints, paintings, and photographs to display in their establishments and homes. Prominent California citizens patronized artists personally, and their companies sponsored advertising campaigns that blanketed the East with illustrated pamphlets and brochures of Sunny California. Governor Milton Latham, the Southern California landowner J. B. Haggin, William Ralston, and D. O. Mills of the Bank of California, the silver tycoon James Flood, and the Big Four of the Southern Pacific Railroad—Charles Crocker, Mark Hopkins, Collis Huntington, and Leland Stanford—are a few of the influential patrons who helped to determine the image of California that would be presented to eastern audiences, as well as to viewers worldwide. Though these citizens often competed against one another in the management of their personal enterprises, they were united in their effort to publicize the desirable features of the Golden State and in their financial dependence on the creation of a permanent community of Anglo-Americans in California.

These elite and middle-class Californians promulgated themes that can be organized into five principal categories. These correspond only generally to a chronology of the second half of the nineteenth century; to a large extent, the subjects existed simultaneously and represented different aspects of the entire California "package" that state promoters offered to viewers. Gold Rush California, Agricultural California, Spanish California, Wilderness California, and Metropolitan California are the groups identified here and the topics around which this study is organized. To set the stage for what will come later, the first chapter reviews representations of California created before the American takeover in 1848, which initiates a certain way of perceiving and picturing the region. The other "Californias," listed above, are addressed in succeeding chapters.

I have not ranked images of California according to the media in which they were executed. In other words, I do not address the issue of a qualitative difference between the oil paintings of formally trained artists, amateur drawings, souvenir stereographs, and magazine advertisements except in terms of the kinds of audiences that were targeted by certain formats. Grand canvases exhibited in the art academies of the East and broadsides pasted on the walls of midwestern railroad depots often communicated the same ideas about California, though they appealed to different economic and regional groups. This type of correspondence is of interest since this is the way that the vision of a Pacific Arcadia was developed and marketed to a wide public. The promotional images I examined functioned, not in an aesthetic void, but as part of a larger network of newspaper editorials, plays, songs, guidebooks, state reports, sermons and novels, and the pervasive effect of development strategies becomes apparent only by taking into consideration the full spectrum of sources. Accordingly, the textual material provided by nineteenth-century American authors is an integral component of my argument. The writings of Richard Henry Dana, Horace Greeley, Bret Harte, Bayard Taylor, and Mark

Twain, as well as works published by state officials, gold seekers, Yosemite guides, and scientists, are interwoven into my discussion of California imagery, just as they were in the minds of contemporary audiences.

In addition to being a cultural history of the nineteenth century, this book also attempts to locate contemporary culture, that of both California and the nation at large, within its sphere. Though I do not make direct comparisons, I hope that readers will recognize certain familiar themes and practices which, while initiated long ago, still resonate for modern audiences. With more than five hundred thousand newcomers immigrating into California each year—more than any other state—it is clear that the powerful persuasive forces set in motion by early promoters continue to operate in our own time.[2] By looking to the past, we can clarify the ways in which the idea of a Pacific Arcadia still defines our experience of the Golden State and identify the processes through which that vision is perpetuated.

Pacific Arcadia

1

A Terrestrial
Paradise

Mass having been said and the day having cleared, there having been much fog, we found ourselves to be in the best port that could be desired, for besides being sheltered from all winds, it has many pines for masts and yards, and live oaks and white oaks, and water in great quantity, all near the shore. The land is fertile, with a climate and soil like those of Castile; there is much wild game, such as harts, like young bulls, deer, buffalo, very large bears, rabbits, hares, and many other animals and many game birds, such as geese, partridges, quail, crane, ducks, vultures, and many other kinds of birds which I will not mention lest it become wearisome. The land is thickly populated with numberless Indians, of whom a great many came several times to our camp. They appeared to be a gentle and peaceable people.

—SEBASTIÁN VIZCAÍNO, DIARY OF
VIZCAÍNO (1602)[1]

European explorers who reached the northwest coast of North America in the sixteenth century were haunted by the fear that, after years of privation and misery aboard ship, they would never locate what they hoped to find in the New World. Early Spanish, English, and Portuguese seafarers had been lured to the distant Pacific by medieval lore that described rich lands lying in the great oceans outside the Strait of

Gibraltar. Tales of terrestrial paradises overflowing with precious gems and melon-sized pearls, of wondrous gardens in the mythical lands of Ophir, Tartary, and far Cathay inspired adventurous navigators to sail into the unknown waters west of the Mediterranean Sea. In 1492 Christopher Columbus's discovery of the great continents that lay in the western oceans seemed to verify the existence of the fabulous places represented in European legends. Subsequent expeditions launched by Spain, Portugal, and England set out to chart the new territory and claim its much-anticipated bounty. However, in the century following Columbus's landing in Hispaniola, even the abundant amounts of gold and silver found in the New World did not satisfy those who had been primed by fictional travel narratives depicting faraway lands, where veins of rich minerals lay on the surface of the earth and diamonds and rubies multiplied spontaneously. Europeans who crossed the Atlantic expected the treasure of the Americas to be easily located and commensurate with the vast expanse of the new continents themselves. The stories of indigenous peoples reinforced the newcomers' belief that a mother lode of mineral wealth still awaited discovery. From the islands of the Caribbean to the coast of Patagonia, local inhabitants described neighboring tribes clothed all in gold and valleys where pearls dangled from the trees.

Nevertheless, though European expeditions scouted the new lands from Florida to Cape Horn, the prize continued to elude them. By the time sixteenth- and seventeenth-century explorers circumnavigated South America and reached the Pacific coast of Mexico, where strong headwinds repelled vessels attempting to sail northward, most had lost the desire for further reconnaissance and either turned back or veered off toward the familiar harbors of the Philippines. The crews that did press on along the coastline, heading into the constant, buffeting wind that scours the western edge of North America, did so with no small measure of desperation, gambling that in this most distant corner of the New World they would find, at last, El Dorado.

It was thus perhaps with a sense of mounting anxiety that Spanish mariners conferred the name *California* on the desolate finger of land that juts into the Pacific at the twenty-third latitude. Customarily, expedition leaders gave the names of royal patrons, Christian saints, or important events on the religious calendar to the territories they claimed for their respective crowns. However, when ships reached the west coast of North America, they often had made hundreds of landings, and the repetitious use of a handful of favorite names that identified new territorial acquisitions—Santa Cruz, Santa María, San José—effectively underscored the lack of distinguishing (or immediately profitable) features in much of the land surveyed to that point. The predictability of these names emphasized the explorers' failure to locate the staggering amounts of gold and silver expected in the New World and undoubtedly intensified the exasperation of crews who had signed on for a percentage of the profits and suffered from the tedium of months or years at sea. Certainly, the monarchs and entrepreneurs who financed overseas ventures waited at home for news of important discoveries and became unwilling to continue to support expeditions that failed to turn up tangible, preferably mineral, evidence of their success.

In these uneasy circumstances, the use of the new and intriguing name *California* would have buoyed both the morale of Pacific voyagers and the hopes of distant administrators. Though it is not known which of the early explorers actually gave the territory its name, *California* was a word familiar to many Europeans as a mysterious treasure island described in a popular sixteenth-century novel, *Las Sergas de Esplanadián* (The Adventures of Esplanadián), by the Spanish author Garcí Ordóñes de Montalvo. The

book, which was widely read in England, Holland, and Spain, entertained audiences with its fanciful reweaving of bits of myth and history that had circulated in Europe for centuries, telling the story of a swashbuckling knight who fought against the Saracens during the Crusades. Thanks to the recently invented printing press, *Las Sergas de Esplanadián* and similar romances were available, not only to members of the aristocracy and clergy, but also to merchants, lawyers, and seamen. The great Magellan, for instance, reportedly kept a copy of a comparable popular narrative, *Pimaleon of Greece*, in his cabin during his many years at sea. Round-the-world voyagers were sustained by tales of heroic adventurers, and it is not difficult to imagine the mesmerizing effect of Montalvo's provocative description of California on the weary and possibly mutinous sailors patrolling the waters of northern New Spain:

> Know that to the right hand of the Indies there was an island called California, very near to the region of the Terrestrial Paradise, which was populated by black women, without there being any men among them, that almost like the Amazons was their style of living…. Their arms were all of gold, and also the harnesses of the wild beasts, on which, after having tamed them, they rode; that in all the island there was no other metal whatsoever…. And sometimes when they had peace with their adversaries, they intermixed with all security one with another, and there were carnal unions from which many came out pregnant, and if they gave birth to a female they kept her, and if they gave birth to a male, then he was killed…. There ruled on that island of California, a queen great of body, very beautiful for her race, at a flourishing age…Queen Calafia.[2]

Rounding the tip of the Baja peninsula, Spanish mariners may have encouraged themselves with the idea that they were on the edge of a great island—one that, like Calafia's realm, would prove to be rich in gold. Certainly, from the fourteenth through the seventeenth centuries, Europeans considered islands to be the most auspicious of all landforms; sailors' lore was filled with stories of places like Atlantis, Avalon, the Isle of Prester John, and other treasure islands, where gold and exquisite gems covered the ground. The production of *islarios,* or documents containing a record of all known islands, proved to be a profitable business for contemporary printing houses, which kept busy updating their volumes to reflect the latest discoveries. Thus, for sailors nearing the cape that would later be called Cabo San Lucas, the sight of what seemed to be the southern tip of an enormous Pacific island appeared as a tantalizing indication of the impending success of their long journey. The presence of local Indians wearing pearls that crew members later described as "about the size of a finger" seemed to confirm that the new land was, in fact, one of the legendary realms.

When word was received in Europe that a great island had been located off the west coast of North America, cartographers took up the job of translating the topographical sketches made by the first explorers into comprehensive charts of the area. The incompleteness of the information provided by the explorers allowed mapmakers to fill in the sections of terra incognita using their own fanciful projections. Cued by the region's peculiar name, geographers from the fifteenth through the eighteenth centuries frequently showed California as a huge landmass hovering off the edge of the continent (figs. 1–3). In 1622 the publisher Michael Colijn of Amsterdam represented California as the largest island in the world on the title page of his book *Descriptio Indiae*

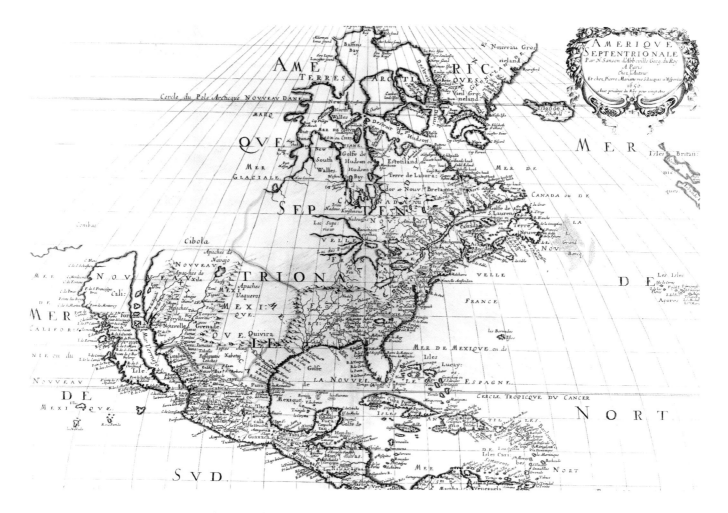

Fig. 1. Nicolas Sanson, Amerique Septentrionale, 1650. Engraved map, 15 3/8 x 21 3/4 in. Stanford University Libraries, Department of Special Collections.

Fig. 2. (next page, top) Nicolas Visscher, Novissima et Accuratissim Totius Americae, c. 1677. Engraved map, 19 3/8 x 23 3/4 in. Stanford University Libraries, Department of Special Collections.

Occidentalis (fig. 4). This map also showed the island lying on the flank of the Strait of Anián, the legendary Northwest Passage that was thought to connect the Atlantic and the Pacific oceans. The nations of Europe considered this waterway to be the key to trade with the Far East and desperately sought its outlets on both sides of the continent. By representing the great island named after the fabled kingdom of Queen Calafia at the mouth of the mythical Northwest Passage, the mapmaker, in effect, envisioned for his clients the pot of gold at the end of the rainbow.[3] Colijn's map, furthermore, was not an isolated example. Well into the eighteenth century, many otherwise accurate topographies seemed to lose their footing on terra firma when they reached the Gulf of California. As late as 1745 a map of the "latest and best observations" of North America showed California floating like a great apparition off the west coast, separated from the mainland by a narrow body of water called, appropriately enough, the Red Sea (fig. 5).

The magnitude of the topographical error reflects not only that the northeast Pacific region was still quite inaccessible to Europeans during this period but also that it remained one of the little-known places where those who still held out hope for the discovery of an earthly promised land could allocate their stock of dreams. Accordingly, the practice of representing California as an island, and of linking the territory to the Strait of Anián, proved to be remarkably resistant to abundant evidence that the region was, in fact, connected to the North American continent. Though Spanish expeditions led by Francisco de Ulloa in 1537 and by Hernando de Alarcón in 1539 demonstrated conclusively that California was indeed part of the mainland, geographers continued to produce maps of an insular California to accommodate popular demand. Conveniently, inaccurate reports from overzealous Spanish explorers arrived with enough regularity to

support what was increasingly viewed in scientific circles as a fantasy. One such account was provided by Fray Antonio de la Ascensión, a Carmelite cosmographer who sailed to California with the Vizcaíno expedition in the first quarter of the seventeenth century. The good *padre* set his superiors' fears to rest when he reconfirmed that California was an island with the Strait of Anián as its northern terminus. The English and Dutch were likewise content to perpetuate the fallacy, as their own territorial designs had come to depend on it. A cautious English geographer, Nathanael Carpenter, summed up the tentative and wishful aspect of European maps when he wrote in 1625, "That California is an island, it may…be well warranted: But the evidence drawne from the [maps], seemes rather to cherish hope, than persuade consent."[4]

Clearly, the weight of observed fact could not suppress the upwelling of romantic ideas that had assumed their own inexorable momentum over the centuries of Europe's isolation from the lands that lay in the Pacific.

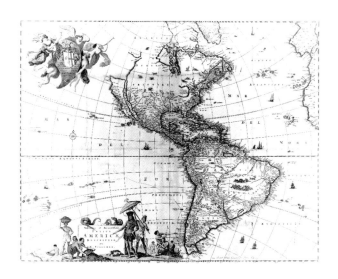

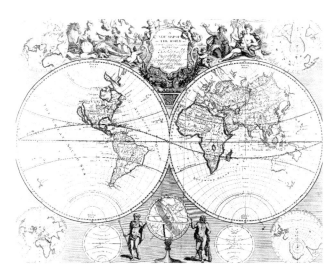

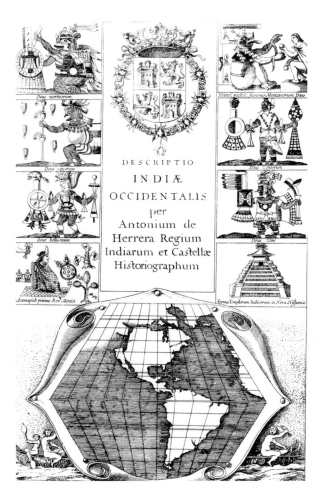

Furthermore, maps of an insular California served the needs of geographers' most important patrons; colonial administrators of the courts of Europe undoubtedly used them to encourage the settlement of the distant outposts of empire, and merchants looking for financial backing for trading ventures in the Pacific would have found them a valuable tool when wooing prospective sponsors. The broader significance of the image of an ideal California that took shape in the early maps, however, lay in its power to sus-

Fig. 3. (above) John Senex, A New Map of the World, 1740. Engraved map, 16 3/4 x 21 1/4 in. Stanford University Libraries, Department of Special Collections.

Fig. 4. (left) Antonio de Herrera, Map of America, 1622. Engraved map, 4 3/4 x 3 3/4 in. Collection of Mr. Glen McGlaughlin.

tain the hopes of an increasingly educated and well traveled audience that somewhere, in one of the few remaining uncharted regions of the globe, a terrestrial paradise awaited discovery.

 Still, by the end of the eighteenth century, all but the most tenacious optimists were forced to relinquish their dreams. The number of ships sailing to the region of California increased dramatically during this period, providing those at home with a wealth of new intelligence about the area's topographical features, native peoples, and abundant wildlife. However, if information was relatively plentiful, evidence of vast mineral deposits or rich pearl beds was notably absent, encouraging widespread acceptance of the fact that the territory was, alas, firmly attached to the mainland. California was soon demoted to the inferior status of countless other unprofitable Spanish holdings. Sparsely settled in the latter part of the eighteenth century by Franciscan *padres* and a handful of conscripts from Mexico, the new colony was largely ignored by a government in Madrid that was slow to recover from its disappointment in a place that should have been a golden island, but was not; a place that should have led to the Northwest Passage, but did not. Nevertheless, the circumstances of California's discovery and naming had

Fig. 5. R. W. Seale, A Map of North America with the European Settlements and Whatever Else Is Remarkable . . . , c. 1745. Engraved map, 14 1/4 x 18 1/8 in. Stanford University Libraries, Department of Special Collections.

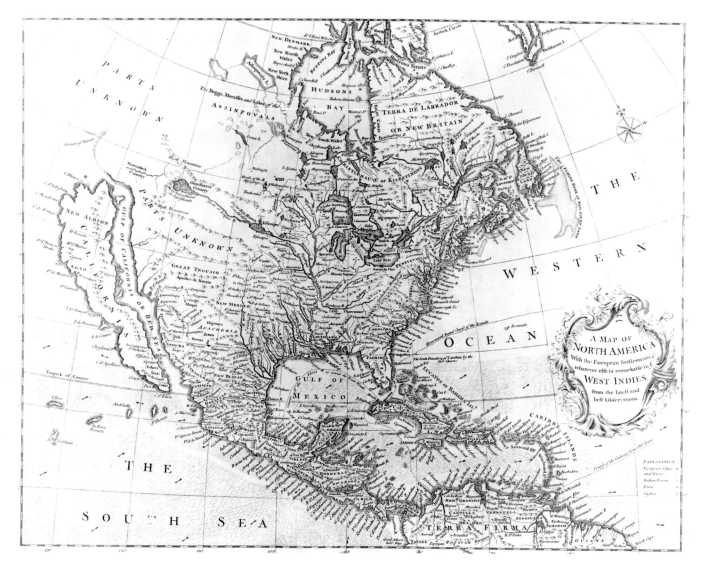

imbued the region with a mysterious aura that would continue to entice those seeking adventure and profit. In the centuries to come, image makers and patrons hoping to capitalize on the enduring appeal of California would base their promotional schemes, if unknowingly, on the extravagant precedent of the early mapmakers who had so willingly rearranged the world's geography to accommodate their clients' desire for an earthly Eden.

Just as the image of an insular California helped to establish the idea that the region was an attractive colonial asset, later pictures made by expeditionary artists of the eighteenth and early nineteenth centuries asserted their patrons' control over the territory. With the distance between New World colonies and their administrators measured in thousands of miles, and news from ships taking months or years to arrive in home ports, pictures made "on the spot" were especially powerful. At a time when images of any kind were rare and special, representations from across the seas gave those who saw them the sense of a magical connection with distant, mysterious lands. In the case of government functionaries responsible for consolidating new frontiers, these representations allowed them to feel a new sense of mastery over remote regions of the earth. Not surprisingly, the first representations made on site in California continued the idyllic themes introduced in the insular maps, though in ways more subtle and diverse than their topographic prototypes. Depending on the agendas of those who created or sponsored them, the earliest on-site portrayals of California, made at the end of the eighteenth century, showed it alternately as a place of abundant natural resources and docile Indians or as a forbidding hinterland inhospitable to all but the degraded variety of native who lived there. The Spanish expeditions that visited California were, of course, eager to confirm that the new colony was well managed and that it offered a multitude of benefits in exchange for the expense of its administration. Artistic representation played a crucial role in relaying this information to the motherland.

Alejandro Malaspina, the leader of a Pacific voyage organized by Spain in 1791, and the highest-ranking Spanish naval officer ever to visit California, selected the artists who joined his crew with special care, making sure that they were capable of rendering what they saw with a high level of competence.[5] Guided by Malaspina's own vision of the province as communicated in his enthusiastic log entries, the ships' artists, Tomás de Suría and José Cardero, provided their superiors with a distinctly flattering picture of life in California. Suría and Cardero made a visual inventory of native animals, bird life, and botanical specimens and included sketches of significant topographical features (figs. 6–9). With a focus on differentiation and categorization typical of the European Enlightenment, the artists divided the natural abundance around them into tidy units that could be easily comprehended by viewers at home. For royal patrons struggling to understand the strange new lands they had claimed, it would have been reassuring to see, as is evident in Cardero's drawing of 1791, that an ornithological specimen from the outer rim of Christendom was, after all, just a variant of the familiar blackbird (fig. 9). Such portrayals provided visual evidence that nature could be relied on to order itself in a predictable way across the vast expanses of the earth and, by extension, served to validate the authority of the monarch, who stood at the apex of the hierarchy of living things, over new territories and their inhabitants.

Suría and Cardero pictured a natural world in California that, because it appeared so easily measured and quantified in their drawings, was ready to offer itself up to agriculture, mining, and other forms of development. Likewise, the artists portrayed the native peoples they encountered in ways that communicated the Indians' tractability

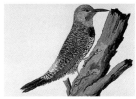

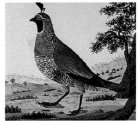

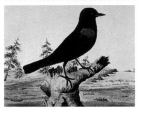

Figs. 6–9. Anonymous, 1791.

Watercolor on paper, 10 x 13 5/8 in.

Museo Naval, Madrid; José Cardero:

Picus, 1791. Watercolor on paper,

9 7/8 x 13 5/8 in. Museo Naval,

Madrid; Tetra Regio Montanus,

Monterey, 1791. Watercolor on paper,

10 x 11 in. Museo Naval, Madrid;

Gracula, 1791. Watercolor on paper.

9 7/8 x 11 in. Museo Naval, Madrid.

and submission, as well as their healthiness and physical strength. Because Spain lacked the human resources to settle all of its colonies, it devised the *encomienda* system in an attempt to transform indigenous inhabitants into Spanish subjects ready to defend the empire. The *encomienda* program involved the establishment of a series of mission outposts, administered by priests and protected by military garrisons, that would convert indigenous tribes to Christianity while educating them in agriculture and animal husbandry. Presumably, in return for these valuable benefits, local peoples would acquire an unshakable loyalty to the Spanish crown and would contribute their labor to the maintenance of the mission settlements.[6] Predictably, Suría and Cardero's drawings showed the missions as flourishing cooperative enterprises, and both Spanish and native subjects as fitting representatives of the great empire. In *Vista del Presidio de Monterey*, a detailed depiction of the settlement at Monterey made in 1791, José Cardero represented the happy symbiosis that he observed there (fig. 10). The artist was first careful to point out the security of the colony and its simple but efficient ability to defend itself. The viewer's line of sight is carefully directed toward the intersection of the sturdy *presidio* walls, encouraging the eye to follow the great V they describe. The sweeping arms of this V, which seem to embrace Monterey Bay in the distance, demonstrate the Spaniards' ability to monitor all incoming traffic and to protect the settlement against outside attack.

Behind the protective wings of the fort, the colony hums with productive activity: two Indians carry a water barrel to a field, while others work the land. Overseeing their work is a Spaniard, recognizable by his wide-brimmed hat, who apparently instructs his charges in horticultural matters. As he gestures with an open hand toward the garden, he leans comfortably on his staff while his pupils listen attentively. Like the sheep in the pasture on the left that are the Indians' visual equivalents, the neophytes, we understand, will be guided by beneficent shepherds. In the middle of the drawing, women hang out the day's washing. It is unclear whether they are soldiers' wives or Indian women in the European dress that would have been required by the Franciscan *padres*. In any case, the presence of these laundresses indicates not only that the colony adheres to salubrious domestic routines but also that it contains the elements necessary for its

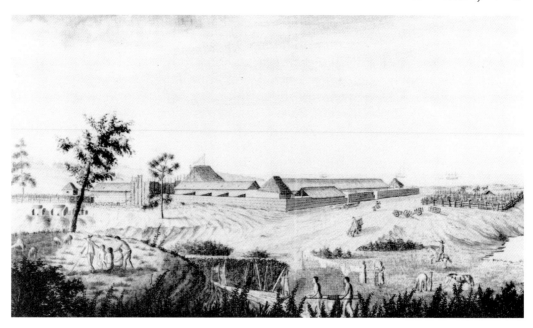

Fig. 10. José Cardero, Vista del Presidio de Monterey, 1791. Watercolor on paper, 11 7/8 x 19 1/4 in. Bancroft Library, University of California, Berkeley. The Robert B. Honeyman, Jr., Collection.

own perpetuation. The female activity placed at the center of the drawing alludes to the creation of families and to the laying down of blood ties that would bind the new territory inextricably to the motherland.Unlike their French or English counterparts, the Spanish saw intermarriage with indigenous peoples as a logical component of their colonial program. Administrators at home believed that, like the carefully tended plants of the mission fields, new *mestizo* populations would flourish under the guidance of knowledgeable Spanish governors, providing the infusion of population required to maintain the outposts of empire.

Although Cardero undoubtedly intended his drawing to be a positive assessment of the status of the colony, it nevertheless contains various components that contradict his otherwise cheering point of view. The repeated instances of animals under restraint—tethered horses in the field, rearing horses dominated by Spanish riders, cattle corralled by the *presidio* walls—serve as metaphors for the involuntary servitude of the native laborers and refer to the often unwilling role of Indians in the *encomienda* system. Furthermore, the pointed wedge of the garrison walls that cuts so imposingly into the fields where the Indians work also hints at the frequently hostile relationship between the settlers and indigenous tribes. Indian unrest was common throughout the California missions from the late seventeenth century into the early nineteenth century, and numerous soldiers and Franciscan *padres* had been killed in native uprisings. If Cardero hoped to communicate the benevolent aspects of mission life, his drawing also alluded to the fears of colonists thousands of miles from the mother country. The thick walls and huddled aspect of the windowless, broad-roofed *presidio* buildings convey the justifiable anxiety of newcomers completely outnumbered by resident peoples becoming increasingly aware of their own marginalized status in the new hierarchy.

Nevertheless, Cardero's drawings of individual subjects in California expanded on the theme of the felicitous alliance between natives and settlers that was introduced in *Vista del Presidio de Monterey*. His sketches of a Spanish soldier and his wife, and of local tribespeople, affirmed that all the elements necessary for the success of the mission system were present (figs. 11 and 12). The sturdy *soldado*, with his broad-brimmed hat and finely tooled leather jacket, is a worthy representative of the Spanish military. The tidiness of the man's costume and his upright posture attest, even in this distant corner of New Spain, that the fighting force in California has maintained its discipline. The sword the soldier holds in his left hand and the pointed spurs on his boots speak of his fighting ability and of the Europeans' mastery of the horse, which made such a profound impression on native peoples throughout North America. With the studied, passive expression of one patiently awaiting further orders, the soldier appears ready to serve his king.

This image of masculine fortitude contrasts sharply with the picture of the soldier's wife, who is portrayed with an emphasis on feminine vulnerability and charm. Where her husband's mouth is set resolutely, the lips of the *mujer del soldado* curve sweetly upward as she modestly averts her eyes from the viewer's gaze. She is dressed in the sort of frock reserved for special occasions, with lace at the waist and sleeves and a beribboned shawl at the shoulders. Presumably, there were social events at the mission settlement to which the *señora* could wear such a dress, and a growing community in which she might enjoy the company of others of relatively cultivated sensibilities. In this way, through its portrayal of a female settler of some refinement, Cardero's drawing referred to the evolution of a recognizably European social system in California and suggested that the seeds of future commercial development, contained within an emerging

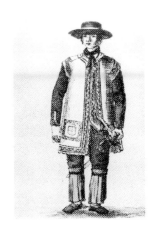

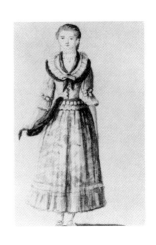

Fig. 11. José Cardero, Soldado de Monterey, 1791. Pen and ink wash on paper, approx. 9 7/8 x 11 7/8 in. Museo de America, Madrid.

Fig. 12. José Cardero, Mujer del Soldado de Monterey, 1791. Pen and ink wash on paper, approx. 9 7/8 x 11 7/8 in. Museo de America, Madrid.

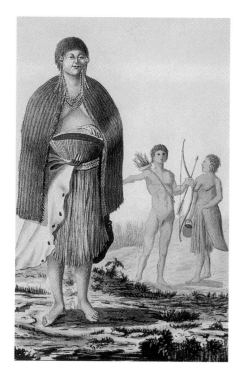

township in Monterey, had already been sown. If the picture of the soldier proved that the Pacific colony was well defended, the image of his wife showed that the distant frontier of the empire had been effectively domesticated as well. The coupling of these two subjects, furthermore, promised not only that indigenous populations would be governed with firmness and efficiency, but also that they would be educated and morally uplifted by their new masters.

Cardero's Indian portraits represented the original inhabitants of the region as people ready to be transformed by the enlightening spark of Spanish civilization. A drawing of male and female Indians, *India y Indio de Monterey* portrays the subjects as the worthy counterparts of Cardero's soldier and his wife in the *encomienda* alliance. Like the drawings of their Spanish equivalents, the details of the Indian portraits allude to their subjects' place in the colonial system. In contrast to the forbidding Amazons of Calafia's isle, the Indian woman in the foreground of Cardero's sketch smiles in welcome and holds a basket as if offering it to the viewer (fig. 13). Her ample body, augmented by her thick fur cape and beaded jewelry, presents a satisfying picture of natural abundance. If the open basket alludes to the gathering of bountiful harvests, it also refers to the readiness of the woman's labor, as well as to her sexual availability. Here, then, is the matriarch of future generations of Spanish subjects, a physical guarantee that grain storage baskets in the new colony would always be full. Flanking her in the background to the right, a male warrior stands alert with bow and arrow. Nobly nude, with a form and bearing closely resembling those of the classical Apollo Belvedere (fig. 14), he embodies the eighteenth-century ideal of the Rousseauian noble savage, completing the other half of the population equation that was required for long-term Spanish settlement in New World territories. Where aboriginal females provided the progenerative element, males possessed the brute strength required for large-scale agricultural projects and the building of forts, roads, and bridges. The ease with which the warrior handles his weapons also marks him as one who, with the necessary training, could serve as a valuable addition to Spanish defenses and help secure the colony against attack from the outside. Certainly, the physical robustness and intelligent demeanor of the California Indians as represented by Cardero showed that they were fit for any number of tasks that might be devised by colonial governors.

Like the Spanish, other foreign visitors to California created their own variations on the theme of the region's natural abundance that originated with the insular maps. However, representations made by artists traveling with French, English, and Russian expeditions in the late eighteenth and early nineteenth centuries denied the claims of effective settlement made in Spanish imagery and gave a focus to different territorial interests and priorities. In 1786 the distinguished French commander Comte Jean-François Galaup de La Pérouse guided his ships, the *Boussoule* and the *Astrolabe*, into the harbor at Monterey, where he was overwhelmed by the plentitude of native wildlife. In his journal La Pérouse described the numbers of whales, pelicans, seals, hares, wildcats,

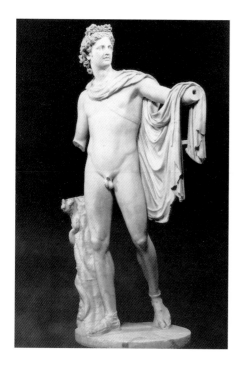

stags, bears, wolves, and partridges he had seen after spending a number of weeks in the territory. "There is not any country in the world which more abounds in fish and game of every description," he declared.[7] La Pérouse's wonder at the "inexpressible fertility" of the region and his observations of its healthful climate and great natural beauty indicated a more than passing interest in California on the part of the French.

Visual evidence provided by the ship's artist, Gaspard Duche de Vancy, directed the attention of government officials at home to opportunities for gaining control of the region. Undoubtedly, La Pérouse's assignment in California included instructions to evaluate the status of the mission settlements, and de Vancy's drawing of the French party's reception at Carmel Mission revealed numerous problems that would have discredited Spanish administrators. *Reception of La Pérouse at Carmel Mission*, a sketch made by de Vancy in 1786, represented the moment when La Pérouse and his crew were first welcomed to the colony at Monterey (fig. 15). The vantage point is that of a spectator who is above the events taking place, as indeed the French must have felt that they were. This lofty point of view was a reminder of the anti-Spanish prejudice that characterized the relationship of the Northern European nations with their Southern neighbor. The idea that the Spanish government was authoritarian, corrupt, and decadent and that Spaniards in general were cruel, greedy, lazy and fanatical in religious matters was widespread in France, England, and Holland at the time de Vancy's study was made. In contemporary Northern European literature, the Spanish were often depicted as evil and grasping *conquistadores* who went to the New World to enrich themselves at the expense

Fig. 13. (opposite, top) José Cardero, India y Indio de Monterey, 1791. Pen and ink on paper, 7 5/8 x 4 7/8 in. Museo Naval, Madrid.

Fig. 14. (opposite, bottom) Apollo Belvedere, c. 350-320 B.C. Marble, 88 in. high. Roman copy after Greek original. Vatican Museums, Rome.

Fig. 15. Tomás de Suría, after Gaspard de Vancy, Reception of La Pérouse at Carmel Mission in 1786, 1791. Pen, ink, and ink wash on paper, 8 3/4 x 10 1/18 in. Bancroft Library, University of California, Berkeley. The Robert B. Honeyman, Jr., Collection.

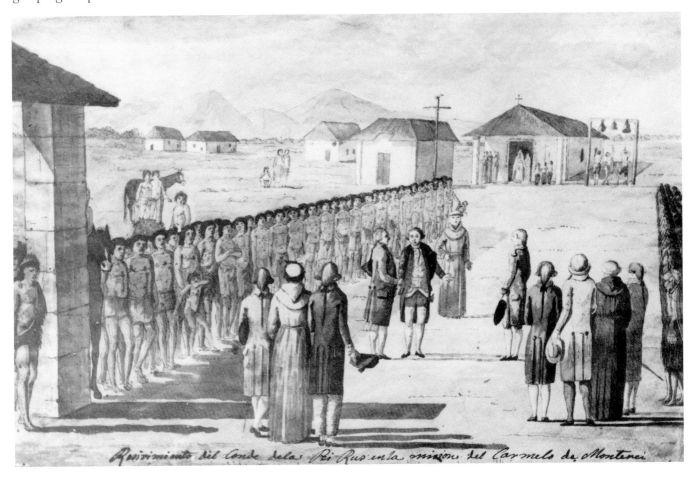

of enslaved aborigines. These beliefs have been subsumed under a single title by modern historians, "the Black Legend."[8]

De Vancy's portrayal gave form and substance to *La Leyenda Negra*. The ceremony depicted is rather drab and pitiful, though the Franciscan *padres* surely had done their best to muster an impressive assembly for their guests. In the background, attendants ring bells to mark the importance of the visit; one can be sure that the deep resounding tones that interrupted the silence of the valley made an impression on all present. The viewer can only imagine the sound and is left pondering the makeshift, scaffoldlike structure that serves as the campanile. To the left, a dark form—perhaps a statue of the Virgin Mary—stands ominously in the doorway of a featureless chapel. Under the gaze of this ambiguous figure, Indians in a long row present themselves for inspection. The artist has carefully noted scanty clothing and has arranged them in a perfectly straight line. At the end of their ranks, a large cross, the Christian symbol of the redemptive powers of suffering, projects toward the heavens.

The French viewer's minimal expectations for a colony settled by the Spanish would have been pleasantly confirmed by *Reception of La Pérouse at Carmel Mission in 1786*. In a region renowned for its natural resources, the land surrounding the settlement appears bare and overgrazed. Furthermore, though the Indians have obviously been trained to stand in line for ceremonies and church rituals, their almost naked state indicates that they have not been incorporated into the Spanish community in a productive way and that the human potential they represent has not been realized. The cross and the other allusions to religious activity suggest that the Spanish have wasted their energies on conversion, neglecting the scrupulous management of agriculture and animal husbandry that was essential for a successful colony. De Vancy has been careful to distinguish La Pérouse and his party from the Franciscan monks and their Indian charges. In contrast to the half-naked Indian neophytes and the tonsured monks in their drab habits, the French captain and his men are dressed in the elegant cutaway coats and white stockings that mark them as representatives of the enlightened philosophies of eighteenth-century France. Surely, the officials who reviewed de Vancy's drawing when the La Pérouse expedition returned to France would have been convinced of the superiority of their own administrative abilities and of the tenuous status of the Spanish missions.

La Pérouse's written account of his experience at the Mission San Carlos Borromeo would have injected a note of urgency to the desolate picture of mission life as portrayed in *Reception of La Pérouse at Carmel Mission in 1786*: "In a word, everything reminded us of a habitation in Saint Domingo, or any other West India colony. The men and women are assembled by the sound of the bell, one of the religious conducts them to their work, to church, and to all other exercises," the commander wrote. "We mention it with pain, the resemblance is so perfect, that we saw men and women loaded with irons, others in the stocks; and at length the noise of the strokes of a whip struck in our ears."[9] La Pérouse's and de Vancy's descriptions of freedom denied to Indian neophytes would have had particular resonance for audiences at home. Poised on the eve of a revolution that would be sparked by Enlightenment ideals of equality and the natural rights of man, the French had ample reason to think of the "liberation" of the bountiful Pacific territory and its enslaved peoples, not only as a convenient opportunity for territorial expansion, but as a moral duty as well. Nevertheless, the social upheaval that followed the events of 1789 distracted French officialdom from its dreams of a Pacific empire,

allowing Spain to retain control of California and its native inhabitants well into the next century.

In any case, as de Vancy had noted, the colony already contained within itself the means of its own undoing. The great distance from home ports, inefficient communications, and irregular supply lines gradually eroded the authority of Spanish governors. At the same time, the Franciscans failed to produce a substantial population of hardworking converts loyal to the crown. By the end of the eighteenth century, despite the fact that, according to Spanish maritime law, the empire's colonies were off-limits to outsiders, foreign ships began to call with greater frequency at Monterey, San Diego, and other California ports. French, English, and Russian expeditions challenged the unenforceable landing prohibition by spending months ashore making inventories of native flora and fauna and documenting the customs of indigenous tribes.

Many of the artists responsible for recording expeditionary data showed a particular interest in the aboriginal culture of California, creating numerous drawings of Indian rituals and everyday activities. Because Spain's legal right to claim California rested in part on its ability to settle the region with Spanish subjects, rival European powers naturally looked for signs of the success or failure of the mission system by studying its targeted population. Overall, the images made by visiting European artists aligned themselves with de Vancy's prototype, *Reception of La Pérouse at Carmel Mission in 1786*, judging the missions to have been ineffective in civilizing the Indians. The drawings and watercolors of two artists who accompanied Russian ships to California in the early part of the nineteenth century depict California Indians who are unlikely candidates for incorporation into the Spanish colonial plan. *Danse des Californiens*, a watercolor painted in 1816 by Louis Choris, a French artist aboard the Russian ship *Rurick*, portrays a mass of dancing Indians who overwhelm the courtyard of Mission Dolores in San

Fig. 16. Louis Choris, Danse des Californiens, 1816. Watercolor over pencil on paper, 7 1/4 x 11 1/2 in. Bancroft Library, University of California, Berkeley. The Robert B. Honeyman, Jr., Collection.

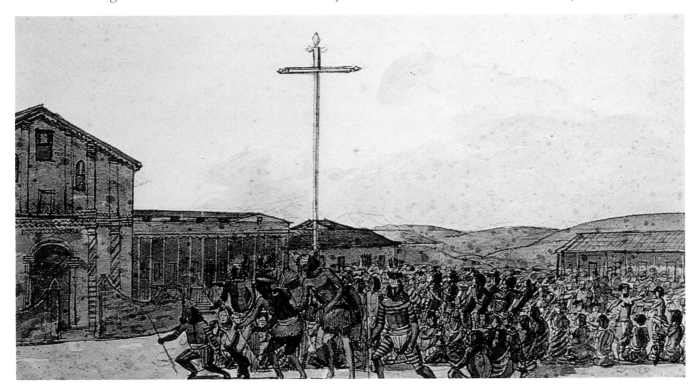

Francisco (fig. 16). Like a wave washing from the nearby ocean, the tribespeople seem ready to drown out all signs of the Spanish presence. Unlike the docile and regimented Indians represented by de Vancy, Choris's feathered and painted dancers advance toward the viewer in a disordered and distinctly menacing way, thrusting their spears and crouching as if poised to attack. Spanish authority, symbolized by the mission church and the large cross that looms in the background, seems unable to restrain the primal energy generated by the dance. Like a force of nature, the Indians are uncontainable and unmoldable, sweeping aside everything in their path and threatening to absorb even the viewer in their swelling numbers.

No Franciscan *padre,* soldier, farmer, or visitor is visible in *Danse des Californiens,* despite the fact that the Indian ceremony, which took place at the center of the Spanish settlement on San Francisco Bay, was an event arranged by the colonists in honor of the *Rurick*'s crew. Rejecting this display as proof of Spanish control over their native subjects, Choris envisioned with his painting a California that had been purged of the troublesome Spanish presence. At the same time, Choris's work alludes to the vitality of local Indian culture and the problem that any nation attempting to dominate California would face, namely, the existence of approximately three hundred thousand indigenous people distributed throughout the region. Significantly, *Danse des Californiens* is one of the few representations of early California that gives any idea of the vast numbers of Indians living in the territory. During the late eighteenth and early nineteenth centuries, foreign visitors traveling along the coast would have encountered many large villages, some with a thousand residents or more, of the Chumash, Costanoan, Coast Miwok, and Pomo tribes. The central valley of California was richly populated with Northern and Southern Yokuts, Lake Miwoks, and Southern Maidu. Even the most forbidding desert landscapes were inhabited by Indians well adapted to the arid environment.[10] Nevertheless, newcomers to California—the Spanish as well as their various European rivals—generally favored depictions of individual natives or small gatherings of Indians, choosing to ignore, for the most part, the problem of an already appropriated landscape. In this context, it is significant that Choris chose to represent the very problem that could undermine European colonial strategies. Still, the artist's willingness to refer to California's abundant population can be interpreted as an expression of his confidence in the superior abilities of his imperial patrons in dealing with such a challenge.

Wilhelm von Tilenau, a German artist who accompanied the 1806 voyage of Count Nikolai Petrovich Rezanov, a representative of the Russian-American Fur Company, also showed the native Californians as members of a thriving culture that had not yet been transformed by Spanish settlers. For the Russians, whose interest in California centered on trapping and fishing rather than on dominating local inhabitants, the independence of the Indians did not pose a significant threat. Russians had successfully negotiated trading agreements with the Aleuts in Alaska and probably anticipated making similar arrangements with the various tribes that lived along the central Pacific coast of North America. One of von Tilenau's California drawings, *Dance of the Indians at Mission San Jose,* emphasizes the strangeness of six California Indians shown in typical costume, each dressed and decorated in a different way (fig. 17). To the nineteenth-century European viewer, these unusual subjects would have appeared as picturesque and slightly threatening natural history specimens, not as the backbone of a colony, as the Spanish had described them. The stocky forms of the dancers, their bodies painted in sections, and their individualized headgear repudiate European ideals of regularity and symmetry and the examples of classical antiquity that had inspired José Cardero's por-

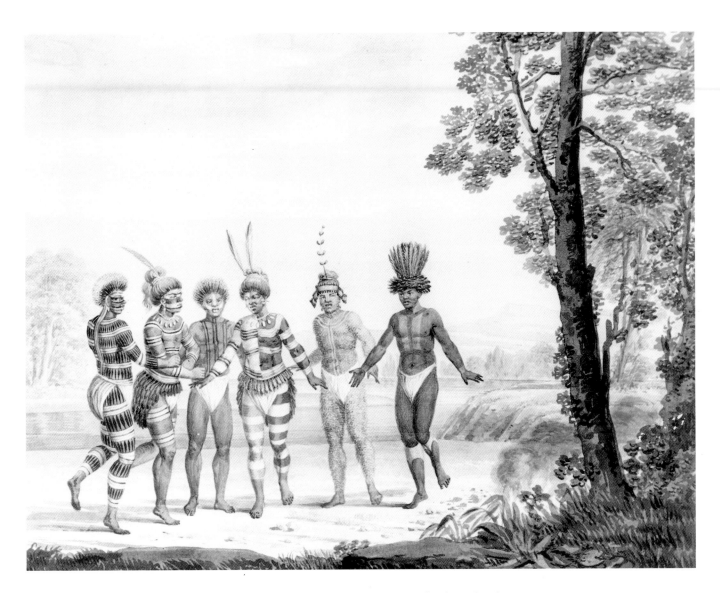

trait of a male Indian in 1791. Indeed, these striped, furred, and feathered tribesmen appear more animal-like than human, making a mockery of Spanish claims that the Indians at the missions had been "civilized" by the diligent efforts of soldiers and priests. The gestures of the dancers at the middle of the row and on the far right—arms outstretched, wrists flexed with palms facing the ground—seem to communicate refusal and rejection, reinforcing the idea of the impossibility of assimilating these untameable creatures into a colonial program.

If some visiting artists liked to focus on California's native peoples, others preferred to eliminate them from their representations, envisioning California as a sparsely populated land, magnificent in its grand emptiness. In an engraving of the *presidio* at Monterey made after a drawing of 1794 by John Sykes, an artist with the British expedition led by George Vancouver, we see California as an England of an earlier era, a *Nova Albion*, where the marks of industrial development and agricultural enclosure that radically altered the aspect of the contemporary English landscape had been erased (fig. 18). With his portrayal of rolling, verdant hills, where riders herd livestock next to a castlelike military garrison, Sykes transports the viewer from the dry *chaparral* of

Monterey to the damp slopes of Cornwall or Devon. Spanish settlers and native Californians are included in the scene, but at such a great distance that the viewer can easily mistake them for picturesque peasants of the type featured in the popular rustic landscapes of Sykes's contemporaries Thomas Gainsborough and John Constable. The lone Indian hut visible in the left foreground introduces the idea of California as a land without a significant indigenous population, and the larger European farm building that looms alongside confirms that arriving colonists will easily command the local inhabitants.

The visual appropriation of California enacted in Sykes's drawing was paralleled by the circumstances of the Vancouver expedition, which greatly strengthened the claims of the English to the new territory. In 1790, after a long series of international difficulties, Spain was forced to sign a treaty with England giving up its exclusive control of the Pacific coast north of California. This event was symptomatic of the general decline of Spanish international power, which would be dealt a death blow by Napoleon's forces invading Spain in the early part of the nineteenth century. George Vancouver was ordered to sail to the Pacific to ensure that the provisions of the treaty were carried out and to exercise the victor's privilege of surveying the surrounding territory. With a heightened sense of the vulnerability of the Spanish empire, the English may have believed that it was only a matter of time until California fell into their hands as well. Certainly, California as depicted in Sykes's drawing was not only an easy target for the formidable British navy but was also a place eminently suited for English control and settlement.

Fig. 18. William Alexander, after John Sykes, Presidio, Monterey, 1794. From Vancouver, Voyage of Discovery to the North Pacific Ocean (1798), 2: facing 440. Library Company of Philadelphia.

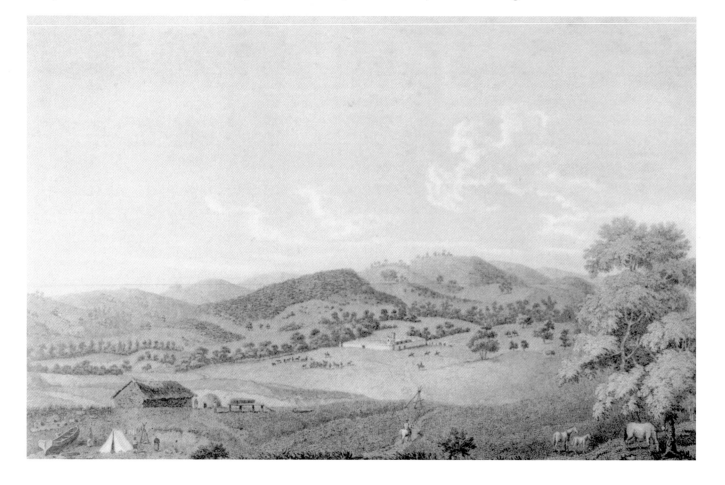

Works by other English artists who traveled to California at the beginning of the nineteenth century seemed to address the increased concern of British government officials for representational accuracy, given the escalating strategic importance of the Pacific region and their possible skepticism that a place so remote could resemble their own fair isle. Mexico, which at that time included California as part of its northern territory, had declared its independence from a greatly weakened Spain in 1823, and the opportunities for takeover latent in the political instability that ensued intensified English interest in the territory. These events also encouraged France and Russia to take another look. A watercolor painted by William Smyth, an artist aboard the British war sloop *Blossom*, which patrolled the waters off California in 1825, substantiated the truthfulness of its descriptions by including the artist himself in the picture. In *The Presidio and Pueblo of Monterey, Upper California*, Smyth appears in the lower right corner of the painting, with his back to the viewer as he looks across the landscape east of Monterey Bay (fig. 19). The corner of his sketching paper is just visible by his left shoulder, and his erect posture indicates that he is attentively recording what he sees. Presumably, just as the artist held up a mirror to himself, so would he truthfully report what he saw in the *presidio* and *pueblo* below. The other witnesses who look over the artist's shoulder as he works act as additional testimony for the veracity of Smyth's account. Having established his powers of observation through these visual strategies, Smyth felt free to indulge in a lyrical description of the terrain that differed only slightly from Sykes's 1794 drawing of the same subject. Once again, the countryside is shown as virtually empty. The grassy, undulating terrain beckons to the farmer and the plow, and richly forested hillsides invite the lumberjack and the builder. Smyth has carefully articulated the rows and clusters of individual trees on the eastern hills as part of his inventory, underscoring the great size of the specimens. It is interesting to note that Smyth's ship, the *Blossom*, was unable to obtain all the new spars it required in Monterey, owing to a shortage of available timber. In this context, Smyth's particular attention to the region's woodlands can be understood as an implicit criticism of the colonists' poor management of the territory's resources. The artist's decision to eliminate from his representation virtually all the occupants of the bustling township at Monterey, which had been decreed an open port in 1821, encouraged the idea that California's governors ruled in absentia, leaving the territory unsupervised and unguarded—a ripe plum ready to be plucked from the bough.

As British officials considered the significance of information provided by visitors like Smyth, a new power began to show an interest in California: the United States. Jockeying for position among the many rival nations that were eyeing the territory with increased attention, American newcomers lost no time in taking up the familiar themes of La Pérouse, Choris,

Fig. 19. William Smyth, The Presidio and Pueblo of Monterey, Upper California, 1825. Watercolor on paper, 12 1/4 x 7 1/2 in. Bancroft Library, University of California, Berkeley. The Robert B. Honeyman, Jr., Collection.

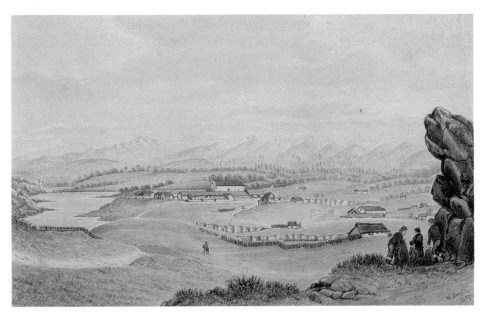

Sykes, and their contemporaries, and in incorporating forms of representation initiated by these early sources into their own territorial strategies. Like their Old World predecessors, Americans who traveled to California in the early part of the nineteenth century pictured it as a land of promise. Though visits to the Pacific region by professional artists from the United States were rare in the first half of the nineteenth century, American visitors were eager to describe the remote and mysterious region to those "in the states" and did so with simple sketches and watercolors and through their letters, journals, diaries, and memoirs. They did not change the theme of abundance and ineptitude that they inherited from those who went before them but added certain emphases that were particular to the American outlook. Most important of these was the sense of national mission that accompanied the American desire to appropriate what they found on the Pacific. Since the Declaration of Independence, Americans had fostered the idea of the "Manifest Destiny" of the United States to create an "empire for liberty" in which the downtrodden masses of other countries would be freed from monarchic despotism.[11] Americans believed that they had freed themselves from Old World vice and oppression and that, by expanding into new territories, they could share with others the peace and prosperity engendered by republican institutions. As Herman Melville explained in 1850: "We Americans are the peculiar chosen people—the Israel of our time; We bear the ark of the liberties of the world.... God has given to us, for a future inheritance, the broad domains of the political pagans, that shall yet come and lie down under the shade of our ark, without bloody hands being lifted."[12]

The territorial growth of the young Republic was thought to be an inevitable part of its march toward future perfection. The ideology of Manifest Destiny soon came to include the concept that Americans were entitled to the entire North American continent. Accordingly, California, with its strategic position at the western edge of the continent, acquired special significance in the minds of the American public. By the 1840s, the coast of the Pacific was considered by many to be the natural terminus of western expansion. William Gilpin, an expansionist friend of President Andrew Jackson, articulated this idea in 1845 when he wrote: "The untransacted destiny of the American people is to subdue the continent...to rush over this vast field to the Pacific Ocean...to confirm the destiny of the human race...to regenerate the superannuated nations."[13]

Even before Americans were allowed to land at the Spanish colonies on the Pacific coast, they had begun to sample its bounty, harvesting the whales, sea otters, and fur seals that populated its waters. New England merchants and whalers began to pay more frequent visits to California, lured by its abundance of resources and by the sense that commercial opportunities were available for the motivated entrepreneur. As they familiarized themselves with California's assets, and with its Mexican governors, Americans were galvanized by the idea of a prize so tenuously held by its owners. Though the visitors needed little encouragement to persuade themselves that the region flanking the Pacific coast of the continent was rightfully theirs, they used visual imagery as a means of legitimizing their actions and of expediting the process of takeover. As American image makers set out to depict what they found in California, their representations were shaped by expansionist rhetoric, as well as by the pictures, travel narratives, and stories created by those who had gone before. The scarcity of American images from California in the early part of the nineteenth century reflected the isolation of the region from the urban centers of the Northeast, as well as the type of American who traveled there. Seamen, fur traders, whalers, merchants, and naval officers, for the most part, they usually confined their descriptions to written accounts. Occasionally, an American visitor

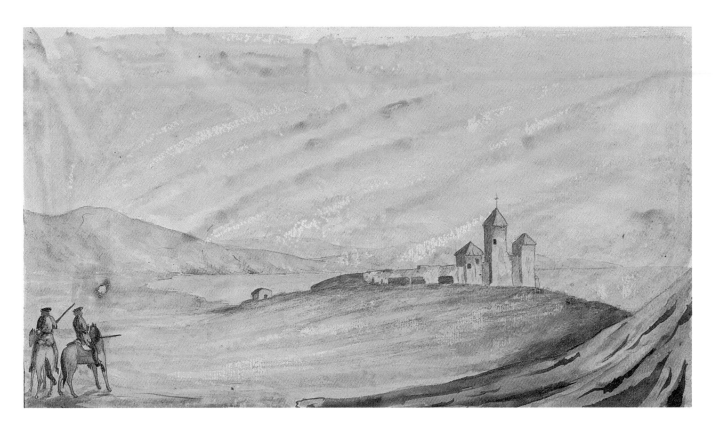

would venture to make a few sketches for friends or relatives, which consequently were available only to a small group of viewers. Nevertheless, these renderings supplemented a steadily increasing stream of information coming out of California and acted as visual testimonials for written chronicles.

American artists began with typical representations of California's fertile terrain and ample harbors. *Mission of San Carmel, California*, a watercolor painted in the early 1840s by William Henry Meyers, a gunner on the American ship *Cyane*, depicts the green, rolling hills surrounding Monterey Bay (fig. 20). Like many of his predecessors, Meyers shows a territory devoid of inhabitants. Passing over the thriving community in nearby Monterey, Meyers chose to represent the deserted mission of San Carmel, which had fallen into disrepair after being abandoned in the 1830s. The towers of the once elegant complex rise in the middle ground, surrounded by crumbling walls and a neglected, uncultivated landscape. In the lower left corner, a pair of American soldiers take in the melancholy scene. Once again, as in earlier pictures made by de Vancy, Sykes, and others, the emptiness of Meyers's broad landscape acts not only as an invitation to settlement but also as an indictment of those who had failed to take advantage of the region's natural resources. It is significant, too, that Meyers showed the mounted soldiers holding their guns pointed directly at the buildings that symbolized Spanish and Mexican control of the coveted territory. Meyers's juxtaposition of the ruined mission and the armed representatives of the American military enacts an imaginary standoff between the original colonists and those who considered themselves the rightful owners of the land. With an optimism engendered by the heady nationalism of the era, the artist shows the mission, the icon of Old World injustice and corruption, buckling under its own weight before an encounter can take place, leaving the emissaries of democracy to win the prize by default.

Fig. 20. William Henry Meyers, Mission of San Carmel, California, c. 1840. Watercolor on paper, 13 1/2 x 8 1/2 in. Bancroft Library, University of California, Berkeley. The Robert B. Honeyman, Jr., Collection.

Meyers's military colleagues, friends, and family who saw his sketches of California would already have acquired an idea about the territory's commercial and agricultural potential from the literature of the period. Countless books and newspapers described the region as a fertile garden with an abundance of land and a gentle climate. Travel accounts such as John Charles Frémont's *Narratives of Exploration and Adventure* of 1842 and Zenas Leonard's *Narrative*, published in 1839, portrayed the travelers' arrival in California, with its breathtaking natural beauty and obvious commercial potential, as the culmination of their western expeditions. Perhaps the most popular book of this kind was Richard Henry Dana's *Two Years before the Mast*, which related the author's experiences as a seaman aboard a Boston ship in the California hide and tallow trade. Like *Las Sergas de Esplanadián* more than three hundred years before, Dana's narrative fascinated its audience with its tale of a sea voyage to distant lands, becoming one of the most widely read of its time.[14] The California described in its pages was a terrestrial paradise for the Yankee trader.

> It is a country embracing four or five hundred miles of sea coast, with several good harbors; with fine forests in the north, the waters filled with fish, and the plains covered with thousands of head of cattle; blessed with a climate, than which there can be no better in the world, free from all manner of diseases, whether epidemic or endemic; and with a soil in which corn yields from seventy to eighty fold. In the hands of an enterprising people, what a country this might be![15]

In *Two Years before the Mast*, the Hispanic Californians supplanted the Amazons of Montalvo's *Sergas de Espanadián* as the evil that had to be overcome to gain entry to the earthly Eden. Dana's qualification of California's perfection as dependent on "enterprise" introduced the other half of the familiar equation. Dana portrayed the "Californios," the name given to the Mexican residents of the territory, as a people unwilling to develop the land and, hence, rightfully disqualified from owning it.[16] With an insistence on the spiritual and temporal quid pro quo that was typical of Calvinist doctrine, Dana presented the Pacific Eden as a place that had to be earned through the correct sort of labor. According to this ideology, the Californios had forfeited the territorial prize because of their indolence. Americans needed only to prove the unworthiness of their rivals to open up, as it were, the golden gate.[17]

Images and written accounts played a pivotal role in the campaign to discredit the Californios. American viewers were alternately shocked and amused by pictures of California that showed a society little changed since the eighteenth century. The most damning evidence presented in these images was that California had remained untouched by the Industrial Revolution, which had transformed life in the United States in the first half of the 1800s. Americans were proud of this metamorphosis, which introduced into everyday life the telegraph, the railroad, steam-powered manufactories, and other technological advances that had come to symbolize for Americans the moral progress of the nation.[18] The inventor Thomas Ewbank articulated the American attitude toward technology, and its connection with moral superiority, in a report of 1849:

> The connection of morals with expanding science…and the necessity of their union to the elevation of the species, are beginning to elicit attention. It is now perceived that deviations from principles of science—either in agriculture,

arts, manufactures, in processes or pursuits of any kind—are errors, and all errors, in an extended sense, are SINS—are violations of divine laws. And though sins of ignorance they carry and will forever carry, their punishment with them, viz: in imperfect results and the infliction of unnecessary inconveniences, expenses and toil, in spending strength for naught.[19]

It would have been within this ideological framework that viewers would have judged the scenes presented in two watercolors made in 1848 by William Rich Hutton, a paymaster of the American volunteer troops in Monterey. Like Meyers, Hutton was not a trained artist but an interested observer who wanted to record what he saw during his travels with the military. On his return to the East, he may have used the pictures he made of California to treat his superiors, friends, and family to a rare view of life on the Pacific. Hutton's visual account included various sketches of California's hide and tallow trade, a subject already familiar to those who had read Dana's *Two Years before the Mast*. A watercolor, *Trying out Tallow, Monterey*, shows Indian laborers stirring cauldrons of beef fat over low fires (fig. 21). The primitive aspect of this simple activity has been heightened by the artist's crude technique; everything about the operation presents a makeshift appearance, from the ragged clothes of the workers to the irregular holes into which the tallow melting pots have been placed. The "sins" of waste and inefficiency are even more apparent in a second work, *Matanza, Monterey*, which shows a slaughter ground littered with animal parts and cattle skins hung up to dry on racks in the background (fig. 22). Overhead, a flock of vultures circles above the heads of Californios who rest and converse. Edwin Bryant, author of *What I Saw in California*, one of the most widely circulated books on California at this time, commented on the "Golgotha-like aspect" of the Mexican *ranchos*. "The bones of cattle were thickly strewn in all directions," he wrote, "showing a terrible slaughter of the four-footed tribe and a prodigious consumption of flesh."[20] It is not difficult to imagine the disdain that these images of waste, and of the most degraded sort of manual labor, would have inspired in an audience infatuated with efficiency and progress.

A growing body of literature took up the theme of the backwardness of the Californios and their lack of enterprise. One author, Alfred Robinson, told his readers that "you might as well expect a sloth to leave a tree, that has one inch of bark left on its trunk, as to expect a Californian to labor, whilst a *real* glistens in his pocket."[21] James Clyman, who came to California in 1846, described the Californios as "a proud, indolent people doing nothing but ride after herds from place to place without any apparent object."[22] Perhaps the most vehement of these accounts was that made by Dana in *Two Years before the Mast*. Though himself a member of New England's maritime elite, he was able to relate his ideas about the unworthiness of the Californios on a level that would be understood by a wide range of American readers—that of dollars and cents. The Mexican Californians were "idle, thriftless people" who would "make nothing for themselves," Dana wrote. Though the countryside supported fine vineyards, "yet they buy at a great price, bad wine made in Boston and brought round by us and retail it among themselves at a real (12 1/2 cents) by the small wine glass." Their cowhides, "which they value at two dollars in money, they barter for something which costs seventy-five cents in Boston; and buy shoes (as like as not made from their own hides, which have been carried twice around Cape Horn) at three and four dollars, and 'chicken skin' boots at fifteen dollars the pair."[23] Here was the Black Legend reinterpreted with a particularly American emphasis on enterprise and progress. For the Yankee, who prided himself on

Fig. 21. William Rich Hutton, Trying
out Tallow, 1848. Watercolor on paper,
9 x 6 3/4 in. The Huntington Library,
San Marino.

his abilities as trader, inventor, and entrepreneur, Dana's portrayal of the indolent lifestyle of the Californios was a serious indictment indeed.

Even artists who had reason to be sympathetic to their Mexican hosts found it impossible to avoid popular stereotypes in their work. Alfred Sully, son of the portraitist Thomas Sully and an artist in his own right, went to California as an army lieutenant. He married the fifteen-year-old daughter of his landlady and considered settling permanently on the Pacific Coast. When his young wife died, however, he returned to the East. Sully's watercolor study of a California *rancho*, believed to be the Rancho Jimeno, portrayed the Californian way of life with warm nostalgia (fig. 23). A charming *señorita* sits atop a golden horse with her gallant *caballero*. Children play in the courtyard, surrounded by adults who work or converse. The addition of an Indian who works on a butchered steer in the middle of the courtyard adds a dissonant note to this otherwise picturesque scene. The stiff legs of the dead animal are poised unceremoniously in midair, as its skin is methodically flayed. The proximity of the slaughter of animals to the everyday life of the community suggests a certain cruelty and indifference in keeping with the American view of the Californios as the heirs of Cortés and the *conquistadores*. This impression would have been supported by the fact that all the workers in Sully's watercolor are Indians, whom most Americans believed to be enslaved victims of Hispanic domination. The Californios in Sully's watercolor do nothing of particular con-

sequence; they promenade and talk to one another. One simply leans against a post, his *serape* pulled comfortably around his shoulders.

The perceived inferiority of Californios was associated with racial mixture, a feature Americans particularly despised. Mexican *mestizos* were thought to have inherited the worst qualities of both Spaniards and Indians, resulting in a "race" more degraded than either parent group. Thomas Jefferson Farnham, writing in the early 1840s, expressed the fear of miscegenation with particular conviction, asserting that "no one acquainted with the indolent, mixed race of California will ever believe that they will populate, much less, for any length of time, govern the country. The law of nature which curses the mulatto here with a constitution less robust than that of either race from which he sprang, lays a similar penalty upon the mingling of Indian and white races in California and Mexico. They must fade away."[24]

The restless Americans were not content to allow the Mexican Californians to "fade away," however, before the United States gained control of the territory. In 1846 the United States declared war on Mexico, and American military forces quickly occupied California. Two years later, the two nations negotiated the terms of the Treaty of Guadalupe Hidalgo, according to which Mexico ceded California and other territories

Fig. 22. William Rich Hutton, Matanza, Monterey, 1848. Watercolor on paper, 9 x 6 3/4 in. The Huntington Library, San Marino.

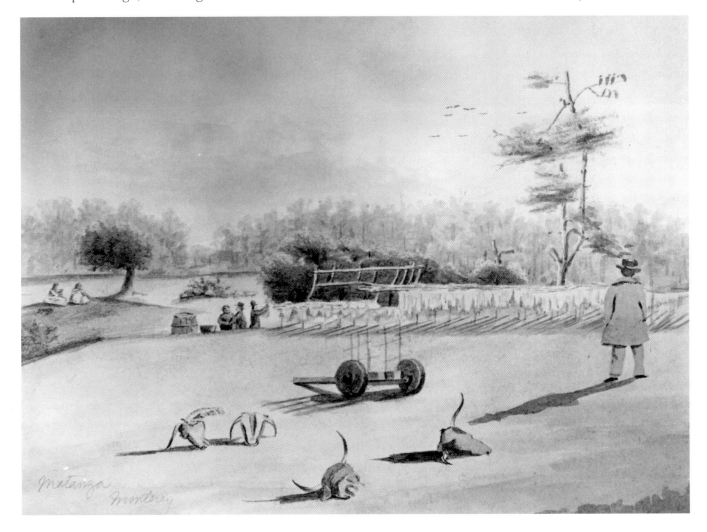

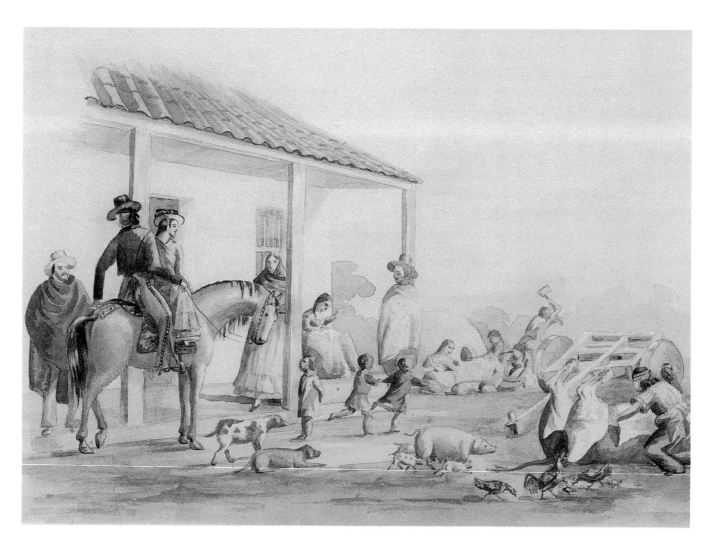

Fig. 23. Alfred Sully, California Rancho Scene, c. 1848. Watercolor on paper, 8 x 11 in. Collection of the Oakland Museum of California, Kahn Collection. Photograph by M. Lee Fatherree.

to the United States. The American expansionist campaign, fortified by strategic writings and select images disseminated by those eager to appropriate California's natural bounty, had achieved its ultimate objective. In the years following the Mexican War, as the process of commercial development and cultural assimilation began in California, representation would come to play an even more significant role in guiding American expectations for the Pacific prize. Daguerreotypes of gold mines in the Sierra, real-estate maps charting the fertile slopes of the Central Valley, grand paintings of breathtaking wilderness landscapes, and panoramic photographs of booming cities would confirm that in California, an "enterprising people" guided by God and the tenets of democracy had finally found ("Eureka!") the golden land of legend.

2

The Golden Dream

There was something exhilarating and exciting in the atmosphere which made everyone cheerful and buoyant.... Everyone in greeting me said, "It's a glorious country," or "Isn't it a glorious country?" or something to that effect. In every case the word "glorious" was sure to come out. I had not been out many hours before I caught the infection, and though I had but a single dollar in my pocket and no business whatever and did not know where I should get my next meal, I found myself saying to everyone I met, "It's a glorious country."

—SUPREME COURT JUSTICE STEPHEN J.
FIELD, ON HIS EXPERIENCES IN CALIFORNIA
IN 1849[1]

𝒩ine days before the signing of the Treaty of Guadalupe Hidalgo, which formally ended the war between the United States and Mexico, gold was discovered in the foothills of the Sierra Nevada. James Marshall, a carpenter building a sawmill along the American River in January 1848, spotted something sparkling beneath the surface of the water. Investigating further, he found that the riverbed was covered with flakes of

gold and began to spread the word of his auspicious discovery. Nevertheless, the remoteness of the settlement where Marshall made his find and the isolation of California from eastern cities allowed the treaty negotiations in Washington to continue uninterrupted by this significant development. On February 2, 1848, Mexico transferred ownership of California to the United States, unaware that it had given away gold deposits that would ultimately generate more than one billion dollars in revenues.[2] In the years to come, Americans would congratulate themselves on their timely acquisition of California, attributing their good fortune to divine benevolence and a healthy dose of Yankee ingenuity.

Marshall's strike seemed to confirm what early explorers and Spanish colonists had long held to be true. Newspapers in the East and in Europe reported that the long-sought El Dorado, the mysterious Land of Gold that had eluded the *conquistadores* of earlier centuries, had been found at last in California. Readers thrilled to descriptions of the remote corner of the continent, where it seemed a God concerned with good house-keeping had swept all the extra bits of mineral wealth, and where untold riches await-ed those with the energy and ambition to finish the job. Perhaps the most influential account of the gold discovery was that of the president of the United States, whose remarks suggested that he, too, was caught up in the general euphoria that accompa-nied the news from the Pacific. In his annual State of the Union speech in December 1848, President James Polk confirmed that "accounts of the abundance of gold in [California] are of such extraordinary character as would scarcely command belief, were they not corroborated by authentic reports of officers in the public service, who have visited the mineral district, and derived the facts which they detail from personal obser-vation…. The explorations already made warrant the belief that the supply is very large, and that gold is found at various places in an extensive district of the country."[3] To sat-isfy skeptical constituents, the president arranged for fourteen pounds of pure California gold to be placed on display in the War Office in Washington, D.C.

With the discovery of gold, the optimistic projections of Richard Henry Dana and New England traders in the 1830s and 1840s seemed to have become a reality. Instead of the measured pace of development that was expected for new American territories, the wealth of California, more than anyone had imagined, became available and exportable, almost overnight. By the end of 1848 many Americans believed that a man could earn as much in a day in the goldfields as he had in a month, or even a year, at home. Furthermore, the gold was reportedly so readily gathered up that even a woman or a child could acquire a fortune with ease. Colonel Richard B. Mason, the military gov-ernor of California, confirmed in August 1848 that "no capital is required to obtain this gold, as the laboring man wants nothing but his pick and shovel and tin pan, with which to dig and wash the gravel; and many frequently pick gold out of the crevices of rocks with their butcher knives, in pieces from one to six ounces."[4] It appeared that training, education, and social position were irrelevant in California; all that was need-ed were a few simple pieces of equipment and an adventurous spirit.

By the end of 1848, a frenzy of "gold mania" swept across California and the East. Simultaneously, an industry arose overnight to provide information about the new El Dorado to a public eager to cash in on the windfall. Nurturing the hopes of their read-ers, newspapers such as the *New York Herald* and the *New York Daily Tribune* competed to furnish the latest and most extensive coverage of events. Despite the fact that appre-ciable amounts of gold had not yet flowed back to eastern coffers, the *Herald* predicted

in its "Commercial Affairs" column on December 7, 1848, that the gold mines would "create a complete revolution in financial and commercial affairs." An editorial in the *Tribune* asserted that the mines would yield "at least One Thousand Million of Dollars."[5]

Journals, guidebooks, and published letters from people who had visited the mines also encouraged their readers with enthusiastic descriptions. A typical publication aimed at those anxious to gather every useful nugget of information about the gold country was *A Pocket Guide to California; a Sea and Land Route Book, Containing a Full Description of the El Dorado, Its Agricultural Resources, Commercial Advantages, and Mineral Wealth; Including a Chapter on Gold Formations; with the Congressional Map, and the Various Routes and Distances to the Gold Regions. To Which is Added Practical Advice for Travelers.* Hubert Howe Bancroft, a California historian who chronicled the gold rush during the 1880s, wrote that "every scrap of information concerning [California] was eagerly devoured. Old works that touched upon it, or even upon the regions adjoining, were dragged from dusty hiding-places and eager purchase made of guidebooks from the busy pen of cabinet travelers."[6]

Americans, both delighted and confused by the effects of the gold discovery, used visual images to help them make sense of circumstances that were completely new and unpredictable. The unsettling effects of the gold rush and the threats it made to the prevailing order were tempered by enthusiasm for the widespread economic opportunity it offered. That enthusiasm was confirmed by visual and written documents. One work that took as its subject the hunger for information about developments on the Pacific Coast and that presented its own wry version of the truth about the gold rush was *California News*, painted by William Sidney Mount in 1850 (fig. 1). Commissioned by Thomas McElrath, publisher of the *New York Daily Tribune* for three hundred dollars, it portrayed a group of middle-class yeomen gathered in a rural post office, listening attentively to a man who reads from the *Tribune*. The effect of the reader's words is electrifying. Behind him, a young woman presses her clasped hands to her chin in an expression of delight and wonder. Her beau or young husband points meaningfully at the newspaper as he whispers in her ear, perhaps formulating a plan for how they, too, might profit from the discovery. A letter written in 1849 by the wife of a struggling New England shopkeeper seems to mirror the circumstances of Mount's young couple: "Joseph has borrowed the money to go [to California]; but I am full of bright visions that never filled my mind before, because at the best of times I have never thought much beyond a living; but now I feel confident of being well off."[7]

In the doorway at the background of Mount's painting, a young man calls out to others in the town to come and hear the latest dispatch, and even the marginalized elements of the community share in the excitement. Apparently, the treasure that the reader must be describing is so vast and so easily accessible that even the child, the old man, and the African American at the right could hope to obtain some of it. The bearded fellow seated across from the reader seems to have already made his decision to set out for California; he is dressed traveler's clothes, and a sailing ticket peeks out of his pocket. A notice laid out on the table urges "California Emigrants" to "look here!!!" and sign up to reserve a space on the next vessel. In 1849 a writer described the riveting effects of the news from California, much as Mount had pictured them:

> I looked on for a moment; a frenzy seized my soul; unbidden my legs performed some entirely new movements of polka steps—I took several—

Fig. 1. William Sidney Mount,
California News, 1850. Oil on canvas,
21 1/2 x 20 1/4 in. The Museums at
Stony Brook, New York; gift of Mr. and
Mrs. Ward Melville, 1955.

houses were too small for me to stay in; I was soon in the street in search of necessary outfits; piles of gold rose up before me at every step; castles of gold dazzling the eye with their rich appliances; thousands of slaves bowing to my beck and call; myriads of fair virgins contending with each other for my love—were among the fancies of my fevered imagination. The Rothschilds, Girards and Astors appeared to be but poor people; in short, I had a very violent attack of gold fever.[8]

Mount reserved the center of the canvas for his most significant subject: a well-dressed gentleman who reacts to the California news with restrained interest. The lis-

tener's cool demeanor, as well as his silk hat and fur-collared coat, suggests that he will not be one to shovel mud in the mines of the Sierra. With this figure, Mount alluded to the merchant class whose profitable business of catering to the needs of immigrants allowed them to capitalize on the prevailing excitement. Without ever lifting a pick or shovel, these entrepreneurs, including Mount's patron, Thomas McElrath, were the inevitable winners of the struggle for wealth that eastern newspapers had christened the "Great California Lottery."

A print published in New York in 1850 presented a less subtle portrait of the much-discussed gold rush speculator (fig. 2). Entitled *Gold! Gold! Gold! Mr. Hexikiah Jerolomans Departure for California*, the print shows a portly merchant on the docks surrounded by his wares, including preserved pork and Valentines. "I'm a going to Cal-i-for-ne," he says, with a leering smile. "If you'd saved your money up as I did … you might have gone with me."

Horace Greeley, editor of the *New York Daily Tribune*, described a few of the opportunities that were suddenly available to men like Mount's elegant businessman: "Bakers keep their ovens hot night and day, turning out immense quantities of ship-bread without supplying the demand; the provision stores of all kinds are besieged by orders. Manufacturers of rubber goods, rifles, pistols, bowie knives, etc., can scarcely supply the demand."[9] In addition, suppliers of clothing, medicine, wagons, agricultural implements, and gold testing and smelting equipment found that they could sell all that they were able to produce without satisfying the requirements of their customers. The "City Intelligence" column of the *New York Post* reported in late 1848 that a ship had sailed for California with a cargo worth more than seventy thousand dollars, which "would supply a very extensive country store." A letter in the *New York Herald* stated: "Any person strolling along our docks cannot but be struck with the quality and quantity of merchandise, of all kinds, which is marked and being shipped to the new El Dorado—California." The letter also claimed that "nearly a million dollars worth of supplies" had been shipped "within the last thirty days."[10] Within the cycle of production and consumption that had been generated by the gold rush, the news itself was perhaps the most valued commodity of all, a fact Mount discreetly noted in his painting.

In *California News*, Mount made fun of the "gold fever" that had afflicted so many of his countrymen and had enriched those who had never set foot in a mine. The artist's judgment is embodied in the small painting of pigs at a trough, strategically placed above the post office door, through which all these good citizens come and go. The metaphor of gold seekers as swine may have been a common one; Henry David Thoreau, writing about the California rabble in his journal, harrumphed:

> The hog that roots its own living, and so makes manure, would be ashamed of such company. If I could command the wealth of all the worlds by lift-

Fig. 2. Unidentified artist, Gold! Gold! Gold! Mr. Hexikiah Jerolomans Departure for California, 1850. Lithograph, 10 1/2 x 7 7/8 in. California Historical Society, San Francisco.

M. HEXEKIAH JEROLOMANS DEPARTURE FOR CALIFORNIA.

ing my finger, I would not pay such a price for it. It makes God to be a moneyed gentleman who scatters a handful of pennies in order to see mankind scramble for them. Going to California. It is only three thousand miles nearer to hell.[11]

Despite the mania for gold that racked the country, the ambivalence that Mount expressed in *California News* was commonly felt. Americans were keenly aware of the criticisms that Alexis de Tocqueville and other Europeans had made in the 1840s—that the culture of the United States was based solely on material wealth and financial gain. Furthermore, wary Yankees were suspicious that the whole affair was nothing more than an elaborate hoax. *The Way They Go to California*, a lithograph published by Currier and Ives in 1849, poked fun at those who abandoned respectable occupations to hunt for gold in El Dorado (fig. 3). The print depicts a frenzied mob of would-be miners attempting to board a vessel bound for the golden shores. Overloaded ships sail toward the horizon as indignant passengers left behind wave picks and shovels in the air and jostle each other off the dock. Above the horizon line, ridiculous contraptions devised by greedy citizens crowd the sky. A fully loaded dirigible displaying the Stars and Stripes on its stern speeds westward, followed by a sausage-shaped "rocket-line" manned by yet another determined gold seeker. The lone rocketeer accelerates and exclaims with glee, "My hair! How the wind blows!"

Another Currier and Ives lithograph from the 1850s caricatured those who chose

Fig. 3. Nathaniel Currier and James Ives, The Way They Go to California, 1849. Lithograph, 12 3/4 x 18 1/2 in. California Historical Society, San Francisco. Photograph by M. Lee Fatherree.

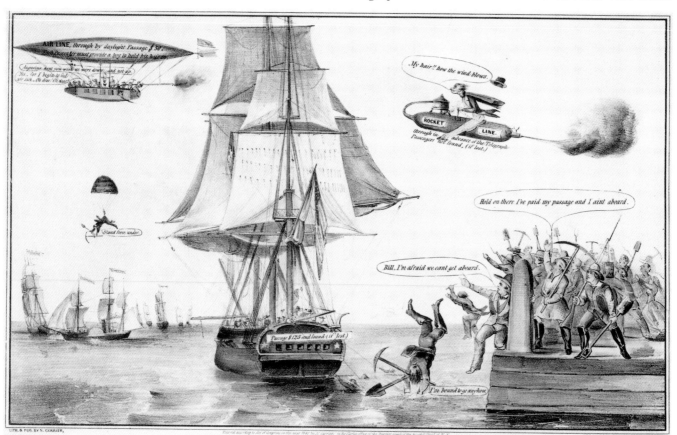

THE WAY THEY GO TO CALIFORNIA.

the overland route to California. *The Independent Gold Hunter on His Way to California* showed a more composed gold seeker traveling on foot (fig. 4). Outfitted with the most practical equipment, including a gold processor that doubles as a hat, and a gold washing and frying pan whose long handle also serves as a fishing rod, the peripatetic prospector, who "neither borrow[s] nor lend[s]," has already walked halfway to California. In the background, a road sign confirms that St. Louis lies 350 miles behind and that California is 1,700 miles ahead. The extreme length of the journey has had no adverse effect on the tidiness and confident demeanor of the Independent Gold Hunter. His unflagging determination is evident in the jaunty way he clamps his cigar between his teeth and in his steady grip on his gear. Currier and Ives's sardonic view of the single-minded acquisitiveness that propelled this gold-seeking juggernaut across the continent allowed those who remained in the East to feel a comfortable sense of superiority and self-congratulation. However, even as the print allowed viewers to distance themselves from the unsavory scramble for wealth taking place in California, the image of the gadget-laden prospector striding purposefully in the middle of nowhere called into question Americans' traditional reverence for independence and ingenuity and encouraged viewers to ponder what the rush for gold said about the American character in general.

Because of the ambivalent popular perception of the gold rush, those who actually considered going to El Dorado needed powerful reassurance that prospecting in California exemplified the finest aspects of the American character. That service was provided in part by pictures and writings that portrayed California as the fulfillment of the American Dream, as a place where democracy and equality were combined with natural abundance to create a terrestrial paradise that awaited those with the gumption to journey there.

Image makers and publishers found a lucrative market in pictures, journals, and books that portrayed the gold seekers as modern "argonauts," the American heirs of Jason, Theseus, Hercules, and the other bold adventurers who sailed on the *Argo* in search of the Golden Fleece. One of the means through which artists and writers fleshed out the analogy between prospectors and the heroes of classical mythology was by representing the trip to California as a journey of equally mythic proportions. Traveling to California, by sea or overland, was long and dangerous, and it was a well-known fact that many who set out never reached the golden shores. Newspapers and books published in the East sensationalized the unfortunate experience of the infamous Donner Party of 1846, whose members resorted to cannibalism while trapped in the snow of the Sierra Nevada. Heightening the sense of the dangers that awaited the unprepared traveler were works like *The Massacre of the Oatman Family*, painted by the California artist Charles Christian Nahl in the mid-1850s, which shows Indians on the warpath (fig. 5). Like the ferocious

Fig. 4. Nathaniel Currier and James Ives, An Independent Gold Hunter on His Way to California, 1850. Lithograph, 12 3/8 x 8 1/4 in. Denver Public Library, Western History Department.

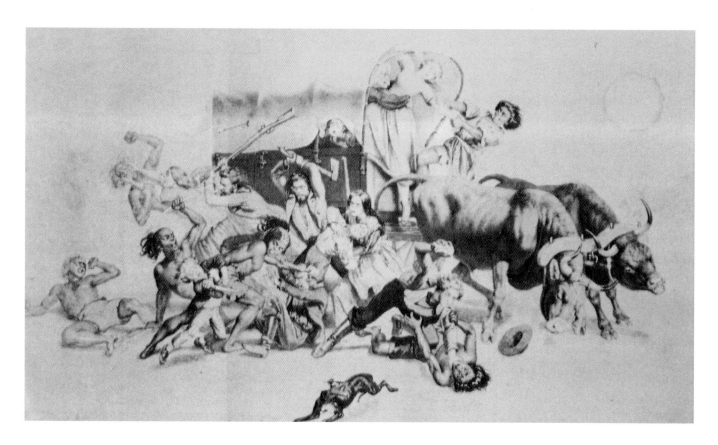

dragon that guarded the Golden Fleece, the reportedly savage peoples who populated the interior part of the continent blocked easy access to the California goldfields. The Oatmans, journeying overland to California in 1851, were attacked by Apache warriors. Mr. and Mrs. Oatman and the other adults in the party were killed. Their two daughters, Olive and Mary Ann, thirteen and seven years old, were taken into captivity by their assailants. The reappearance of Olive Oatman five years later, in 1856, inspired an outpouring of newspaper articles and even a dramatic book, *The Captivity of the Oatman Girls*.

Nahl's audience would have been familiar with the tragic story, and the artist seems to have been intent on wringing every bit of sympathy for the unfortunate victims. He highlights the pathos of the Oatmans' valiant attempt to ward off their attackers, whose demonic expressions foretell the cruel fate of the victims. These are the devils who shortly will carry off the Oatman daughters as they cry out to parents unable to protect them. The Indians' barbarism rouses to a frenzy even the gentle oxen who pull the family wagon; their bulging bovine eyes plead with viewers to share the desperate fear of the horrific moment.

While pictures of Indian monsters linked gold seekers with the mythical ordeals faced by classical heroes, images of the perilous sea voyage to California connected prospectors even more definitively to the ancient argonauts. A series of popular lithographs published by Currier and Ives in the 1850s described the noble clipper ships that ferried passengers from New York through the boiling seas around Cape Horn and on to San Francisco (fig. 6). These "California Clippers," whose sleek hulls and elegant rigging made them the queens of the California run during the 1850s, were designed to guarantee swift passage to El Dorado. Currier and Ives capitalized on the public's fascination with these American *Argos* capturing in reasonably priced prints the grace of the attenuated vessels as they skimmed across the water. Unfortunately, the design of the

ships, which allowed them to complete the passage to San Francisco in as little as ninty-six days, also tended to make them unstable in high winds. The pictures of clippers in distress that Currier and Ives included in their inventory of marine subjects showed that the sail to California also entailed a considerable amount of risk (fig. 7). Images of clippers with masts broken, heeling at sickening angles under gale-force winds, confirmed that those who endured the lengthy argosy to the golden shores had earned the distinguished appellation "argonaut."

In addition to the rigors of the journey, those who came to El Dorado had additional reasons to consider themselves part of a new elite. The cost of equipment and transportation to California was substantial, averaging from $750 to $1,000 in a time when 75¢ was an average daily wage. Though gold seekers were often forced to sell or mortgage their homes and farms or spend their life savings to get to California, the rush for gold required a certain level of economic well-being, making it primarily a middle-class phenomenon. As Bancroft explained in 1888, "the cost of passage served to restrict the proportion of the vagabond element, so that the majority of emigrants belonged to the respectable class, with a sprinkle of educated and professional men, and members of influential families."[12]

In the years immediately following the discovery of gold, publishers and artists found it relatively easy to provide these "respectable" newcomers with images that gold seekers were proud to show to others and delighted to save for posterity. These were the days of placer mining, when deposits of gold lay on the surface and were easily visible in riverbeds. Placer mining could be carried out with only a pick; even small knives could be used to pry the nuggets from the earth. Though visual precedents for mining activities were rare in contemporary American imagery, it was simple to convey the pleasures of gathering up such gold.

An important source of romanticized representations of the early mining days were the pictorial letter sheets that were eagerly bought as souvenirs by California immigrants. Letter sheets, which contained a printed picture as well as a space for writing, allowed miners to offer those at home a glimpse of mining life in far-off El Dorado. These nineteenth-century equivalents of the modern postcard were widely available—newspaper advertisements referred to collections of thousands—and miners could choose from a wide variety of California subjects. Topics ranged from "The Mining

Fig. 6 (left). Nathaniel Currier and James Ives, Clipper Ship "Sovereign of the Seas," c. 1850. Lithograph, approx. 12 x 15 in. Shelburne Museum, Shelburne, Vermont.

Fig. 7 (right). Nathaniel Currier and James Ives, A Squall off Cape Horn, c. 1850. Lithograph, 11 3/8 x 15 3/8 in. Library of Congress, Prints and Photographs Division.

CLIPPER SHIP "SOVEREIGN OF THE SEAS."

A SQUALL OFF CAPE HORN.

Business in Four Pictures" to "Coining Money at the San Francisco Branch Mint," with idyllic mining scenes and humorous depictions of the everyday activities of the argonauts among the most popular.

Prospecting on Feather River, Cal. is a representative letter-sheet illustration certain to capture the attention of loved ones in New York or Boston (fig. 8). The picture portrays an intrepid pair of prospectors in the sublime Pacific wilderness, searching for gold beside a raging cataract. This ideal image flattered the gold-seeking sender even as it encouraged the fanciful expectations of the eastern city dweller who was its typical recipient. Here was glorious California, shown as a sylvan Eden, where mammoth natural features dwarfed visitors. Significantly, however, while the letter sheet extolled the beauty of the California wilderness, it provided no evidence that the intrepid argonauts pictured had actually improved their economic status. Neatly sidestepping the issue of success in the gold mines, the magnificence of the scenery depicted in the letter sheet called for viewers to put aside pecuniary concerns and to calculate instead the transcendent value of the entire California experience. The image suggested that the prospectors' manly outdoor pursuits would strengthen their bodies and fortify their characters, regardless of the outcome of their labors in the goldfields.

The Lone Prospector, by Albertus Del Orient Browere (fig. 9), took up in the more refined format of oil on canvas the same theme as *Prospecting on Feather River, Cal..* The title of the work encouraged viewers to pay special attention to the solitude of the subject, a grizzled miner who makes his way across a wooded landscape. In the hierarchy of mining life during the early years of the gold rush, the prospector enjoyed an elite status. While most gold seekers kept to the security of familiar plots of land, prospectors were unwilling to submit to the routine work such mining required. These restless optimists wandered continually in

Fig. 8. Unidentified artist, Prospecting on Feather River, Cal., c. 1855. Lithograph/pictorial letter sheet, 11 1/4 x 8 3/4 in. California Historical Society, San Francisco.

Lith. & Pub.ᵈ by Britton & Rey S.F.

PROSPECTING ON FEATHER RIVER, CAL.

search of better prospects, even though they usually earned far less than those who remained with proven claims.[13] *The Lone Prospector* celebrates the independence of the wandering argonaut, whose *Argo* is the sure-footed mule, the only animal able to ferry him over the steep trails of the Sierra. The miner's few supplies—bedroll, pan, pick, and shovel—are neatly packed behind the saddle. The rifle he carries and the cool, appraising glance that he levels at the viewer warn passersby to keep their distance and reinforce the idea of the prospector's exclusive position.

Browere portrayed the prospector as the equivalent of the legendary mountain men who led the pioneering expeditions that opened up the West. He is shown as the successor of Daniel Boone, Davy Crockett, and other American heroes who lived outside

Fig. 9. Albertus Del Orient Browere, The Lone Prospector, 1853. Oil on canvas, 25 x 30 in. Collection of Hideko Goto-Packard.

the artificial restrictions of civilization, in direct and symbiotic association with nature. A description of a Rocky Mountain trapper made by Washington Irving in 1837 seems to parallel the artist's representation of the California miner:

> There is perhaps no class of men on the face of the earth who lead a life of more continued exertion, peril and excitement, and who are more enamored of their occupation:…No toil, no privation, no danger can turn [him] from his pursuit. His passionate excitement at times resembles a mania…he is to be found clambering the most rugged mountains… searching for routes inaccessible to horse, and never before trodden by white man…and such as we have slightly sketched it is the wild, Robin Hood kind of life, with all its strange and motley populace, now existing in full vigor among the Rocky Mountains.[14]

By representing the gold-rush miner as an explorer and scout for civilization and settlement, *The Lone Prospector* encouraged the clerks, tailors, and farmers who came to look for gold in California to cast themselves in the role of the swashbuckling trailblazers who filled the pages of American popular literature. Of course, gold seekers did not hide the fact that they were interested in the quick acquisition of wealth and intended to return shortly to the comfort of their homes in the East. As Prentice Mulford, an easterner who came to California in 1849, explained, "Five years was the longest period anyone expected to stay. Five years at most was to be given to rifling California of her treasures, and then that country was to be thrown aside like a used up newspaper and the rich adventurers would spend the remainder of their days in wealth, peace and prosperity in their Eastern homes."[15] Nevertheless, those who came to California found it appealing to think of themselves, particularly when encouraged by vivid images like *The Lone Prospector*, as the latest examples in a glorious tradition of American explorers.

Photographs of miners in the gold country also promoted the ideal of gold seekers as daring lone prospectors. The photograph had unique characteristics that made it particularly effective in communicating certain ideas about the gold rush. Americans at midcentury believed that, where drawn and painted images allowed the feelings of the artist or sitter to intrude on visual truth, the photograph provided an objective record of reality, something Edgar Allan Poe called the "identity of aspect with the thing represented."[16] Because of the skepticism that endless hyperbole and conjecture about the gold rush produced in the American public, the photograph's claim of authenticity made it a highly valued means of representing life in California. With the camera as their impartial witness, gold seekers could cash in their experience in the Golden State with pictures that documented their participation in the grand historical moment and authenticated their status as that most revered of American heroes: the self-made man.

Daguerreotype portraits tended to emphasize the self-reliance of subjects in the goldfields, revealing them as hearty men who had earned, through their willingness to toil and confront nature directly, the right to gather the riches of the earth. The lucky few who struck it rich might have themselves photographed with the material evidence. *Miner with Eight-Pound Gold Nugget* provides a rare example of a lone prospector who could satisfy the expectations of eastern viewers (fig. 10). The sitter tidied himself up properly for the portrait; shining sausage curls dangle behind his ears and his smooth cheeks reveal the barber's work. However, though his shirt and kerchief are neatly

*Fig. 10. Unidentified photographer, Miner with Eight-Pound Gold Nugget, c. 1850.
Daguerreotype, approx. 5 x 4 in. Collection of Mr. and Mrs. Philip Kendall Bekeart.*

laundered, the miner did not choose formal clothing, preferring to be shown in the working garb of the typical argonaut. Miners in the gold country adhered to a strict sartorial formula that was considered an essential component of the California experience. Even when sitting for the photographer, they proudly wore the rugged outfits that marked them as hardworking prospectors. In an account of his visit to California in 1851, the English reporter J. D. Borthwick noted that in the portraits the miners had made, "men of a lower class wanted to be shown in the ordinary costume of the nineteenth-century—that is to say, in a coat, waistcoat, white shirt and neckcloth; while gentlemen miners were anxious to appear in character, in the most ragged style of California dress." Describing a street scene in San Francisco, Borthwick also observed that "old miners, probably on their way home, were loafing about, staring at everything, in all the glory of mining costume, jealous of every inch of their long hair and flowing beards, and of every bit of California mud which adhered to their ragged old shirts and patchwork pantaloons, as evidences that they, at least, had 'seen the elephant.'"[17]

Seeing the elephant was the term used to describe a visit to the goldfields, an apt description that alluded to the circus, to exotic spectacles, and sleight of hand. *Miner with Eight-Pound Gold Nugget* addressed the skepticism inherent in the curious expression, and in prevalent attitudes toward the gold rush in general. The mammoth "nugget" the miner clasps to his bosom is the heart of El Dorado laid bare, the Word made manifest. The addition of gold tint, shining like a halo around the specimen, underscores the sanctity of the find. Here is the ultimate response to Doubting Thomases in the East who dismissed the gold rush as the work of confidence men. Through the unquestionable authority of the photograph, the image asserts that California mining is the work of righteous men, whose hard physical labor is punctually rewarded by an approving god.

Most argonauts who sat for photographic portraits were unable to present such

Fig. 11. Unidentified photographer, George W. Northrup, c. 1850. Daguerreotype, approx. 5 x 4 in. Minnesota Historical Society, Unique Image Collection.

Fig. 12. Unidentified photographer, Miner in a Fur Hat, c. 1850. Ambrotype, 5 1/2 x 4 1/4 in. Bancroft Library, University of California, Berkeley.

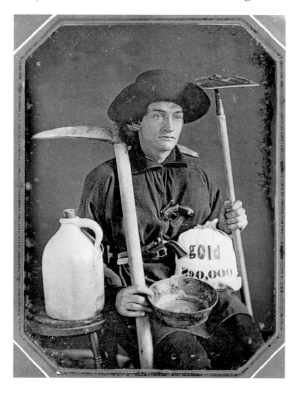

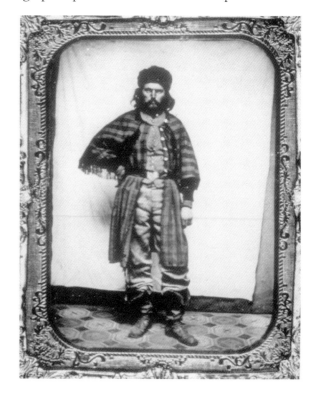

useful proof of value of their work, however. They had to make do with the familiar costume and mining paraphernalia to communicate positive ideas about the gold rush. Those who had little gold to display offered picks and knee-high work boots for the viewers' consideration (figs. 11–14). These props suggested that the sitters had interrupted their work in the goldfields just long enough to sit for their portraits and seemed to promise, though perhaps less persuasively than the large gold nugget, that the big strike was imminent.

Daguerreotypes of miners in work clothes or holding mining equipment also relied on viewers' familiarity with other gold-rush images to make their point. During the early 1850s, pictures of California mining that emphasized the vigorous physicality of the labor, as well as the wholesomeness of the outdoor setting, were widely disseminated in California and the East. Charles Nahl and his colleague Frederick August Wenderoth collaborated on a painting of 1851–52, *Miners in the Sierras*, which provides a typical example of this type of image (fig. 15). The painting portrays a small group of forty-niners laboring in the midday sun. One of the miners has stopped to take a drink from a bucket, as his companions continue to break up the river rocks and shovel the debris into the "long tom," a wooden trough used to sift out gold. The workers are dwarfed by the magnitude of the rugged landscape that surrounds them. Their small cabin, the only indication of settlement, appears insignificant beside the great boulders of the claim site. In the overwhelming vastness of the terrain, the patient labor of the miners assumes heroic proportions as well. Their wide-legged, straight-backed stance conveys their manly willingness to take on such a difficult project, as well as their pride and satisfaction with their work. The miner who drinks is so eager to continue that he does not lay down his shovel but rather rests its handle against his waist to be able to pick it up again more readily.

Fig. 13. Unidentified photographer, Miner with a Pick-axe, c. 1851-52. Daguerreotype, approx. 5 x 3 in. Bancroft Library, University of California, Berkeley.

Fig. 14. Unknown photographer, Miner, c. 1850. Daguerreotype, approx. 5 x 4 in. Collection of Peter E. Palmquist.

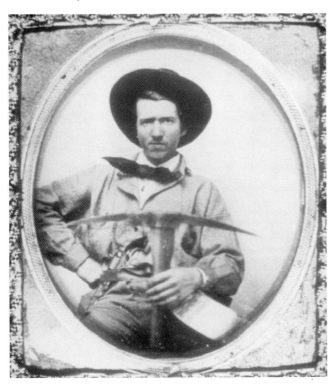

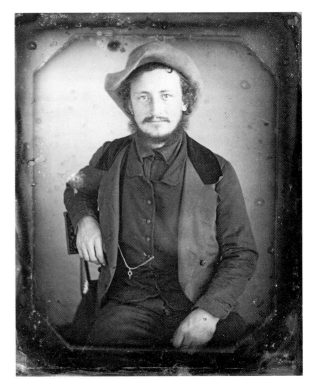

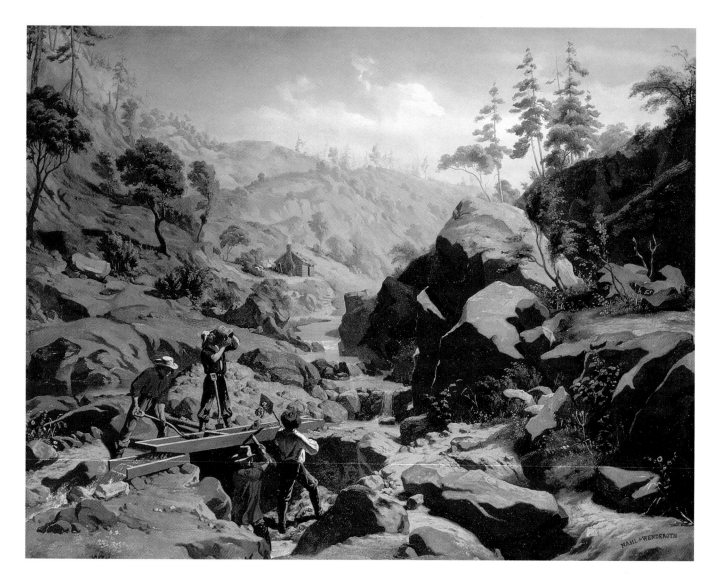

Fig. 15. Charles Christian Nahl and Frederick August Wenderoth, Miners in the Sierras, 1851–52. Oil on canvas, 54 1/4 x 67 in. National Museum of American Art, Smithsonian Institution, Washington, D.C.; gift of the Fred Heilbron Collection.

By the way it highlights the natural setting, and through its portrayal of the miners' absorption in their work, *Miners in the Sierras* defines the act of digging for gold as part of an intimate relationship between man and nature, in which the miner, through his labor, creates value out of what was previously raw and unusable. Nahl and Wenderoth's miners are mineral farmers, digging in the goldfields of the Sierra "until each spot shall be in cultivation, multiplying and fruitful."[18] Like farmers, they work the earth with simple tools and are subject to the rhythms of the days and the seasons. The transitory, speculative nature of placer mining is erased from the scene, as is the golden object of the men's activities.

The idea of miners as farmers played into the nostalgia of a city-based audience for a simpler agrarian past. Middle-class urbanites clung to Jefferson's idea that "those who labor in the earth are the chosen people of God," even as they concentrated themselves into increasingly large metropolitan centers. These city dwellers were the tireless buyers of an endless stream of books and magazines, popular prints, paintings, and poetry representing the pastoral ideal of farm life. An engraving of 1867 from *Harper's Weekly Magazine* illustrates the type of rural scene appreciated by Americans at midcentury (fig. 16). Despite the fact that California was the most urbanized state in the Union at that

time, relative to the size of its population, Nahl and Wenderoth chose to represent it as a variant on the agrarian tradition that was thought to undergird the nation.[19]

Though Nahl, Wenderoth, and other image makers pictured California's vast landscape as a place where resources were inexhaustible, the gold rush was, in fact, a brief phenomenon. The years 1848 and 1849 were the halcyon days when relatively small numbers of miners with pans, knives, and other simple tools could easily harvest the gold that lay close to the surface. By the early 1850s, however, the individual nomadic prospecting that had been the dream of most argonauts was largely a thing of the past. The lone prospector, or the small partnership envisioned in *Miners in the Sierras*, could usually no longer profitably work a claim. Accessible surface deposits had been exhausted by the more than one hundred thousand argonauts who had picked over the goldfields since 1848. After 1851, getting the precious ore required elaborate systems of flumes, dams, and sluices, which were increasingly operated by mining companies able to make the sizable initial investment and to hire salaried laborers.

When the days of easy diggings were over, the clerks, farmers, and clergymen who had populated the goldfields filtered back to Sacramento, San Francisco, and smaller urbanized areas in the state. Many decided to settle in California, creating a growing merchant class dedicated to the commercial development of the region. The former argonauts took advantage of opportunities offered by industries that originally emerged

Fig. 16. J. W. Enninger, Gathering Pumpkins—an October Scene in New England, c. 1867. Wood engraving, approx. 14 x 15 in. Library of Congress, Prints and Photographs Division.

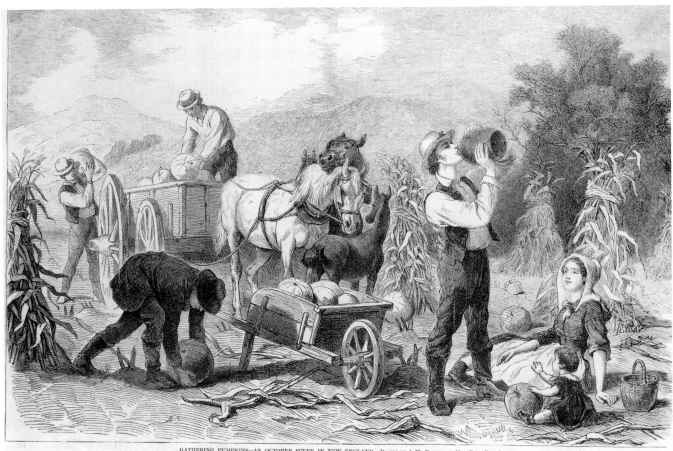

GATHERING PUMPKINS—AN OCTOBER SCENE IN NEW ENGLAND.—Drawn by J. W. Ehninger.—[See First Page.]

Fig. 17–19. Charles Christian Nahl:
The Gambler. From Delano, Pen Knife
Sketches; or, Chips off the Old Block
(1853), 25. Private collection; The
Greenhorn. From Delano, Pen Knife
Sketches; or, Chips off the Old Block
(1853), 7. Private collection; The
Miner. From Delano, Pen Knife
Sketches; or, Chips off the Old Block
(1853), 11. Private collection.

to sustain the mining population—manufacturing, banking, transportation, retail marketing, and agriculture. Because the success of these ventures depended on a permanent population of local consumers, the settlers worked to establish social and cultural institutions based on eastern prototypes that they hoped would, in turn, encourage further immigration. Business leaders promoting settlement were highly conscious of the unorthodox history of the state and worried about the effect the gold rush would have on future economic development. Though California owed its initial growth to wild speculation, its developers hoped to change this early pattern by representing the state as a place where investors could make reasonably accurate financial projections.

The desire for a prosperous future altered the way that California's past was presented to American audiences. As the golden era drew to a close in the early 1850s, pictures of lone prospectors in the wilds of the Sierra gave way to images of argonauts in more settled environments. Pictorial letter sheets, newspaper illustrations, and paintings focused on nostalgic descriptions of mining camps in the gold country, places whose very names—Helltown, Whiskey Flat, Last Chance, Rough and Ready—seemed to resist latter-day attempts to idealize them. These were the settlements that sprang to life as supply outposts for the large numbers of gold seekers who swarmed over the Sierra after 1848. Wherever a rich strike was made, enterprising merchants quickly set up stores that supplied miners with shovels, shirts, liniment, and other needed items. Saloon keepers, professional gamblers, and prostitutes also arrived to share the good fortune. Men who owned mining operations could afford to stay at boardinghouses; others went to the camps on Sundays to spend what they had earned during the week as hired laborers. If the local gold deposits held out, the camp developed into a town. In most cases, however, miners moved on after the claims were exhausted, followed by a retinue of businessmen and -women in search of new opportunities.

Because of their remoteness from government authority, mining camps were plagued by violence and lawlessness. William Perkins, a resident of the Sonora camp in Tuolumne County, recorded in his journal the murders that occurred in the settlement. During one monthlong period in 1850, he counted eleven killings. The dead included two men from Massachusetts whose throats were slit as they slept in their tents, a Mexican stabbed to death by a Frenchman, and a Chilean shot in a gunfight. Perkins discovered the body of another victim on his doorstep when he returned home one night. Observing that gambling continued uninterrupted when a man was gunned down at the bar of the local saloon, Perkins remarked, "It is surprising how indifferent people become to the sight of violence and bloodshed in this country."[20]

By the late 1850s, the brutality of the camps had faded from the memory of the American public, helped along by carefully edited por-

trayals of camp life. Pictures of the golden era showed the settlements, not as riotous free-for-alls, but as refining mechanisms through which superior social groups established their rightful dominance. By defining a series of moral "types" who populated the camps—the industrious miner, the greenhorn, the gambler, the harmless inebriate, the idle miner—such images suggested that even the toughest settlements were regulated by the same order that governed society in the East (figs. 17–19). These types allowed viewers to feel the gold rush was aligned, despite initial appearances to the contrary, with the development of respectable society in California.

Writing in the 1880s, Hubert Howe Bancroft reiterated the optimistic assessment that was expressed in pictures of the camps:

> A marked trait of the Californians was exuberance in work and play, in enterprise or pastime—an exuberance full of vigor. To reach [California] was in itself a task which implied energy, self-reliance, self-denial and similar qualities; but moderation was not a virtue consonant with the new environment. The climate was stimulating. Man breathed quicker and moved faster; the very windmills whirled here with a velocity that would make a Hollander's head swim. And so like boys escaped from school, from supervision, the adventurer yielded to the impulse, and allowed the spirit within him to run riot…. Amid the general free and magnificent disorder, recklessness had its votaries, which led to…a full indulgence in exciting pastimes. All this, however, was but the bubble and spray of the river hurrying on to a grander and calmer future.[21]

Not surprisingly, the glimpses of mining-camp shenanigans published in California letter sheets, illustrated books, and newspapers avoided graphic descriptions of murder and mayhem. They described benign examples of naughtiness that showed miners as members of a grand fraternal order devoted to adventure and fun. Rough and Ready, Helltown, and Last Chance cast off the aspect of genuine wickedness and villainy, becoming instead colorful settings for extended bachelor parties that made the daily routines of those at home seem hopelessly drab in comparison. Such images made light of worries about the nature of gold-rush society and its consequences for the state's progress, using humor to cajole concerned viewers into a more positive frame of mind.

A series of lithographs made from sketches by the artists August Ferran and José Baturone revealed the harmless indiscretions of the argonauts. Published in the early 1850s, *Album Californiano: Colección de tipos observados* contained examples of miners afflicted by "A Light Indisposition," resolving "Solid Arguments," and enjoying "Solid Comfort" (figs. 20–22). As illustrations of the unfettered atmosphere of the gold country, these "California types" are reassuringly temperate in their misbehavior. Indeed, their most serious sin, rather than murder or robbery, seems to be sloth. The argonauts, who yawn, lean, and stagger, appear to be suf-

fering from a glandular deficit that saps their energy for more spirited mischief making. Clearly, these sedate fellows are merely on a brief detour from the straight and narrow path. When the "bubble and spray" of the golden era dies down, they will be hotel keepers, policemen, and bankers in the new order. In any case, the miners' lack of animation and the static, posed nature of their forms confirm that the gold rush has run out of steam—leaving a more tranquil society to emerge in its wake.

The "foreigner" was another type defined in pictures of camp life. Representations of ethnic outsiders played an important role in shifting viewers' perception of the gold-rush camp by suggesting that, even in the wilds of California, cultural parameters were clearly defined. Such images identified and isolated aliens, including indigenous Californians, Spanish-speaking Californians, and Chinese, using humor to communicate the idea that these residents were ridiculous or incompetent (figs. 23–25). The Chinese, who immigrated to California in large numbers during the 1850s, were a favorite target of white settlers reluctant to share the state's resources. One contemporary print, *Celestial Empire in California*, shows

Figs. 20–22. (previous page) Augusto Ferran: A Light Indisposition, 1850. Tinted lithograph, approx. 10 1/8 x 8 1/8 in. © Collection of The New-York Historical Society; Argumentos Solidos (Solid Arguments), 1850. Tinted lithograph, approx. 10 1/8 x 8 in. California Historical Society, San Francisco; Posiciones Comodas (Comfort), 1850. Tinted lithograph, 10 7/8 x 8 7/8 in. California Historical Society, San Francisco; gift of Henry R. Wagner.

Fig. 23. (above) Frank Marryat, Quilp. From Marryat, Mountains and Molehills (1855), 73. Private collection.

Fig. 24. (right) Frank Marryat, John Chinaman. From Marryat, Mountains and Molehills (1855), 333. Private collection.

Chinese miners in a typically unflattering light. The print depicts the "Celestials" on a day of repose, engaged in the activities criticized most often by whites: eating, caring for their hair, and gambling. The huddled aspect of the subjects and their lack of individualized features hint at the foreigners' lack of respect for individualism—the most revered component of the gold rush as set forth by those promoting the state. The image also provides evidence of the "numberless legions" of Chinese that whites in California feared might "one day overthrow the…Republic of the United States."[22]

The top frame shows Chinese helping themselves to a communal dish, possibly the "rice and saltworms" described in popular books of the 1850s, opening their mouths wide as they drop in the "dubious looking" morsels with their chopsticks.[23] Other Chinese are occupied with tonsorial matters. On the right, a man scowls as the front of his head is shaved by a countryman. In the background, we see another whose queue is

being braided. The queue the object of endless derision in contemporary accounts, and the sight of "John Chinaman" busy with his tresses was guaranteed to elicit a disdainful snicker from the American viewer.

If the top half of the print demonstrates that the Chinese had repugnant personal habits, the bottom section suggests that they were also immoral. In this section, the Chinese are shown crowded into a dark gaming hall, their grimacing faces made grotesque by the glaring torchlight. The greed of the gamblers is expressed by the attentive way they follow the proceedings on the table with hooded eyes. In the background, other groups of gamblers swarm conspiratorially around other gaming tables,

Fig. 25. Unidentified artist, Celestial Empire in California, c. 1854. Lithograph/pictorial letter sheet, 10 1/2 x 8 3/16 in. California Historical Society, San Francisco.

seemingly ad infinitum. Clearly, these are not the gamblers with hearts of gold who graced the pages of popular gold-rush stories, but an element that is disturbing and out of place on American shores.

The image of those commonly referred to as the "heathen chinee," coupled with pictures of the other reprehensible types who populated the mining camps, served as the perfect counterpoint to the image of the industrious miner, symbol of the solidarity of the merchant class in California. Where pictures of outsiders and misbehavers conceded that California was still in an evolutionary phase, representations of industrious miners pointed the way for the future development of the state. During the years following the gold rush, images of industrious miners became increasingly bold in the claims they made about the salubrious effects of the gold rush. During the 1850s, it was enough to show miners in a well-built cabin to assert that the foundations of correct society had been laid. By the 1870s, as mining imagery became untethered from the verifiable facts of the past, the same ideas were communicated by portrayals of camp residents writing home dutifully to their parents, doing their weekly laundry, and forming groups for Sunday Bible study.

Fig. 26. Henry Walton, William Peck—Rough and Ready, 1853. Oil on board, approx. 12 x 17 in. Oakland Museum of California.

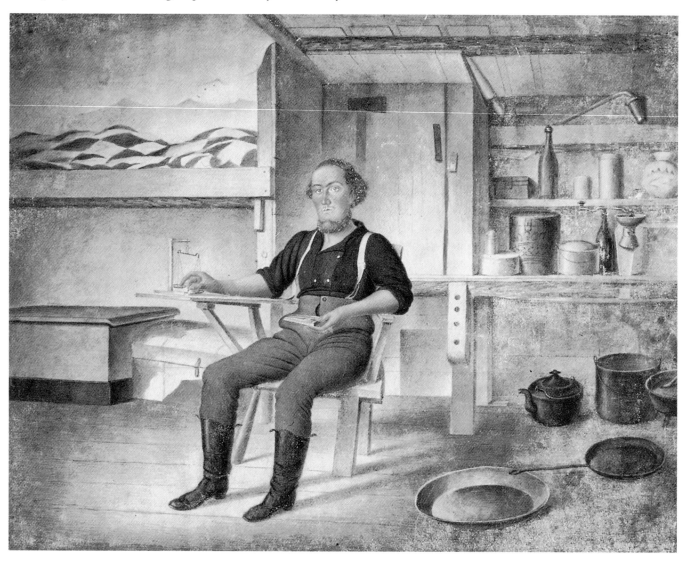

A portrait of an argonaut made at the beginning of the 1850s is an early example of the industrious miner type (fig. 26). The subject, William Peck, shown in his cabin at Rough and Ready, embodies the transformation of the unencumbered lone prospector into the respectable Yankee entrepreneur. Surrounded by the carefully noted inventory of his washbowl, cooking pots, blanket, and axe, Peck looks out at the viewer with a confident expression. His well-constructed house isolates him visually from the camp environment and suggests that the sitter owns a claim providing a steady income. Peck's mining success is also implied by his numerous supplies, which represent a substantial

Fig. 27. Unidentified artist, Miner's Coat of Arms, c. 1855. Lithograph, 10 3/16 x 7 11/16 in. California Historical Society, San Francisco.

financial outlay. In the camps, housing, tools, and simple amenities were outrageously expensive, owing to the cost of transportation from the state's urban centers and to the captive market of buyers in the Sierra. During a time when seventy-five cents represented an average daily wage in the East, an egg in the camps cost seventy-five cents; boots, thirty-five dollars; a blanket, twelve dollars; and a barrel of flour, thirty-five dollars—shocking amounts that astonished the nation.[24]

Peck is not content, however, to let his well-equipped cabin speak for itself. In his left hand, he holds a quantity of gold dust while, with his right hand, he touches the scales that will measure and confirm the amount. The measuring of value is, indeed, the idea that informs the whole painting, answering the question that was on the lips of everyone in the camps, and of those who waited at home: How much did you make? The painting assures the viewer that Peck has made a tidy profit during his sojourn in

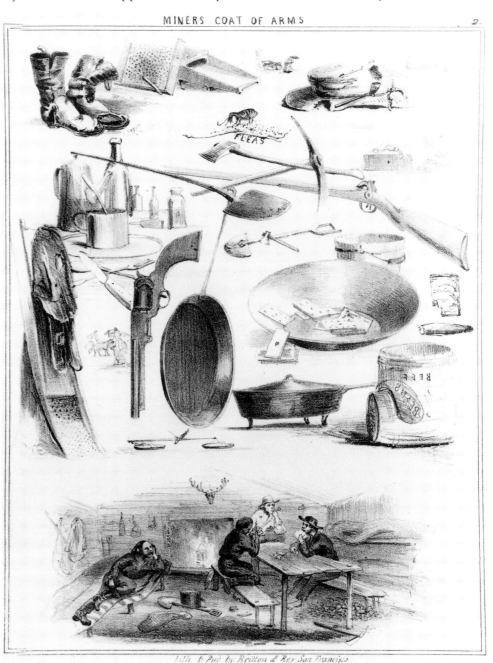

MINERS COAT OF ARMS 2.

Lith. & Pub. by Britton & Rey San Francisco

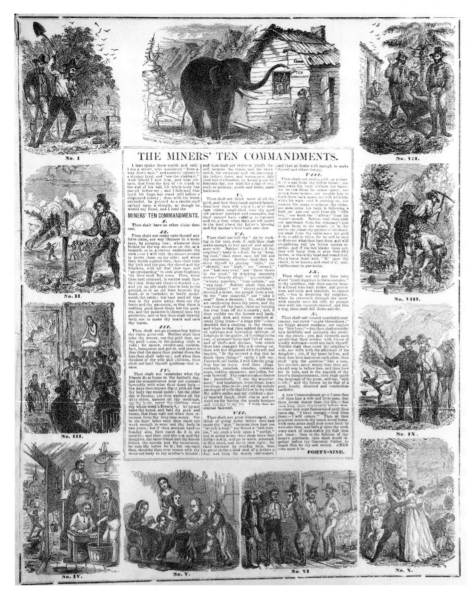

Fig. 28. Unidentified artist, The Miners' Ten Commandments, c. 1853. Wood engraving, approx. 10 x 16 in. California Historical Society, San Francisco.

the mines. It also demonstrates that, even at the infamous Rough and Ready camp, industrious miners could rely on the inevitable sequence of hard work and reward to sustain them. Furthermore, Peck's sturdy boots and rolled-up sleeves imply that he has not yet finished his labors—more strikes, and bigger ones, are to come.

Popular visual media, including prints, lithographs, and pictorial letter sheets, did much to effect the metamorphosis of the lone prospector into the industrious miner. While these forms often pointed out the bizarre and the curious in their descriptions of mining life, they did so in a way that implied that transient oddities were to be expected in a state that had developed as rapidly as California, but that all would soon settle into a familiar normalcy. Two of the most popular prints of this sort, which were subsequently also issued as letter sheets, were *Miner's Coat of Arms* and *The Miners' Ten Commandments* (figs. 27 and 28). In the first, miners' equipment is laid out for the viewers' inspection, as in Peck's cabin. A dilapidated pair of boots, pistol, shovel and pick, cooking pot, mining cradle, and fleas make up the exhibit. At the bottom of the print, a sketch of a familiar cabin interior is included. By calling this humble display a "coat of arms," the print humorously links the miners of California with medieval knights and European aristocrats. The use of the heraldic device also affirms that hereditary aristocracy, much despised by all red-blooded Americans, had been replaced in California by a meritocracy that rewarded enterprise and hard work. A patriotic observer of miners in the Sierra expressed the prevailing sentiment when he declared, "Clear out of the way with your crests, and crowns, and pedigree trees, and let this democrat pass!"[25]

The publishers of *The Miner's Coat of Arms* showed an astute appreciation for the tastes of their clients. Americans at midcentury were highly conscious of the differences between the United States and Europe and attached extraordinary importance to the nation's democratic "mission." The print latched onto the prevalent fascination with the

past (over one-fourth of all best-selling books of the period were histories or historical in subject matter) and the desire of the American public to define the country's place in history.[26] George Templeton Strong, an easterner writing in his diary in 1854, articulated the national sentiment:

> We are so young a people that we feel a want of nationality, and delight in whatever asserts our national "American" existence. We have not, like England and France, centuries of achievements and calamities to look back on; We have no record of Americanism and we feel its want…. We crave a history instinctively, and being without the eras that belong to older nationalities—Anglo-Saxon, Carolingian, Hohenstauffen, Ghibelline, and so forth—we dwell on the details of our little all of historical life, and venerate every trivial fact.[27]

Fig. 29. Unidentified artist, "Pull Away Cheerily," c. 1851. Printed sheet-music cover, 14 x 10 in. Bancroft Library, University of California, Berkeley.

Miner's Coat of Arms presented the golden era as the American answer to the Carolingian and Hohenstauffen eras. Behind its tongue-in-cheek approach was the insistence that the gold rush should be interpreted as a healthy manifestation of America's rejection of the despotisms of the Old World. The miner's humble gear, and the allusions pick axes, dusty hats, and boots made to work, risk taking, and life in the great outdoors, made these items fitting symbols of the national character as it revealed itself in California, and of the ways in which the Golden State was aligned with a common national purpose.

Where *Miner's Coat of Arms* linked the gold rush to American democratic ideals, *The Miners' Ten Commandments*, a witty revision of the biblical decalogue published in 1854, suggested that miners in California were guided by the same Christian tenets that acted as a beacon for the nation. Though satirical in tone, *The Miners' Ten Commandments* proposed certain bona-fide rules for behavior in the goldfields. "Thou shalt have no other claim than one," admonished the God of Mining. The commandments also decreed that "Neither shalt thou take thy money, nor thy gold dust, nor thy good name, to the gaming table in vain," and "Thou shalt not think more of all thy gold, and how thou canst make it fastest, than how thou wilt enjoy it, after thou hath ridden rough shod, over thy good old parent's precepts and examples." Apparently, contemporary audiences were charmed by the idea that gold-rush argonauts could be tamed by the golden rule;

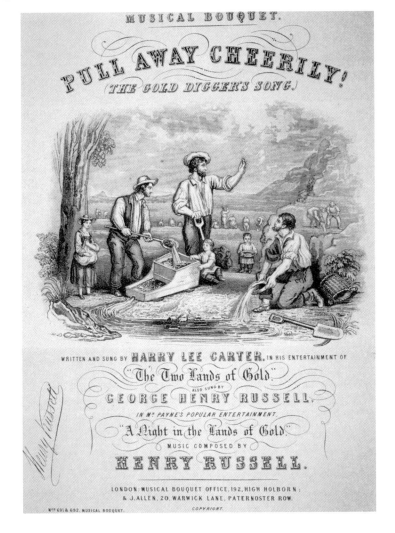

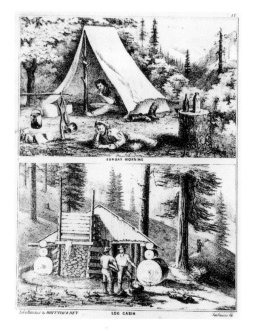

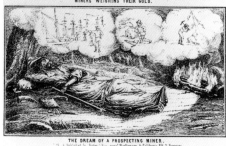

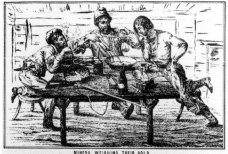

when published in letter-sheet form, it sold almost one hundred thousand copies in one year.[28]

The transition of the miner from lone prospector to industrious miner and the increased dignity of mining labor were subjects taken up in popular songs of the 1850s. "The Miner's Song," allegro in tempo, told of miners who rose with the sun and eagerly began the workday: "'Tis time the pick axe and the spade / against the rocks were ringing / And with ourselves the golden stream / a song of labor singing." Another melody, "The Gold Digger's Song," urged the miner to "Pull away cheerily, Not slow or wearily / rocking your cradles, boys, fast to and fro / ha', ha', ha', ha', ha', ha." The lyrics of these and other gold-rush tunes focused on the physical aspect of mining and alluded to a workforce that was not only hardworking but also cheerful and musically inclined (fig. 29).

A promotional tract written in 1858 attempted to have the last word on the diligent character of the industrious miner. "[Miners] have done more hard work in California in the last eight years," the author wrote, "than has ever been done in any country by the same number of men, in the same length of time and, I think I may safely say, double that time, since the world was made."[29] To this, the state's ardent boosters could respond with a hearty "Amen."

The theme of the industrious miner that was introduced by works like the portrait of William Peck and reinforced by *Miner's Coat of Arms*, *The Miners' Ten Commandments*, and popular songs surfaced repeatedly in paintings, illustrated newspapers, and books during the decades following the gold rush. Charles Nahl, who by the mid-1850s had established his reputation as the foremost artist in California, used the subject again and again in the sketches he made for local publications. He also experimented with the setting of the miner in a cabin

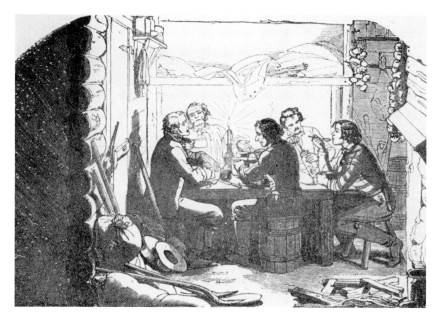

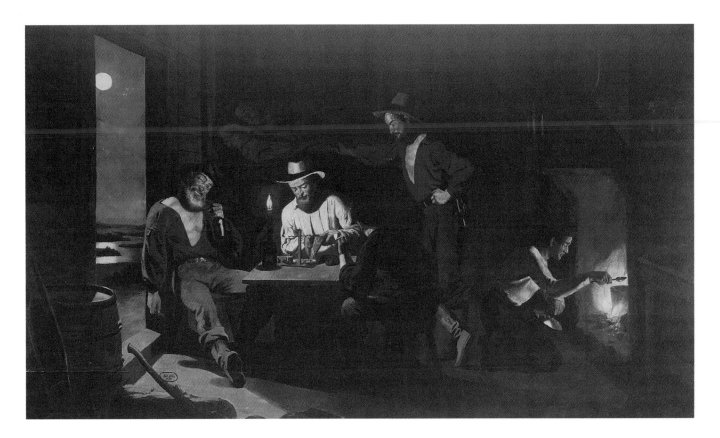

interior that was used so effectively in William Peck's portrait and that was a popular subject in local illustrated newspapers and letter sheets (figs. 30 and 31). A typical example of Nahl's work in this vein, which was included in a book of gold-rush stories by the author Alonzo Delano in 1855, shows a group of forty-niners gathered for their evening meal (fig. 32). A single candle illuminates the faces of the men and their simple surroundings. Despite the absence of gentility in the miners' rustic abode, the tools that lie on the ground and the animated camaraderie of the diners suggest that all was as it should be in the foothills of the Sierra. The sketch seemed to echo ideas expressed in *The Annals of San Francisco*, a chronicle of California's largest city published in 1855: "California is perhaps not yet quite so subject to the influence and strength of LAW as most of the Atlantic states or the more civilized countries of Europe," the authors admitted, "but she is fast being gently and securely broken in to its majestic and salutary sway. Her career has been unlike that of any modern nation, and the many anomalies in her history must be peculiarly and leniently judged."[30]

In 1856 a client commissioned Nahl to make an oil painting of miners in a cabin interior (fig. 33). The work, entitled *Saturday Night in the Mines*, was first displayed in a Sacramento saloon. It is unknown whether Nahl knew the destination of his work when he received the commission; in any case, he presented the subject in a way that ensured the painting would be noticed by all but the most intemperate customers. The canvas measures ten by sixteen feet, making the figures only slightly less than life-size. The heroic scale of *Saturday Night in the Mines*, which recalls the epic history that was the California argonaut's glorious precedent, also serves to include the viewer in the miners' informal gathering. The human scale of the subject invites onlookers to step metaphorically into the cabin and to join the simple pleasures of the evening activities, which, as the title of the painting indicates, take place at the end of the day and at the close of the work week.

Fig. 33. Charles Christian Nahl, Saturday Night in the Mines, 1856. Oil on canvas, 120 x 192 in. Iris & B. Gerald Cantor Center for Visual Arts at Stanford University.

Fig. 32. (bottom, opposite page) Charles Christian Nahl, Old Block's Cabin, c. 1856. From Delano, Old Block's Sketchbook (1856), 7. Private collection.

A moon peeks through a door casually left open, and light of a cooking fire wash-es the miners' faces with a golden glow that alludes to the object of their activities in California, even as it fills the room with a sense of serenity and domesticity. Nevertheless, as the viewer's eyes adjust to the dimness, it is apparent that the cozy household envisioned by Nahl reveals certain distinctly odd characteristics. Rather than a motherly figure, a miner stirs the cooking pot. Furthermore, there is no meal in evi-dence yet—the only thing visibly consumed is hard liquor, by a smiling, grandfatherly figure who leans drunkenly on a chair as he raises a bottle to his lips. Next to him, another miner weighs a quantity of gold dust, as his two "pards" look on attentively. At the rear of the cabin, rather than a babe in a cradle, a weary miner sleeps in his bunk.

Despite the strangeness of the miners' circumstances, the flattering light of the tran-quil interior invites viewers to notice the ways the adventurers have ordered their life in California according to eastern standards of respectability. The cabin is well organized and comfortable, and chores have been divided democratically so that, while some of the miners take their turn with the cooking, others are free to relax. The axe that sits on the floor beside the drunken miner affirms that he, too, has done his share of the work and has earned his nightcap. Earning and work are, in fact, the unifying elements of the composition. The miner who calculates the value of the week's gold diggings at the cen-ter of the canvas legitimizes the unusual setting and peculiar activities of his partners by confirming the worth of the labor that the gold represents. The ritual he enacts serves to redeem the unorthodox mining fraternity and obliges the viewer to agree that, indeed, all might be forgiven in the name of this higher good.

Reinforcing the idea of the honest, outdoor quality of the miners' work is the nat-ural setting glimpsed through the doorway and the men's heavy, mud-spattered boots. These elements, combined with the coziness of the cabin and the appealing informality of the comrades who wait for their dinner as it simmers on the fire, work to dispel lin-gering doubts about the nature of mining-camp life. Indeed, the only acknowledgment of the negative effects of the loosening of the restraints of society in gold-rush California occurs in the figure of the drunken miner who, in his benign and smiling tipsiness, begs to be "peculiarly and leniently judged." Certainly, through its promise of abundant resources, tranquility, and personal freedom, Nahl's idyllic vision of an enchanted evening in the Sierra is calculated to have a similarly intoxicating effect on the viewer.

Saturday Night in the Mines pictured the gold rush as a strategic moment in the evo-lution of the state, when self-reliant argonauts established a benevolent social order that would predominate in later years. During the 1860s and 1870s the writings of Bret Harte, Mark Twain, and other local-color authors also reinforced the idea that mining society, despite its flaws, contained a seed of civilization that would flourish in the fol-lowing decades. Harte's irreverent parables about rowdy miners and their redeeming virtues were especially popular, particularly in the East. Writing at the end of the Civil War, the author understood the yearning of his largely urban audience for simpler times and faraway places. In 1871 the *Atlantic* magazine offered Harte ten thousand dollars for exclusive publishing rights to his California stories, making him the highest-paid author in the United States to that date.[31]

More than fifteen years after the gold rush, Harte's tales conveyed the essence of "seeing the elephant" for city dwellers in Boston and New York. "The Luck of Roaring Camp," one of Harte's most widely read stories, described a group of hardened miners who care for the newborn infant of the camp prostitute after she dies in childbirth.

Following a brief description of the squalid circumstances surrounding the baby's conception and birth, Harte apprised his readers of the impending moral transformation of the camp through the figure of Kentuck, a rough-mannered prospector:

> As Kentuck bent over the candle-box half curiously, the child turned, and, in a spasm of pain, caught at his groping finger, and held it fast for a moment. Kentuck looked foolish and embarrassed. Something like a blush tried to assert itself in his weatherbeaten cheek. "the d——d little cuss!" he said, as he extricated his finger with perhaps more tenderness and care than he might have been deemed capable of showing. He held that finger apart from its fellows as he went out, and examined it curiously. The examination provoked the same original remark in regard to the child. In fact, he seemed to enjoy repeating it. "he rastled with my finger," he remarked to Tipton, holding up the member, "the d——d little cuss!"[32]

The saccharine benevolence of "The Luck of Roaring Camp" and the numerous imitations it inspired appealed to audiences affected by the serious economic problems that plagued California and the nation during the 1870s. The Civil War and the building of the transcontinental railroad, which had buoyed the state's economy and that of the nation for almost ten years, were finished by the end of the 1860s. Flush times were followed by a decade of falling prices, unemployment, and social unrest. Americans

Fig. 34. Charles Christian Nahl,
Sunday Morning in the Mines, 1872.
Oil on canvas, 72 x 108 in. Crocker Art
Museum, Sacramento, E.B. Crocker
Collection.

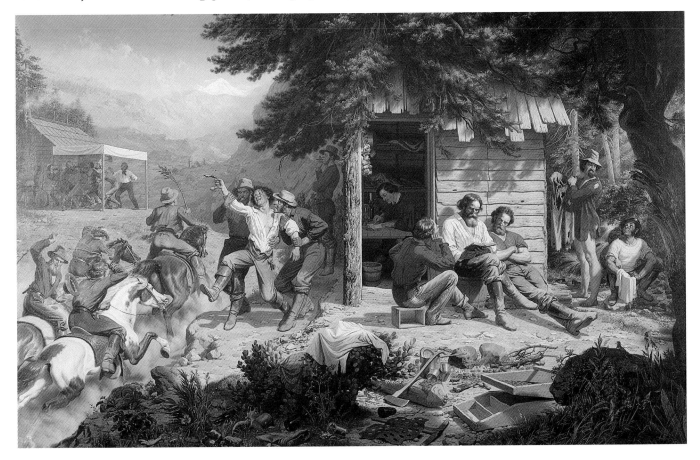

looking for an end to the economic depression would have found it comforting, certainly, to contemplate Harte's gold-rush parables. By celebrating the American genius for self-government and enterprise, and by affirming the resilience of citizens' moral foundation, such stories foretold a swift amelioration of the nation's financial woes. Conveniently, these tales also promoted California as a source of inspiration during the national soul-searching that accompanied the economic troubles.

Even as Harte's stories sought to redeem the California gold seeker in the mind of the American public, other works attempted the full-scale apotheosis of the gold-rush miner. A California scene painted by Charles Nahl in 1872, *Sunday Morning in the Mines*, illustrated the burden of weighty ideals that had accrued to the figure of the miner twenty years after the discovery of gold (fig. 34). Commissioned by the railroad tycoon E. B. Crocker to decorate the stairway leading to his celebrated ballroom, *Sunday Morning in the Mines* drew its inspiration from Michelangelo's frescoes in the Sistine Chapel and from the works of other old masters that portrayed the divine settling of accounts for the blessed and the damned.

Sunday Morning in the Mines envisioned a typical mining camp in the foothills of the Sierra. The artist portrayed the settlement on Sunday, the day on which miners could either confirm or deny the bonds of the society from which they had come. On the other days of the week, argonauts worked together, united by their quest for gold. On the Lord's Day, however, idle miners differentiated themselves from industrious miners by the way they chose to spend the Sabbath. To convey the idea of the moral schism that became manifest on Sunday, Nahl divided his canvas into two halves: predictably, idle miners were pushed into the left, or sinister, side of the painting. Significantly, their activities are no longer the harmless antics of Nahl's earlier works or of the rowdy forty-niners described by Harte. As if convinced of the immunity granted by the passage of the years, *Sunday Morning in the Mines* openly confesses the sins of camp residents.

Many are portrayed as genuine criminals—uncontrolled and vicious. In the background, a brawl erupts among a group of cardplayers who attack each other with unrestrained fury. One miner prepares to bring a stool down on the head of his adversary, as another strangles his opponent. A well-dressed city slicker shoots his victim in the back of the head before fleeing with a bag of gold. A few feet away, galloping at full speed through the middle of the camp, miners whip their horses in a race to nowhere. A youthful miner on a Sunday binge cheers them on, waving high his bag of gold dust, the week's earnings. Two vicious-looking characters grasp his arms to prevent him from stumbling into the horses' path, at least long enough to steal his bag of gold. Behind them, a bystander surveys the tumult of murder and mayhem before him—and calmly smokes a cigarette. In the distance, the lofty Sierra—handiwork of the Almighty—are also silent witnesses.

The left side of the painting is separated from the right by a large pine, evocative of the biblical tree of knowledge. On the right side of this symbolic barrier, the Sabbath is properly observed. One industrious miner, whose features recall the God of the Old Testament as envisioned by Michelangelo on the Sistine ceiling, reads the Bible to a pair of contemplative friends. Inside the cabin, a neatly dressed and shaved miner writes a letter that begins, "Dear Mother." Flanking these exemplary argonauts, and demonstrating that gold-rush cleanliness was indeed next to godliness, are a pair of half-naked miners who joke as they attempt to wash their threadbare work clothes. The ground in front of them is covered with tools, cooking pots, drying laundry, and other items that hint at

the miners' virtue and reinforce the image of respectability personified by the "right" miners.

Sunday Morning in the Mines presented the gold rush as a refining mechanism through which the flawed elements of California society would be purged, leaving only a superior class of men who, by the inevitable default of those beneath them, would control the new order. The painting did not portray the golden era as a struggle in which the strong wrested power from the weak, but as a process that merely accelerated the unavoidable self-destruction of flawed newcomers, allowing positions of leadership to fall to their betters. In this way, *Sunday Morning in the Mines* represented for its elite audience a historical reflection of events occurring in California during the 1870s, when economic uncertainty and social unrest threatened to upset the tentative order the merchant class had established. Through its glorification of California's past, the painting reassured the artist's well-to-do client and his guests that certain innate aspects of their character would allow them to prevail over the races and economic classes that posed a threat to the status quo.

The pervasive idea of "Lex Saxonum," or the Anglo-Saxon's peculiar instinct for self-government, was the engine that powered *Sunday Morning in the Mines*. A book published in 1885, *Mining Camps: A Study in American Frontier Government*, articulated the Darwinian approach to California history that was favored by the business elite, and which the painting enacted so vividly:

> It is the place held by the Argonaut as an organizer of society, that is most important. He often appears in literature as a dialect-speaking rowdy, savagely picturesque, rudely turbulent: in reality, he was a plain American citizen cut loose from authority, freed from the restraints and protections of law, and forced to make the defense and organization of society a part of his daily business. In its best state, the mining camp of California was a manifestation of the inherent capacities of the race for self-government. That political instinct, deep-rooted in Lex Saxonum, to blossom in Magna Charta and in English unwritten constitution, has seldom in modern times afforded a finer illustration of its seemingly inexhaustible force. Here, in a new land under new conditions, subjected to tremendous pressure and strain, but successfully resisting them, were associated bodies of freemen bound by common interests, ruled by equal laws, and owing allegiance to no higher authority than their own sense of right and wrong.[33]

By staging his painting as a contest between civilization and chaos, Nahl called on historical memories of pilgrims and their struggle in the wilderness and other ideas central to the American experience. Industrious miners were portrayed as the new chosen people who, like their New England ancestors, would vanquish the savages of the new land and thus earn title to the bounty that surrounded them. Undoubtedly, the elite group of Californians who would have seen *Sunday Morning in the Mines* at E. B. Crocker's famous Sacramento mansion would have been flattered by its heroic interpretation of their past, and encouraged by its optimistic allusions to their future.

Though the golden era was long over when Nahl created his grand canvas, gold mining still existed in California during the 1870s. It was, of course, something utterly different from the uncomplicated process alluded to in *Sunday Morning in the Mines*. By

the 1870s hydraulic mining, which employed a high-powered stream of water to loosen the soil, had become the favored method for extracting the remaining gold of the Sierra. Scouring the face of a hillside with powerful hoses, miners were able to process massive amounts of "pay dirt" and profitably work sections that contained as little as five cents' worth of gold in a cubic yard. Lone prospectors were replaced by armies of Chinese and Mexican laborers who erected the complex systems of flumes and sluiceways that provided the vast amounts of water required by the hoses. These workers also processed the debris created by the hydraulic process, sifting through deep mud to locate the gold dust washed from the cliffs.

Though the construction of a hosing operation was expensive and labor-intensive, the results were reasonably profitable for mining companies able to shoulder the start-up costs. Despite its advantages, however, hydraulic mining was devastating to the landscape and permanently altered the topography of the gold country. Entire mountainsides were often cut away. One pit left by hydraulic hoses measured over one mile long and was 550 feet deep.[34] Nevertheless, a visitor to the mines in the 1880s described the results of the new technology in glowing terms: "I have visited the mining region, the realm of the 'Argonauts of Forty-Nine.' Titans have been at work there. The land for miles is like a battle-field where primal forces and giant passions have wrestled. Rivers have been turned aside; mountains hurled into chasms, or stripped to bedrock in naked disarray."[35]

Just as the "titans" of California industry continued to scratch away at waning gold deposits during the latter years of the century, so image makers and their patrons con-

Fig. 35. Carleton Watkins, Primitive Mining—the Rocker Calaveras Co., Cal., c. 1883. New Boudoir Series. Albumen silver print, 4 3/8 x 6 15/16 in. California State Library.

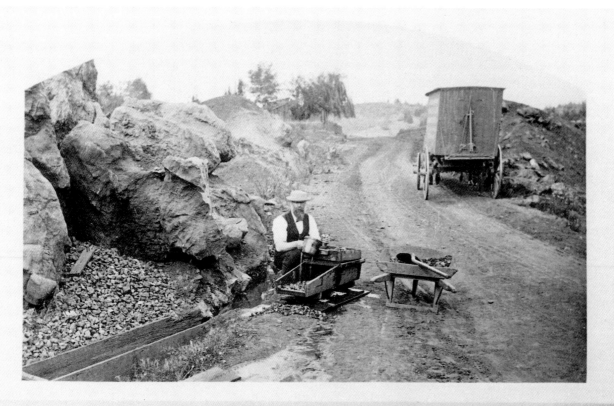

B 3542. Primitive Mining; the Rocker Calaveras Co., Cal.
Watkins' New Boudoir Series Yo Semite and Pacific Coast, 427 Montgomery Street, San Francisco.

tinued to employ the figure of the gold-rush miner to promote the virtues of the state. A self-portrait made by the preeminent California photographer Carleton Watkins about 1883 re-created a typical gold-rush scene for audiences obviously inured to, but still captivated by, even the most transparent constructions (fig. 35). In white shirt and waistcoat, with his studio wagon parked in the background, Watkins cast himself as the venerable lone prospector. Rocking the mining cradle that he had probably brought along as a studio prop, Watkins eked out the last bit of pay dirt from a mined-out subject, paying homage to the idea of the independent argonaut that had proved to be such a rich vein for image makers like himself.

A Pioneer Embossed Washout Closet advertised in the catalogue of the San Francisco-based Budde Company in 1895 demonstrated that, even fifty years after the gold rush, mining imagery could be adapted to new media with profitable results (fig. 36). By this time, sanitary fixtures were considered an essential feature of the "better class" of urban homes in California. Middle-class city dwellers were proud of modern plumbing that proved Californians had access to the latest domestic conveniences. The pioneer-embossed toilet was offered to the more discriminating client who could afford the extra price of the decorated model. According to its own records, the Budde Company had great success with more elaborate units like this model, which helped the company win a gold medal at the California Midwinter Exposition in 1893.[36]

The lone prospector on the Budde bowl is impervious to his unorthodox setting. In typical fashion, he sets to work, swinging his pick at the pile of rocks in front of him. He is surrounded by an idyllic landscape; the modest tent he has pitched close by is sheltered by a grove of trees. Above, the picture of the miner gives way to a scene that portrays a wagon train of California immigrants, watched by a wary grizzly bear as it wends its way toward the horizon. Despite appearances to the contrary, the Pioneer Embossed Washout Closet confirmed that the image of the gold-rush miner had not outlived its usefulness at the end of the century and would not be relegated to the dust-bin of history. Just as the Budde Company found it worthwhile to present the argonaut as a model of regularity, other local industries would continue to extract benefits from the long-lived symbol of the industrious miner, flushing out new meanings to suit the changing circumstances of modern times.

The middle-class and business elites that commissioned, purchased, and promoted idealized representations of the gold rush during the nineteenth century used the images to justify and rationalize their activities in the Golden State. The legitimization of wild speculation and breakneck-paced extraction of the state's resources enacted in pictures of prospectors and mining camp life

Fig. 36. Unidentified artist, Pioneer Embossed Washout Closet, 1895. Printed brochure, approx. 9 x 6 in. Romain Trade Catalogue Collection, Department of Special Collections. University Library, University of California, Santa Barbara.

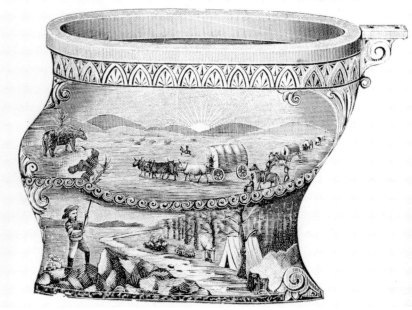

Pioneer Embossed Washout Closet.

would be repeated, though with other subject matter, throughout the nineteenth century, when inventive entrepreneurs set their sights on agriculture, tourism, and the establishment of a transcontinental railroad. As local business interests looked to the future for new enterprises to replace the waning mining industry, they turned again to the past for inspiration. Since the notion of a Pacific El Dorado was no longer substantiated by new discoveries in the goldfields, developers drew on other aspects of the myths that had begun in the seventeenth and eighteenth centuries with the chronicles of La Pérouse and Malaspina and the drawings of French, Spanish, and English expeditionary artists. Like their predecessors, the newest generation of promoters found it expedient to foster the idea of California as an agrarian paradise. Through the creation and dissemination of a body of images and writings that culminated in the decades between 1860 and 1890, merchants, bankers, railroad owners, and real-estate speculators in the state worked to persuade audiences across the country that Americans did not need to wait until the hereafter to experience the verdant pleasures of Eden but could enjoy them in the here and now on the Pacific.

3

Cornucopia of the World

What would our visitor…be likely to say, if told that the landscape, so brown and lugubrious beneath him, enclosed an agricultural opulence of which the figures seem almost miraculous; that its grain crops average double those of the Eastern States; that fruits were then ripening all around him in surpassing luxuriance and beauty; and that the growth of the grape in that blasted landscape during the last three years, surpasses anything known in the most favored districts of the Rhine lands, France or Italy?…the State which seems given over, in a general view, to the "abomination of desolation," is really the field of two immense "horns of plenty"—one widening downward from the pinnacle of Mount Shasta, the other widening upward from the mountains of San Bernardino, crammed with all the riches of granaries and orchards, and overflowing all upon the metropolis in the center of the coast line by the Golden Gate! He would see that we are called upon by our copious blessings to be the most grateful and the most patriotic people on the globe.

—THOMAS STARR KING, ADDRESS TO THE SAN JOAQUIN VALLEY AGRICULTURAL SOCIETY, 1862[1]

*A*s long as the goldfields continued to offer up their riches, the nature of the California landscape and the fertility of its soil were subjects of peripheral importance to those who came to the state or read about it in the East. However, when the gleam of El Dorado began to tarnish during the early 1850s and disgruntled prospectors headed for more promising diggings in Nevada and Colorado, interest in California's

natural environment shifted to the forefront. The state's agricultural potential, largely ignored by newcomers harvesting the profits from the goldfields, became critical to merchants, real-estate speculators, bankers, and railroad operators threatened by dwindling numbers of customers. Business leaders agreed that farming was the industry most likely to encourage permanent settlement in the state and provide the economic stability lacking during the tumultuous years of the gold rush.

To promote agriculture in California, local developers sponsored a promotional campaign that included as a strategic component images that portrayed the state as the fulfillment of the American agrarian ideal. During the second half of the century, they blanketed the East with painted landscapes, newspaper illustrations, and pamphlets intended to entice weary city dwellers in New York and Chicago to the shores of the Pacific. Banking on California's reputation as a place where the extraordinary became ordinary, pictures of pears the size of loaves of bread, attractive middle-class homes next to irrigated strawberry farms, and sunny orange groves in January unveiled the state as the "cornucopia of the world," where grain, fruit, and vegetables—often of gargantuan size—could be grown on a dependably regular basis. Latent within these visions of pastoral bliss, of course, was the promise that profits commensurate with the size of the produce were there for the taking. Promoters understood that, for viewers primed by extravagant gold-rush visions, it required only a minor adjustment to shift the focus from auriferous deposits in the Sierra to wheat and oranges in the state's Central Valley. Pictures of California as the agricultural mother lode insisted there was still "gold in them thar hills," while soothing concerns about gold-rush rowdiness, the aridity of the state's climate, and a land monopoly that made a mockery of Jeffersonian values.

The early years of the campaign to promote California as an agricultural region coincided with the Civil War. Conveniently, pictures of the state's peaceful rural areas took on greater power when juxtaposed with the images of death and destruction that filled American newspapers and magazines. Addressing American fears about the resiliency of the Republic and durability of its democratic institutions, visions of California as an oasis of agrarian calm confirmed that the simple yeomanry, the backbone of the nation, was renewing itself in the farthest reaches of the West.

Nevertheless, despite the favorable impact of the Civil War on promotional efforts, boosters pitching farming in California to eastern audiences faced daunting obstacles. The American public was confused by conflicting information about the state's terrain and weather. Many easterners at midcentury had read the enthusiastic accounts of Americans who traveled to California before the gold rush, including Richard Henry Dana's descriptions in *Two Years before the Mast*. Though these early narratives extolled the richness of the Pacific territory and the mildness of its climate, they were contradicted by the published stories of forty-niners who crossed the desert land of Utah and Nevada to reach California. The argonauts' descriptions of the forbidding territory that lay beyond the Rockies led many readers to conclude that the region—all the way to the shores of the Pacific—was desolate and barren. Adding to the general confusion, newspapers in the East frequently included reports of disastrous floods in California, a problem that seemed to occur with alarming regularity.

Certainly, the writings of Bret Harte, the popular author who served as a special correspondent to the *Springfield Republican* during the mid-1860s, did little to reassure eastern readers of the state's beneficent weather or its agricultural potential. Indeed, Harte appeared to take particular pleasure in pointing out the irregularities of the

California climate. During the rainy months, he complained to his readers about the "preposterous dampness" that pervaded the state:

> There is a subaqueous flavor to all things and nature drips. Along the skirts of the foot-hills there are strong suggestions of a very recent Silurian beach, and we wouldn't be surprised at picking up trilobites, brachiopods and other damp, uncomfortable creatures of an early geological period in the roadside puddles, for the country is in fact but half reclaimed from primal chaos.[2]

Harte continued his gleeful assaults on the state's weather in a poem entitled "California Madrigal," in which he described the state's arid summer season: "Then fly with me, love, ere the summers begun / and the mercury mounts to one hundred and one," he beckoned to the reader, "Ere the grass now so green shall be withered and sear / In the spring that obtains but one month of the year."[3]

As Harte's criticisms of the state's particular environmental conditions point out, the American idea of what constituted an agrarian paradise needed to be revised significantly for California to become one. Traditional eastern farming methods as practiced in Virginia and New York were impossible in California's dry *chaparral* and windswept headlands. Accordingly, the state's developers worked to bridge the gap between the local environment and what was familiar to those in the East. They attempted to modify the perceptions of viewers through images of California that tended to fall into three categories: portrayals of virgin landscape that suggested the land's potential; scenes of agricultural production; and portraits of Californians responsible for the transformation of the land. Many of these images were sponsored by settlers hoping to attract other permanent residents. Others resulted from the efforts of landowners hoping to capture the attention of eastern investors. With different cooks stirring the visual pot, it is not surprising that the resulting stew contains elements that contradict each other. Paintings of traditional rural communities refuted photographs of large-scale, mechanized "bonanza" wheat farming, and landscapes picturing overflowing lakes and rivers canceled out book illustrations depicting "dry farming" techniques in the Central Valley. Still, the sheer abundance of agricultural imagery served up to audiences in the East and Midwest in the last decades of the century tended to discourage careful scrutiny. The pictures shared the common theme of the feast that had been laid on California's table and, working collectively, extended a cordial invitation to the American public to dig in.

To convey the idea of the land's untapped potential, California image makers turned to the rich heritage of agrarian imagery and themes that had been widely current in American culture since the middle of the eighteenth century. From the writings of Benjamin Franklin and William Cullen Bryant to the paintings of Asher B. Durand and William Sidney Mount, farm life had been extolled as the source of an especially American brand of goodness and contentment. James B. Lanman, writing in the widely circulated *Hunt's Merchants' Magazine* in the 1830s, articulated in rhapsodic terms the national reverence for cultivators of the soil: "It can scarcely be denied," he asserted, "that agricultural enterprise, the basis of almost every form of human pursuit, should be encouraged as the safeguard of a country, the promoter of its virtue, and the solid foundation of its permanent happiness and long-lasting independence."[4]

A painting by Albert Bierstadt, the celebrated artist from the East, pictured the land cradled between the Sierra Nevada and California's coastal range as the perfect site for

the promotion of virtue (fig. 1). Executed in the early 1870s, *The Sacramento River Valley* portrays the part of the state that was considered best suited for farming. In the foreground of the painting, dark oaks frame the landscape and balance the lighter forms in the valley below. There, the Sacramento River, a silver ribbon that bisects the valley, nestles in the crook of rounded hills. Like the great woodlands of English estates, the ground is free of the clutter of underbrush, allowing the eye to penetrate deep into the distance. The painting captures the moment when the sun settles below the western horizon, bathing the landscape in a hallowed glow. The mood of hushed reverence inspired by the golden light is accentuated by the absence of figures or animals in the scene. It is as if, after passing over the crest of the mountains, the onlooker has entered a sacred precinct, a prelapsarian garden untouched by the stroke of the plow or the axe. Certainly, as Bierstadt portrayed it, the Sacramento River valley promised that, in the care of the enterprising newcomer, the land would provide "permanent happiness and long-lasting independence."

The placement of the river at the center of the canvas had important meanings for the railroad magnates and other business leaders who were Bierstadt's chief patrons during his two-year sojourn in California. Compared with other states attractive to homesteaders, including Kansas, Missouri, and Oregon, the amount of rainfall in California was notoriously low, a fact supported by the weather statistics disseminated by competing booster organizations in other states. Prospective settlers leery of the expensive irrigation systems often required in California tended to look elsewhere to stake their claims. In this context, *The Sacramento River Valley* presents the reassuring vision of a land where water is easily accessible. Furthermore, in contrast to the raging cataracts described by pioneers moving into the far West, the Sacramento River appears as a slow-moving waterway well suited to agriculture and commerce.

Where *The Sacramento River Valley* portrayed California as a place virtually untouched by settlement, *View South from Sonoma Hills*, a wide-angle panorama painted by Virgil Williams in 1864, shows the state in the earliest stages of development (fig. 2). The painting plays up the unfolding potential of the land through a series of visual devices. At the center of the lush pastureland, the artist included a pair of guides to direct viewers' attention to the territory's significant features. The two men who converse as they sit in the shadow of a passing cloud are clearly excited by what they see before them. The figure on the left points purposefully toward the right, prompting viewers to scan the landscape to find what he might be discussing with his companion. Perhaps he is remarking on the rich stand of trees that fills in the contours of the low hills or the cattle that graze contentedly on the slopes. He could be describing what lies at the end of the road below him, maybe the port, where the steamships (whose puffs of smoke can just be made out in the distance) unload their cargo and take on passengers. Alternatively, the rifle resting behind him suggests he has brought down a bird and points to command the dog who rushes off to the right to retrieve the quarry. California was celebrated in contemporary accounts for its immense population of waterfowl; even the most inexpert marksman could bring down a duck or a goose from skies reportedly blackened with passing flocks.

Whatever the object of the pointing man's attention, it is of significant interest to his friend, who turns around and leans forward to get a good look. His actions urging the viewer to do the same, the second figure insists the viewer make a second inventory of the landscape, since following his gaze brings the eye again around the circuit of the canvas. The outer rim of the flattened circle described by the road curving across the

Fig. 2. Virgil Williams, View South from Sonoma Hills, 1864. Oil on canvas, 30 x 48 in. The Bedford Family Collection.

bottom up to the stretch of water in the distance includes the conversing pair, the well-traveled road, and the suggestion of shipping activities; at the center, like an enormous bull's-eye, is the rich and empty acreage that motivates the activity at the perimeter. At the heart of the painting, then, is land wide open for settlement whose inhabitants are awakening to its commercial possibilities.

The idea of new settlers' incipient harvest of California's natural abundance set forth in *View South from Sonoma Hills* was also articulated by Mark Twain during a lecture he gave in San Francisco in the 1860s. Surprisingly, even the famously skeptical author appears to have been caught up in the same optimism that pervades *View South from Sonoma Hills*. "Over slumbering California is stealing the dawn of a radiant future!" he declared. "This sparsely populated land shall become a crowded hive of busy men…and your deserted hills and valleys shall yield bread and wine for unnumbered thousands."[5] Delivered straightface by a popular public figure who specialized in exposing humbug and artifice, these words acted as a powerful endorsement of local boosters' most extravagant claims.

While they advertised California's agricultural possibilities, works like *View South from Sonoma Hills* and *The Sacramento River Valley* also distracted attention from the system of land organization in the state that prevented most settlers from establishing small farms. Despite attempts by the federal government to equalize local land distribution, land ownership in the state was more concentrated than in any other part of the nation. In 1875 a census performed by Professor Ezra S. Carr of the University of California at Berkeley indicated that most of the state's arable lands, representing an area nearly twice the size of Massachusetts, was owned by a handful of men. Even greater than the holdings of individual owners, however, were those of the Central Pacific Railroad, the largest private landowner in the state.[6] The company's role in the construction of the transcontinental railroad, the largest engineering project ever attempted in the United States, entitled the company to a princely 11 1/2 percent of the entire land area of the state as part of the federal government's package of rewards. Of course, most of this land was subdesert terrain that would have little value until it was settled and irrigated. Leland Stanford, Mark Hopkins, Collis P. Huntington, and Charles Crocker, the powerful "Big Four" who owned the Central Pacific, understood quite well the significance of this aspect of the arrangement.

As a result of these patterns of land ownership, during the second half of the century most of the state's agricultural lands were divided into vast tracts, where livestock was raised, or into "bonanza" grain ranches run by absentee owners uninterested in making improvements on their properties or in building rural institutions and towns. Farmworkers were usually unskilled migratory laborers, many of them Chinese, who were imported at planting and harvest time and let go during the intervening months. The absence of rural community life in California was lamented by the California journalist and civic leader Anna Morrison Reed in an address to the California Agricultural Society in 1887:

> For two hundred miles in the Sacramento, and for three hundred in the San Joaquin Valley, you may travel without seeing a tree planted to shade a country home. The cooking is done by Chinese, the wife and daughters reside in some distant city, the farmer lives a wretched bachelor life, surrounded by

brutal farm hands who sleep in straw…. They have lived, some of them, in the same spot for twenty years, yet…they have not a convenient outhouse of any description, they do their washing under a tree, and boil their clothes in the pot they scald the hogs in.[7]

During the second half of the century, image makers portraying agricultural production in California did so against the backdrop of criticism like Reed's. Paintings intended for the dining rooms and parlors of the wealthy sidestepped the problems of land ownership in the state, however, by focusing on the timeless rituals of rural life and the familiar features of the prosperous farm: well-fed cattle, stacks of hay, and tidy farm buildings. On the other hand, photographers and printmakers, whose works were a central component of traveling booster displays and real-estate advertisements, showed a stranger, less dignified world, where machines took over men's work and produce grew to hilarious proportions. While acceding to the fact that farming in the state followed different rules, such popular images played up to the idea of Yankee ingenuity, engaging viewers with the notion that the advanced technologies used to cultivate the earth in California and the outsize produce that resulted were the latest manifestation of the national genius for invention.

Harvest Time, painted by William Hahn in 1875, is an example of the way certain artists in California approached the theme of agricultural production (fig. 3). Hahn chose as his subject the time of year when farmers gather the riches of the earth. Implicit in the idea of the harvest is the notion of the patient labor preceding it: plowing, planting, protecting the crop. *Harvest Time* reveals that the rhythms of rural life bind together all those who till the soil, even farmers in California's remote valleys. Indeed, despite the bleached, treeless hills in the background, which locate the scene in the western

Fig. 3. William Hahn, Harvest Time, 1875. Oil on canvas, 36 x 70 in. Fine Arts Museums of San Francisco; gift of Mrs. Harold R. McKinnon and Mrs. Harry L. Brown.

landscape, Hahn's farmers are virtually indistinguishable from their eastern counterparts or, at least, from the nostalgic representations of farm life popular in the East and Midwest during this period.

The operation pictured in *Harvest Time* is an egalitarian activity, in which horses do most of the heavy work and farmers are assisted by simple machines that operate almost invisibly, largely hidden from view. The men work cooperatively, performing familiar tasks—guiding the horses, feeding the thresher, and stacking the bags of wheat. Their attitudes and clothing indicate that, in contrast with the "brutal" hired laborers described by Reed, these workers share equal status. The measured pace of their labor, as indicated by the slackness of the whip held by the central figure who, hand in pocket, directs the horses circling in the foreground, is an implicit manifestation of the richness of the California soil. As Hahn has represented it, the California harvest is chiefly a supervisory process, where farmers contribute their know-how and the earth responds with luxuriant growth.

The idea of the natural continuum expressed in the painting is reinforced by two features that enclose the harvesting activity on the left and right. Reminders of other kinds of fruitfulness in California, a girl and two boys sit in front of the bagged wheat, whose abundance they mirror. Waiting for fathers, uncles, and neighbors working in the field, the children introduce the theme of community life. This next generation of harvesters, who chat as they loll in the warmth of the midday sun, contradicts Reed's description of the "wretched bachelor life" led by farmers in California. Their presence conjures visions of spelling bees, church socials, and grandmothers' visits—all the aspects of country living that Lanman characterized as "the solid foundation of permanent happiness."

Like the children, the farm buildings that can just be made out in the far distance reiterate the idea that the land has been able to sustain settlement. Shaded by broad trees that also refute Reed's accusations, the whitewashed houses hint at the comfortable life of those who work the land. These are the homes to which the harvesters will retire at the end of the day, reaping the rewards of their labor with supper and sleep.

Although it is the work of agricultural production that animates the canvas, the artist also included a reference to the spontaneous expression of the land's fertility, the bounty that offered itself freely to settlers. At the center of the canvas, against the backdrop of the harvest activities, a dog brings the children a small animal it has caught. With this seemingly superfluous element, *Harvest Time* refers to California's reputation as a sportsman's paradise, where hillsides were blanketed with deer and elk and rivers teemed with salmon. Rather than the sweat of the brow, this harvest required only a sharp eye and minimal experience with the rifle or lure, so easy was it to gather up.

Many artists took up the theme of agricultural production during the 1860s and 1870s, showing different parts of the state tended by diligent farmers. Paintings like *Farming in the Livermore Valley* and *Summer Morning near Los Gatos* demonstrate that it was not only the Central Valley that was under cultivation but also areas to the north and south of San Francisco—promoting the idea that the state was checkered with small rural communities awaiting other settlers (figs. 4 and 5). Still, the actual practices of farming in California were quite different from the activities portrayed in these works.[8] In fact, by the latter part of the century, California cultivators were referred to, not as "farmers," but as "growers." This subtle difference indicated the contrast between traditional farming as represented in paintings of rural life in California and agriculture as it

Fig. 4. Edwin Deakin, Farming in the Livermore Valley, 1874. Oil on canvas, 24 x 20 in. California Historical Society, San Francisco; gift of Mrs. W. A. Reynolds. Photograph by M. Lee Fatherree.

Fig. 5. Raymond Dabb Yelland, Summer Morning near Los Gatos, 1880. Oil on canvas, 28 x 48 in. Garzoli Gallery.

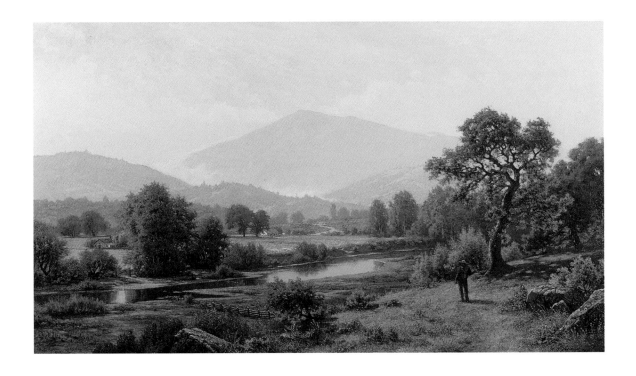

was managed in the San Joaquin and Sacramento valleys, and in other parts of the state. Even local newspapers, usually the conduit of flattering information on local activities, criticized the transient, speculative nature of agriculture in California. In 1855 the *Alta California* complained that "[the grower] very likely is too impatient to plant fruit trees and vines. He can hardly think of waiting for them to grow. No! He must get his returns immediately. He came to California for a fortune, and if he is not making it rapidly he is discontented and eager to try something else."[9]

For the most part, agriculture in California had little in common with the slow-paced activity portrayed in *Harvest Time* and other paintings of the state's rural life. During the period when these works were executed, California growers typically avoided projects that required long-range planning, such as planting an orchard or improving a strain of vegetable, that were characteristic of eastern practices. Wheat offered growers the quick turnover they required, and it was a crop that could be grown without irrigation. Furthermore, the aridity of the California climate allowed the grain to ripen on the plant, making it so dry and hard that it could be safely shipped to distant markets. The principal market for the crop, in fact, was not in California or the East but in Liverpool, England, where it was sold on the great Corn Exchange.[10] By 1875, the entire Central Valley had become a vast wheat-growing region, with twenty thousand acres or more continuously planted to the crop, without fertilizer or rotation.

This sort of "soil mining" required a high degree of mechanization, and wheat farming in California became famous for its extensive use of increasingly large and sophisticated machinery. The traditional walking plow was replaced by the Stockton Gang Plow, which had several plowshares attached to a beam and was drawn by eight mules. At the ranch of Dr. William Glenn, the celebrated "Wheat King," spring plowing began with one hundred mule teams pulling gang plows in echelon formation, where operators and machines spread out in a continuous line. When the crop was ready, huge combined harvesters cut, threshed, and bagged the grain. One of the most impressive of these machines was the Monitor, an immense separator that required fifty mules to move it. This mammoth device enabled workers to gather up the crop in record time and amounts. Glenn's most famous harvest was in 1880, when his 500,000-bushel crop was said to have required an eight-mile-long train of 1,250 freight cars for transport to the port.[11]

The pivotal role of bonanza wheat farming in the state's development inspired Frank Norris, an aspiring California novelist, to plan an epic trilogy around the subject in 1899. In his first volume, *The Octopus*, which Norris summarized as "the fight between the farmers of the San Joaquin and the Southern Pacific Railroad," the author expressed the idea of the commodity's independent power, and the detachment of its cultivation from traditional agrarian systems:

> A vast silent ocean, shimmering a pallid green under the moon and under the stars; a mighty force, the strength of nations, the life of the world....As if human agency could affect this colossal power! What were these heated, tiny squabbles, this feverish, small bustle of mankind, this minute swarming of the human insect, to the great majestic, silent ocean of the Wheat itself! Indifferent, gigantic, restless, it moved in its appointed grooves. Men. Lilliputians. Gnats in the sunshine, buzz impudently in their tiny battles, were born, lived through the day, died, and were forgotten; while the Wheat,

wrapped in Nirvanic calm, grew steadily under the night, alone with the stars and with God.[12]

The difference between bonanza farming and traditional American farming spurred image makers in California to come up with other ways of representing agricultural activities. Images that celebrated California as the thinking man's paradise, showing huge combines at work in the fields or complicated irrigation systems meticulously arranged, attempted to shift viewers' ideas about farming in its ideal aspect. Rather than treat the heavy reliance of California agriculture on engineering and advanced technology as a liability, certain photographs and prints showed that, through the use of special machinery, the proper selection of crops, and irrigation, farmers could enjoy harvests that were ten- and twentyfold what they had known in the East.

By the 1880s, publishers were able to reproduce photographs in books, magazines, and newspapers, and this method was used extensively to communicate the benefits of technological farming in California. Americans in the latter half of the nineteenth century were intrigued by the technology of the camera, the chemical processes that went into the development of a photograph, and the ways in which the two worked together to "capture" natural phenomena. These factors encouraged land developers to use photographs as a promotional tool, since they conveyed especially well the ways in which mechanization and nature were positively aligned in California. In addition, the photograph responded to the skepticism of audiences grown weary of exaggerated claims about California by offering an image that was considered to be irrefutable.

In the 1860s and 1870s giant farm machinery was a favorite subject for photographs intended for publication in booster literature (fig. 6). The overwhelming

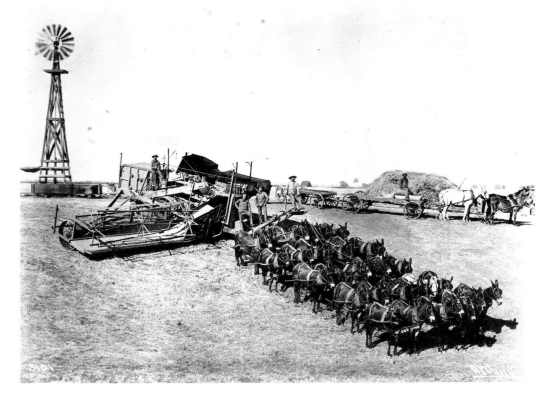

Fig. 6. Unidentified photographer, Harvester—Schmeiser Manufacturing Co., c. 1880. Photograph, 4 x 5 in. California State Library, Sacramento.

A LARGE PEAR.

It must ever be a source of astonishment and gratification to Californians, that the prolific production of our soil is such as almost to challenge the world. Who could ever dream that in a country comparatively new, so much perfection has already been attained in the culture and growth of fruits, flowers and vegetables, as to give us, in a few brief years, advantages that are as yet unpossessed by older States. Where, but in California, for instance, has there ever grown a pear of such proportions as that on an opposite page ?—its natural size, from a photograph taken by Mr. Carden, of Bradley's Daguerrean Gallery, near our office, and kindly loaned us for the purpose by Mrs. E. J. Weaver, of the Washington Market—weighing, as it does, two pounds twelve ounces avoirdupois, and is one of five, all nearly as large, from a very young tree in the orchard of Mr. Beard, Mission of San Jose; and gathered, too, before they were ripe, to be exhibited at the State Fair at San Jose, and were the largest offered for exhibition.

Next month we shall find room for a more extended notice of some of the vegetable wonders that we have seen —the products of California soil.

THE FARMER.
Who makes the barren earth
 A paradise of wealth,
And fills each humble hearth
 With plenty, life and health ?
Oh, I would have you know
 They are the men of toil—
The men who reap and sow—
 The tillers of the soil.

Fig. 7a–b. Unidentified artist,

A Large Pear, 1859. From

Hutchings' California

Magazine 3 (March 1859).

Bancroft Library, University of

California, Berkeley.

number of combines, threshers, and harvesters that filled the pages of promotional pamphlets, books, and magazines made it seem as if California crops were capable of harvesting themselves. These images included the California yeoman almost as an afterthought, picturing a farmer whose chief function was to start up and direct complicated machinery, then stand back to allow the fertility of the soil to express itself in pecks and bushels.

Photographs of technological farming neatly reversed the order of cause and effect that initiated the use of such large and expensive

machinery in California in the first place. The great size of bonanza farms and the resulting absence of rural communities that in the East provided the labor to work small holdings meant that farm owners had to rely on imported workers and on technology; in any case, manpower alone could not have dealt with plantings and harvests on such a tremendous scale. Photographs of the modern advancements on California farms erased the fact that growers were in fact the slaves of their machines and that, without them, such industry would have been impossible.

Underlying images of technological farming in California was the idea of the tremendous size and quantity of California produce. Information on this subject filled local newspapers and journals that targeted eastern readers. "A Large Pear," a short illustrated article that appeared in *Hutchings' California Magazine* in March 1859, was one of numerous descriptions of outsize vegetables and fruits that strained the credulity of the reader and viewer (fig. 7). "Where, but in California," the author queried, "has there ever grown a pear of such proportions as that on an opposite page?" Acknowledging the implicit lack of faith of his audience, the writer insisted the truth of the image was confirmed by the fact that it had been exactly reproduced "from a photograph taken by Mr. Carden, of Bradley's Daguerrean Gallery." Another image, also published in *Hutchings' California Magazine*, amused readers with the imaginary consequences of the size of California's agricultural products (fig. 8). The illustrations showed residents knocked down by boulder-sized cherries and houses decimated by "small-

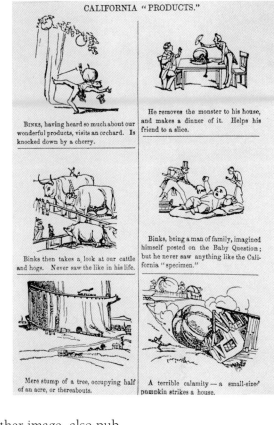

CALIFORNIA "PRODUCTS."

BINKS, having heard so much about our wonderful products, visits an orchard. Is knocked down by a cherry.

He removes the monster to his house, and makes a dinner of it. Helps his friend to a slice.

Binks then takes a look at our cattle and hogs. Never saw the like in his life.

Binks, being a man of family, imagined himself posted on the Baby Question; but he never saw anything like the California "specimen."

Mere stump of a tree, occupying half of an acre, or thereabouts.

A terrible calamity—a small-sized pumpkin strikes a house.

sized" runaway pumpkins. One segment depicted a "mere stump of a tree" able to accommodate a whole railroad attached to its flanks. Apparently, humans were also enhanced by the miraculous growth-inducing powers of the California environment, as shown in the picture of a harried couple that tries to feed an enormous, squalling baby using buckets and shovels.

The Southern Pacific Railroad—the new name for the reorganized Central Pacific—targeted the next generation of vegetable and fruit consumers in its efforts to publicize the state's produce. During the 1880s, the company distributed free of charge the *California Prune Primer*, a booklet designed as a supplemental reader for elementary schoolchildren (fig. 9). Delighted teachers and parents deluged the railroad with requests for extra copies, and, by 1901, more than six hundred thousand readers had been given away. Its success led the company to issue other

CALIFORNIA
PRUNE
PRIMER

SOUTHERN PACIFIC
PRIMER SERIES
No. 2

E. O. McCORMICK
PASSENGER TRAFFIC MANAGER

T. H. GOODMAN
GENERAL PASSENGER AGENT

SAN FRANCISCO, CALIFORNIA

Fig. 8. (above) Unidentified artist, California "Products," c. 1858. From Hutchings' California Magazine 3 (October 1858). Bancroft Library, University of California, Berkeley.

Fig. 9. (below) Southern Pacific Railroad Company, California Prune Primer, 1901. Southern Pacific Company Primer Series, no. 2. Promotional booklet, approx. 12 x 9 in. California State Railroad Museum, Sacramento.

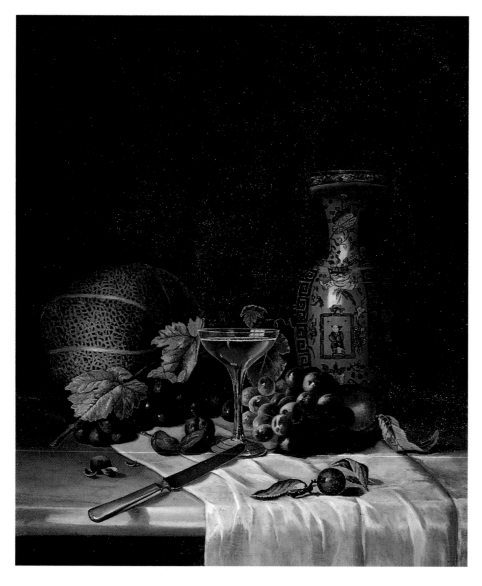

California primers, including the *California Orange Primer*, the *Eat California Fruit Primer*, and the *California for the Settler Primer*.

While the imaginative primers appealed to schoolchildren, even the sober reports of the State Agricultural Organization were guaranteed to captivate adult readers when they described "a beet weighing seventy three pounds: a carrot, weighing ten pounds, measuring one foot and eight inches in circumference, and three feet and three inches in length...a tomato, seventeen inches in circumference...a cornstalk, twenty-one feet and nine inches in height." This type of statistical information was often an important component of literature promoting immigration, since it quantified vague claims of abundance into pounds and inches and, by extension, into dollars and cents.

Acclaim for California's agricultural products was not limited to material sponsored by local publishers and boosters, however. The exponents of high culture in the metropolitan areas of California added their voices to the litany of praise that was found in promotional tracts. In San Francisco, the Reverend Thomas Starr King entertained his parishioners with his comments on huckleberries the size of watermelons and "squashes as large as the nucleus of an average comet."[13] Bret Harte discussed California's fruits and vegetables in various articles written for the *Springfield Register*, describing "strawberries that look as if they had been arrested on their way to become pine-apples" and "golden pumpkins that might have contained Cinderella's coach without great stretch of the imagination."[14]

Painted still lifes of California produce, highly popular subjects during the 1870s and 1880s, also pictured the state's famous fruits and vegetables, though they eschewed the portrayal of the outsize specimens winning blue ribbons at state fairs. Such works gave attention instead to items that might appear on the plates of wealthy and middle-class patrons (fig. 10). During this period, the most celebrated painter of still lifes in California was Samuel Marsden Brookes, whose paintings of luscious cherries and plums were widely praised by local critics. His fashionable canvases filled the parlors of respectable families and were displayed to enthusiastic viewers in local galleries. One popular subject, which Brookes repeated in several compositions, was an arrangement of game or fruit with champagne bottles. A painting of the 1860s, *Still Life with Game*,

Champagne, and Vegetables, featured items that might have been served in the homes of well-to-do California families (fig. 11). An appetizer of radishes and butter would have been followed by a main course of grouse and quail. This might have been accompanied by cauliflower, a costly vegetable that could only be successfully grown in a few areas of the state. Champagne would have been a fitting complement to such an elegant repast. The bottle painted by Brookes carries the name of I. Landsberger, a local entrepreneur who provided financial assistance to California's premier winemaker, Arpad Haraszthy, and who would have been a typical buyer of the artist's work.[15]

Still lifes of local produce were a logical accompaniment to pictures of technological agriculture, since they suggested that the network necessary for the next step of the farming process—the distribution of products—was already in place. The existence of this kind of economic infrastructure, in turn, confirmed that order had been imposed on rough-and-ready California and that stable social hierarchies had emerged. Furthermore, the existence of a "cultivated public taste," which these paintings made manifest, attested to the exemplary nature of the new order in California. Accordingly, the years of greatest popularity of still-life themes coincided with the establishment of various cultural institutions in the 1860s and 1870s, including the San Francisco Artists' Union, the San Francisco Art Association, and the Bohemian Club, organizations that local residents believed marked the coming of age of their society. The art critic Benjamin Park Avery, writing in the *Overland Monthly* in 1868, praised the "aesthetic progress" of San Francisco, remarking that "already there are more evidences of aesthetic culture than exist in any other community so isolated, so exposed to frontier influences, and so youthful."[16] In this way, still lifes of fruits and vegetables were part of a larger

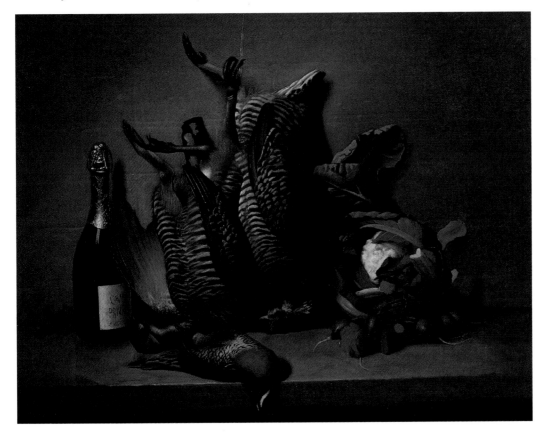

Fig. 11. Samuel Marsden Brookes, Still Life with Game, Champagne, and Vegetables, c. 1865. Oil on canvas, 20 x 16 in. The Delman Collection.

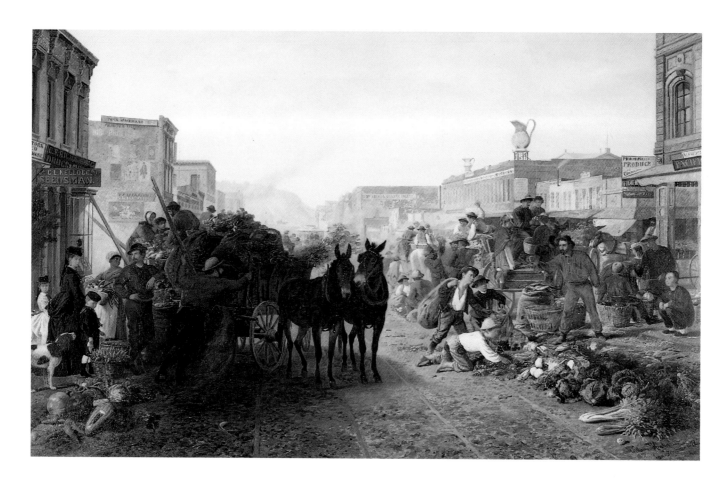

process by which Californians claimed their place at the national table and asserted their right to assume all the responsibilities and privileges of a full-fledged member of the Union.[17]

A painting by William Hahn of 1872, *Market Scene, Sansome Street, San Francisco,* expanded the still life of California produce into a complete description of Pacific society (fig. 12). Using the setting of San Francisco's bustling wholesale district, *Market Scene, Sansome Street* pictured the buying and selling of agricultural products that linked the various elements of the community. Celery, cabbages, carrots, and pumpkins are featured as the objects of an exchange that anchors the state's famously diverse population to a stable market system. On the left, an elegantly dressed matron inspects a vendor's wares as her children watch the colorful spectacle around them. Nearby, a domestic worker totes her mistress's purchases in a basket. At the center of the canvas, grocers maneuver a wagon full of produce to where it can be unloaded. On the right, a group of boys helps to lay out carrots, probably in hope of some small payment. In front of them, a Chinese man sits patiently on his haunches, waiting for his vegetables to sell or for the instructions of his employer.

Embracing the busy scene in the foreground, like the two "immense 'horns of plenty'" described by Thomas Starr King, are rows of shops that line the street on either side. Store owners would often pay artists to include the names of their establishments in important works, and this may account for the prominent display of the signs of certain shops. Kellogg Seedsman, Ship Bread and Cracker Bakery, and Moron and Miller Produce are some of the businesses whose signs are visible, names that would probably have been familiar to those who saw Hahn's painting at the Snow and Roos Art Gallery in San Francisco. The most conspicuous advertisements are two enormous pitchers atop

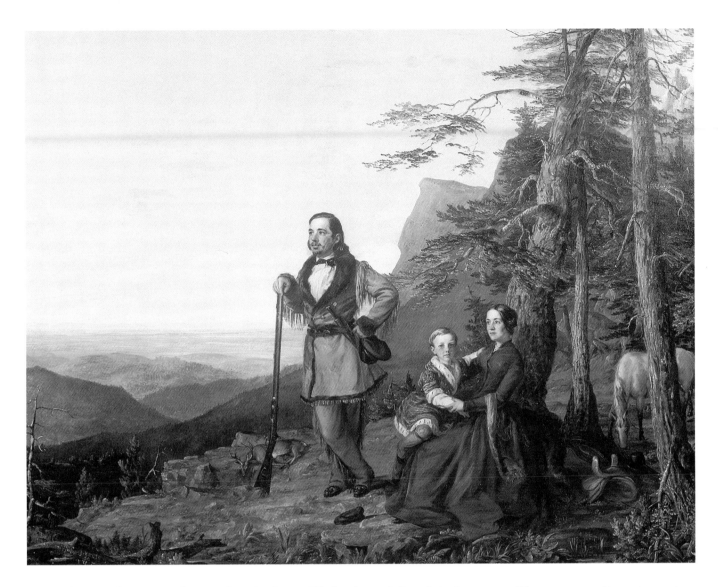

a building with a sign that reads: *Crockery, Wholesale and Porcelain Importers.* The immense size of these vessels, when viewed in conjunction with the plethora of vegetables arrayed in the street below and the multitude of shops ready to do business, suggested that the cup of the Californian did indeed "runneth over." Both in terms of the amount of goods available and in the coordination of interaction between employers and employees, consumers and producers, *Market Scene, Sansome Street* depicted a California society that, like the choicest vintage or the perfectly ripe pear, had reached full maturity.

The idea of the maturity of California's society expressed in *Market Scene, Sansome Street* was complemented by portraits of the worthy individuals who made up the community. Pictures of hearty pioneers, cultivated gentlemen, and their wives and retainers acted as a center around which representations of agricultural production and the land's potential could orbit. By demonstrating the exemplary character of those responsible for managing the state's bounty, such images completed the vision of a land ideal for farming and settlement.

An early example of this type of local portraiture is *The Promised Land*, painted by William Smith Jewett in 1850 (fig. 13). The painting, which was executed at the peak of the gold rush, is remarkable for its studied avoidance of argonaut themes. Instead, the

Fig. 13. William Smith Jewett, The Promised Land—the Grayson Family, 1850. Oil on canvas, 50 x 65 in. Daniel J. Terra Collection, Photograph courtesy of the Terra Museum of American Art, Chicago.

work represents the moment in 1846 when the Grayson family arrived in California, reaching the summit of the impassable Sierra years before the quest for gold transformed the territory. The end of the family's long journey is alluded to by the golden sunset that holds the steady gaze of the travelers and by the empty sidesaddle that lies at Mrs. Grayson's side.

Writing later for a California journal, Colonel Grayson described his happiness on seeing the valley for the first time:

> The broad valley of the Sacramento and the far-off mountains of the coast range, mellowed by distance, and the delicate haze of Indian summer lay before me—whilst the timber growing upon the border of the Rivers Las Plumas and Sacramento, but dimly seen at that distance, pointed out our course. I looked upon the magnificent landscape with bright hopes for the future.[18]

Grayson's hopes for the future did not include gold mining or transient speculation, however. Through *The Promised Land* which he commissioned with careful instructions to the artist on the way the subject was to be treated, Grayson made clear the kind of development he foresaw for California. Setting the subjects apart from the rabble currently swarming over the goldfields, the title asks the viewer to think of the Graysons as pilgrims, guided by the beneficence of God and sustained by him during the long journey. The fine clothes they wear, ill-suited for a three-thousand-mile trek across the continent, also distinguish them from the denizens of the mining camps. The colonel's clean white shirt and fur-trimmed jacket and the elegant drawing-room dress of his wife mark

Fig. 14. Thomas Gainsborough,
Robert Andrews and His Wife, c. 1749.
Oil on canvas, 27 1/2 x 47 in.
Reproduced courtesy of the Trustees of
The National Gallery, London.

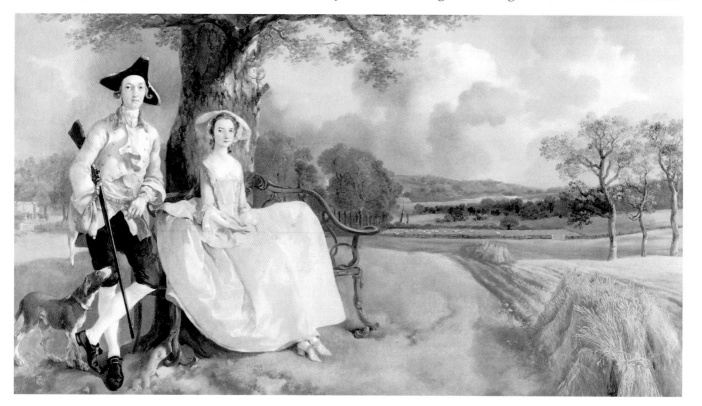

them as chosen people. Looking like a young Tudor, their young son in his ermine robe confirms the family's position of leadership and the founding of a Pacific dynasty. Nearby, a slain deer suggests both the traditional sacrifice of thanksgiving and the new-comers' God-given right to claim the bounty of the land.[19]

The idea of exclusivity suggested by the painting's theme of a promised land, with its implicit counterpart of a chosen people, was reinforced by the artist's borrowings from a type of painting fashionable in eighteenth-century England: the outdoor conversation piece (fig. 14). A type of outdoor portraiture favored by wealthy landowners, the conversation piece flattered its patrons through its identification of the picturesque landscape with those who controlled it. The conversation piece celebrated the mastery of nature by aristocrats and gentry who were often depicted in rustic dress or engaged in leisurely outdoor pursuits.[20] *The Promised Land* presented the Graysons as the heirs to this noble tradition, constructing a legitimate pedigree for the new society in California. This linkage with the familiar past also promoted the idea that the settlement of California was unfolding in an orderly sequence, rather than as part of a chaotic free-for-all.

The fact that Grayson was represented with his family would have been a matter of significance for contemporary audiences. Ladies of (suitable character) and children were notoriously rare in California during the period when the painting was executed. The shortage of women was a topic of considerable discussion in both California and eastern newspapers during the early 1850s. A few years later, Mark Twain poked fun at this state of affairs in his book *Roughing It*, in which he described an incident he claimed had occurred during his stay in California:

> In those days miners would flock in crowds to catch a glimpse of that rare and blessed spectacle, a woman! Old inhabitants tell how, in a certain camp, the news went abroad early in the morning that a woman was come! They had seen a calico dress hanging out of a wagon, down at the camping-ground-sign of emigrants from over the great plains. Everybody went down there, and a shout went up when an actual, bona fide dress was discovered fluttering in the wind! The male emigrant was visible. The miners said: "Fetch her out!" He said: "It is my wife gentlemen—she is sick—we have been robbed of money, provisions, everything, by the Indians—we want to rest". "Fetch her out! We've got to see her!" "But gentlemen, the poor thing, she—" "FETCH HER OUT!" He "fetched her out", and they swung their hats and sent up three rousing cheers and a tiger; and they crowded around and gazed at her, and touched her dress, and listened to her voice with the look of men who listened to a *memory* rather than a present reality—and then they collected twenty-five hundred dollars in gold and gave it to the man, and swung their hats again and gave three more cheers, and went home satisfied.[21]

The idea of a place largely without women piqued the interest of audiences outside the United States as well. European artists entertained their viewers with satirical projections about the consequences of the situation. Cham, a pseudonymous caricaturist for the Paris newspaper *Charivari*, portrayed a box of young ladies ready for shipment with the caption, "M. Willaume exporting to California an *article* very much in demand" (fig. 15). Honoré Daumier also contributed a cartoon to *Charivari* in October 1850,

which depicted two hopeful spinsters encouraged by the news from California. One of the homely pair says: "They say that pretty women are more and more in demand in California." Her companion replies: "Well, then I really *must* go!" (fig. 16).

In the context of gold-rush California, then, the presence of Grayson's wife and son in *The Promised Land* asserted the colonel's superior status as a pioneer rather than as a miner wallowing in the riverbeds of El Dorado. In this way, the painting embodied the idea that the key to the development of the land of plenty was a growing population of the right sort of immigrant: those willing to model new settlements on traditional eastern communities. As it highlights the unexploited potential of the land that lies at Grayson's feet and the egalitarian opportunity it ostensibly represents, the painting also sets forth, through its cataloguing of the family's virtues and accomplishments, the rules according to which the treasure would be divided.

Palo Alto Spring, a group portrait of the Stanford family painted by Thomas Hill in 1878, pictured the abundant rewards Grayson seemed to foresee for new settlers in *The Promised Land*. Representing the Stanfords on the lawn beside their country residence, *Palo Alto Spring* gave viewers an idea of the gentility and refinement that the new breed of Pacific cultivator could attain (fig. 17). When the Southern Pacific owner Leland Stanford was asked his occupation, he generally replied, "farmer,"[22] hoping to link his accomplishments with the great democratic tradition uniting the (yeomanry) of the nation (and, no doubt, to counter the numerous newspaper articles that labeled him a ruthless monopolist).[23] It was thus fitting that he chose

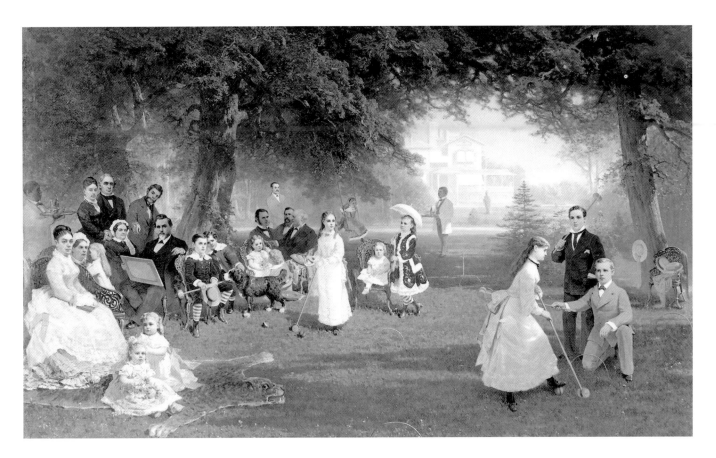

his Palo Alto farm, hailed in railroad-sponsored publications as the biggest in the world, as the location for this important family commemoration.

As the owner of vast chunks of the California landscape, Stanford was, understandably, one of the principal champions of "scientific," or irrigated, farming. His irrigated horticultural projects in the dry Tehama Valley were the object of considerable renown and were held up as a model of the feasibility of technological agriculture in the state.[24] Stanford was also famous for his specialized breeding of horses and cattle, which had produced numerous prize-winning examples. One of Stanford's champion trotters, Abe Edgington, was immortalized in Eadweard Muybridge's famous photographic series of a horse in motion (fig. 18). *Palo Alto Spring* pictured the human aspect of such work, portraying the strapping sons and daughters who were the product of correct thinking and a sunny climate.

David Starr Jordan, first president of Stanford University, clarified the ideas embodied in the Stanford family portrait in a lecture on the superior physical characteristics produced by the California lifestyle. Citing the effects of an ideal climate and an abundance of fresh fruit, Jordan reported the findings of a scientific study that compared the "bodily dimensions" of female college students in Massachusetts with those of their counterparts on the Pacific Coast. "California college girls, of the same age, are larger by almost every dimension than are the college girls of Massachusetts," he explained. "They are taller, broader shouldered, thicker chested (with ten cubic inches more lung capacity), have larger biceps and calves, and a superiority of tested strength."[25] Certainly, the vision of the ruddy vitality of the Stanford family as portrayed in *Palo Alto Spring* celebrated the benefits of healthful living in the Golden State.

In addition to representing the robustness of its subjects, *Palo Alto Spring* also pictured the respectability and sophistication of the emergent social order in California.

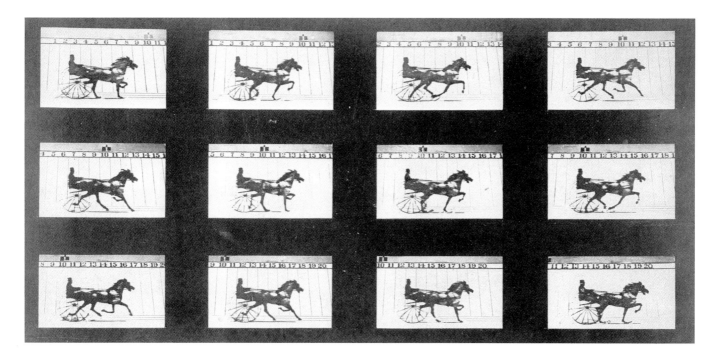

Fig. 18. Eadweard Muybridge, Horse in Motion, 1878. Albumen print mounted on printed card, approx. 5 x 7 in. Iris & B. Gerald Cantor Center for Visual Arts at Stanford University, Muybridge Collection.

The emphasis given to the gathering of the clan denotes the importance of traditional family life, while the book on Jane Stanford's lap and the painting held by Leland Stanford hint at their intellectual pursuits. The most compelling indication of the superiority of these new Californians, however, is the evidence of material well-being that envelops them as they gather on the great lawn at their country seat. From the rich fabrics of their clothing and the leisurely game of croquet the children play to the discreet servants who bring drinks from the manor house, the painting functions as an inventory of the rewards earned by the Stanford family, the "best and truest" of a new California breed.[26]

The presence of the Stanfords' servants who, like bookends, flank the family, completes the picture of the good life in California. The servants' dark complexions mark them as Hispanic or Native American—peoples who, along with the Chinese, were considered an essential component of the California economy. Those who wanted to promote the immigration of easterners into California extolled the availability of nonwhite labor as one of California's greatest resources. Charles Nordhoff, the author of numerous promotional guidebooks sponsored by the railroad, included a chapter entitled "The Chinese as Laborers and Producers" in his book *Northern California, Oregon, and the Sandwich Islands.* "The admirable organization of the Chinese labor is an irresistible convenience to the farmer, vineyardist, and other employers," the author explained. "It is a fact…that they do a great deal of work which white men will not do out here; they do not stand idle, but take the first job that is offered to them."[27] *Palo Alto Spring* portrayed the benefits of the unique labor market in California through the pair of housemen who linger in the shadows of the painting, ready to serve the Stanford family.

Nordhoff and other boosters acceded to the fact that indigenous and foreign workers required a certain amount of training to perform their work properly. Nevertheless, though the employer often had to invest a significant amount of time in educating such employees, the low cost of these workers made such efforts more than worthwhile. The widely read *Emigrant's Guide to Oregon and California* informed readers that California Indians could be employed for the small expense of providing them with "a coarse tow shirt, and a pair of pantaloons of similar cloth, and with such food as meat alone."[28]

A state law passed in 1850, the Act for the Government and Protection of Indians, ensured the continuity of this convenient system by legalizing and encouraging the indenture or apprenticeship of Indians of all ages to white residents.[29] An image published in *Hutchings' California Magazine* hinted at the financial implications of such legislation, showing a group of Native Californians above the boldface caption: *The Bargain* (fig. 19). Readers who hired Native Californians as domestics and field laborers would have agreed that the use of these workers was highly cost-effective; employers needed only to exercize their ingenuity to discover how best to "make them useful" and had the additional satisfaction of knowing they were helping their wards become meaningful contributors to the new Pacific order.[30]

Images of obedient foreign workers in California would have had special significance for Americans during the 1870s, when the nation was in a deep depression, and labor unrest was widespread. A financial panic in 1873, precipitated by the collapse of the financier Jay Cooke's banking empire, marked the end of the period of economic growth that had accompanied the Civil War and railroad construction in the 1860s. Strikes and other expressions of worker dissatisfaction occurred with increasing frequency, culminating in the Great Railroad Strike of 1877, in which crowds of disaffected laborers from Pittsburgh to San Francisco clashed with police. Talk of revolution led some business leaders to reconsider the structure of the industrial system and to recognize the need for reform. Others hardened their position and looked for alternatives to what they saw as relinquishing a measure of their control.[31] "Alien" labor offered this group the means to resist the urgent demands of American workers, and it was within this context that California promoters disseminated pictures of able-bodied Chinese, Hispanics, and Native Californians.

Still, many Americans rejected the idea of nonwhite labor, particularly the claim that Native Americans could be transformed into tractable domestics and efficient farmhands. Addressing this resistance, an image included in *The Annals of San Francisco* enacted the transformation of the California Indian from savage to useful laborer (fig. 20). A narrative history of the city, and of California in general, *The Annals*, published in 1855, was intended as an inventory of new settlers' accomplishments and was directed at eastern readers curious about the Golden State. Like a series of time-lapse photographs, the images

Fig. 19. Charles Christian Nahl, The Bargain. From Hutchings' California Magazine 3 (April 1859): cover.

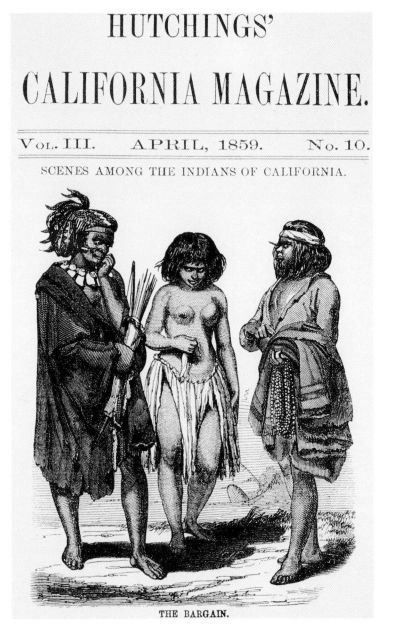

HUTCHINGS'

CALIFORNIA MAGAZINE.

Vol. III. APRIL, 1859. No. 10.

SCENES AMONG THE INDIANS OF CALIFORNIA.

THE BARGAIN.

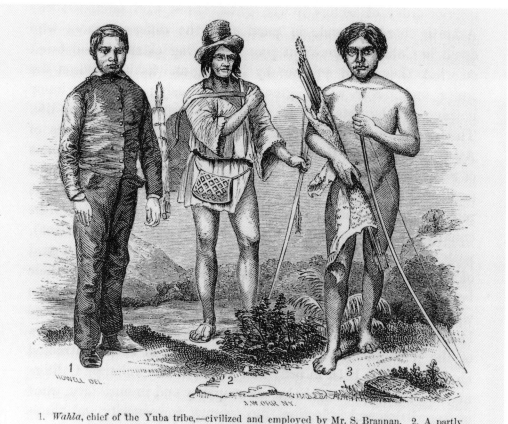

Fig. 20. Charles Christian Nahl,
California Indians. From Soule,
Gihon, and Nisbet, The Annals of
San Francisco (1855), 52. Private
collection.

1. *Wahla*, chief of the Yuba tribe,—civilized and employed by Mr. S. Brannan. 2. A partly
civilized Indian. 3. A wild Indian.—From daguerreotypes by Mr. W. Shew.

sequentially erased readers' conception of the Indian as untamed—on the right—or as degenerate—in the middle. These second- and third-rate models were replaced with a first-rate subject suited up and ready for work. The figure on the left fulfills promoters' promises: his dark outfit, that of a domestic servant, indicates his role in the community, while the emptiness of his hands and his attentive posture allude to his readiness to serve. At this stage of his evolution, the subject merits a name; the text identifies him as "Wahla, Chief of the Yuba Tribe—civilized and employed by Mr. S. Brannan." Wahla worked for Samuel Brannan, one of the state's most successful businessmen, and later became the coachman of Milton S. Latham, governor of California.[32]

Jessie Benton Frémont, wife of famed explorer John Frémont and celebrated California hostess,[33] described in her memoirs her success in transforming Native Californians like Wahla into domestic servants:

I had grown up among slaves and could make allowances for untutored people, as I knew them of all grades, from the carefully trained and refined house servants to the common field hands; and knew that with them, as with us, they must have nature's stamp of intelligence and good-humor, without which any teaching and training is not much use. As the early Mission Fathers had taught weaving and cooking to the women, and simple agriculture and the care of flocks and herds to the men, and left in the fine mission buildings proof of their capacity as workmen, so I experimented on these Indian women with advantage to them as well as to ourselves.[34]

Governor Latham was so impressed by the results of careful training in Wahla's case that he commissioned California's foremost artist, Charles Christian Nahl, to paint the chief's portrait. *Sacramento Indian with Dogs*, executed in 1867, fleshed out the theme of the transformed Indian introduced in *The Annals of San Francisco* (fig. 21). The painting not only represents the high level of refinement that "untutored people" could achieve with the correct sort of guidance but also portrays the life of ease and well-being that was possible for settlers in a land where outsiders were available to do the work "which white men will not do."

Nahl's painting shows that Wahla had been a model trainee. Except for his dark complexion and glossy black hair, the traces of his ethnic origins have been erased. Starched and pressed, the headman of the village has become the footman at the country estate, transformed into someone who, while certainly not a member of genteel society himself, played an essential role in its definition. In addition to helping ladies and gentlemen alight from their carriages, Wahla the faithful retainer, and others like him, would serve as a marker by which the new California elite could clarify their own status.

Nineteenth-century viewers would have recognized the artist's references to the paintings of Gainsborough and Reynolds and to the eighteenth-century outdoor portrait. However, the substitution of the wealthy patron's likeness with that of the aboriginal coachman must have come as something of a surprise for Latham's select audience.

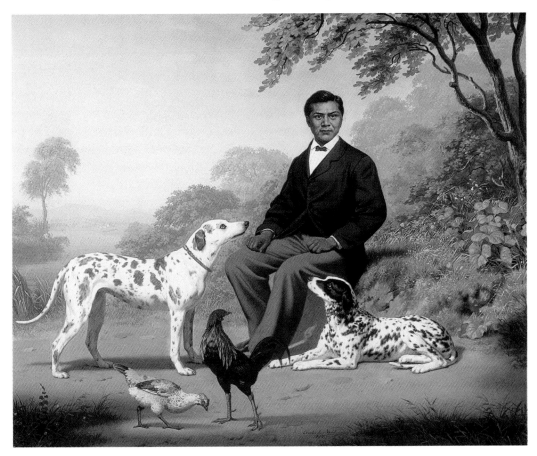

Fig. 21. Charles Christian Nahl,

Sacramento Indian with Dogs, 1867.

Oil on canvas, 42 1/16 x 49 1/4 in.

Fine Arts Museums of San Francisco;

gift of Mrs. Milton S. Latham.

Nevertheless, *Sacramento Indian with Dogs* made the same assurances that gratified the English nobility who had their likenesses made by artists one hundred years before. Like the purebred dogs and the chickens in the foreground—the other domesticated creatures in the Brannan menagerie—Wahla's sleek and well-tended appearance testified not only to the refinement of his master but also to the efficiency and organization of the economic system of which he was an integral component.

By the latter part of the nineteenth century, the campaign to promote California to prospective settlers—haphazard and sporadic during the 1850s and 1860s—became a more organized process. Spearheaded by the Southern Pacific Railroad, which owned millions of acres of California land, developers formulated a carefully structured program to attract newcomers to the Golden State. Benjamin C. Truman, author of various railroad-sponsored tracts, including *Semi-Tropical California* of 1874, gave the rallying cry of the more aggressive approach to immigration: "Look this way, ye seekers after homes and happiness!" he called. "Ye honest sons of toil and ye *pauvres misérables* who are dragging out a horrible life in the purlieus of Eastern cities! Semi-Tropical California welcomes you all."[35]

The new promotional operation hinged on ensuring that eastern *pauvres misérables* had the right ideas about California's climate and its lesser-known southern half. Up to this point, most of the state's development had taken place in the north, where higher quantities of rainfall made settlement more attractive. However, the owners of the Southern Pacific realized that, to sell more of the land granted to them by the federal government as part of the subsidy for the transcontinental railroad, they would need to draw settlers into Southern California. Since this area lacked both adequate rainfall and the more developed communities attractive to middle-class immigrants, the railroad used its influence to promote irrigation and to create settlements centered around "dry farming" production.

Those peddling real estate near Los Angeles and San Diego seized on the idea of "Semi-Tropical California" as an image to fire the imaginations of potential settlers and visitors. The word *tropical* encouraged audiences to envision a place that was lush, green, and warm, while the qualification *semi* tempered fears of steamy junglescapes, malarial fevers, and indolent natives. Truman wrote disdainfully about the climates of Florida, Cuba, and Italy when compared with that of Southern California. "[They] are covered with a rank, rich growth of tropical vegetation, saturated always with moisture, and undergoing a constant and rapid decomposition."[36] In contrast, semitropical California was presented to viewers in Minnesota, Illinois, Iowa, and Kansas as the marvelous combination of a warm climate that promoted health and accelerated plant growth with a salubrious dryness that eliminated the sticky humidity that activated molds and mildew and dampened Yankee enterprise. During the 1880s and 1890s, the theme of semitropical California would prove to be remarkably successful in bringing new settlers to the state and would be repeated in countless variations over the next one hundred years.

The Land and Passenger Departments of the Southern Pacific took a leading part in the campaign to advertise Southern California from the late 1860s to the end of the century.[37] At first, promotional activities were relatively simple, consisting of notices in newspapers, aid to booster organizations such as the Immigration Association of California, letters to prospective buyers in the East and in Europe, and pamphlets distributed at railroad stations. By the 1880s, however, the railroad adopted more exten-

sive measures to reach prospective settlers. Knowing that failure to stimulate land purchases could mean receivership, they redoubled their efforts to populate the land. In 1883 the company appointed an "immigration commissioner" who immediately established offices in New York, Chicago, Philadelphia, and most of the large American cities, as well as in London, Bordeaux, and Berlin.[38]

One of the most successful promotional texts distributed from these posts was a booklet entitled *California: Cornucopia of the World*, which was widely read in the East and Midwest and published in several editions.[39] A promotional poster from the 1880s abbreviated the book's narrative into an image that was understandable at a glance (fig. 22). At the top right, an irrigation spigot releases a flood of water that is transformed into a spiraling cornucopia of exotic fruits. Pineapples, bananas, grapes, and oranges tumble toward the viewer, alongside the statistical enticement: "43,795,000 acres of

government lands untaken." These fruits were presented not only as items for personal consumption but also as the type of high-value specialty crop that would enrich the Pacific farmer. Following the development in the 1880s of refrigerated freight cars, which allowed such produce to be marketed outside California, the railroad encouraged newcomers to devote their energies to fruit production, "for health and wealth." The sale of small-scale horticultural tracts, as opposed to the vast acreage required for grain cultivation, enabled the company to maximize the value of their landholdings. Small plots of land also promoted a denser population that would stimulate the east-west freight and passenger traffic that was the lifeblood of the Southern Pacific system.

Promotional images during the latter part of the century showed that California's bounty was available to the American Everyman, or at least to those with enough cash for a down payment. The primary vehicles for the dissemination of this vision were not, in general, fine paintings executed by famous artists, but the popular media,

Fig. 22. Unidentified artist, California, Cornucopia of the World, c. 1870. Lithographic poster, published by Rand McNally and Co. Collection of the New-York Historical Society.

KERN COUNTY GROUPS.

Fig. 23. (above) Carleton E. Watkins, Kern County Groups, c. 1889. Albumen silver print, approx. 8 x 10 in. The Huntington Library, San Marino.

Fig. 24. (right) Carleton E. Watkins, Stacking Alfalfa Hay, Stockdale Ranch, c. 1887-88. Albumen silver print, approx. 8 x 10 in. Library of Congress, Prints and Photographs Division.

which included newspaper illustrations, photographic advertisements, crate labels, and broadsides. From the context of these humble sources, pictures of California fruit beckoned to ambitious Americans as the means to achieve higher status and to make the leap from farmer to "gentleman farmer." Since the days of Thomas Jefferson and George Washington, the cultivation of fruit, flowers, and vegetables had been considered an elite activity reserved for citizens of a certain social standing. Before the Civil War, for example, the most important members of select society in eastern cities belonged to horticultural societies, where they exchanged ideas about such things as the care of camellias and hybridization.[40] The practice of horticulture was viewed by these groups as evidence of an advanced civilization and was associated with moral rectitude and the good breeding of human stock.[41] By making the production of fruit one of the pillars of their promotional campaign, California developers were thus appealing simultaneously to the cherished republican values of their audience as well as to the desire of ambitious Americans to rise above the level of their peers.

A series of photographs made by Carleton E. Watkins of Kern River County provides an example of images of Southern California sponsored by the Southern Pacific Railroad and other promoters of California real estate (fig. 23). The railroad and individual landowners regularly employed Watkins to catalogue their holdings, and his photographs were often instrumental in the successful defense of ownership claims in dispute. Watkins had established such a close relationship with the railroad magnate Collis P. Huntington that he named his only son Collis as a tribute to his influential patron. With his pictures of Kern County, Watkins displayed the photographic expertise that attracted important clients who came to depend on him to provide the images that were a strategic component in the marketing of desert land in Southern California.

Watkins's Kern County

Fig. 25. (left) Carleton E. Watkins, Headgate, Kern Island Canal, c. 1887–88. Albumen silver print, approx. 8 x 10 in. Library of Congress, Prints and Photographs Division.

Fig. 26. (below) Carleton E. Watkins, Kern Island Canal, Greenfields Ranch, c. 1887–88. Albumen silver print, approx. 8 x 10 in. Library of Congress, Prints and Photographs Division.

client was James Ben Ali Haggin, one of the state's largest landowners. A large percentage of the 350,000 acres that belonged to Haggin's Kern County Land Company was up for sale and primed for development. In July 1888 the *Kern County Californian* contained an article that explained what Watkins would do to help Haggin promote his land. The photographer's task was to take "a series of photographic representations of the waterways, canals and headgates that constitute the great irrigation system of the Kern Valley." The newspaper reported that "these photographs will be issued by Haggin…in pamphlets containing statistical and other valuable descriptive matter for general distribution."[42]

Most of Watkins's Kern County views were photographed with a camera anchored to the top of a traveling studio wagon. From this vantage point, fifteen feet above the ground, Watkins could avoid unflattering close-ups of cattle pastures and desert scrubland and concentrate instead on the broad vistas and general scenes that brought out the area's best features (fig. 24). While Watkins also took pictures of farms, dairies, local residences, and town buildings, his main purpose was to capture the miraculous effect of irrigation projects. The result was a sort of aqueous Kama Sutra, an inviting catalogue of ways that water could be positioned, guided, and contained in the service of agriculture. Watkins showed water stretched across the landscape in pleasing geometries: penned up in wooden reservoirs, flowing in natural waterways, rushing by bridges, and reflecting agricultural landscapes (figs. 25 and 26). Water appeared in these photographs as an animate force, insinuating itself into the barren ruts of undeveloped acreage and transforming desert into farmland, where watermelons and corn could be seen ripening in the field and juicy-looking "Late George Cling

LATE GEORGE CLING PEACHES.

Peaches" were boxed for export (fig. 27).

A picture of Watkins's photographs at the San Francisco Mechanics' Fair in 1889 demonstrates how such images were displayed to the public (fig. 28). Lined up next to pumpkins and cucumbers at the fair, the Kern County views provided a crucial component of the "seeing is believing" formula that underlay such exhibitions. The photographs integrated the products displayed into a comprehensible whole of production and consumption, while extending an invitation to viewers to become part of the lucrative cycle. In addition, they verified the claims made in promotional books available at such fairs, including Charles Nordhoff's railroad-sponsored *California for Health, Pleasure, and Residence*. "I find that the question of whether our race can practise irrigation of land, and do it well and profitably, is settled beyond a peradventure," Nordhoff wrote. "There is water enough for all uses; and that which seemed to me ten years ago so desirable, and yet so far off, is as good as done—the whole great valley system of California, with its healthful climate and its wonder-

Fig. 27. Carleton E. Watkins, Late George Cling Peaches, 1888. Albumen silver print, approx. 8 x 10 in. The Huntington Library, San Marino.

Fig. 28. Carleton E. Watkins, Kern County Exhibit, c. 1889. Albumen silver print, approx. 8 x 10 in. The Huntington Library, San Marino.

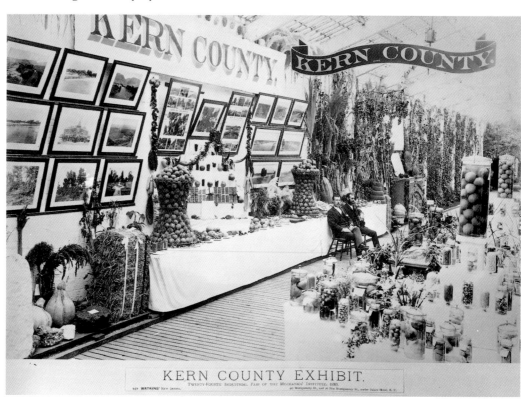

KERN COUNTY EXHIBIT.

fully fertile soil, is open to the profitable and happy settlement of a farming population, so far as the overcoming of natural obstacles goes."[43]

While Watkins's Kern County views worked to convince audiences of the feasibility of large-scale irrigation, other images focused on the benefits of farming smaller tracts of land and, in particular, on the attractions of citriculture. By the 1880s, the orange had become the focus of developers' efforts to promote settlement in California and became the symbol of everything the state offered to the newcomer. Promotional tracts explained that orange cultivation required little physical labor and was thus perfectly suited to the accustomed activity levels of American urbanites. An article in the *Observer*, of Ontario, California, clarified the idea that growing oranges in California required no special talents and was an occupation open to all classes of Americans:

> In the cultivation of fruit (the most charming, healthful and lucrative of occupations, and decidedly the most fascinating) are to be found men from almost every walk of life. They have come from every State in the Union and from every Province of Canada, and not a few from the Old World. These men left the judge's bench and the banker's office, the editorial chair, the merchant's counter and the accountant's desk, the legal forum and the use of the lancet, the farm and the factory, the mechanic's tools and the professor's toga, for a more congenial occupation and a congenial clime. They found both—and more.[44]

In the scenes depicted on orange-crate labels, the romantic ideal of citriculture as described by the *Observer* was conflated with the tangible, edible orange itself. Developed initially in the 1880s and 1890s by growers wishing to personalize their products and to foster a measure of brand loyalty in their clients, orange-crate labels became one of the most successful formats for the dissemination of the vision of the good life in Sunny California.

The themes portrayed in orange-crate labels tended to fall into a few main categories.[45] Some promoted their product by representing fantasy or mythical subjects that linked irrigated orange farming with the glories of classical antiquity. Portraying Atalanta's race against Hippomenes, a label for the Hesperides brand called attention to many of the state's most attractive features as advertised in booster literature, including the region's Mediterranean climate, the sophistication of the state's artistic expressions, the orange's health-giving qualities, and the average Californians' high level of physical fitness (fig. 29). The label showed the mythical Atalanta stooping to pick up California's new and improved substitute for the golden apples of antiquity. In a delicious contradiction typical of such advertising efforts, the orange company did not seem to consider the negative implications of one essential element of the ancient story—that Atalanta, swayed by her greed for the fruit, was duped by the golden orbs tossed in front of her and lost the race. Presumably, because of the growing national demand for oranges, vendors could afford to ignore the finer points of classical mythology.

Still, other labels that purported to show middle-class life as it actually existed in California demonstrated that state residents were indeed at the head of the pack. A label for the Suburban brand described the kind of economic and physical well-being enjoyed by local cultivators (fig. 30). It presented a presumably typical California dwelling situated in the middle of an orange grove, with the title suggesting that this

little corner of semitropical paradise was conveniently located near an important metropolitan center. From the shade of her parasol, the mistress of the property surveys her bounteous acres, which are flanked by snowcapped peaks indicating the winter season.

The lady's suburban cottage, with its open timber work and fieldstone chimney, was of the rustic type espoused by the prominent California poet and naturalist Charles Keeler. Keeler lectured extensively at the turn of the century on the relationship of architecture to spirituality and moral values and held up the rustic home as the finest expression of the state's superior culture. These buildings were described by Keeler and other authors in the state as the locus of a particularly Californian kind of goodness. Slow-paced, yet intellectually bracing, the congenial lifestyle of the "simple" homeowner was touted as a cure for the

Fig. 29. Unidentified artist, Hesperides Brand Oranges, 1912. Chromolithograph, approx. 10 x 12 in. Private collection.

Fig. 30. Unidentified artist, Suburban Brand Oranges, 1915. Chromolithograph, 8 1/4 x 10 3/4 in. Private collection.

Fig. 31. (opposite page) Unidentified artist, Pot-o'-Gold Oranges, c. 1915. Chromolithograph, 8 1/4 x 10 3/4 in. Private collection.

Fig. 32. (opposite page) Unidentified artist, Mazuma Oranges, 1923. Chromolithograph, 8 1/4 x 10 3/4 in. Private collection.

assorted ills brought on by modern existence. The enviable circumstances of local residents were described by an eastern visitor who observed that "they sit on the verandas of their pretty cottages—the refined essences of abstract existences—inhaling the pure air of the equal climate, reading novels or abstruse works of philosophy, according to their mental activity, from day to day, and waiting from year to year for their oranges to grow."[46] One can easily imagine the favorable effect of this vision on the American homemaker and orange-juice squeezer, beset by quotidian worries and climatic insults in the metropolitan areas of the East and Midwest, to whom such information was addressed.

The association of horticulture and an outdoor lifestyle with moral improvement was also encouraged by the popular writings of Luther Burbank, one of the most prominent Californians of his generation. A self-taught nurseryman, Burbank was responsible for the development and improvement of numerous stocks of fruits, flowers, and vegetables, including the Burbank potato. Burbank also concerned himself with human development and with the ways in which spiritual and physical development could be improved by the natural environment. His ideas, as explained in his books *The Training of the Human Plant* and *The Harvest of the Years* and in countless newspaper articles, articulated certain beliefs about the beneficent influence of nature in California, ideas that were a strategic part of the promotional campaigns of land developers.

Despite the elevated tone of many of the labels, one type of orange-crate signage dispensed with the focus on health, gentility, and the romantic niceties that characterized other labels. These showed customers the hard cash that was, after all, the principal attraction of citriculture as formulated in booster campaigns. The profitability of orange culture was effectively communicated by images that showed the fruit nestled next to piles of coins or atop wallets bulging with cash. Evoking the imagery of the not-so-distant gold rush, the Pot-o'-Gold brand showed its fruit as the treasure at the end of the rainbow, while Mazuma brand represented a half-peeled orange sitting on a bankbook whose cover reads: *An Account with a Wise Buyer* (figs. 31 and 32).

The "wise buyers" who were the intended audience for orange-crate labels were also the target of another sort of imagery that equated California's products with affluence and abundance: the state fair and exposition display. These exhibits combined samples of produce, photographs, prints, manufactured articles, paintings, raw materials, and natural-history specimens in multimedia extravaganzas that captured

the attention of audiences across the country and in Europe through sheer sensory overload.

California's display at the New Orleans World's Fair in the winter and spring of 1885 was one of the first of a series of successful promotional exhibits. It sprawled over twenty thousand square feet of indoor space and continued outdoors in a three-acre California Park, which was made up of flowering shrubs and orchard and ornamental trees. The exhibit effectively erased memories of the excesses of the gold rush, replacing them with the vision of a horticultural Eden. A New Orleans newspaper confirmed that "no person can look through the extensive and instructive exhibit which is being made by the State of California without being struck with the emphasis laid by California on the grain, wine and fruits of that region, while the entire subject of the mineral wealth of the quondam golden State is left entirely in the background." The author added that "there is…nothing that reminds one of 'the days of old, the days of gold, and the days of forty-nine.'"[47]

The Chicago Citrus Fair of 1886 helped to clarify further the image of California that promoters hoped to establish in the minds of the American public. The fair set off California's citrus production to its best advantage. Los Angeles County sent a railroad car of oranges and lemons, while the towns of San Gabriel, Alhambra, Santa Ana, Anaheim, and Orange sent live plants and trees, wines and brandies, in addition to cars of citrus fruit. The samples were artfully arranged in large, geometrical formations that impressed fair-goers with their size and opulence. "Nothing…could be more charming to the eye than the oranges, lemons, citrons, limes, figs, nuts of various sorts, the palm and banana trees, the gay grasses and thorny cacti, with flowering plants and minerals intermixed," rhapsodized a reporter for the *Chicago Standard*. "One comes from the midst of it all into the raw atmosphere of a Chicago March day, almost with a feeling of surprise, so much does the imagination sympathize with the surroundings of such a scene."[48]

California's great display at the World's Columbian Exposition in Chicago in 1893 was the culmination of the promotional work that began at other locales. Anticipated as the largest international fair to date, the Columbian Exposition offered California promoters the chance to reach a wider audience than ever before. California's entry, even in the context of the extravagant showmanship that characterized most of the displays, was generally acknowledged to be overwhelming. In size and variety of material, it was the largest of the collective exhibits, with the state's various counties seeking to outdo each other in the scale and opulence of their arrangements. San Diegans brought a 120-year-old date palm weighing 45,000 pounds and replanted it under the dome at the center of the California Building. Santa Clara contributed an immense statue of a horse and rider sculpted from dried prunes. Los Angeles County matched this with a larger-than-life elephant made from walnuts, in addition to a liberty bell and a thirty-five-foot tower made with local oranges. Viewers were also treated to the sight of an entire bearing lemon and orange grove replanted on the fairgrounds (fig. 33).[49]

As visitors strolled through the live palms, ferns, flowering shrubs, citrus trees, and other exotic plants that filled the California Building, the leafy pleasures of semitropical California came into focus. Supplementing the lush vegetation, exhibit organizers also included abundant references to the state's cultural progress. Various "rooms" were created to give viewers an idea of the general refinement of California living. Visitors entered the San Francisco Room under a carved redwood archway that informed them

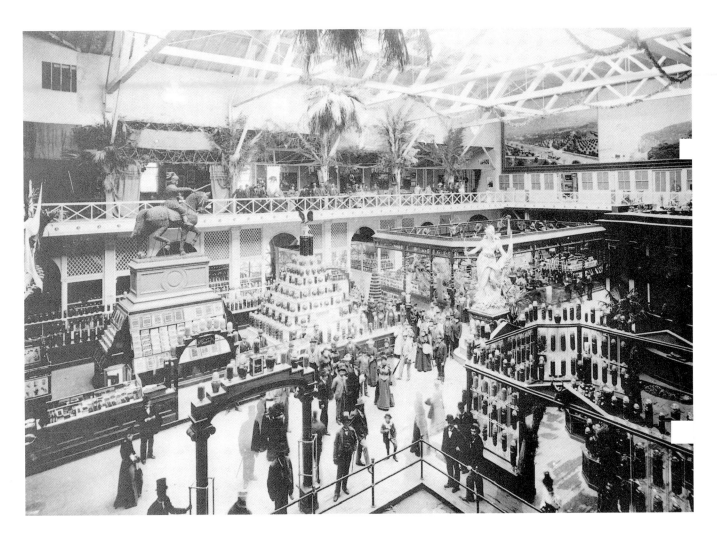

Fig. 33. C. D. Arnold, Interior of the California Building, 1893. C. D. Arnold Collection, vol. 3, pl. 77, Chicago Public Library, Department of Special Collections.

that this was a place for "Art: Literature: Music: Industry" (fig. 34). The redwood-paneled octagonal interior contained a bound album of all the music ever composed in the state, bookshelves full of volumes by each of the most celebrated California authors, various sculptures by San Francisco artists, and "specimens of embroidery finely executed." The Wildflower Room was planned "as a gentle reminder of the freshness and beauty of rural life in California." Here, large watercolors of California wildflowers were hung on walls covered with olive green silk, and artificial California poppies were arranged decoratively around the room.

With these intimate and carefully decorated chambers, state boosters invited fairgoers into the elegant parlors of California residents, allowing them to sample the kind of living made possible by the natural bounty that filled the California pavilion. In these rooms, the great piles of fruit and the assortment of flowers, vegetables, livestock, timber, and the wealth of California products that made up the display were condensed into something that the residents of eastern and midwestern cities would find more directly appealing: the promise of a leisurely life of books, music, and other intellectual pursuits and the abundant comforts of the more than simple home.

In their heroic efforts to promote California at the World's Columbian Exposition, California's developers did not ignore the fact that attracting permanent residents was

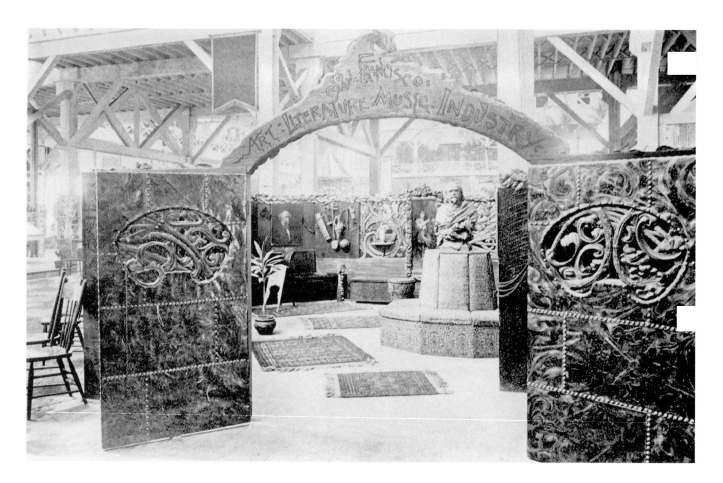

Fig. 34. Unidentified photographer, The San Francisco Room. From California World's Fair Commission, Report of the World's Fair Commission (1893), facing 36. Private collection.

just one of the means to take advantage of the state's varied resources. Apart from the various land booms of the 1880s and 1890s, lackluster immigration statistics in the last quarter of the century confirmed that Americans continued to think of California, however lush and fertile, as too remote from the nation's commercial and cultural centers to represent a viable option for settlement. Henry James articulated this recalcitrance when he described being "bowled over" by California's natural opulence, but tempered his enthusiastic remarks with the condescending aside: "I speak of course all of nature and climate, fruits and flowers; for there is absolutely nothing else."[50]

Nevertheless, for easterners who were not persuaded to settle in California by idyllic images of farming on the Pacific, promoters had something else to offer. A month-long holiday in the Golden State, relative to the weighty issues of immigration and permanent settlement, represented a simple concept to market in the East. Certainly, since the days of the gold rush, Americans in the rest of the nation had been curious about California, but the state's isolation and its reputation for lawlessness discouraged pleasure excursions. With the completion of the transcontinental railroad in 1869, however, a large part of the problem was eliminated. By train, easterners could travel to California in little more than a week—less than the time it took to sail to England or France.

In addition to advertising this new and efficient means of transportation, business leaders needed to create and embellish the idea of California as a worthy vacation destination. Many readers had not forgotten the admonitions of writers like Hinton Rowan

Helper, who warned his audience in 1855 about "filthy fare in hotels and restaurants," "banditti in the mountains," and the "alarming depravity of the adolescent generation" in his widely read book, *The Land of Gold*.[51] Over the next fifty years, those with a stake in the state's development responded with images that insisted a trip to the Pacific was well worth the effort. California appeared in these works, not as the tourist nightmare that the unhelpful Helper described, but as a place where the *pauvres misérables* of the East could realize their dreams of a perfect holiday, enjoying the picturesque charms of the Old World while surrounded by the breathtaking natural beauty of the New.

4

Rush
for the
Wilderness

\mathcal{D}uring the years immediately following the gold rush, efforts to promote California to outsiders centered on the assertion that those settling in the state had successfully reproduced the traditional order of eastern communities. Ambition, hard work, and moral character were the attributes that animated the images of miners and farmers that were disseminated in the East and through which local developers hoped to

stimulate immigration. After the completion of the transcontinental railroad in 1869, however, promotional imagery in California underwent a fundamental change in focus. Scenes of industrious argonauts digging in the goldfields and farmers harvesting the fruits of their labor gradually gave way to representations that emphasized leisure and entertainment. This shift in emphasis, although evident in mining and agricultural imagery, is most apparent in pictures that promoted California as a tourist destination.

Though they had been produced since the early 1850s, images advertising tourism in California had been limited in number and scope. Portrayals of local society and scenery were addressed to the hearty few willing to trek to the Pacific and to easterners wishing to inform themselves about the state from the comfort of their armchairs. It was neither expected nor intended that such works would inspire an influx of tourists. Indeed, paintings of California displayed in eastern galleries and illustrations of the state featured in popular journals tended to act as an end in themselves by satisfying the curiosity of the American public about the land that lay at the distant edge of the continent.

Still, by the middle of the nineteenth century, the touring vacation trip had emerged as a favorite activity of both elite and middle-class Americans. A revolution in transportation in the 1820s and 1830s, including the building of toll roads, canals, and railways, and the use of steam navigation, opened areas in the East and beyond that had previously been inaccessible to tourists and accustomed Americans to traveling holidays. By the 1850s, excursions to the Catskills and the White Mountains, to seaside resorts along the Atlantic seaboard, and Europe were commonplace, whetting the appetites of American tourists for new and exciting destinations.

The national passion for travel had special significance for those interested in the continuing development of California. Railroad owners, financiers, and merchants in the state were inspired by the commercial success of tourist resorts like Saratoga Springs and Niagara Falls and were eager to take advantage of the expanding circuit of American travel. They calculated that a vigorous tourist industry would allow them to create value from remote wilderness land, where it was difficult to farm or establish urban communities. Accordingly, as eastern and midwestern citizens looked for new and fashionable locations to pass their leisure time, California's business leaders rolled out the proverbial welcome wagon in the form of the transcontinental railroad, the construction of which they had initiated and managed to a large extent. The opening of the cross-country line, in turn, was accompanied by images of the state's abundant scenic attractions, strategically placed on the pages of national journals, in broadsides displayed in railway stations, and on the walls of galleries in New York, Boston, and other eastern cities.

In contrast to gold-rush California or semitropical California, the theme of wilderness California did not require a lengthy introduction to American audiences. Viewers and readers in all parts of the country had already been primed by a body of images and writings about nature that became current during the 1830s and 1840s. Californians drew on these prototypes as they fashioned the image of an outdoor paradise on the Pacific. Americans in the first half of the century had been inspired by French and English literature dealing with the sublime and the picturesque and had come to believe that their natural environment was one of the few areas in which the nation could be compared favorably to Europe.[2] Americans held that their own wilderness, with its boundless forests, endless prairies, and breathtaking mountain ranges, had been wrought with a bolder hand than the more domesticated landscapes of Europe. In turn,

pride in the country's natural magnificence relieved some of the anxiety felt by Americans when they compared their young Republic with the ancient grandeur of European culture. By the 1830s and 1840s, the exaltation of the country's wild scenery had blossomed into a full-fledged crusade for the appreciation of nature, spearheaded by writers like William Cullen Bryant and Henry David Thoreau, and by artists like Thomas Cole.

Beginning in the 1860s and continuing through the end of the century, pictures of the natural wonderland in California were displayed to audiences who had already "done" the Catskills, the White Mountains, and the Adirondacks, and who were looking for new American landscapes to explore. By the time the transcontinental railroad was completed in 1869, viewers across the country had been tantalized by images of the Golden State for more than ten years, and many were eager to experience its wonders firsthand. Images would play a strategic role in fostering this interest by linking the awesome *terribilità* of nature in California with the American sense of national mission and by alluding frequently to the safety and comfort of the tourist experience there. By the 1870s, prepared by pictures and writings that led them to believe that a trip to California was not only a patriotic act but also a journey so easy that there would be "no inconveniences which a child or a tenderly reared woman would not laugh at," tourists from the East began to venture to the distant Pacific.[3]

The encouragement to make the leap of faith and board the train to California was provided in part by guidebooks, which helped familiarize uncertain travelers with every step of the transcontinental trip, that took a little more than a week. At least thirty transcontinental guidebooks were published during the 1870s and 1880s, with one popular version, *Crofutt's Transcontinental Tourist Guide*, selling almost 350,000 copies.[4] Another widely read publication during this period was *The Pacific Tourist*, which was sponsored by the Central Pacific and Southern Pacific railroads. Like the railroad construction itself, "the guide was projected on an immense scale and completed at commensurate cost," as the editor explained in the preface. "It represented over nine months spent in personal travel—over a line of 2500 miles—getting with faithfulness all possible facts of interest and the latest information. Over forty artists, engravers and correspondents were employed...the result being the most elaborate, the costliest and the handsomest Guide Book in the world."[5] The results of the project were impressive, with the book selling over 100,000 copies in the first year, and going through several editions in the decade following its publication.

Despite the sale of hundreds of thousands of transcontinental guidebooks, the cost of the trip to the Pacific during the 1870s made it prohibitively expensive for all but the wealthiest Americans. A round-trip ticket from Boston or New York cost a minimum of $300, with meals and sleeping berths added on separately. One guidebook published in 1873 calculated an expense of $1,200 for an excursion across the continent, which included side trips to "the chief points of interest in California and Colorado."[6] Furthermore, once travelers had reached their destinations, the outlay per day was estimated to be two and a half times the cost of travel in Europe.[7] Accordingly, images and promotional writings addressed themselves to the well-to-do client, who expected a great deal in return for the considerable price.

The first things promoters chose to emphasize were the comfort of transcontinental travel and the genteel company that passengers would enjoy during their trip. An illustration of "Palace-Car Life on the Pacific Railroad" was designed to appease

Fig. 1. Unidentified artist, Palace-Car Life on the Pacific Railroad. From Schearer, The Pacific Tourist (1884), frontispiece. Private collection.

travelers' anxieties about the long voyage and to erase from their minds the image of the notoriously crowded third-class immigrant trains that transported settlers with just enough money to pay the lowest fare (fig. 1). The image pictured the elegant accommodations that a "superior class of people" could expect. One passenger described the refined opulence of these moving palaces: "The sleeping cars are fitted up with oiled walnut, carved, and gilded, etched, and stained plate glass, metal trappings heavily silver-plated, seats cushioned with thick plushes, washstands of marble and walnut, damask curtains, and massive mirrors in frames of gilded walnut. The floors are carpeted with the most costly Brussels, and the roof beautifully frescoed in mosaics of gold, of emerald green, crimson, sky-blue, violet, drab and black."[8]

Supporting the comforting information provided in guidebooks, the publicized excursions of certain famous personages also helped to accustom readers to the idea of making the trip to California. In 1877 Frank Leslie, the well-known publisher of the New York–based publication Frank Leslie's Illustrated Magazine, set out for California in a campaign designed to increase the circulation of his journal. In addition to numerous friends and employees, Leslie was accompanied by his second wife, Miriam, also known as the "Baroness de Bazus," who had already toured the country with the celebrated actress Lola Montez as "Minnie Montez, Lola's little sister."[9] On their departure from New York, more than a hundred friends gathered at Grand Central Station to bid farewell to the Leslies, an occasion that was carefully recorded for readers by staff writers and artists (fig. 2). As porters loaded hampers of champagne and fruit into a Wagner drawing-room car that had been renamed "The Frank Leslie," firecrackers were set off under the wheels, heightening the excitement of the occasion.

Leslie's western journey was to last five months, and from July 1877 to the end of 1877, his magazine included long dispatches from the party as a regular feature. Readers thrilled to descriptions of gambling casinos, mining camps, magnificent scenery, and the San Francisco mansions of railroad tycoons. As well as stimulating his readership, Leslie's popular accounts helped make travel to California an attractive option for the members of his class. The engaging written descriptions of the journey and the lavish illustrations included with them also spoke to average citizens who would not forget the celebrated "Frank Leslie Excursion to the Pacific Coast." When railroad and accommo-

dation costs became more reasonable during the 1880s and 1890s, middle-class tourists were ready to make their own forays to the Golden State.

Vacationers traveling by train to California crossed the state line near Donner Lake. An 1873 painting by the eminent eastern artist Albert Bierstadt, *Donner Lake from the Summit*, pictured the landscape that travelers like the Leslies saw when the train first passed into California (fig. 3). The work was commissioned by Collis P. Huntington, one of the Big Four railroad barons, to commemorate the construction of the transcontinental line.[10] Donner Lake lay at the summit of the Sierra and, for Huntington, represented the completion of the most dangerous and arduous part of the project. For American audiences, the painting would have evoked other memories as well in its portrayal of the treacherous pass where the unfortunate Donner party spent the winter of 1846-47. A late start on their overland journey and an early snowfall trapped the overland travelers at this point. The story of starvation and cannibalism related by survivors in a series of contemporary publications shocked the nation and made the name "Donner" an infamous one.[11]

Popular recollection of the tragedy was still intense in the late 1870s when Frank Leslie made his trip to California. Describing the passage of his train through Summit Station in the Sierra, the journalist wrote in his report to *Leslie's Illustrated Magazine*: "The road, turning aside from the Truckee River, passes near the site of Starvation Camp, where in the winter of '46, the Donner Party perished by cold and starvation....One of the most vivid pictures of all our journey is this of Donner Lake, with its weird, tragic

Fig. 2. Unidentified artist, Boarding the Train at Grand Central Depot, New York City. From Frank Leslie's Illustrated Newspaper 44 (July 7, 1877): 2. Stanford University Libraries, Department of Special Collections.

BOARDING THE TRAIN AT GRAND CENTRAL DEPOT, NEW YORK CITY.

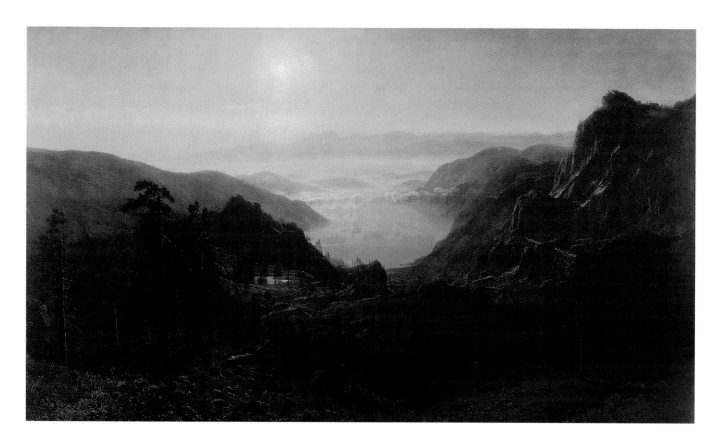

Fig. 3. Albert Bierstadt, Donner Lake from the Summit, 1873. Oil on canvas, 72 x 120 in. Collection of The New-York Historical Society.

story clinging around it, lying white and shining between the dark forests and the snow peaks under quiet stars."[12]

A critic for the *Overland Monthly*, a California journal aimed at eastern readers, discussed Huntington's intentions in commissioning the painting: "[The Donner Pass] was chosen at the instance of the gentleman for whom the picture was painted, because right here were overcome the greatest physical difficulties in the construction of the road, while the immediate vicinity was the scene of the most pathetic tragedy in the experience of our pioneer emigration, for it was on the shore of Donner Lake that the Donner Party was caught in the winter snows, and suffered horrors worse than the death which overtook so many of them," the writer explained. "The two associations of the spot are, therefore, sharply and suggestively antithetical: so much slowness and hardship in the early days, so much rapidity and ease now; great physical obstacles overcome by a triumph of well-directed science and mechanics."[13]

Donner Lake from the Summit was thus able to communicate simultaneously the great sacrifice that the settlement of the Golden State had demanded and also the "rapidity and ease" of a vacation excursion made possible by the "triumph of well-directed science and mechanics." The painting articulated the idea of a speedy passage over the impassable Sierra through the visual device of the attenuated silver line of the train that threads its way through the mountains on the right side of the canvas.[14] The tiny size of the train relative to the looming rock formations around it confirmed that passengers would experience, from the comfort and safety of a Pullman car, the thrill of the overland trip of days gone by. However, where early immigrants had to concern themselves with preserving life and limb at this most difficult point in the journey, transcontinental passengers could lean back and enjoy the spectacular views that Bierstadt described.

By defining the land bounded by the Sierra not only as a region of great scenic wonders but also as a place where development adhered to eastern cultural models,

Bierstadt drew on certain visual prototypes to make the point his patron wanted to communicate through the painting. The lake was a common feature of landscapes painted in the East, which, in the context of American culture in the first half of the century, indicated the penetration and settlement of the interior of the continent. In addition, where marinescapes and river scenes often alluded to transition, travel, and social change, lake views emphasized permanence and the unchanging patterns of the land. With the rapid advance of industrialization in the second half of the century, paintings representing idyllic lake scenes provided an escape from the quickening tempo of urban life by evoking the memory of the time when America had been an agricultural nation populated by yeomen farmers. During the 1860s and 1870s, numerous artists, including Martin Johnson Heade, John F. Kensett, David Johnson, and John W. Casilear, made studies of lakes that ignored the relentless progress taking place in nearby cities and towns and focused instead on the tranquility of the lakeside setting associated with an earlier age (fig. 4). Lake George in the Adirondack Mountains was a special favorite of these painters. The artists sold their works to buyers who often had been vacationers at the popular resorts on the banks of Lake George. By 1876, the lake offered twenty hotels and numerous private camps and was also conveniently accessible from New York by rail.[15] Those who could not afford to buy such paintings could view examples at the National Academy of Design in New York, the Pennsylvania Academy of the Fine Arts in Philadelphia, and at the Boston Athenaeum. They could also purchase any of an endless variety of prints, gift cards, and illustrated books devoted to the subject.

It was not by chance that Huntington chose Donner Lake as the subject of his important commission during the years of Lake George's greatest popularity. In his selection of the California lake as a new icon of Anglo-American culture in California, Huntington counted on viewers' ability to make connections with similar spots in New York and New Hampshire and to identify the Pacific site with all the good things

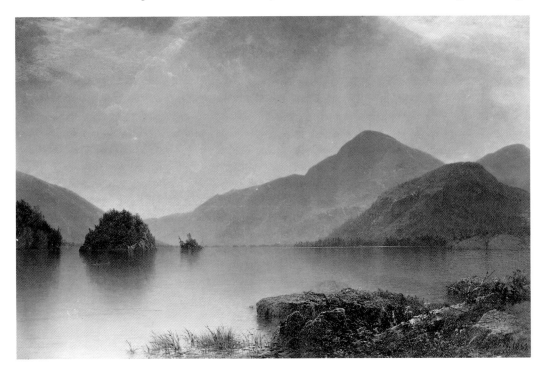

Fig. 4. John F. Kensett, Lake George, 1869. Oil on canvas, 44 1/8 x 66 3/8 in. The Metropolitan Museum of Art; bequest of Maria DeWitt Jesup, 1915. (15.30.61).

conjured by representations of the eastern lakes. *Donner Lake from the Summit* asserted that, with the introduction of the railroad, California would be opened to the kinds of recreational excursions that tourists enjoyed in other parts of the country. It also suggested that, with the boost provided by new commercial opportunities, the state would be able to provide residents with the time and means for leisure pursuits.

The completion of the continental railroad, the implicit subject of Bierstadt's *Donner Pass from the Summit*, coincided with the publication of a wilderness guidebook from which can be deduced the type of audience for which California itineraries were planned and to which images of wild California were directed. Many of those willing to venture to the western edge of the continent embraced ideas about nature and physical well-being set forth in a book written by the Reverend William Henry Harrison Murray, *Adventures in the Wilderness; or, Camp Life in the Adirondacks*. The Reverend Murray's treatise on the wilderness instructed readers in the art of outdoor living. It provided step-by-step guidance on hunting, fishing, hiking, making shelters, and camp cooking. Since Murray was also a minister at the Park Street Congregational Church of Boston, one of America's most prestigious and affluent parishes, his advice on outdoor life seemed to be guaranteed by other, more weighty sources of authority. Certainly, Murray's talents as a lecturer and the publication of numerous volumes of his sermons, which earned him the title "Beecher of Boston," helped to cement his reputation as a spiritual guide and primed readers to accept his ideas on the physical aspect of life as well.

Adventures in the Wilderness espoused the simultaneous development of body and soul, a practice Murray defined as "muscular Christianity." The notion of the intimate connection between physical and moral health was not new; the philosophy had gained popularity in the East after its introduction in the 1850s by English clergymen and by two Boston ministers, Thomas Wentworth Higginson and Edward Everett Hale. Muscular Christianity embodied the change in Protestant ideology that had occurred by midcentury, which placed a new emphasis on the power of the individual to effect his or her ultimate salvation through correct behavior. The Calvinist notion of predetermination, which had characterized American religious beliefs through the early part of the century, gradually lost favor during this period. The "new" Christian rejected the physical denial that had been a mark of virtue decades earlier, and spiritual health was increasingly equated with a robust and healthy body. Advocates of muscular Christianity, like the Reverend Murray, encouraged the practice of vigorous physical exercise as the best remedy for moral weakness and its physical counterpart, the "narrow-chested and shrivelled-skinned" physique. "Whose piety is of that broad-chested sort which has sufficient lung-room for the healthy inspiration?" Murray asked his readers. "Whose practice in spiritual gymnastics is so well sustained as to keep every tendon flexile, and every artery in a healthy beat? Nothing stirs the spirit of admiration and reverence in me more than to see a young man twenty lower himself to the weights, clasp the handles and lift six hundred pounds. How the creative skill and benevolence of God are brought out by such an exhibition of physical power!"[16]

According to Murray, the best place for muscular Christians to flex their physical and spiritual muscles was in the wilderness. Dissipated urbanites needed to remove themselves from the debilitating influences of the city and its negative effects on mental and moral health. City life reduced the brain to a "flaccid state of inanition" and put "burdens on men beyond what flesh and blood can bear."[17] The wilderness vacation was encouraged by Murray as a sort of holy ritual through which city dwellers could communicate with the infinite and, in so doing, restore their exhausted physical and spiri-

tual energies. Murray described the woods as the place where "God is everywhere" and, consequently, as the place where men, given new opportunities for heroic action and adventure, could raise themselves up in the eyes of the Almighty. The wilderness vacation was thus not a sybaritic exercise in self-indulgence but a constructive kind of leisure, characterized by strenuous exercise, early morning *levées,* and the cooking of simple fare supplemented by hunting and fishing.

The outdoor living espoused by Murray, as well as by other popular nature writers during this period, provided urban readers with a focus for the leisure time that was increasingly available to them, thanks in part to various labor-saving technological advances that had taken place in the early part of the century. Other authors, including Emerson, Thoreau, and Henry Ward Beecher, had written about the benefits of nature, but Murray gave urban middle-class readers a specific recipe for the blending of lofty ideas and free weekends, including instructions on how to reach remote areas, what kind of clothing to wear, and which guns and fishing rods to bring along. American readers responded positively to the author's formula; *Adventures in the Wilderness* was a resounding success, going through several editions in the decade after it was published. The book also helped to launch a flood of tourists, called "Murray's Rush," to the Adirondack region, establishing it as a favorite vacation spot for decades to come.[18]

Of course, by the 1860s, the Adirondacks and many other wilderness areas in the East were overrun with tourists. Muscular Christians needed new mountains and forests in which to exercise their physical and spiritual powers. In this context, California's vast Sierra beckoned as the ultimate test of the wilderness pilgrim. In fact, many easterners were already familiar with the rugged beauties of Yosemite Valley, the Mariposa Grove, and other regions of California through the writings of Thomas Starr King, California's own Reverend Murray. Before coming to California from his native Boston, King had authored a widely read book on the White Mountains, in which he extolled the moral benefits of the wilderness excursion. After being transferred to San Francisco, the peripatetic minister arranged to visit the Sierra, including Yosemite Valley and the Mariposa Grove, and was enraptured by what he saw. Coming face to face with what he considered the superior manifestations of God's greatness in Yosemite, the Reverend remarked to a friend, "If you can find any copies of King's book on the New Hampshire ant-hills, I advise you, as a friend to the author, to buy up the remaining edition and make a bonfire."[19] Afterward, King expounded at length on the subject in his sermons, which were given titles such as "Lessons from the Sierra Nevada" and "Living Water from Lake Tahoe." In addition to lecturing to his own San Francisco congregation about "Yosemites of the Soul" and the spiritual catharsis that had resulted from his experience of California's natural wonders, the minister also spread the news to easterners in a series of letters published in the *Boston Evening Transcript* in 1860 and 1861. In a dispatch to the newspaper from December 1860, King described his first trip to Yosemite to his eastern readers. In this epistle, the usually loquacious King emphasized the magnitude of his vision in the valley, and his humility before it, by deferring to the words of a state report:

I quote from a recent report to the State Agricultural Society. The italics are mine.

"*The thing* is there away up in the Sierras; and all we have to say is that he who has threaded the streets of Nineveh and Herculaneum, scaled the Alps, and counted the stars from the tops of Egypt's pyramids, measured the Parthenon,

and watched the setting sun from the dome of St. Peter's, *looked into the mouth of Vesuvius, and taken the key note of his morning song from the thunder of Niagara,* and has not seen the Yosemite, is like the Queen of Sheba before her visit to King Solomon—the half has not been told of him." Shall I attempt to improve on that? No, verily.[20]

King's *Transcript* letters were widely read and did much to popularize the natural magnificence of the state. Oliver Wendell Holmes told the minister, "We read all you write from California with great pleasure." John Greenleaf Whittier also expressed his interest in "thy occasional letters in the *Transcript*." Henry W. Bellows wrote after King's death, "You will find the newspapers in which his portraiture of these sublime and charming scenes are found, carefully laid away in hundreds of New England homes, as permanent sources of delight."[21] Undoubtedly, these articles also acted as a catalyst for King's readers, spurring them to make their own pilgrimages to the Pacific.

When muscular Christians made the decision to travel to California, the next step was the selection of an itinerary. Artists making pictures of the state's scenery, often under commission from local businesses, directed tourists' choice of places to visit. The most frequently portrayed scenic attraction was Yosemite Valley, the centerpiece of the California tourist industry and the crown jewel among the gems of Pacific scenery that were offered to visitors. One of the first images to be published of Yosemite Valley was a lithograph produced from a drawing of Yosemite Falls made by Thomas Ayres (fig. 5). Ayres was a native of New Jersey who had come to California as an argonaut in 1849. Though he had not made his fortune in the mines, Ayres was able to earn a living with the sketches he made of local scenery. In 1855 Ayres was engaged by James B. Hutchings, a San Francisco journalist who intended to publish an illustrated magazine devoted to California topics, to accompany him on what was to be the first tourist excursion into Yosemite. The artist made a series of sketches of what he and his patron considered the valley's most outstanding features, including El Capitan, Yosemite Domes, Cascades of the Rainbow (Bridal Veil Falls), and the Yosemite Falls, which was widely distributed in lithographic form.

Samuel Bowles, the editor of the *Springfield Republican*, helped to frame American viewers' first glimpse of Yosemite Valley though Ayres's images in a passage from his popular book, *Across the Continent*, of 1865. "The Yosemite!" the writer exclaimed. "The overpowering sense of the sublime, of awful desolation, of transcending

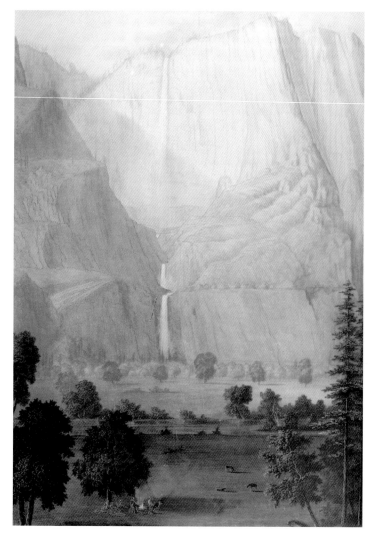

Fig. 5. Thomas Ayres, The High Falls, Valley of the Yosemite, Cal., 1855. Drawing in charcoal, white chalk, and pencil on textured paper, approx. 9 x 14 in. Yosemite Museum, National Park Service.

Marvelousness and unexpectedness, that swept over us, as we reined our horses sharply out of green forests, and stood upon high jutting rock that overlooked this rolling, upheaving sea of granite mountains, holding far down its rough lap this vale of beauty of meadow and grove and river—such tide of feeling, such stoppage of ordinary emotions comes at rare intervals in any life." Bowles concluded his remarks with a dramatic climax: "[Yosemite] was the confrontal of God face to face, as in great danger, in solemn, sudden death. It was Niagara, magnified."[22]

Of course, if Yosemite was the new Niagara, potential visitors needed to be reassured that it remained free of what Henry James had described as the "horribly vulgar shops and booths and catchpenny artifices" that detracted from the great falls in the East.[23] One of the foremost photographers of Yosemite during this period, Carleton E. Watkins, would do much to establish the reputation of the pristine California wilderness. He made a series of trips to the valley from the 1860s to the 1880s. On his first visit in 1861, Watkins brought with him a stereoscopic camera and a mammoth-plate camera, which produced negatives that measured eighteen by twenty-two inches. The equipment necessary for the production of wet-plate photographs required Watkins to transport by mule—in addition to the cameras, tripods, dark tent, chemicals, and pro-

Fig. 6. Carleton E. Watkins, Yosemite Falls from Glacier Point, 1870s. Albumen silver print, 28 x 24 1/4 in. Stanford University Libraries, Department of Special Collections

cessing trays—more than one hundred glass plates, many of which weighed nearly four pounds. During his stay, Watkins produced thirty mammoth and one hundred stereoscopic negatives, which showed, in spite of the mass of equipment that had mediated between the photographer and his subject, a landscape untouched by man (figs. 6 and 7). Not surprisingly, easterners were transfixed by Watkins's visions of a natural paradise in California.[24] Oliver Wendell Holmes, who contacted the photographer through their mutual friend, Thomas Starr King, obtained a number of these stereographic views, which he praised in the highest terms as "a perfection of art which compares with the finest European work."[25] Holmes also expressed his admiration in an article he published in the *Atlantic Monthly* in July 1863.[26] King sent Watkins's photographs to Ralph Waldo Emerson, who also responded favorably. With easterners of such distinction as his champions, it was inevitable that the photographer's work would become widely known.

An exhibition of Watkins's photographs in the prestigious Goupil Art Gallery in New York in 1862 introduced his California views to what proved to be a

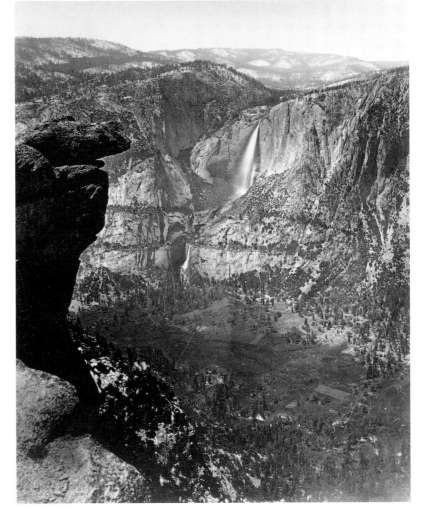

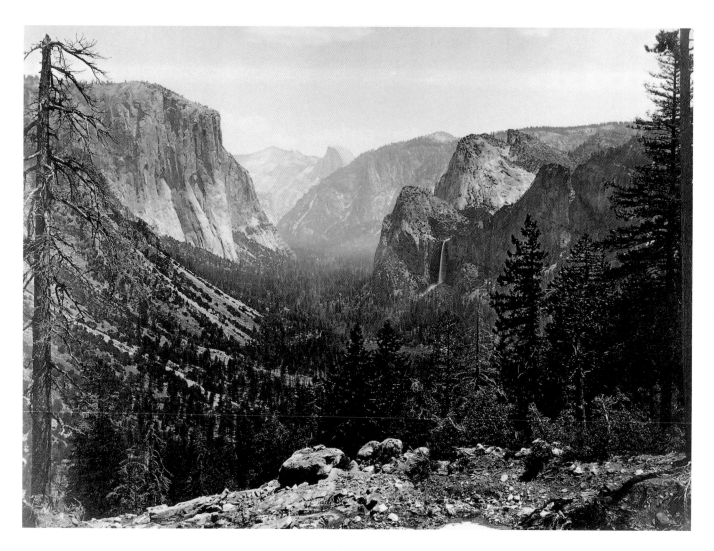

Fig. 7. Carleton E. Watkins, Yosemite
Valley from Inspiration Point, 1870s.
Albumen silver print, 28 x 24 1/4 in.
Stanford University Libraries,
Department of Special Collections.

large and enthusiastic audience. Articulating the positive response of viewers, the *New York Post* published a glowing review of the photographs, calling them "unequaled" and insisting that "Nothing in the way of landscape can be more impressive or picturesque."[27]

Though Watkins's exhibition at Goupil's had introduced the California wilderness as a subject for sophisticated connoisseurs, it was the work of Albert Bierstadt, a New York artist, that would confer definitive legitimacy on the state's natural attractions. Bierstadt planned his first trip to California in 1863. One of his traveling companions was Fitz Hugh Ludlow, art critic for the *New York Post* and author of *The Hasheesh Eater*, who planned to take "copious notes" while Bierstadt made sketches of the scenery.[28] Ludlow confirmed the influence of Watkins when he wrote before his departure: "We were going into the vale whose giant domes and battlements had months before thrown their photographic shadow through Watkins' camera across the mysterious wide Continent, causing exclamations of awe at Goupil's window, and ecstasy in Dr. Holmes' study."[29] Ludlow's account of the journey, which was narrated in a series of letters to the *New York Post* and in a number of articles for the *Atlantic Monthly*, played an important role in preparing audiences for the images Bierstadt created. The critic's rhapsodic

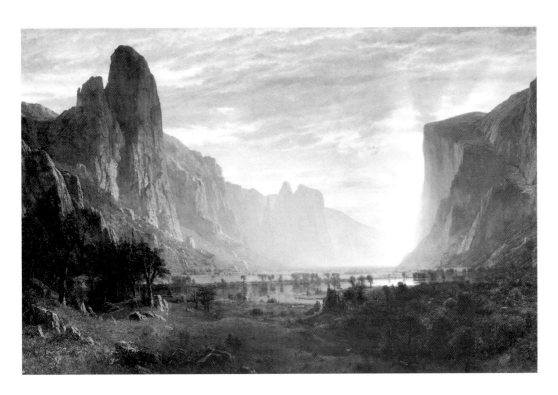

Fig. 8. Albert Bierstadt, Looking down Yosemite Valley, 1865. Oil on canvas, 64 1/4 x 96 1/2 in. Birmingham Museum of Art; gift of the Birmingham Public Library.

descriptions of the valleys and mountains of the state would serve as the libretto to Bierstadt's grand *Opera Californiana*, which, in turn, would apprise visitors of the most highly regarded panoramas to be visited during a sojourn in the state.

Bierstadt's arrival in California caused a sensation. It was the first time that a successful member of the eastern art establishment had come to the state for the express purpose of recording the local scenery. A San Francisco journal, *The Golden Era*, articulated the wish that was on the mind of every member of the business elite who welcomed the artist to the Pacific: that Bierstadt would introduce California to the "select world of Art." Merchants, hotel owners, financiers, and railroad tycoons could "rejoice that the scenery of our good state will go with him, to make the old world open its eyes and send tourists out here, even before the Pacific Railroad is finished."[30] Bierstadt obliged his California hosts by creating a series of California paintings that were widely exhibited and reproduced in the East and that set the standard for nature viewing in the state.

Bierstadt's works acted as an itinerary for travelers to follow when they came to California, and many tourists came to the state looking specifically for the scenes the artist had depicted.[31] The artist's paintings of Yosemite confirmed that the valley was the most important stop. One of Bierstadt's most popular portrayals was *Looking down Yosemite Valley* of 1865, which was exhibited at the National Academy of Design the same year (fig. 8). Ludlow described a similar scene for his readers in his account of the moment when he and Bierstadt first arrived at the entrance to Yosemite: "Our eyes seemed spellbound to the tremendous precipice which stood smiling, not frowning at us, in all the serene radiance of a snow-white granite Boodh—broadly burning rather than glistening, in the white hot splendors of the setting sun."[32] Visitors to the National Academy could thus have carried with them the mental image of Ludlow's smiling rocks as they viewed Bierstadt's painting. In the half-circle formed by the valley and adjoining

Fig. 9. Southern Pacific Railroad Company, Yosemite Valley and the Big Tree Groves, *c. 1880. Promotional brochure, 9 x 14 in. California Railroad Museum, Sacramento.*

cliffs and the chasm between them, spectators directed by Ludlow's prose may have been able to conjure in their imaginations a vast gap-toothed grin, the tectonic welcome of the California "Boodh."

The effectiveness of *Looking down Yosemite Valley* in popularizing the California wilderness and in inspiring tourists to visit the Pacific was suggested by an article written in 1869 by the California author Ambrose Bierce. Responding to the erroneous news that the painting had been destroyed in a fire, "bitter" Bierce wrote:

> It is with grim satisfaction that we record the destruction by fire of Bierstadt's celebrated picture of Yosemite Valley. The painting has been a prolific parent of ten thousand abominations. We have had Yosemite in oils, in watercolor, in crayon, in chalk and charcoal until in our very dreams we imagine ourselves falling from the summit of El Capitan or descending in spray from the Bridal Veil cataract. Besides, that picture has incited more unpleasant people to visit California than all our conspiring hotel keepers could compel to return.[33]

In addition to introducing audiences to the wonders of Yosemite, Bierstadt's paintings primed viewers for their visits to other parts of the state. For the most part, these works described the areas linked by the Central Pacific Railroad as part of a scenic loop that was to become increasingly well traveled as the century wore on (fig. 9). The Mariposa Grove, where great stands of giant redwoods were located, was, next to Yosemite, the most important stop on the tourist circuit. Bierstadt pictured the grove as a forest primeval (fig. 10), where indigenous inhabitants were reduced to pygmy size by the luxuriant expression of nature's power. Though the giant sequoias dominate the landscape to such an extent that even sunlight can only partially penetrate the forest, Bierstadt portrayed the trees as a benevolent presence, sheltering the Indians who live in a hollow at the base of the largest specimen. The forest people are accustomed to the magnificent spectacle that had rendered Thomas Starr King speechless and calmly gather food and converse by the side of the river that bisects the canvas.

Though Bierstadt generally portrayed only native peoples in his painterly survey of California's scenic wonders, he included a group of anglers in a dramatic portrayal of night fishing at Lake Tahoe, another requisite stop for visitors following the customary travel plan. Eastern readers had been informed of the beauties of the lake through the

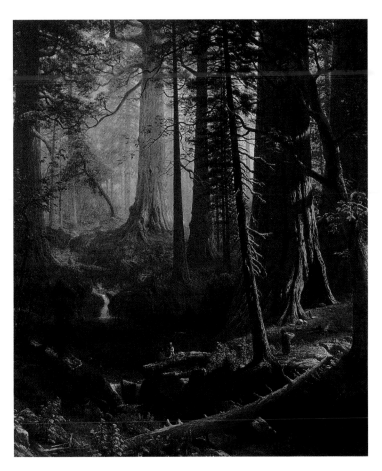

Fig. 10. Albert Bierstadt, Giant
Redwood Trees of California, 1874. Oil
on canvas, 52 1/2 x 43 in. Berkshire
Museum, Pittsfield, Massachusetts; gift
of Zenas Crane.

writings of the preeminent geologist Joseph Leconte and the published letters of the
Reverend Thomas Starr King. Mark Twain also visited the lake and described it as "a
noble sheet of blue water" that was "the fairest picture the whole earth affords."[34] The
lake was such a popular place to visit and, during the 1870s and afterward, so often the
subject of artistic portrayals, that Bierstadt seemed determined to offer a unique inter-
pretation of the site. In *Lake Tahoe: Spear Fishing by Torchlight*, painted about 1875, the
artist handily proved his ability to distinguish himself from the rabble selling souvenir
sketches at local resorts (fig. 11). He chose to show the lake at night, focusing on a small
inlet and including only the faintest suggestion of the grand scenery beyond. Where
most portrayals of Lake Tahoe excluded evidence of any human presence, Bierstadt
demonstrated that, in addition to its pristine beauty, the lake was also ideally suited for
recreational pursuits. The water reportedly teemed with marine life—cutthroat and sil-
ver trout, salmon, white fish, and rock bass—and, as an avid outdoorsman himself,
Bierstadt was particularly interested in recording its attractions for fishing.

Nevertheless, the activity the artist chose to portray, while presenting unique
opportunities for showing off his artistic abilities, represented the least sporting method
of catching fish. A flaming torch both attracted and stupefied fish too wily to be caught
during daylight hours. Fishing became easy work through the use of this device, and
commercial fishermen, who were often Italian and Portuguese immigrants hired by local
hotel owners and merchants, could remain in the shallow water and spear as many trout
as their employers required for the next day's menu.[35] Still, as Bierstadt pictured the

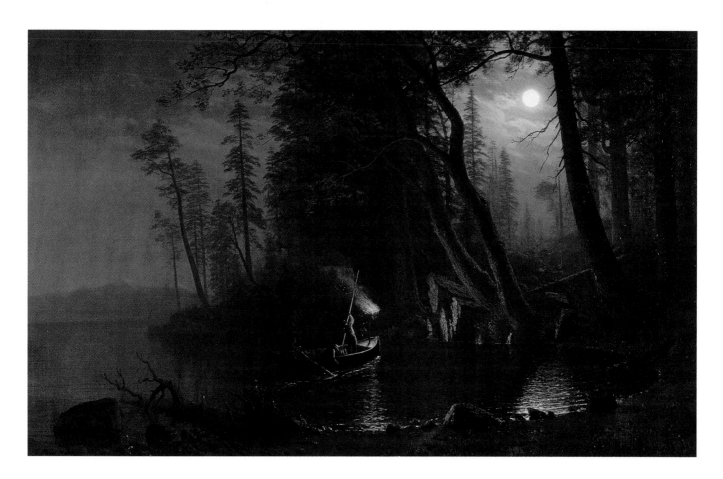

Fig. 11. Albert Bierstadt, Lake Tahoe: Spear Fishing by Torchlight, c. 1875. Oil on canvas, 31 x 49 in. Private collection.

scene, it promised yet another colorful sight that visitors could take in during an excursion to the area. The white hot flame of the torch draws the viewer's gaze, like a big-mouth bass about to be skewered, to the center of the canvas. The eye then drifts to places where the light rebounds. At the peak of his powers, the artist reveled in the description of lakeside trees awash in a crimson glow and the reverberating circles of flame reflected in the water. Bierstadt continued his play with the effects of nighttime illumination with a full moon that answers the torchlight below. Where everything touched by the blaze of the fire takes on a heated red, the moonlight washes the distant landscape with a silvery coolness, heightening the idea that some kind of unearthly magic is afoot in this watery realm.

Lake Tahoe: Spear Fishing by Torchlight is just one example of Bierstadt's skillful use of water as a device to engage viewers' interest in the California scenery. The artist used water features in almost all his important representations of the state's principal viewspots, from Donner Lake in the north to the more remote Kern River valley at the southern end of the Sierra (fig. 12). In addition to affording an opportunity for the artist to display his consummate skill in capturing the nuances of reflection, water magnified the forms in the wilderness landscape, intensifying the visual effect of mountains and rocky chasms by effectively doubling their presence. At the same time, the inclusion of water negated the popular perception of California as arid and parched, something that suited the development plans of Bierstadt's most important California clients. Such works also appealed to eastern patrons, however. Spear Fishing by Torchlight was purchased by the New York department store magnate A. T. Stewart and was displayed as part of his famous collection, considered by many to be among the finest in the country.

Bierstadt reserved his most exuberant expression of the state's water features for the portion of California that travelers would visit when first arriving in the state or directly before their departure: the rugged coastline adjacent to San Francisco (fig. 13). A day's jaunt by carriage to the ocean was a requisite part of a tour of the state's largest city and, though the trip was often windy and cold, guidebooks reassured tourists that much of the road was "splendidly macadamized."[36] Despite any physical discomforts, the trip to the beach symbolically completed the long transcontinental trek and acted as a culmination for those who had ventured to the nation's western edge. Appropriately, Bierstadt portrayed California's windswept coast as a climax of nature's power. In his choice of Seal Rocks, a popular viewspot in front of the Cliff House Hotel, the artist may have been inspired by Bret Harte, who discussed the same location in an article published in the state's foremost literary journal, *The Californian*, in 1868:

> The lesser rocks, where the sea lions were wont to bask in the sunlight, were scarcely ever free from the surging of tumultuous seas that boiled, hissed and seethed around them. At times a wave, larger than its fellows, charging upon the single peak known as "Seal Rock," and breaking half-way up its summit, would fling half its volume in snowy foam twenty feet above the crest, to fall and fill with a leaping torrent each ravine in the rocky flanks of the lonely

Fig. 12. Albert Bierstadt, Kern's River Valley, c. 1871. Oil on canvas, 35 1/2 x 52 in. Private collection.

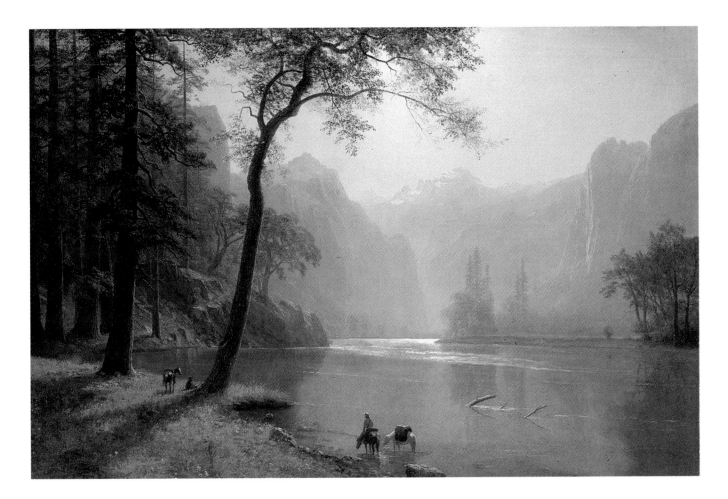

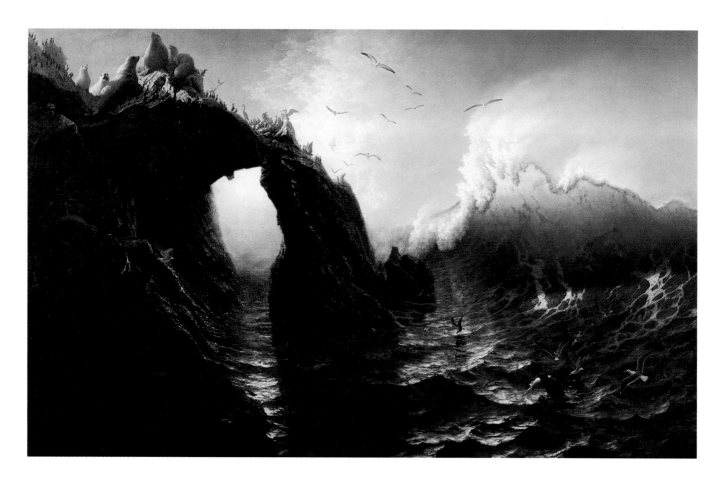

peak. Far out to sea, wave after wave heaved their huge leaden sides like the scales of some undulating monster....The view was unsurpassed in grandeur.[37]

Just as Harte described it, *Seal Rocks, San Francisco* pictured the "rocky flanks" of the California coast as the counterpart in sublimity of the magnificent Sierra. Bierstadt heightened the dramatic effect of the wild surf by placing the viewer in the path of a foaming breaker that hesitates in midair before crashing onto the rocks below. The threat of the mighty wave and its insistence on human vulnerability, however, is tempered by the jolly presence of roly-poly sea lions and waddling seabirds who luxuriate in the abundance of water and sunlight. The profusion of pelicans, sea lions, and fish, in turn, harkens back to the enthusiastic reports of eighteenth-century European expeditions to the region, including the account of Jean-François de La Pérouse, who marveled at the great numbers of whales, sea otters, and seals in California's waters and described in his journal a shoreline that was "covered with pelicans."[38] In the foreground of the painting, Bierstadt alluded to the gastronomical enjoyment of such riches, showing seals feasting on golden Garibaldi fish and gulls plucking choice morsels from the water.

If *Seal Rocks, San Francisco* and Bierstadt's other grand pictures of California introduced eastern viewers to "the grandest scenery on earth," potential tourists still needed to be assured that the state offered all the amenities they required and confirmation of the accessibility of wilderness areas. Often on commission to hotel and railroad owners and others who had a direct interest in the tourist industry, artists and photographers produced images that helped fill the gap between the virgin wilderness portrayed by

Fig. 14. Unidentified photographer, The Dining Room at the Lick House Hotel, c. 1870. Albumen print. Bancroft Library, University of California, Berkeley.

Bierstadt and the purchase of a transcontinental ticket. Pictures of happy vacationers on horseback, camping in the woods, inspecting the local flora, and enjoying meals *al fresco* helped transform the awesome power of nature as depicted by Bierstadt, Watkins, and others into something that was approachable, enjoyable, *gemütlich*.

The manner in which representations of the California wilderness were displayed or viewed was an integral part of their role in accustoming audiences to the idea of California as a comfortable vacation site for nature-lovers. During the 1860s, the location of eleven panels of Pacific Coast scenery in the banquet room of the Lick House, one of San Francisco's most prestigious hotels, was a noteworthy example of the importance of placement in promoting a certain interpretation of the California wilderness (fig. 14). The panels, which were painted by the English-born artist Thomas Hill, were arranged to form a panorama around diners who, as they sampled oysters from the bay and quaffed the excellent local wines, could imagine themselves on the slopes of the Sierra or in groves of mammoth trees. In this way, the satisfaction produced by the consumption of a hearty meal was connected to the aesthetic pleasure derived from the landscapes on the wall. The imaginary outdoor setting, with its suggestion of bracing air and crackling campfires, may also have enhanced the hearty appetites of the diners in the banquet hall. In any case, the favorable reception of these and other similar works, which may have had something to do with the full stomachs of many of his viewers, cemented Hill's local reputation. When the Central Park architect Frederick Law Olmsted came to California from New York to investigate the possibility of making Yosemite Valley and the Mariposa Grove a state park, Thomas Hill was one of the artists whom he chose to make a study of the areas' "scenic values."[39]

Stereoscopic photographs allowed pictures of the California wilderness to be placed in the most strategic place of all—the parlors of prospective visitors. The rage for stereographs was in full flower by the 1870s, with more than one hundred American companies offering trade lists of a thousand views or more. In 1883 the internationally

respected photochemistry professor Herman Vogel declared, "I think there is no parlor in America where there is not a stereoscope."[40] Through the visual magic of the stereoscope, viewers could bring the three-dimensional wonders of California into their own homes. There, in the lap of domesticity, they could acquaint themselves with California's beauties. The stereographic image translated the imposing manifestations of God's power into something familiar and accessible. In addition, the level of detail the pictures provided made such images "inexhaustible," according to Oliver Wendell Holmes, who also believed that "the more trivial they are in themselves, the more they take hold of the imagination."[41] Perhaps with this in mind, stereograph companies provided audiences with images not only of awe-inspiring chasms and lofty mountainscapes but also of the most commonplace features of life in the Sierra. From pictures of Indian servants washing laundry in tourist camps, to hastily arranged pinecone displays, no aspect of wild California escaped the probing stereographic eye (figs. 15 and 16). In this way, with easychairs taking the place of stiff saddles and uncooperative mules, viewers could enjoy an imaginary ramble through the woodlands and vales of the Pacific, with wilderness California and California as a tourist wonderland superimposing themselves and becoming equivalents through a twist of the stereoscope handle.

The domestication of the California wilderness effected by the stereograph was reinforced by other practices. The giant sequoias, for example, were the object of numerous strategies that made audiences feel at ease with the "vegetable monsters." In 1854 the stripped bark of a genuine *Sequoiadendron giganteum,* which had been named "Mother of the Forest" because of its size and beauty, was placed on exhibit in New York's Crystal Palace, under the direction of Horace Greeley, editor of the *New York Tribune* (fig. 17). Greeley described the sequoias as something of which, at last, Americans could think as the equivalent of the ancient temples of Greece or the Egyptian pyramids: "That they were of very substantial size when David danced before the ark, when Solomon laid the foundations of the Temple," he mused, "when Theseus ruled in Athens, when Aeneas fled from the burning wreck of vanquished Troy, when Sesostris led his victorious Egyptians into the heart of Asia, I have no doubt."[42] The impresario P. T. Barnum articulated the same sentiment with a characteristic flair for the dramatic when he insisted, "I could not stand to look at a bigger tree without taking chloroform."[43] Nevertheless, despite Greeley and Barnum's awe for the trees, they were obviously not so big or so old that they could not be cut down and transported to New York for the viewing pleasure of ticket holders. In 1858 public enthusiasm for the exhibit motivated promoters to send the Mother of the Forest to the original Crystal Palace in London, where the "sylvan mastodon" was placed directly opposite sculptures of giant heathen gods from Nubia (fig. 18).[44]

Fig. 15. (top) Unidentified photographer, Digger Indian—Washer Woman, c. 1880. Stereograph, approx. 3 x 5 in. Collection of Peter E. Palmquist.

Fig. 16. (bottom) Thomas Houseworth, Pinecone, c. 1880. Stereograph, approx. 3 x 5 in. Collection of Peter E. Palmquist.

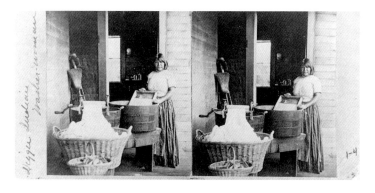

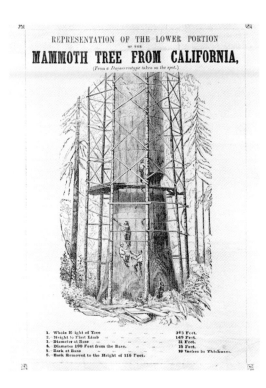

REPRESENTATION OF THE LOWER PORTION
MAMMOTH TREE FROM CALIFORNIA,
(From a Daguerreotype taken on the spot.)

1. Whole Height of Tree 363 Feet.
2. Height to First Limb 149 Feet.
3. Diameter at Base 31 Feet.
4. Diameter 100 Feet from the Base, ... 15 Feet.
5. Bark at Base 18 Inches in Thickness.
6. Bark Removed to the Height of 116 Feet.

Unhappily, the bark ultimately caught fire and, in a spectacular blaze, burned to the ground—an inauspicious ending for what American viewers had perceived as an icon of the nation's preeminence.

Image makers often portrayed the giant sequoias in ways that, while acknowledging the trees' great size, affirmed the dominance of humans over the natural world. Sequoias with natural or man-made openings and fallen redwoods were frequent subjects in representations made by artists and photographers who visited the groves. Image makers made visual records of mammoth specimens that had been scaled, cut, stripped, pierced, or struck by lightning and seemed to delight in portraying the decay and dismemberment of the woodland giants (fig. 19). The Wawona Tree, whose natural cavity had been enlarged in 1881 to a nine-foot-high, eight-foot-wide, twenty-six-foot-long tunnel, became a favorite subject in prints, photographs, and paintings. From the 1880s through the end of the century, the blighted tree was featured in a rich variety of constructions (figs. 20 and 21). The Southern Pacific Railroad used the tree as a promotional device in brochures and magazines on numerous occasions. An advertisement published by the railroad company in *Country Life* in 1904, for example, demonstrated that the California wonder was only slightly taller than the famous Flatiron Building in New York, the crowning example of contemporary building technology (fig. 22). The image of the Big Tree and the famous skyscraper standing side by side seemed to represent a draw in the ongoing competition between man and nature. On closer inspection, however, this was clearly not the case. While the sequoia had the advantage in terms of size, the text made it clear that man-made structures like the Flatiron Building would prevail. The predatory aspect of the urban culture pictured in the advertisement was revealed by the comment that "cut into one-inch boards, [the tree] would entirely sheath the building on all sides." Informed by this bit of trivia, readers could appreciate the versatility of the mighty California trees, which not only delighted tourists making excursions to the wilds of California but also could be considered an almost endless source of

Fig. 17. (left) Unidentified artist, Mammoth Tree from California, 1858. Lithograph, approx. 13 x 10 in. Collection of Peter E. Palmquist.

Fig. 18. (below) Unidentified artist, Mother of the Forest on Display in Sydenham Crystal Palace, 1858. Lithograph, approx. 10 x 7 in. Crystal Palace Archives.

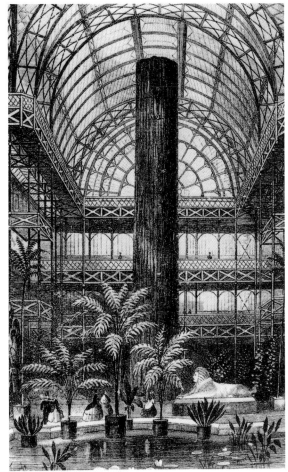

Mother of the Forest on Display in Sydenham Crystal Palace, 1858. Crystal Palace Archives

Fig. 19. (top) Edward Vischer, The Mammoth Tree Grove, 1862. Lithograph, 10 3/4 x 13 1/2 in. California Historical Society, San Francisco, C. Templeton Crocker Collection.

Fig. 20. (right) Unidentified photographer, Automobile Passing through the Wawona Tree in the Mariposa Grove, 1903. Photograph, 10 x 13 1/8 in. Seaver Center for Western History Research, Natural History Museum of Los Angeles County.

Fig. 21. (below) Isaiah Taber, Section of "Wawona," 28 Feet Diameter, 275 Feet High. Mariposa Grove, 1880s. Mammoth albumen print, 16 x 20 1/2 in. Yosemite Museum, National Park Service.

top-grade construction lumber for America's expanding cities.

Another advertisement utilizing the Wawona Tree was a flyer that touted the benefits of Kalliodont toothpaste (fig. 23). The company sold prints of various California views that included a detailed description of the dentifrice on the reverse side. The text informed the reader that "the large sale of this dentifrice in so short a period after its introduction is accounted for by the fact, that after once used it leaves such a pleasurable sense of cleanliness to the mouth, and beauty to the teeth and gums, that it is considered almost indispensable." Large sales called for large trees, and the image of the Wawona emblazoned in full color on the front of the flyer lent an air of excitement and grandeur to the product that was not normally associat-

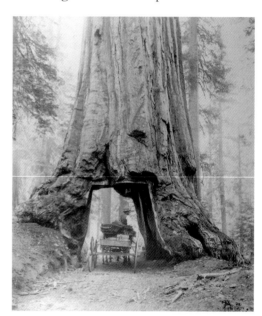

ed with oral hygiene. The picture of the great cavity in the Wawona Tree may have also served as a subtle reminder of the unpleasant consequences of neglecting the teeth.

The Big Trees were often given names that imbued them with human characteristics (fig. 24). These titles helped to transform the "sylvan giants" into dear friends and relatives—presumably from a very distant branch of the family. The Old Bachelor, Three Sisters, Husband and Wife, and Mother and Son were some of the for-

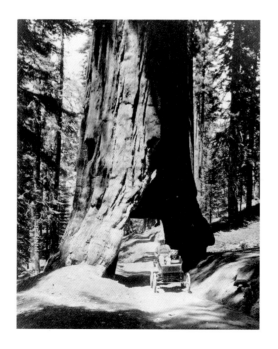

est inhabitants on whom tourists could call and who often were already familiar to visitors through the stereoscopic image. James Hutchings, who opened a hotel in Yosemite in 1864, had another means of introducing tourists to their arboreal hosts. The renowned Big Tree sitting room at Hutchings House had been built around a 175-foot specimen, which, as is evident in a print from the 1880s, communicated to guests through the word festooned on its base: WELCOME (fig. 25).

The merging of the California wilderness with the middle-class

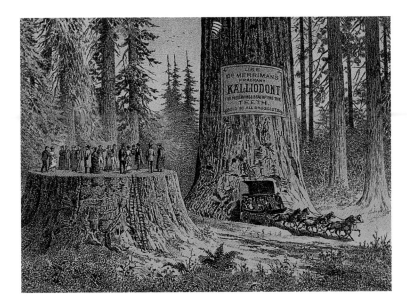

American home was made complete in the 1880s and 1890s when camping excursions to the Sierra and other remote areas became widely popular. A painting by Thomas Hill from the mid-1870s, *Our Camp*, was symbolic of the growing interest in outdoor rambles and also helped to introduce the activity to viewers (fig. 26). The work represented the wilderness camp of the artist, who regularly trekked into the Sierra with other painters, including William Keith and Virgil Williams, to make sketches of the mountain scenery. These outdoor impressions would later be worked into larger studio paintings, which found a popular market in the urban areas of the state. Despite the numbers of people who went along on such outings, Hill chose to represent the campsite during a period when it was vacant. The shadows on the ground indicate that it is the middle of the day, when members of the party would have been far afield making the plein-air studies that were the basis for their

Fig. 22. (above left) Unidentified artist, California: The Home of the Big Tree. From Country Life in America 6 (July 1904): 299.

Fig. 23. (above right) Unidentified artist, Kalliodont Toothpaste, 1880s. Printed flyer, 7 x 9 in. Private collection.

Fig. 24. (below left) List of the names of the Big Trees. From Whitney, Yosemite Guide Book (1871), 132. Private collection.

THE BIG TREES. 125

TABLE OF MEASUREMENTS OF HEIGHT AND CIRCUMFERENCE
OF TREES IN THE CALAVERAS GROVE.

Name of Tree.	Circumference 6 feet above ground.	Height.
	Feet.	Feet.
Keystone State	45	325
General Jackson	40	319
Mother of the Forest (without bark)	61	315
Daniel Webster	47	307
Richard Cobden	41	284
T. Starr King	52	283
Pride of the Forest	48	282
Henry Clay	47	280
Bay State	46	275
Jas. King of William	51	274
Sentinel	49	272
Dr. Kane	50	271
Arbor vite Queen	30	269
Abraham Lincoln	44	268
Maid of Honor	27	266
Old Vermont	40	265
Uncle Sam	43	265
Mother & Son (Mother)	51	261
Three Graces (highest)	20	262
Wm. Cullen Bryant	48	262
U. S. Grant	34	261
General Scott	43	258
George Washington	51	256
Henry Ward Beecher	34	252
California	33	250
Uncle Tom's Cabin	59	250
Beauty of the Forest	39	249
J. B. M'Pherson	31	246
Florence Nightingale	37	246
James Wadsworth	27	239
Elihu Burritt	31	231

The exact measurement of the diameter and the ascertaining of the age of one of the largest trees in this grove was made possible by cutting it down. This was done soon after the grove was discovered, and is said to have occupied five men during twenty-two days. The felling was done by boring through the tree with pump-augers; it was no small affair to persuade the trunk to fall, even after it had been completely severed from its connection with the base. It was done, however, by driving in wedges on one side, until the ponderous mass was inclined sufficiently, which was not effected until after three days of labor.
The stump of this tree was squared off smoothly at six feet above the ground, and the bark being removed, a pavilion was

Fig. 25. (right) Unidentified engraver, The Big Tree Room. From Hutchings, In the Heart of the Sierras (1886), 345. Private collection.

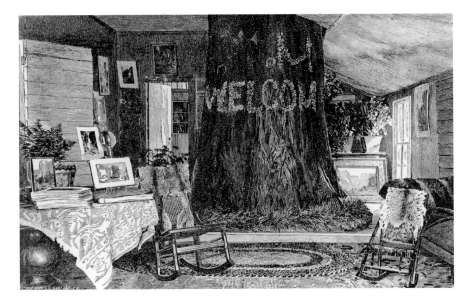

Fig. 26. Thomas Hill, Our Camp
c. 1875. Oil on canvas, 12 x 18 in.
Collection of the Oakland Museum of
California, Kahn Collection.

finished paintings. The emptiness of the site allowed audiences to populate it with out-doorsmen they knew from literature and myth and, at the same time, brought to mind the highly publicized western expeditions of recent history. Spectators may have recalled the various literary lights who enjoyed the great outdoors and who embodied the essence of muscular Christianity, including Ralph Waldo Emerson, Henry David Thoreau, and Walt Whitman. Well-read urbanites who saw *Our Camp* on a visit to the artist's studio may also have been reminded of the renowned Philosophers' Camp that Emerson and other eastern intellectuals had established in the Adirondacks in the summer of 1857. There, in the woods north of Long Lake, the Boston transcendentalist and the polished gentlemen who joined him at the campsite became associates of the sylvan gods (fig. 27).[45]

While it evoked ideas of artists and writers like Emerson, who focused on the aesthetic potential of the land and the spiritual uplift it provided, the painting also made reference to those who came to the wilderness to extract its material riches and to lay the groundwork for the advance of commerce and industry. Hill's camp evoked the memory of early fur trappers and western scouts, including Daniel Boone and Kit

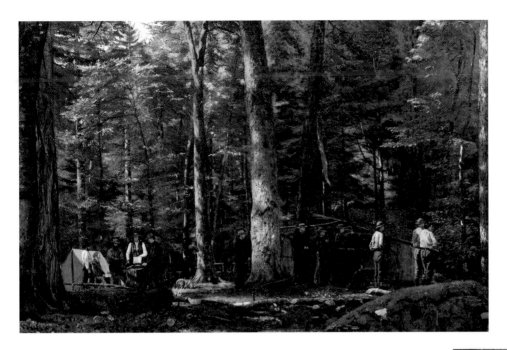

Fig. 27. (left) W. H. Stillman, *Philosophers' Camp in the Adirondacks, c. 1857. Oil on canvas. Concord Free Library, Concord, Mass.*

Fig. 28. (below) Jules Tavernier, *Midsummer Jinks: The Cremation of Care, c. 1883. From The Annals of the Bohemian Club (1900), 2: frontispiece.*

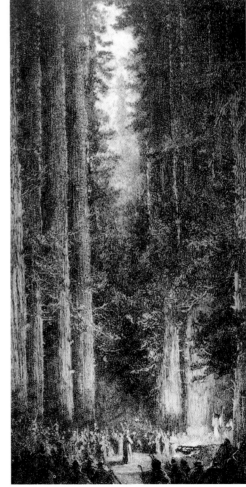

Carson, who were among the first white men to penetrate into the interior of the continent. It also recalled the Days of Gold, when miners in California lived in tented camps, at least until they earned enough in the diggings to erect more permanent dwellings. In addition, *Our Camp* brought to mind the numerous geological surveys that were carried out in the West from the 1840s through the 1870s by federal and state agencies. Led by the nation's most eminent scientists and guides, including Captain John C. Frémont, Clarence King, and John Wesley Powell, who were accompanied by accomplished artists and photographers,[46] these expeditions were responsible for defining the new boundaries of the expanding nation and for making an inventory of its natural assets.[47]

While Thomas Hill was making sketching trips in the Sierra with other local artists, the select patrons who bought his large finished works were also trekking into the wilderness. A "hejira to the Redwoods" was an annual tradition of the Bohemian Club of San Francisco, an exclusive fraternal organization whose members included the state's wealthiest businessmen as well as successful writers, artists, and journalists. These summer encampments, called the Midsummer Jinks, were a time for California's leaders to reaffirm their solidarity through ceremonial activities under the stars. The invitations that summoned members to the groves usually alluded to the various amusements that awaited: "Brethren of Bohemia!" read one such notice, "Once more the lofty forest aisles invite us to rest amid their towering columns, and drink in the balsamic odor of the woods (with a possible corrective) in that pure enjoyment of Nature which is Bohemia's inheritance."[48] A rousing banquet was always held, and plays were written and acted out by members. The most important

activity of the gathering, however, was the annual Cremation of Care, in which the year's troubles and worries were symbolically consigned to a great bonfire.

A painting by Jules Tavernier, a San Francisco artist and club member, portrayed the event as a Druidic rite, with the Bohemian tree-worshipers dwarfed by the "sylvan mastodons" around them (fig. 28). A reproduction of the painting published in *Harper's Magazine* in 1883 showed Californians enveloped by an overarching nature, immersing themselves in ecstatic contact with the sublime. However, a pair of photographs from the same period demonstrates that an induction into the primordial mysteries of the redwood grove also took place under the most comfortable and refined conditions. One picture shows a group of Bohemians in Elim Grove, newly accessible thanks to the recent construction of a special line by the North Pacific Railroad. The introduction of the steaming locomotive into the recesses of the forest suggests that the Bohemians'

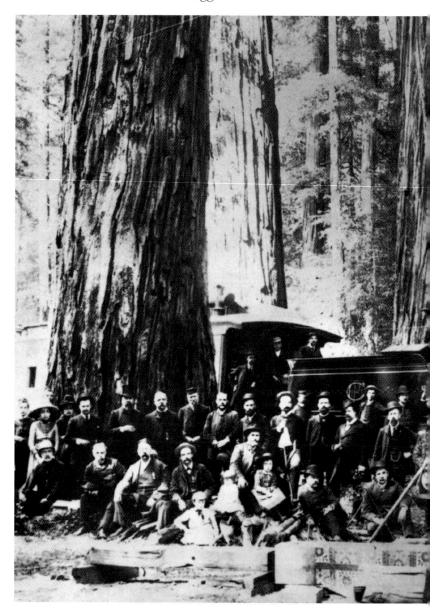

"pure enjoyment of nature" depended on something more than a simple "corrective" to be truly palatable (fig. 29). The curious name Elim, in fact, was nothing more than the word *Mile* reversed, indicating that the spot was only one mile from the main track.

Another photograph, titled *The Midsummer Camp*, shows that the wilderness gatherings of typical Bohemians afforded all the comforts to which elite members were accustomed (fig. 30). The photograph focused on a group of middle-aged men seated comfortably in camp. The finely tailored clothing they wear is appropriate for the select nature of the gathering and affirms that these are no ordinary woodsmen. Hiking and rock climbing are clearly not on the schedule of these well-dressed campers. The tents behind them reinforce

Fig. 29. Unidentified photographer, Elim Grove, 1880s. Photograph. Bancroft Library, University of California, Berkeley.

the idea of exclusivity and comfort, as well as of a certain business-like approach to the wilderness. Rather than speaking of the knapsack and walking stick, these canvas structures, with their scalloped awnings and elegant stripes, hint at military campaigns and successful battles. It is in this context that the camera considers these financial emperors and conquerors of the wilderness who rest in the company of their peers. Bohemian Bonapartes, they stare steadfastly at the camera, allowing it to take their measure and daring it to find something incongruous in the roughly painted picture of a bovine above their heads. Big men among the Big Trees, these select citizens would help to imbue camping in California with a special mystique that would entice others who aspired to enjoy the great outdoors in genteel company.

The outdoor excursions of Bohemian Club members and San Francisco artists like Thomas Hill were part of an elite experience that, at first, only a privileged few could manage. By the 1880s and 1890s, however, rambles in the Sierra had become a more common experience, and greater numbers of muscular Christians took advantage of the opportunity to exercise their bodies and mold their morals in California. Many of these visitors had been inspired by the writings of John Muir, a botanist and Sierra mountain guide who had published a series of articles on the range in *Century* magazine during the 1880s.[49] With a readership of two hundred thousand subscribers, *Century* dominated the field of polite eastern journals, and Muir's name and ideas quickly became widely known. Though his writings appealed to distinguished citizens like Theodore Roosevelt and Emerson, Muir's message was addressed to a wide audience. Providing a link with the ideas of the Reverend Murray and

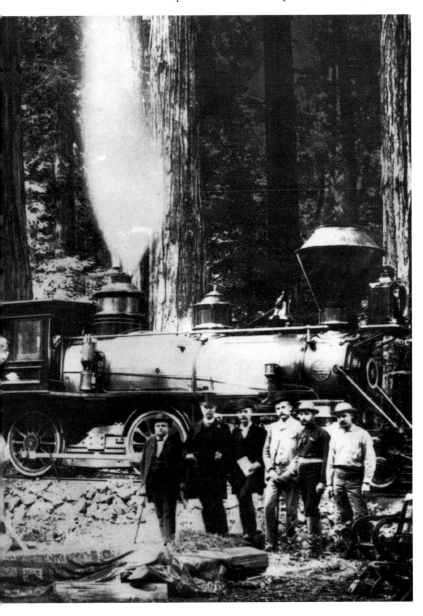

Thomas Starr King, he urged city dwellers to abandon the pettiness of urban life and to embrace the vagabond existence—if only for a few weeks. The Sierra Club, which Muir had founded with the help of Robert Underwood Johnson, the publisher of *Century* magazine, held regular "outings" to provide structured camping excursions for wilderness neophytes. The stated goal of Muir's club was "to explore, enjoy and render accessible the mountain regions of the Pacific Coast."[50] To those who accompanied him into the mountains, the naturalist promised that the "glaciers and wild gardens" of the Sierra offered an escape from "getting a living, hard work, poverty, loneliness" and "need of renumeration,"[51] ideas that complemented the pictures of wild California circulating during the same period.

Entranced by Muir's ecstatic prose and drawn by the Edenic visions of California they had been exposed to for years, significant numbers of middle-class campers began to arrive in the Sierra in the 1880s. Image makers took advantage of the presence of these tourist pioneers to show viewers that a wilderness trek was not something reserved for the upper

classes and their attendants. In particular, women on camping expeditions and other outdoor excursions were a favorite subject of artists and photographers who wanted to convey the idea not only of the domestication of the California wilderness but also of its new accessibility to a wide range of visitors. Ladies were shown on fishing expeditions, around the campfire reading, and engaged in familiar domestic activities (figs. 31–34). Such images were accompanied by popular literature that encouraged readers to feel that the day-to-day management of the mundane details that were such an important part of a comfortable outing had been consigned into women's capable hands. Books and articles instructed women on how to raise their camping experience to "a fine art." James Hutchings, the publisher and hotel owner, advised that a full *batterie de cuisine* be brought along for the preparation of meals. In addition to a sheet-iron cookstove and a generous length of stovepipe, the editor recommended a bake oven, an array of camp kettles, frying pans, tea- and coffeepots, bread, roasting, and dishpans, as well as plates, cups, knives, forks, and tea- and tablespoons. As an afterthought, Hutchings remarked: "To these do not forget to add a whetstone, towels, soap, brooms…needles and thread, scissors, buttons, matches and candles; writing paper, pens, ink, envelopes, postage stamps."[52]

If women had hoped that they would be able to enjoy a loosening of the strictures of daily routine as part of outdoor living, this was clearly not the case. Nevertheless, by the last two decades of the century, they tramped to the Sierra in record numbers with their families, inspired by idyllic pictures of their counterparts and fortified by practical hints in popular magazines. In turn, pictures of these women of the wilderness proved that wild California was a place where even a tenderly reared woman could enjoy the wide-open spaces—once she had completed her domestic duties.

While images of happy campers in California revealed to

Fig. 33. (above) Unidentified photographer, Washing Day in Camp. From Sunset 6 (April 1901): 202.

Fig. 32. (left) Unidentified photographer, Camping Chores, c. 1885. Frank B. Rodolph Album. Bancroft Library, University of California, Berkeley.

Fig. 34. (below) Pranishikoff (?) after Paul Frezeny, On the Way to Yosemite Valley, 1878. Wood engraving, approx. 10 x 12 in. Collection of William B. Floyd.

viewers across the country that the Pacific Eden had opened its gates, pictures of tourists at Glacier Point demonstrated that American Adams and Eves had also made their appearance in the Garden. During the latter part of the century, Glacier Point had been one of the most popular attractions in Yosemite Valley, as it afforded unexcelled views of all the celebrated rock formations below and of the High Sierra beyond. The viewspot had been widely publicized in popular prints during the second half of the century and, in 1872, was featured as one of the finest examples of the nation's sublime landscape areas in *Picturesque America*, a best-selling contemporary publication on the American wilderness.[53] The magnificence of the panorama at Glacier Point elicited the kind of response given by a party in the 1890s: "We spring to our feet and wave our hands, while we sing 'Hallelujah!' as the doors of this heavenly city are thrown open to receive us."[54] Enhancing the drama of the view was the long and difficult trip to the summit, which climaxed with a hair-raising horseback ride up a trail that zigzagged for four miles up the side of the mountain. Though many travelers were unnerved by the ascent, and though the sight of the vertiginous drop-off at the end reportedly caused "spiders of ice to crawl down one's spine,"[55] sightseers were portrayed at Glacier Point as the masters of the new landscape. Showing visitors on what appeared to be the top of the world, images demonstrated that, in California, the world lay quite literally at the tourist's feet.

American viewers who saw these representations of Glacier Point had an abundant

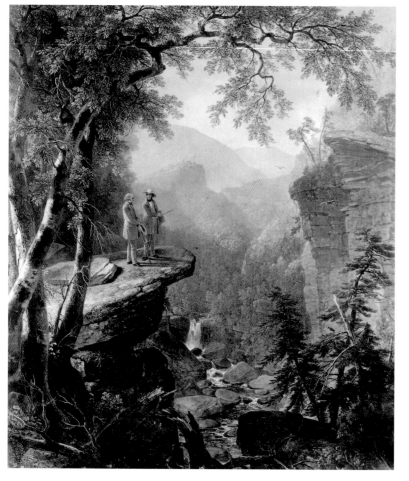

Fig. 35. Asher B. Durand, Kindred Spirits, 1849. Oil on canvas, 46 x 36 in. New York Public Library.

visual inventory on which to draw in their contemplation of such portrayals. Since the early nineteenth century, American artists had used the convention of the "view from above" to convey the idea of appropriation and mastery.[56] Asher B. Durand's commemorative painting of Thomas Cole and William Cullen Bryant, *Kindred Spirits*, painted in 1849, is one of the most noteworthy examples of this type of image (fig. 35). The subjects, an artist and a poet renowned for their interpretations of nature, stand on a rocky outcropping that affords a panoramic vista of the surrounding wilderness. Their clothing, well-cut and elegantly rustic, marks them as city dwellers who have come to be refreshed by the beauties of the Catskills. On the right, Thomas Cole points toward the chasm below in a gesture of explanation, as if to direct his companion's gaze to some worthy detail of the vast terrain. As Cole interprets the landscape for Bryant, the viewer is invited to speculate as to what edifying information passes between these two "kindred spirits." The enlightened commentary of these wilderness philosophers, surely, would permit a deeper understanding of the natural world that is their chosen domain and a

greater appreciation of its aesthetic and spiritual value. However, the viewer is too far away to eavesdrop on the conversation or to share in the intellectual initiation to the sublime mysteries of nature.

A painting by William Hahn, *Yosemite Valley from Glacier Point*, drew on the artistic precedent of *Kindred Spirits* in its portrayal of a peak experience, though it shifted the venue from the Catskills to the mountains of California (fig. 36). In contrast to Durand's reverential representation of the wilderness and its acolytes, *Yosemite Valley from Glacier Point* pictured a more prosaic experience of nature. The painting shows a typical excursion party at the summit of the Sierra, enjoying the sights on a brilliant summer day. A well-to-do couple and their daughter stand at the center of the canvas, discussing the magnificent scenery. As the woman looks through her binoculars, her husband—her kindred spirit—comments on what she sees, perhaps expounding on the controversies surrounding contemporary geological studies of the valley. Was the valley the product of slow and steady transformation, as proposed by Uniformitarians? Or was it the result of a sudden spasm of activity, as the so-called Catastrophists believed?[57] By their elegant coats and their dignified reaction to the wonders in front of them, we understand that these tourists are sophisticated urbanites who would have been conversant with such theories. They also would have been familiar with the works of Bierstadt and Watkins and may have been drawn to the California wilderness by a desire to seek out firsthand the views that they had enjoyed in the art galleries of New York or Philadelphia. That persons of such obvious taste and refinement had made the journey into the wilds of the Sierra would have been a powerful endorsement to their peers, as well as to those who aspired to be like them.

Fig. 36. William Hahn, Yosemite Valley from Glacier Point, c. 1874. Oil on canvas, 27 1/4 x 46 1/4 in. California Historical Society, San Francisco; gift of Albert M. Bender.

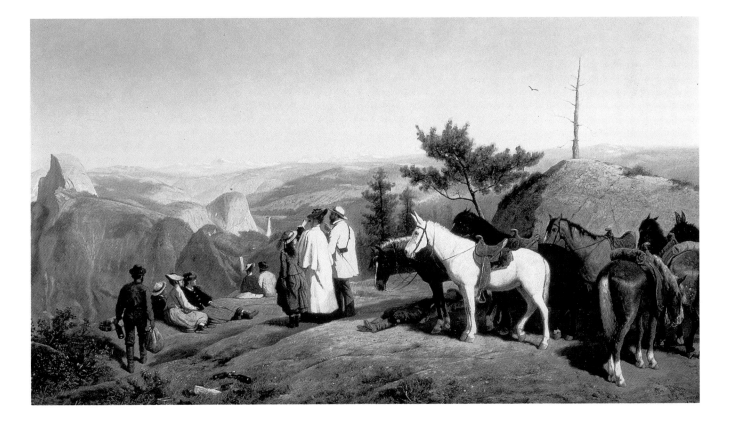

The discarded wine bottles and other detritus at the lower left side of the painting, though suggestive of the spoiling of Yosemite's pristine environment, would nevertheless have reassured the contemporary viewer that Glacier Point was a frequently visited attraction and one where tourists were provided with the necessary comforts. The figure of the guide who appears at the left of the canvas, toting a wine bottle and a heavy sack, indicates that the party will partake in a picnic—an inevitable component of a journey to Glacier Point—which will supply them not only with needed sustenance but also with the material that made for colorful retellings on returning home. Tourists could regale friends and family with accounts of their elevated repast at Glacier Point, spiced by a description of the visual feast that lay below.

Though Hahn's painting plainly represented the rather mundane aspects of a visit to Glacier Point, it discounted the difficulties of the journey. Treks to the peak, and around Yosemite in general, were notoriously rugged. Travelers' descriptions of the spectacular landscapes of Yosemite Valley were often accompanied by a litany of woe from the less-than-muscular Christians who had made the trip. One Yosemite visitor characterized the excursion as "a hard one for the hardiest and terrible for the ladies," causing them to suffer "the wounds and bruises of 100 miles of the roughest and steepest mountain traveling on horseback," and to return with "sunburnt faces wrinkled and drawn down with excessive fatigue."[58] Another discouraged traveler described a similar experience:

> And now begins the weary trudge again. Oh, positively we shall never live through it. We are obliged to be lifted from our horses every two or three miles, and placed under the shade of trees to rest. The sun creeps higher and higher. It pours its burning rays upon our aching heads, for we are again mounted. The pack mule runs away; we all run with unpleasant regularity after it, our horses trotting like trip hammers and beating the very breath out of our bodies. And so on and on we go. Eight miles! It is eighty![59]

Horace Greeley, the editor of the *New York Tribune*, had not been in the saddle for thirty years when he visited Yosemite in 1860. By the time he reached his hotel on the valley floor, the distinguished journalist was "utterly helpless" and had to be carried bodily for the next two days. When James Hutchings commented on Greeley's lameness in San Francisco three weeks later, Greeley replied: "Oh! Mr. Hutchings, you cannot realize how much I suffered from this jaunt to Yosemite."[60]

Nevertheless, the contented company that basks in the sunlight in *View from Glacier Point* appears to have escaped such suffering. The reclining figures affirm that the California visitor could expect a healthy measure of repose in addition to the vigorous exercise that was a well-known feature of such a trip. Furthermore, the placid horses and mules who wait to bring the tourists down the mountain are not the sort that would "trot like trip hammers" or "beat the very breath" out of greenhorn riders. Their presence implies that standing or walking was an entirely voluntary activity and that, contrary to reports, prospective visitors from the East need not worry about a lack of physical prowess when considering a vacation to California.

By the mid-1870s, tourist excursions to Glacier Point were common enough that local operators thought it wise to supplement the experience with additional entertainments. James McCauley, owner of the Mountain House, a hotel near the lookout point,

and builder of a four-mile toll trail to the summit, choreographed various activities for his customers. Derrick Dodd, a visitor of the early 1880s, related a memorable part of his tour:

> The landlord appeared on the scene, carrying an antique hen under his arm. This, in spite of the terrified ejaculations of the ladies, he deliberately threw over the cliff's edge. A rooster might have gone thus to his doom in stoic silence, but the sex of this unfortunate bird asserted itself the moment it started on its awful journey into space. With an ear-piercing cackle that gradually grew fainter as it fell, the poor creature shot downward; now beating the air with its ineffectual wings, and now frantically clawing at the very wind, that slanted her first this way and then that; thus the hapless fowl shot down, down, until it became a mere fluff of feathers no larger than a quail. Then it dwindled to a wren's size, disappeared, then again dotted the sight a moment as a pin's point, and then—it was gone! After drawing a long breath all around, the women folks pitched into the hen's owner with redoubled zest. But the genial McCauley shook his head knowingly and replied: "Don't be alarmed about that chicken, ladies. She's used to it. She goes over that cliff every day during the season." And, sure enough, on our road back we met the old hen about half up the trail, calmly picking her way home![61]

In addition to such aeronautic demonstrations, McCauley put on a spectacular show every evening at Glacier Point that could be viewed from the comforts of the valley floor. After building a large bonfire, he would push the glowing embers over the cliff in a spectacular "firefall" that plummeted down thousands of feet. This famous display was continued well into the twentieth century. Tourists at Camp Curry, a popular permanent camp in Yosemite, looked forward to the moment when the proprietor David Curry would bellow from the camp to the peak above: "Let the fire fall!" and counted it among the most memorable experiences of their trip.[62]

During the 1880s and 1890s, as greater numbers of visitors ventured to Glacier Point, photography replaced paintings, drawings, and lithographs as the most often employed medium for making pictures of the site. The rapid photographic portraits provided by studios set up near the summit satisfied tourists' demands for a conveniently portable record of their lofty experience. These images not only provided visitors with a souvenir of their Yosemite excursion; they were also published in promotional magazines and newspapers and used to advertise various products. In contrast to earlier portrayals of the untouched wilderness in Yosemite, such Glacier Point photographs focused on the human subject, tourists who were unfazed by the most terrible manifestations of nature's power and who were arriving in droves to take advantage of the region's recreational entertainments. In these images, tourists became leisure pioneers, intrepid conquerors who had overcome the earlier recalcitrance of nature. No longer the awed and silent witnesses who were the implicit observers in Bierstadt's paintings or Watkins's mammoth plates, they greeted the valley's most dizzying precipice with levity, defiance, or nonchalance. Atop the narrow rock that jutted out over the 3,254-foot drop, thrill-seeking tourists thrust their bodies into the jaws of death as souvenir snapshots proved that the cataclysmic power revealed by Watkins and Bierstadt had been subdued. Tourists on the precipice kicked up their heels or dangled

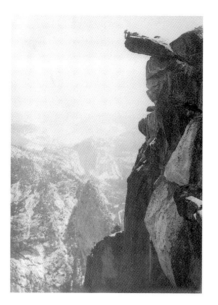

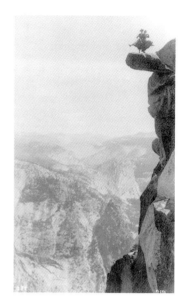

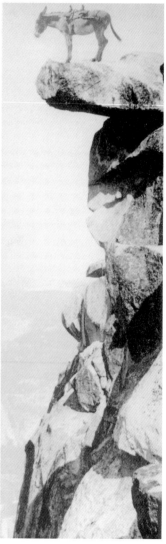

Fig. 37. (top left) Isaiah Taber, James
Hutchings, Glacier Point, Yosemite
Valley, Cal., c. 1880. Albumen print,
approx. 4 x 7 in. Yosemite Museum,
National Park Service.

Fig. 38. (top center) Unidentified pho-
tographer, Glacier Point, 7201 FT., c.
1880. Silver gelatin print, approx. 4 x 7
in. Yosemite Museum, National Park
Service.

Fig. 39. (top right) George Fiske,
Dancing on the Overhanging Rock at
Glacier Point, c. 1890. Albumen print,
4 1/4 x 7 1/2 in. Yosemite Museum,
National Park Service.

them over the edge. Ladies assumed romantic poses. Gentlemen struck defiant ones. The most agile among them performed somersaults and handstands (figs. 37-41). After the delightful antics of these various Kilroys, viewers may have found the sedate portrait of Theodore Roosevelt at Glacier Point in 1903 something of an anticlimax (fig. 42). The president did not need to pose on the brink of the cliff, however, to indicate that the Pacific wonderland was open for business and that its resources had been fully developed for the comfort and enjoyment of the vacationer.

While the image of the Rough Rider at Yosemite established beyond any doubt who was in command of the Pacific wilderness, another picture demonstrated how that control had been effected, and on what authority it rested. The photograph of an automobile shown poised at the edge of the abyss was the last word in Glacier Point views and demonstrated definitively that the once inaccessible viewspot had been converted into a recreational vehicle (fig. 43). The gleaming black roadster above the plunging void that symbolized the final frontier in California also alluded to the role that other technological inno-

Fig. 42. (left) Underwood and Underwood, Teddy Roosevelt and John Muir at Glacier Point, 1903. Stereograph card, approx. 3 x 5 in. Bancroft Library. University of California, Berkeley.

Fig. 43. (below) Unidentified photographer, Henry Washburn and His Automobile at Overhanging Rock, 1903. Photograph, 13 1/4 x 10 11/16 in. Seaver Center for Western History Research, Natural History Museum of Los Angeles County.

vations, including the railroad, the telegraph, and the combine wheat harvester, had played in the development of the state's natural resources. Obviously, complaints to management about the discomforts of travel by horseback had been addressed and, henceforth, with the juggernaut of progress advancing through the Sierra, visitors to the California wilderness would be guaranteed a smooth ride.

Fig. 40. (opposite, center left) Julius Boysen, Antoine Gillette, Acrobat, Performing a Somerault on Overhanging Rock at Glacier Point, c. 1880. Silver gelatin print, approx. 4 x 7 in. Yosemite Museum, National Park Service.

Fig. 41. (opposite, lower right) Julius Boysen (?), View of Burro (Winky?) Posed on Overhanging Rock, c. 1880. Silver gelatin print, approx. 4 x 7 in. Yosemite Museum, National Park Service.

5

Spanish Arcadia

Never before or since was there a spot in America where life was a long, happy holiday, where there was less labor, less care of trouble, such as the old-time golden age under Cronus or Saturn, the gathering of nature's fruits being the chief burden of life, and death coming without decay, like a gentle sleep.

—HUBERT HOWE BANCROFT, CALIFORNIA PASTORAL, 1888

After 1869, when travel to the Pacific represented a real possibility for increasing numbers of Americans, pictures describing California's tourist assets took on a new importance. A principal component of the package of visual delights offered to potential visitors in the East was the portrayal of the rich cultural heritage left behind by the state's former Spanish residents. Pictures that described the stately pace of mission

life and the gay abandon of the old *rancho* days nurtured the idea that a graciousness long absent from the lives of wage earners in the East was still present in California.

Of course, the state's Spanish history had not always represented a usable past. Beginning with Richard Henry Dana in the 1840s, Americans who wrote about their travels in California inevitably included unflattering descriptions of the region's Hispanic residents and their way of life. Though the practice of deriding the Spanish and, later, the Mexicans in California originated with the French and English, American travelers adopted the tradition with fresh energy. The vehemence of the American contempt for Mexican Californians was conveyed in the account of the Yankee trapper James Clyman, who toured the territory during the 1840s. Clyman dismissed his hosts as "a thieving, cowardly, dancing, lewd people," who, furthermore, were also "generally indolent and faithless."[1]

Anglo-Americans did not warm to their new compatriots after California became a state in 1850. Newcomers from the East were afraid that, by living among Mexican Californians, they might become infected by the endemic laziness that Richard Henry Dana had called the "California Fever."[2] During the gold rush, for example, Yankee argonauts refused to tolerate Hispanic miners in the diggings and enacted a series of statutes and taxes designed to prevent "greasers" from competing against them in the mines.[3] Consequently, for Anglo-Americans who decided to settle in El Dorado, part of their efforts to re-create the communities and institutions they had left behind in the East included erasing all evidence of the Latin way of life. As a result, by the end of the 1860s, many significant aspects of Spanish culture had been effectively neutralized, including the *rancho* system, the remnants of mission culture, and the influence of important Mexican-American families. The thoroughness of the campaign to rid the state of its Spanish characteristics was revealed by an English journalist in the 1870s, who remarked on the "effacement of the Spanish element" in California, noting that "the 'nombres de España' only remain; the 'cosas' thereof have entirely vanished."[4]

The diligent campaign to scrub away the traces of California's Spanish past during the 1850s and 1860s and the exuberant Hispanophilia of the later decades of the century act as a testament to the tenacious adaptability of the state's business leaders. Spurred by the completion of the transcontinental railroad in 1869, as well as by the financial collapse that followed in its wake during the 1870s, California's developers expediently reconsidered old resentments. The American passion for travel, evident in the growing popularity of tourist destinations including Saratoga Springs, Niagara Falls, and the European Riviera, represented a means to revive local businesses teetering on the brink of disaster. In this context, California's Old World heritage suddenly represented, rather than a burden and an embarrassment, a potentially lucrative tourist attraction. Those who had been the most energetic critics of the state's Hispanic residents now became enthusiastic boosters for Spanish California, promoting the venerable missions, the quaint remnants of Mexican *pueblos*, and the colorful traditions of California's Spanish-speaking population as cherished features of the state's cultural assets.

As part of the resuscitation of "the Spanish element" during the 1870s, the developers of tourism, including railroad and steamship companies, local newspapers, hotel owners and landowners, encouraged associations with distant locales that had traditionally attracted a large portion of Americans traveling abroad. The images and writings they sponsored emphasized California's similarity to Greece, the Levant, the Iberian

peninsula, the French Riviera, and Italy. Of course, according to the Southern Pacific's tourist brochures, the natural beauty and temperate climate of the state actually surpassed those of the most popular Mediterranean resorts. Furthermore, American travelers electing to visit "America's Mediterranean Shores" instead of Europe could enjoy the satisfaction of having made the patriotic choice. The added benefits of the American genius for organization and efficiency, as well as the natural fastidiousness of the local citizens, guaranteed that "Our Italy" would be "an Italy…without the trying features of that exquisite land."[5]

Pictures promoting tourism generally avoided representations of contemporary Hispanic society, steering clear of simmering ethnic conflicts that might detract from an enjoyable holiday. Instead, paintings, prints, and photographs showed life in California as it was purported to have existed in the first half of the century, portraying the years that preceded the rush for gold as an age of *fandangos* and *fiestas*. Such images encouraged the idea that, by following the recommended circuit of mission visits and old *pueblo* tours, visitors could relive the tranquility of the bygone Spanish era. "It is not unpleasant to think," wrote Charles Dudley Warner, the author of numerous promotional tracts, "that there is a corner of the Union where there will be a little more leisure, a little more of serene waiting on Providence, an abatement of the restless rush and haste of our usual life."[6]

The emphasis on leisure and the past in images of Spanish California, a startling departure from the traditional American preoccupation with hard work and progress, was calculated to appeal to a growing segment of the population disillusioned by the changes brought about by industrialization and the emergence of large-scale corporations. The latter decades of the nineteenth century represented a period of national soul-searching during which Americans pondered the relationship between mass production, individual expression, and physical health. At the same time, as Americans changed from small business owners and farmers into salaried corporate employees, scheduled vacation times became available for travel and recreation. For those living in a society in which the efficient management of time had become a central focus and who had weeks allotted specifically for amusements and holidays, Spanish California beckoned as a vacation destination, where time was not a luxury that needed to be parceled out in quarters of an hour and five-minute increments, but was something so abundant that it could be freely spent.[7]

At the same time, the idea of an alternative to the smoky, crowded metropolises of the East held particular appeal for Americans concerned by the deleterious effects of city life on health. *A Treatise on Hygiene and Public Health*, a compendium of studies published by medical experts in 1879, heightened national anxiety about the effects of modern civilization by including a list of ills attributable to the urban environment. Chief among these were nervous disorders produced by the overuse of certain organs and constrained postures, as well as by the inhalation of poisonous gases and dust. In 1881 George Beard, a medical researcher and writer, expanded on the ideas of the earlier study with his book *American Nervousness: Its Causes and Consequences*. The book was widely read by concerned Americans, who at last had a name for the syndrome that they believed was caused by what Beard defined in his chapter titles as the "Necessary Evils of Specialization," "Clocks and Watches," the strain of punctuality, and the "Effect of Noise on the Nerves." As a contrast to the frenetic pace of life in modern America, Beard included descriptions of the measured pace of the daily circuit of activities in ancient

Athens, which he extolled as an example that Americans would do well to emulate. "We have our occasional holidays, and a picnic or other pleasure party is cautiously allowed, or some anniversary is celebrated," Beard explained, "but the Greek's life was a long holiday, a perpetual picnic, a ceaseless anniversary."[8]

By holding up Mediterranean culture as a remedy for metropolitan malaise, *American Nervousness* played directly into the hands of California tourist developers. Promoters advised easterners that a vacation on "the Mediterranean Shores of America" would allow "nervous" Americans to cast aside their doubts about the future of the American metropolis and to re-create themselves in idyllic surroundings. A letter written by the author Henry James evoked the sense of physical well-being and relaxation that accompanied an escape to California. Basking in the gracious comforts afforded by the Spanish-style Hotel del Coronado in San Diego, James described his own experience of the Pacific Arcadia: "The days have been mostly here of heavenly beauty, and the flowers, the wild flowers, just now in particular, which fairly *rage* with radiance, over the land, are worthy of some purer planet than this," he wrote. "I live on oranges and olives, fresh from the tree, and I lie awake at night to listen, on purpose, to the languid list of the Pacific, which my windows overhang."[9]

To suit the taste for the forbidden fruit of indolence, image makers tended to present scenes of Spanish California in a highly theatrical manner that gave viewers permission to relax and enjoy the show. The dramatic exaggeration of such works imbued exotic scenes with a comforting predictability and remoteness, while also reconfirming the anti-Hispanic preconceptions of American audiences raised on Protestant doctrine. Capitalizing on the popularity of Wild West exhibitions and gypsy entertainments staged for American travelers in Italy and Spain, portrayals of old *rancho* days relied on viewers' familiarity with certain stock characters and themes. Initially, through the 1870s, representations tended to focus on the passionate energies of the inhabitants of Spanish California; artists gave free rein to their imaginations describing wild-eyed *vaqueros* chasing errant cows into the sunset, handsome *bandidos*, and scantily clad *señoritas* dancing with abandon. During the 1880s, however, as patrons reconsidered what would most likely attract tourists, such imagery began to lose its naughtiness, and more sedate subjects, particularly portrayals of mission life and Spanish religious rituals, predominated. In images at the turn of the century, formerly youthful Spanish suitors reappeared as weighty *alcaldes* and dancing ladies who previously went unescorted were chaperoned by vigilant *dueñas*. This new respectability went hand in hand with reduced railroad rates calculated to attract middle-class families to the Pacific, acting as a guarantee that those of tender years would be exposed only to the most salubrious influences during their holiday in California.

A favorite motif of artists portraying scenes of Spanish California was the rider on horseback (fig. 1). Beginning in the gold-rush days and persisting through the end of the century, images of Hispanic horsemen appeared in illustrated journals and books intended for eastern readers and in paintings that California railroad magnates displayed as examples of what passengers could expect to see for the price of a transcontinental ticket. So often was the Spanish Californian portrayed astride a fiery steed that he seemed to acquire the attributes of a centaur—the mythical creature who, half-human and half-beast, was thought by ancient Greeks to live on the edge of the civilized world in distant Arcadia.

Many Americans became familiar with the figure of the California horseman

Drawn by Capt.ⁿ Smyth, R. N. Lith.ᵈ by L.M. Lefevr

CALIFORNIAN MODE OF CATCHING CATTLE,
WITH A DISTANT VIEW OF THE MISSION OF ST JOSEPS.

through written descriptions made by early visitors, including Bayard Taylor and the English journalist Frank Marryat. In *Mountains and Molehills*, Marryat's widely read account of his travels in California, the author enthused about the marvelous horsemanship of his Hispanic hosts. Though Marryat confided that the "vaccaros" were "as lazy a set as ever were seen," he characterized them as equestrian daredevils who wanted "at all times to ride furiously."[10] Mark Twain also included a description of the exciting spectacle of the California *vaquero* in his popular book *Roughing It*:

> I had never seen such wild, free, magnificent horsemanship outside of a circus as these picturesquely clad Mexicans, Californians and Mexicanized Americans displayed…every day. How they rode! Leaning just gently forward out of the perpendicular, easy and nonchalant, with the broad slouch-hat brim blown square up in front, and long *riata* swinging above the head, they swept through the town like the wind! The next minute they were only a sailing puff of dust on the far desert.[11]

Like Twain's account, pictures of the California horseman rarely showed him traveling at a measured pace. The *vaquero* always appeared setting off at a gallop or reining in a frenzied horse, his black locks tossing in the updraft as he cast a dramatic glance in the direction of the viewer. In keeping with the extravagance of his horsemanship, the rider typically was portrayed in lavish outfits that Yankees would have considered excessive for everyday circumstances. Tight-fitting jackets, colorful waist sashes, and elaborate *calzoneras*—full-length embroidered trousers that were often adorned with a row of silver buttons down the side of each leg—were carefully described by image makers for American viewers fascinated by what they perceived as evidence of the characteristic

Fig. 1. R. N. Smyth, Californian Mode of Catching Cattle. From Forbes, California (1839), facing 273. Private collection.

NATIVE CALIFORNIAN AT FULL SPEED, TAKING THE BURIED ROOSTER BY THE HEAD.

vanity of the indolent Californians. Reinforcing this idea was the fact that, though the rider was always represented traveling at great speed, he was never shown arriving at his destination or doing anything of a productive nature. A characteristic illustration that appeared in *Hutchings' California Magazine* in July 1860 showed the mounted Californian playing a "typical" game, in which the rider attempted to grasp a buried rooster by the neck and pull it out without reining in his horse. The image captured the "Native Californian at Full Speed," in the climactic moment of the dangerous game in which the rider was often unseated and dragged for a considerable distance (fig. 2). Though the text accompanying the illustration described the contest as "of a highly exhilarating and amusing character," such an image was certain to elicit disapproving clucks from readers concerned by the prodigal use of time and chickens.

While some pictures portrayed California riders frittering away their energies in pointless games, others represented *vaqueros* who occupied their time with criminal activities. A favorite subject in this vein was the infamous Joaquín Murieta, a Mexican bandit who allegedly had organized a series of holdups in the northern part of the state during the winter of 1852 and 1853. The reports of victims, however, led authorities to believe that the robberies were committed by different men who, coincidentally, were all named "Joaquín." The *San Francisco Alta* commented on this conundrum in August 1853: "Every murder and robbery in the country has been attributed to 'Joaquín,'" the newspaper announced. "Sometimes it is Joaquín Carrillo that has committed all these crimes; then it is Joaquín something else, but always 'Joaquín!'"[12] The mystery of a countryside full of Hispanic criminals with the same name was considered

Fig. 2. (above) Charles Christian Nahl, Native Californian at Full Speed. From Hutchings' California Magazine 4 (July 1860): 19.

Fig. 3. (right) Charles Christian Nahl, Joaquín Murieta. From Ridge, The Life and Adventures of Joaquín Murieta (1854), frontispiece. Private collection.

JOAQUÍN MURIETA
The California Bandit

solved when a Texas bounty hunter, responding to the governor's offer of one thousand dollars for the "marauder of the mines," delivered the pickled head of "Joaquín" to a local sheriff in 1853. The head, along with the mutilated hand of Murieta's alleged partner, Three-Fingered Jack, was displayed for a number of years in traveling shows and local "museums."

In 1854 Charles Christian Nahl, the preeminent California artist of the gold-rush years, provided the illustrations for a dime novel that purported to tell the true story of the outlaw, *The Life and Adventures of Joaquín Murieta, the Celebrated California Bandit*. In 1859 the artist's depictions of Murieta appeared in the *California Police Gazette*, which serialized the bandit's story. These illustrated accounts were highly popular with local readers who wanted to know the story of the real Joaquín (fig. 3). A decade later, in 1868, Nahl revisited the subject, creating a large oil portrait of the desperado that was the last word in such portrayals. The forty-by-thirty-inch *Joaquín Murieta* was exhibited at the San Francisco Mechanics' Institute Fair of 1868, where it appeared alongside displays of advanced machinery, agricultural products, and other examples of the state's progress (fig. 4). In the context of the fair, Nahl's dramatic rendering of the "Brigand Chief of California" gave visitors the entertainment they expected. His painting showed Murieta as the embodiment of the popular stereotype of the cruel and murderous Hispanic,

Fig. 4. Charles Christian Nahl, Joaquín Murieta, 1868. Oil on canvas, 39 3/4 x 29 3/4 in. Collection of Gregory Martin.

come to life in downtown San Francisco. Murieta gallops toward the viewer on a frantic black stallion that threatens to leap into the exhibition hall and scatter the well-dressed viewers enjoying their Saturday outing. The bandit's eyes are fixed in a demonic stare and his lips pull away in a snarl from his straight white teeth. He raises a dagger in his hand, ready to plunge it into the bosom of his enemies. On the far left of the canvas, we see evidence of Murieta's impending doom in the flash of guns fired in his direction.

Those who saw Nahl's painting at the fair were likely to have read *The Life and Adventures of Joaquín Murieta* and would have recognized the scene portrayed as the rousing finale of the book, when the bandit, "rushing along a rough and rocky ravine," makes a last desperate attempt to evade the rangers who were charged with bringing him to justice. Audiences knew that in the next instant Murieta's life of crime would be cut short, as would he, with his capture and decapitation by the avenging posse. Certainly, it seems that viewers' familiarity with the by now hackneyed subject would have discouraged Nahl's elaborate reenactment. Nevertheless, it was precisely the predictable nature of the story that made it worthy of such continual consideration. Through the image of the notorious Mexican criminal—who was also famously dead—Nahl's painting exorcised white Californians' lingering fear of ethnic violence and racial contamination. While it confirmed the suspicions held by Anglo-Americans that Hispanics (many named Joaquín) were responsible for the majority of violent crimes in the state, *Joaquín Murieta* also promised that those who antagonized the forces of order would be dealt with accordingly. Thus, emptied of its threat, the image of the violent Hispanic took its place at the Mechanics' Fair, where, along with mounted grizzly bear heads and elaborate irrigation devices, it invited viewers to consider just how far California had advanced in the few decades that had passed since the state's entry into the Union.

After the completion of the transcontinental railroad in 1869, the frenetic energy that characterized pictures of Murieta and other Spanish horsemen up to that time seemed to dissipate. The idea of lawlessness inherent in such images was replaced by a mood of benevolent high spirits in which *vaqueros* were portrayed in a more sedentary manner—lounging, smoking, or simply waiting on their horses. These later works focused on aspects of attitude and costume, rather than the risky equestrian feats of earlier years. When riders were shown galloping, roping, or roughhousing, such activities generally were pushed into the background and often appeared as little more than an artistic afterthought. Significantly, pictures of newly calm *vaqueros* coincided with the peak in popularity of Buffalo Bill's traveling show, in which western scouts and cowboys performed daring stunts on horseback and displayed their unerring marksmanship. In turn, the fame of Buffalo Bill's company, which performed in all the major eastern cities as well as in Europe, stimulated the growth of collateral industries that satisfied the public's desire for pictures and stories of frontier heros and horsemen. From the 1870s through the turn of the century, American printmakers did a brisk business selling scenes of cowboy life, while publishers did their best to keep up with the nationwide demand for dime-novel "westerns."

In this context, the California *vaquero*, as the Hispanic prototype and forebear of the revered frontier icon, represented a profitable opportunity. During the last quarter of the century, newspapers and journals that had carefully ignored the state's Spanish-speaking residents now featured articles detailing the interesting habits of the *vaquero*.

Fig. 5. James Walker, Vaqueros in a Horse Corral, 1877. Oil on canvas, 24 1/4 x 40 in. Thomas Gilcrease Institute of American History and Art, Tulsa.

Artists in California busied themselves providing illustrations for such publications, as well as producing fine oil paintings of *rancho* days for local patrons looking for fresh alternatives to the ubiquitous still life and pastoral landscape. One of the most prominent artists to take up Hispanic themes during this period was James Walker, a New York artist who had painted the walls of the United States Capitol with scenes of the Mexican War. Changing from the Spanish-speaking foe to the Spanish-speaking *compadre* proved to be easy for Walker, and he described the life of the *vaquero* in a series of colorful oil paintings that attested to his close observations of the subject. *Vaqueros in a Horse Corral*, one of Walker's largest canvases, showed California cowboys tending to stock in a dusty paddock (fig. 5). A rider at the center lassoes a skittish white stallion and tightens the rope as he begins to lead the horse out of the corral. Behind him, in the moment before he captures a glossy bay, another *vaquero* on foot swings his graceful *riata* above his head. Other ranch hands take their ease outside the corral, watching and chatting as their *compadres* work.

Rather than focusing on feats of horsemanship, Walker took great care in describing the particulars of his subjects' clothing. The artist arranged the figures to provide an unobstructed view of the *vaqueros*, as well as of their horses and saddles, from the front and back, rewarding careful scrutiny of the painting with myriad details. The *vaqueros* wear flat-brimmed hats that shade their faces and obscure the individual features that might draw the eye away from their outfits. Two of the men are draped in broad *serapes* that protect them from the settling dust: The artist used a finely pointed brush to define the elaborate pattern of the red fabric. Rows of bold silver buttons punctuate the riders' jackets, pant legs, and empty saddles displayed to maximize ease of inspection. A pair

of horses, placed symmetrically on the left and right edges of the canvas, act as parentheses that contain the forms in the center. Like their masters, the horses stand idly in the warm afternoon sunlight, allowing the viewer to study the fine workmanship of their tack.

Despite Walker's efforts to evoke the rousing excitement of horse roping, his meticulous attention to costume and the static, posed quality of the *vaqueros* as he presents them imbues *Vaqueros in a Horse Corral* with the air of a staged performance. This sense of artifice is accentuated by the dusty haze that falls over the scene, bleaching the color from the forms in the corral. The horses and their riders have a milky, ghostlike quality, as if perceived as a distant memory of days gone by. Certainly, during the 1870s, it would have been increasingly difficult for artists to locate scenes like the one Walker portrayed. By that time, most of the great *ranchos* had been divided into smaller tracts that had been irrigated, mined, or settled with growing communities. In addition, California developers had been eminently successful in their campaign to push evidence of Hispanic culture to the edges of the new society. In this context, it was enough for Walker to make a visual inventory of the trappings of *vaquero* life—belts and buckles and the kinds of things that could be bought by tourists at local curio shops—rather than a more authentic portrayal of the worn-out remnants of *rancho* days that patrons neither expected nor desired.

The choreographed calmness of *Vaqueros in a Horse Corral* marks a change in the tempo of *vaquero* imagery which, during the 1850s and 1860s, had galloped to a lively *vivace*. During the 1870s, pictures of the *vaquero* slowed to a more restrained *allegro ma non troppo* and even to the ponderous *andante* that would become the standard cadence for representations of the subject by the turn of the century. *Ranch Scene, Monterey, California*, a 1875 painting by one of California's most successful artists, William Hahn, embodies the shift in pace that took place during the last quarter of the century (fig. 6). Hahn's portrayal of riders stopping for a *cerveza* at an *adobe* ranch building seems to identify at last the unspoken destination of all the racing *vaqueros* of earlier years. The long shadows cast by the forms in the painting indicate the end of the day, and the stillness of the figures reinforces the idea of repose and refreshment. While the *vaqueros* wait for foamy lagers brought by the *dueña* of the house, cattle take deep drafts from the wooden trough at the center. On the left, chickens scatter across the dusty courtyard, ignored by riders who, in livelier days, would have grabbed the birds up by the neck as they raced by.

Like Nahl's portrait of Joaquín Murieta, Hahn's *vaqueros* appear to have reached the end of the line. Where Murieta made his last stand in a blaze of gunfire and flashing white teeth, however, the *vaqueros* in *Ranch Scene, Monterey* have simply ground to a halt, like wind-up toys that have lost their momentum. They sit heavily in their saddles, ready to rest after a long ride. Even the cattle, which seemed to hover perpetually on the brink of stampede in earlier portrayals of *rancho* days, are gentle as milch cows as they wait their turn at the trough. It is only in the figure of the most distant rider in the background, who appears to rein in a shying horse, that the painting alludes to the wild horsemanship that animated the images of previous decades. Still, the figure's suggestion of incipient movement is canceled out by the steer in the viewer's line of sight that, tired or dying, collapses awkwardly into the dust.

The new tractability of the California *vaquero* as represented in images like *Ranch*

Scene, Monterey helped to align the idea of Spanish California with the tourist-related projects of local companies. Monterey, the setting of Hahn's painting, was also targeted by the real-estate arm of the Southern Pacific Railroad, the Pacific Improvement Company, as the site of a luxurious new resort. Advertised as the largest in the world, the Hotel Del Monte was intended as the showcase of the railroad's network of tourist lodgings in the state. The resort's 126 acres of landscaped gardens included stables, a polo field, tennis courts, a maze of seven-foot-high cypress hedges, and a glass-roofed bathing pavilion with four swimming pools, each heated to a different temperature to suit every taste. When the hotel opened in June 1880, it was hailed in local newspapers as the "Queen of American watering places" and "the court in which Dame Fashion holds her levees."[13]

In this context, it is obvious that the menacing image of the ubiquitous Joaquín had outlived its usefulness. The idea of outlaws lurking in the cypress maze or, even worse, the prospect of substandard service by surly Hispanic waiters was not in keeping with the impression the Pacific Improvement Company wanted to impart. On the other hand, the tranquil, contemplative mood of *Ranch Scene, Monterey* and the attentive hospitality of the woman who brings a tray of drinks to the weary *vaqueros* conveys a sense of restfulness and well-being conducive to the idea of a holiday in Monterey. In addition, the painting served as a preview of the picturesque sights visitors might enjoy

Fig. 6. William Hahn, Ranch Scene, Monterey, California, 1875. Oil on canvas, 36 x 40 in. Collection of the Oakland Museum of California, Kahn Collection; gift of Mr. and Mrs. Sydney L. Schwartz to honor Dr. and Mrs. John J. Simpson and in memory of Mr. and Mrs. William E. Gump.

while touring the area. In any case, since one of Hahn's most important clients was Leland Stanford, owner of the Southern Pacific Railroad, the artist had special insights into the Pacific Improvement Company's long-term vision for the region.

During the 1870s, changes in the image of the *vaquero* that were evident in paintings like *Ranch Scene, Monterey* and *Vaqueros in a Horse Corral* were also accompanied by a new interest in the community life of old California, particularly in the lively *fiestas* that roused residents from the torpor of daily routine. Charles Nahl, who always kept his finger on the pulse of his patrons' changing tastes, took up the subject with the same verve he had devoted to Joaquín Murieta a few years earlier. In 1873, for a commission from the railroad tycoon E. B. Crocker, the artist produced *The Fandango*, which represented a group of Californios at a dancing celebration (fig. 7). With the freedom afforded by the large, six-by-ten-foot canvas, Nahl indulged his love of high color and dramatic movement. The image that resulted was both a technical tour de force and an encyclopedic summary of popular Spanish California themes.

Galvanized, perhaps, by the eminence of his client, Nahl seems to have been determined to provide good value for his services by including every Hispanic type he could conjure—the racing *vaquero*, the loafer, the flirtatious *señorita*, the swarthy hothead, the ragamuffin, and the chivalrous *caballero*. While contemporary detractors commented that it appeared that Nahl had used the same model for all the figures, the similarity of

Fig. 7. Charles Christian Nahl, The Fandango, 1873. Oil on canvas, 72 x 108 in. Crocker Art Museum, Sacramento, E. B. Crocker Collection.

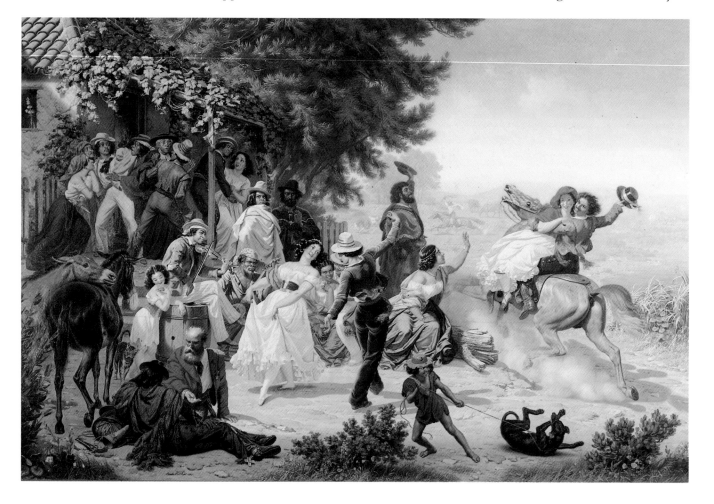

the revelers in the painting had more to do with the limits of the visual repertoire of Spanish subjects than the artist's unwillingness to make a large outlay for models. Nahl was free to exercise his artistic judgment in terms of the harmonious arrangement of the forms and to show off his technical bravado with the dazzling realism of the portrayal. However, like the steps of the *fandango* followed by the elegant couple that pivots at the center of the canvas, the particulars of the painting were predetermined. Mirroring the circular geometries the dancers trace with their feet, the painting leads the viewer's gaze in a circuit from one stock character to another. There is the provocative *señorita* who lifts her flounced skirt to reveal a tiny and elegantly pointed foot—a figure calculated to beguile even the most hard-boiled Yankee viewer. Her companion, the gallant *caballero*, is dressed in a close-fitting suit of olive corduroy that shows off his movements to their best advantage. To the right, a revised and improved Joaquín rides off with his inamorata. Where Nahl's earlier subject seemed to hurtle into the viewer's space, this swashbuckling suitor makes a speedy exit instead, turning back as he rides away to cast a captivating

THE HYBRID.

Fig. 8. Charles Christian Nahl, The Hybrid. From Hutchings' California Magazine 1 (February 1857), 1. Bancroft Library, University of California, Berkeley.

smile at his audience and saluting with his *sombrero* in an outstretched hand. His friends wave heartily as he leaves the merriment, and one can almost hear them call in lilting voices: "Adios! Adios!"

Though *The Fandango* initially appears to be a scene of happiness and contentment, it also includes various references to other, less pleasant emotions that Anglo-Americans associated with the Hispanic temperament. In the foreground, a dark-skinned boy drags a dog sprawled on its back, an allusion to the cruel animal games, including bearbaiting and bullfights, that Hispanics were thought to enjoy. In the background to the left, a mysterious altercation takes place, threatening to disrupt at any moment the pleasant *fandango* at the front. A group of ladies and a grandfatherly type plead with a pair of men who threaten to come to blows, the predictable choreography for matters of slighted honor and vengeance. Evidently, the natural complement to the gusto with which Hispanic revelers pursued their pleasures was a penchant for violence that was both unpredictable and illogical. For Anglo-American viewers, the obvious explanation for such instability of character was the mixing of races evident in the varying skin colors of the subjects.[14] A picture that appeared in *Hutchings' California Magazine* in February 1857 apprised readers of the unfortunate results when those of "Castillian" blood intermingled with indigenous peoples and those of mixed ancestry. The product of this union was the degenerate Hispanic "hybrid" who whittles away his time in useless activities (fig. 8). The inevitable demise of such a race is hinted at by the figure in the left foreground of *The Fandango*, portrayed in the manner of Jacques-Louis David's Aristotle addressing his acolytes before his death (fig. 9). The vigorous farewells that are made on

the right also suggest the end of the Spanish era and Anglo-Americans' powerful desire to see their Spanish-speaking *compadres* ride off permanently into the sunset.

Reassured by Nahl's treatment of the Hispanic theme that the threat of cultural confrontation had been neutralized, the elite callers who saw *The Fandango* at Crocker's Sacramento mansion could devote themselves to matters of style and aesthetic nuance when viewing the image. The comments of these viewers may have been similar to those of a contemporary art critic who ignored the issue of the painting's Hispanic subject, while praising the work in the highest terms. "The texture and effect of the silks in the dresses represented in this picture are simply perfection," the writer proclaimed. "The bright sunlight on the old red tiles of the roof corner, and the play of the broad vines on the leaves of the porch, is a bit of painting to make the reputation of any artist in any city of the world."[15]

By the 1880s, the ambivalent attitude toward Spanish California that was frankly expressed in *The Fandango* and other works of the 1860s and 1870s was submerged in a wave of unabashed nostalgia for the days "before the Gringo came."[16] Paintings, prints, and photographs produced in the last two decades of the century pictured the years before the gold rush as an Arcadian golden age of easy comforts and gracious hospitality. The change in the tone of works that dealt with Hispanic culture was due in large part to the runaway success of a novel about Old California that sparked a nationwide fascination with California's Spanish past. Published in 1881, *Ramona* was a stirring

Fig. 9. Jacques-Louis David, Death of Socrates, 1787. Oil on canvas, 51 x 77 1/4 in. The Metropolitan Museum of Art, Catherine Lorillard Wolfe Collection, Wolfe Fund, 1931. (31.45).

romance about an Indian girl and her sweetheart, Alessandro, and their mistreatment at the hands of white oppressors. This California-style *Romeo and Juliet* was written by Helen Hunt Jackson, who came to California in 1881 as an investigative reporter for *Century Magazine*. Through her story, which first appeared as a serial in the *Christian Union*, the author intended to call attention to the plight of the state's native people and to speed reform efforts, much as *Uncle Tom's Cabin* had done for the issue of slavery before the Civil War. As a counterpoint to her descriptions of the vicious activities of Anglo-American settlers in *Ramona*, Jackson wrote lovingly about the "good old Spanish days," when benevolent *padres* cared respectfully for their Indian charges and ranch owners led lives of understated gentility and reverence for God. Instead of absorbing the instructive lesson that was offered in the book, however, American readers focused on the story's passionate romance and the beauties of Spanish California that Jackson described:

> It was a picturesque life, with more sentiment and gayety in it, more also that was truly dramatic, more romance, than will ever be seen again on those sunny shores. The aroma of it all lingers there still; industries and inventions have not yet slain it; it will last out the century—in fact, it can never be quite lost.[17]

Unwittingly, the reform-minded Jackson had tapped into the national preoccupation with the effects of modernization that characterized the final decades of the century. The prevalent sense of the end of one age and the beginning of another encouraged Americans to look to the past, to make an assessment of contemporary culture and speculate about the changes the new century would bring. This fin-de-siècle tallying of accounts drew attention to the new secularism of American society and its increasing reliance on technology and science to mediate the experiences of everyday life. The inexorable mechanization and bureaucratization—what Jackson called "industries and inventions"—that had transformed community life during the previous century led Americans to reconsider the meaning of Yankee ingenuity and to question the value of progress. In this context, Old California, with its close-bound families, its fervent Catholicism, and its pastoral way of life, held out the promise of redemption from the sins of modernity. Of course, despite the sudden interest in California's golden years, the dismal circumstances of the state's native peoples remained a subject of peripheral significance.

By the middle of the 1880s, to the surprise and delight of promoters of tourism in the state, Americans began to flock to California, eager to make pilgrimages to the places described in *Ramona*. For once, local developers found that their efforts to stimulate tourism were following on the heels of the nationwide demand for tours, pictures, and souvenirs of "Ramona's Country." Local businesses scrambled to accommodate visitors fascinated by what was now spoken of as the state's Spanish "heritage." Their promotional efforts were spearheaded by Charles Fletcher Lummis, author and editor of one of the state's foremost promotional magazines, *Land of Sunshine*.[18] As a complement to his journalistic efforts, Lummis made his own life an advertisement for the romantic lifestyle described in *Ramona*. He dressed in Spanish costume on a daily basis, wearing the rich corduroys, waist sashes, and wide-brimmed hat of the *vaquero* (fig. 10). He also built a rambling house in the Spanish style he named El Alisal, the Spanish name for the

giant sycamore tree that grew on his property. At El Alisal, Lummis played the part of the great *Don*, organizing an endless succession of *fiestas* at which he hosted the important writers, artists, and actors of his day, including Frederic Remington, Charles Russell, Will Rogers, and John Muir.

Lummis understood that parties and entertainment were a crucial feature of the Spanish metaphor, and he did his part to encourage the idea of life in California as a perpetual holiday. The Southern Pacific booster Benjamin C. Truman, the author of *Semi-Tropical California*, alluded to the new sense of gaiety when he described the people of Los Angeles as "a dancing people…indeed, everything but a funeral wound up with a dance." An image from a souvenir program for the Semi-Centennial Admission Day Celebration Ball, held in San Francisco in 1900, made the direct connection between the *fandango*-loving residents of early California and the "dancing people" who felt themselves to be the early Californians' spiritual descendants (fig. 11).

With a flood of images, articles, and books devoted to Spanish California, Lummis and his colleagues labored to resuscitate the culture that business leaders had been so eager

to snuff out during the previous decades. Still, like the exhumation in the 1880s of the remains of Father Junípero Serra, the eighteenth-century founder of the mission system, the new interest in the state's Hispanic culture was confined, for the most part, to people and things that had vanished years before. Artists and photographers played a strategic role in the mission revival, creating the material that gave substance to the fiction of Ramona and the way of life in Old California. For the more literal-minded, there were picture postcards showing "the place where Ramona was married" or reenactments of the first meeting of Ramona and Alessandro on the *rancho* (fig. 12). More generalized evocations of Old California days were also popular, particularly genre scenes depicting daily life at the missions and on the old *ranchos*.

One of the many artists at the turn of the century who earned a comfortable livelihood turning out representations of Old California was Alexander Harmer. A former student of Thomas Eakins in Philadelphia, he was also a close friend of Charles Lummis, who regularly encouraged the artist to create scenes of life in early California that could be reproduced in *Land of Sunshine*. Harmer's dreamy representations of *rancho* days helped to articulate the physical characteristics of the new Old California and gave viewers images to carry in their minds as they visited the deserted sites of ruined missions and the remnants of Spanish *pueblos*. Having seen Harmer's reinterpretations of the Spanish past in newspapers and journals, as well as on restaurant menus and the walls of California business establishments, tourists who went to these sites could easily imagine the "Mission Belles" who had promenaded along the same paths years before and could perhaps smell the exotic spices and toasting *tortillas* in the marketplace under the arcade. Visitors might also dine from a set of mission-motif plates that were designed by the artist, and which were subsequently copied by the Wedgwood company in England. President Herbert Hoover was given a set of these dishes as an inauguration gift and reportedly used them for breakfast meetings at the White House (fig. 13).[19]

One of Harmer's most elaborate depictions of Old California was a painting

Fig. 10. (top, previous page) Unidentified photographer, Charles Lummis, c. 1900. Photograph. The Huntington Library, San Marino.

Fig. 11. (bottom, previous page) Semi-Centennial Admission Day Celebration, 1900. Pamphlet illustration, approx. 8 x 12 in. Private collection.

Fig. 12. (top) A. C. Vroman, The Chapel Door (Camulos). From Jackson, Ramona (1888), facing 238. Private collection.

Fig. 13. (below) Wedgwood Company, California Mission Plate, c. 1890. Earthenware. Collection of Mr. David Bisol.

entitled *Fiesta in Old California (A Day at Pacheco's)*, which was published as the frontispiece of the July 1899 issue of *Land of Sunshine*, as well as in a successful calendar series during the same period (fig. 14). The journal text was written by a Californian who reportedly had attended the event portrayed in the drawing: the arrival of the *Don of Casa Pacheco* on an important Spanish holiday. The writer described the idyllic afternoon for the magazine's readers:

> Men and women were thick as bees, swarming about the place in the honey-sweet air. Tall, handsome caballeros, and pretty plump señoritas, niños that were as happy and healthy as only children can be who breathe the salt air that comes in from Pacific seas; old men and women with the fire of life still shining in their bead-bright eyes, though their skin was withered and flesh shrunken; young men and girls, laughing and gay and in love. These and the Indians—scores upon scores of them—and the horses (such as you never see now on the rancho), these, I say, made up a mass of moving, glowing life that day at Pacheco's.[20]

In its portrayal of Spanish Californians at a festive gathering, *Fiesta in Old California* revisited the themes that Charles Nahl explored more than twenty years earlier in *The*

Fandango. Logically, with the decades that passed between the painting of the two works, the weight of middle age appears to have settled on the party. There is a slowing of the step, a thickening of the waist, and a fixing of expression that marks the passage of time. The passionate response to music and the sense of abandon that characterize *The Fandango* has been replaced with good manners and respect for authority in Harmer's work. While the revealing dresses of Nahl's female subjects always seemed to be riding up or slipping down, Harmer's women are clothed in heavy skirts, broad shawls, and elaborate *mantillas*. Rather than dancing, they sink to the ground like roosting hens, nodding and gossiping about the details of the day. The ladies kneel in a circle around Don Pacheco, the aging patriarch of the *rancho* who inherits the space formerly occupied by the dancing suitor of *The Fandango*. Pacheco reins in his horse as he doffs his *sombrero*, greeting those around him with a courteous smile. Bound by the tethers of decorum and the physical limitations of advancing years, Pacheco and his guests exchange pleasantries as they wait for the feast that is being prepared at the great barbecue visible in the upper right corner of the canvas. The satisfaction of other, more earthy appetites has been pushed into the background, as has the danger of social disorder that in *The Fandango* was portrayed as an inevitable counterpart to the passion of the dance.

The differences between Nahl's and Harmer's paintings suggest that artists engaged in an ongoing struggle to strike the right balance between gaiety and decorum when portraying Old California. In this context, the unpopulated California missions presented a less problematic way to advertise the state's Spanish past and its enduring connection with the Old World.[21] Supplied with an evocative image of one of the abandoned old buildings, *Ramona* readers and tourists could envision their own ideal Hispanic population, unfettered by the often clumsy interventions of the artist. Of course, as part of the general effort to eradicate the *cosas de España* during the years following the gold rush, the missions had been allowed to deteriorate to the point where many were nothing more than a pile of *adobe* rubble—scenes of decay that resisted the efforts of even the most vivid imaginations. During the 1880s, however, the indefatigable Charles Lummis began a statewide campaign to repair and preserve the buildings. In an article he wrote for *Drake's Magazine* in 1889, Lummis described the missions with romantic fervor:

> Staunchest survivors of the old regime of restfulness and romance, are the venerable mission churches; and even they are fast crumbling above the dust of a forgotten people. Noble monuments they are to the noblest of missionaries—those heroic Franciscans who pierced the deserts of an unknown world, subdued its savage tribes; and conquered the wilderness for Spain and the church.

In other writings, however, Lummis showed a more pragmatic approach to the ancient structures, calling them "next to our climate and its consequences, the best capital Southern California has."[22]

From the 1850s through the 1870s, numerous artists made studies of mission buildings as part of the general inventories of land and property in the territory that were made as part of the process of settlement. The first to execute a series of drawings of all the California missions was Edward Vischer, who worked on the project from 1861 to 1878. The state was flooded with aspiring artists during this period, attracted

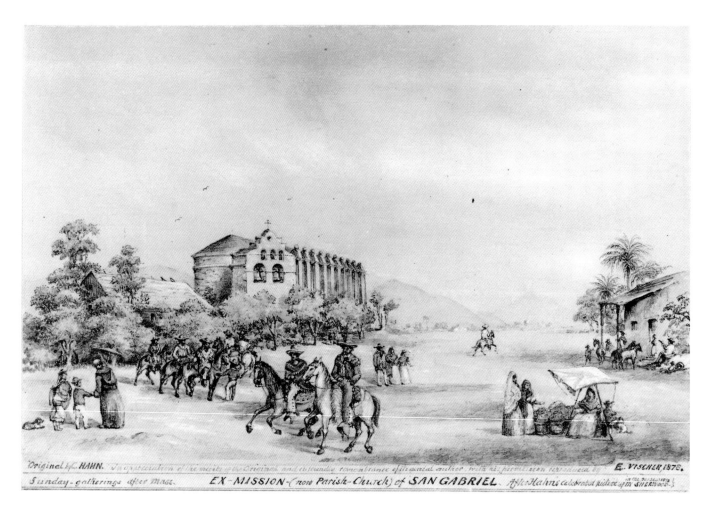

Fig. 15. Edward Vischer, Mission San Gabriel Arcangel, 1878. Watercolor drawing, 15 3/8 x 12 7/8 in. Bancroft Library, University of California, Berkeley. Vischer Bequest volume.

by the influx of Comstock silver money and, later, by the flush times that surrounded the construction of the transcontinental railroad. To sell their works in this competitive atmosphere, artists found it helpful to select a thematic niche for themselves. With still life, gold-rush history, and landscape scenes taken by noteworthy artists like Samuel Marsden Brookes, Charles Nahl, and William Keith, Vischer settled for the missions—a less desirable, but conveniently well-defined, topic. He sold his mission drawings as a series, bound in albums offered to customers as elegant mementos of a California sojourn and, in his own words, as "antiquarian christmas offerings." Vischer's thorough but abbreviated approach to the subject well suited the format of the souvenir album. Admitting that his views were "more painstaking than artistic," he usually pictured the missions from a distance, sketching out the main elements and adding pertinent details. Though Vischer enlivened his portrayals with imaginative figures in Spanish dress, horses, and cattle, he remained faithful to the often uninteresting forms of the ruined buildings (fig. 15).

During the 1880s and 1890s, mission series began to appear with increasing frequency. Though these works often still appeared as collections in albums, their treatment of the subject was quite different from Visher's visual index. Artists and photographers of this period brought the viewer in direct contact with the old structures and lavished their attention on every crumbling brick and rotting beam. Abandoning the quest

for factual detail, they adopted the elegiac, poetic quality of paintings made by American artists in Italy a few decades earlier (fig. 16). Utilizing the same reverential tone for the moldering remains of mission churches that Thomas Cole, Jasper Cropsey, and others had employed in their representations of Roman ruins, these image makers invited viewers to equate California with the Old World and to see the missions, like the Colosseum

or the Athenian Acropolis, as the relics of a glorious past. Of course, artists and photographers had to be skilled in the use of chiaroscuro, the long-distance view, and muted light to allow viewers to make this visual connection (figs. 17–20). In the hands of the less adept, the dilapidated old buildings could present a difficult challenge (fig. 21).

By the mid-1880s, the mission had become a ubiquitous symbol of the Golden State, permeating all aspects of its culture and the ways in which that culture was represented to the rest of the country. Missions were an inevitable feature of tourist

Fig. 16. Jasper Cropsey, Evening at Paestum, 1856. Oil on board, 9 1/2 x 15 1/2 in. The Frances Lehman Loeb Art Center, Vassar College; gift of Matthew Vassar.

Fig. 17. Carleton E. Watkins, Mission San Jan Capistrano. View from the West, c. 1880. Albumen silver print, 14 15/16 x 21 1/4 in. Department of Special Collections, University Research Library, University of California, Los Angeles.

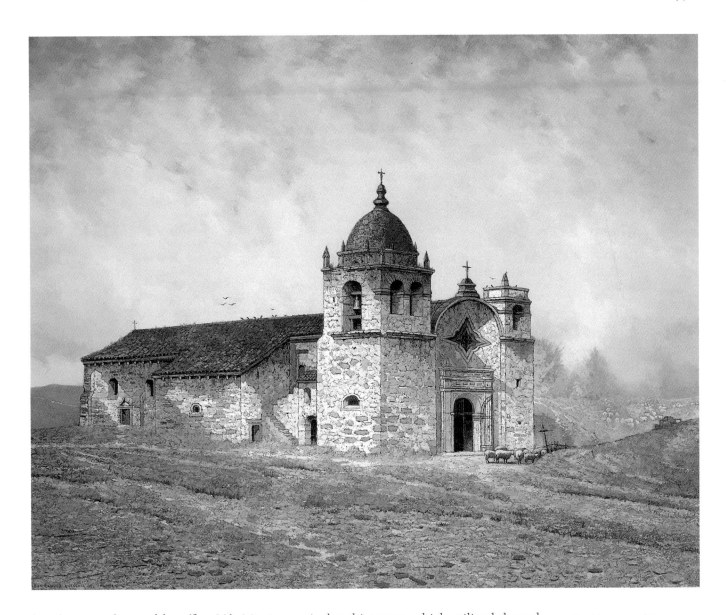

brochures and pamphlets (fig. 22). Mission revival architecture, which utilized the red-tile roofs and stucco walls of the Spanish churches, also became popular during this period, causing thousands of ersatz San Juan Capistranos and San Juan Bautistas to spring up across the state as office buildings, schools, homes, and hotels. The Mission Inn in Riverside was one of the more exuberant examples of this type. It hosted both President Roosevelt and President Taft in the early 1900s and contained various "authentic" Spanish features which delighted visitors, including the Cloister Wing, the Carmel Mission Wing, the Spanish Art Gallery, the Catacombs, the Music Room of the Spanish Renaissance, and the Alhambra Suite. Also remarkable for its use of mission motifs was the university built by Leland and Jane Stanford on their Palo Alto stock farm. With its tile roofs, central quadrangle, low sandstone buildings, and arched arcades, Stanford University was a Spanish dream village, brought to life by an infusion of young men and women who were the heirs of grand Spanish forebears. In Chicago,

Fig. 18. (previous page) Henry Chapman Ford, Mission San Carlos (Carmel), Interior from Entrance, 1881. Oil on canvas, approx. 28 x 22 1/2 in. The Historic Mission Inn Foundation and Museum, Riverside.

Fig. 19. (above) Edwin Deakin, Mission San Carlos Borromeo de Carmel, 1895. Oil on canvas, 50 x 60 in. Santa Barbara Mission Archive Library.

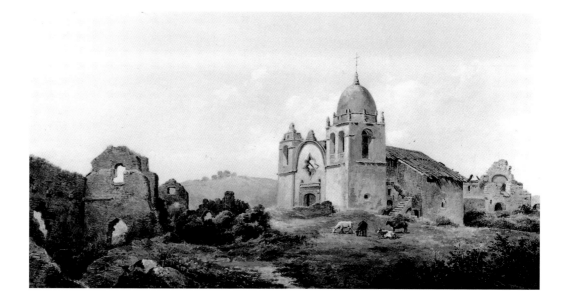

Fig. 20. Juan B. Wandesforde, Mission San Carlos Borromeo de Carmelo, 1880s. Oil on canvas, 20 x 36 in. Santa Barbara Historical Society; gift of Alexander James Campbell

Fig. 21. Unidentified photographer, Mission San Antonio, c. 1884. Photograph, approx. 8 x 10 in. University of Southern California, California Historical Society/Ticor Collection.

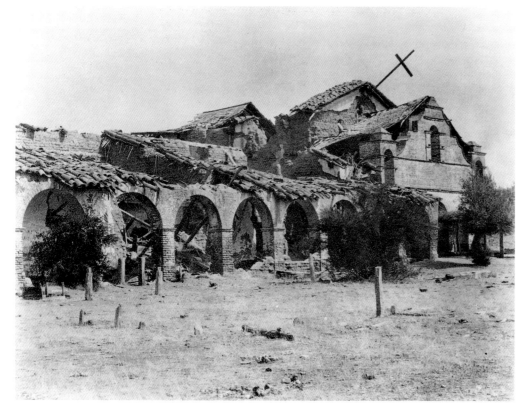

at the World's Columbian Exposition, local organizers relieved themselves of the impossible task of choosing which of the missions to copy by patterning each facade of the California Building after a different church (fig. 23).

Thanks to the efforts of artists, writers, architects, and local business leaders, by the end of the century the idea of California as America's little corner of the Old World was indelibly etched into the national consciousness. Once the establishment of the Spanish metaphor was no longer an end in itself, Latin themes could be used, not only to encourage tourism, but for other types of promotion as well. Scenes of old *rancho* days and portrayals of mission life, pinched and prodded over the years by image makers and their patrons until they evolved into all-purpose symbols of social harmony and goodness, ultimately became useful tools in the marketing of local products.

For those suffering from sore throats and bronchial irritations, California Mission Lozenges promised a speedy end to "disagreeable tickling sensations in the throat" (fig. 24). An

Fig. 22. Union Pacific Railroad Company, *California Calls You*, 1913. Promotional booklet, approx. 10 x 7 in. California State Railroad Museum, Sacramento.

Fig. 23. (top) C. D. Arnold, Exterior of
the California Building—Columbian
Exposition, 1893. Photograph, approx.
8 x 10 in. Chicago Public Library,
Department of Special Collections.

Fig. 24. (below) California Mission
Eucalyptus Lozenges. From Land of
Sunshine (January 1897).

advertisement distributed by the Wireless Shop of Los Angeles promoted the company's
Perflex Radio with a picture of a tonsured Franciscan ringing a bell in the shaded court-
yard of San Gabriel Mission (fig. 25).[23] Across from the *padre*, a radio with a diamond-
shaped antenna sits atop an elegant table. A text explains the curious image:

> As the Mission Bell rung by the Padre of Old called the Indians to the Sanctity
> of their place of worship, so the modern clear toned Perflex Radio Receiver
> calls the family to the sanctity of the Home—and again the contrast of the

pure tones of Perflex Radio to the harshness of some receivers is as the comparison of the mellowness of the Mission bell to the blast of the automobile horn.

The two advertisements demonstrate how, facing the exigencies of the tourist trade and the quest for market share, California's developers moderated their traditional distaste for Hispanic culture and learned to celebrate the *cosas de España* as part of their efforts to stimulate the state's economy. Where Americans at midcentury had feared they would be infected with the "California Fever" of Hispanic laziness, they now could rely on Mission Lozenges to alleviate a variety of ailments. Where settlers from the East had lamented that the Mexican Californian's lack of industry was incompatible with progress, the symbols of Spanish California were now adopted as guarantees of quality and fine workmanship for mass-produced merchandise. Thanks to the campaign of

images and writings that had been disseminated across the country by the Southern Pacific and other businesses, by the early twentieth century the indolent and potentially violent "Joaquíns" of earlier days had been replaced by men of the cloth ready to ring in the new era. The Padre of Old also tolled the bell to mark the passing of the old-time recklessness and abandon, which had been distilled, like the finest of the California vintages, into "mellowness" and "Sanctity." Through the blending of Yankee technological know-how with Old World gentility, as represented by the Perflex radio at the heart of the mission courtyard, California seemed at last to have become the Pacific Arcadia that Richard Henry Dana envisioned almost one hundred years earlier from the deck of the tallow ship *Pilgrim*.

6

Urban Visions

It is an odd thing, but anyone who disappears is said to be seen in San Francisco. It must be a delightful city and possess all the attractions of the next world.

—OSCAR WILDE, 1882[1]

While railroad companies, bankers, and merchants disseminated pictures that promoted California as a land ideally suited for tourism, they also called attention to the verso of images of leisure with paintings, lithographs, and photographs of busy city life in San Francisco, the largest urban center in the West. The expectations that had been engendered by representations of comfortable excursions to the missions and the

Sierra, as well as by those of successful gold-rush miners, mammoth cabbages, and docile native laborers, were symbolically fulfilled in images that showed San Francisco as a world-class metropolis. City views that identified San Francisco with economic success, social refinement, and advanced technology provided a sense of the accessibility of the state's resources, as well as its scenic pleasures, by visualizing the social and economic infrastructure that allowed the region's vast abundance to be converted into something the average citizen could obtain or view. Pictures of stately neoclassical banks, the Nob Hill mansions of the city's elite, streets filled with shops, and panoramas showing that the urban network extended almost as far as the eye could see communicated to investors, vacationers, and prospective immigrants that California had opened its doors for business and was ready to deliver everything that had been promised to its customers (fig. 1).

In defining San Franciso for those in the East, local developers addressed American audiences for whom a distaste for city life traditionally had been thought of as something of a patriotic duty. During the eighteenth century, religious and political leaders customarily described the metropolis as a hungry parasite, siphoning off the fruits of yeoman farmers' honest labor to agents, middlemen, and others of questionable moral character who made up the urban population. Benjamin Franklin expressed this idea in a letter of 1784: "The People of the Trading Towns may be rich and luxurious," he wrote. Nevertheless, "the Country possesses all the Virtues that tend to private Happiness and public Prosperity."[2] By the middle of the nineteenth century, however, attitudes about the source of "public Prosperity" and the unhealthy relationship between rural areas and

Fig. 1. Raymond Dabb Yelland, Cities of the Golden Gate, 1893. Oil on canvas, 55 x 96 1/2 in. Berkeley Art Museum, University of California; gift of the artist. Photograph by Benjamin Blackwell.

the city began to shift. While contemporary images and writings paid lip service to the dignity and importance of the agrarian lifestyle, these nostalgic representations seemed only to confirm its subordination to other forces. With the national economy increasingly dependent on financial and commercial ventures located in the city, and on the labor of urban wage earners, the image of the independent farmer as the power behind the metropolis ceased to resonate for the majority of Americans. "Our country has entered upon a stage of progress in which its welfare is to depend on the convenience, safety, order and economy of life in the great cities," declared Frederick Law Olmsted in 1877. "It cannot prosper independently of them; cannot gain in virtue, wisdom, comfort, except as they also advance."[3]

While the farmer became the object of sentimental yearnings for days gone by, it was the city that came to be thought of as the locus of production, power, and autonomy. Because of its role in transforming raw materials into usable products and distributing them to the populace, the city came to be understood as the force that put bread on the tables of American families and clothes on their backs. In addition, the strategic cultural, political, and financial institutions centered in metropolitan areas were seen as providing not only the organization that designated where resources were to go but also the impetus ensuring that the transfer of assets would take place quickly and efficiently. Though Americans complained about the adverse effects of metropolitan life, during the second half of the nineteenth century they came to believe in increasing numbers that the city was the dynamo that energized the country, the pulsating heart that circulated its resources to a nation of wage earners.

Pictures of San Francisco addressed these changing attitudes toward the city and, during the second half of the nineteenth century, underwent several shifts in focus to suit the tastes of viewers around the nation, as well as the needs of the patrons who sponsored them. Images from the gold-rush years through the 1860s seemed intent on quantifying the city's assets, in terms of the number of shops, churches, and government buildings, the quantity of ships in the harbor, and the acres of developed real estate. Such visual inventories, the meat and potatoes of local chambers of commerce and land companies, were characterized by their frankly promotional point of view. The pictures, which were mostly photographic works and lithographs published as letter sheets and illustrations in booster publications, laid out the facts for immigrants, prospective investors, and the merely curious, with the remarkable accomplishments of the city's builders standing in for refinement of design or painterly technique. The small business owners who were the sponsors, as well as the unseen subjects, of such images, had little interest in nuance or embellishments that might interfere with viewers' ability to consider the resources displayed (fig. 2).

Though visual inventories continued to be produced through the turn of the century, by the 1870s they were eclipsed by the more polished contributions of academically trained artists, who arrived in large numbers during this period as part of the economic effervescence surrounding the construction of the transcontinental railroad. These artists were patronized by railroad tycoons, silver kings, bank presidents, and other wealthy residents who made up the city's new elite. San Francisco appeared in the works of these artists as the Paris of the Pacific, the London of the Lower Forty—complete with gay boulevard life, exotic foreign quarters, and delicate fogs that softened the contours of buildings and busy thoroughfares. The idea of the efficient infrastructure that governed the operations of such a city was discreetly implied in such works,

leaving the explicit enumeration of mundane municipal details to the less adept. Still, the assertions made in these paintings were the same as those of earlier and less urbane prints and photographs—that San Francisco offered unique opportunities for financial success and a congenial environment for the newly well-to-do (fig. 3).

As the century drew to a close, pictures of San Francisco acquired a dreamy, utopian quality. Inspired by the dawning of a new age, as well as by recollections of the aspirations that first brought white settlers to El Dorado fifty years earlier, image makers and their patrons abandoned themselves to fantasy in their interpretations of the city by the Golden Gate (fig. 4). The great earthquake and fire that devastated San Francisco in April 1906, rather than dampening the high spirits of local visionaries, seemed to ignite an even greater fervor for the image of the ideal metropolis. With the slate of the city's varied imperfections wiped clean by widespread destruction, artists directed viewers around the nation to the "spectacular" San Francisco that could be. Gathering all the promotional skills they had mastered during the previous fifty years—in their campaigns to camouflage the anarchy of the gold-rush years, to sell desert land for farming, and to entice middle-class vacationers three thousand miles across the continent—local developers set to work to ameliorate the American public's perception of the disaster.

Images of San Francisco first appeared in significant numbers during the gold-rush years, when eastern newspapers and promotional literature from California were filled with reports of the city's phenomenal growth. Bayard Taylor, the correspondent for the *New York Tribune*, described San Francisco's rapid development in breathless terms:

> Of all the marvelous phases of the present, the growth of San Francisco is the one which will most tax the belief of the Future. Its parallel was never known, and shall never be beheld again. I speak only of what I saw with my own eyes.

Fig. 2. Unidentified artist, San Francisco, 1852. Lithograph/pictorial letter sheet, 8 1/4 x 10 5/8 in. California Historical Society, San Francisco. Photograph by M. Lee Fatherree

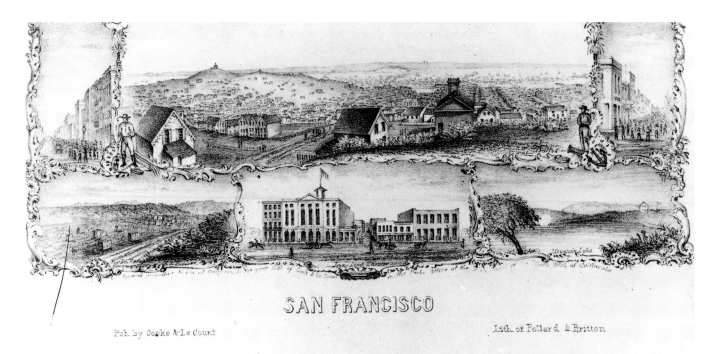

SAN FRANCISCO

Pub. by Cooke & Le Count Lith. of Pollard & Britton

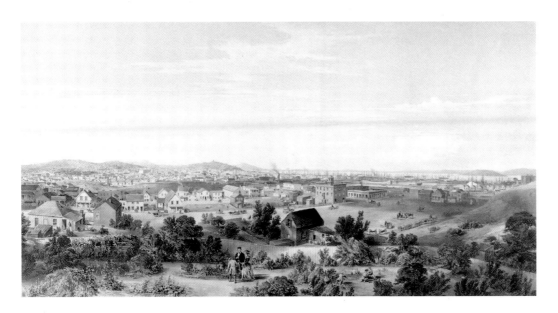

Fig. 3. (left) F. N. M. D. Otis, San Francisco from Rincon Point, 1855. Lithograph, 26 1/4 x 45 1/16 in. California Historical Society, San Francisco.

Fig. 4. (below) Arthur Mathews, The City, n.d. Watercolor and pencil on paper, 27 7/8 x 21 7/8 in. Santa Barbara Museum of Art; gift of Harold Wagner.

When I landed there, a little more than four months before, I found a scattering of town tents and canvas houses, with a show of frame buildings on one or two streets, and a population of about six thousand. Now, on my last visit, I saw around me an actual metropolis, displaying street after street of well-built edifices, filled with an active and enterprising people, and exhibiting every mark of permanent commercial prosperity....Now lofty hotels, gaudy with verandas and balconies, were met with in all quarters, furnished with home luxury, and aristocratic restaurants presented their long bills of fare, rich with the choicest technicalities of French cuisine....Like the magic seed of the Indian juggler, which grew, blossoms, and bore fruit before the eyes of his spectators, San Francisco seemed to have accomplished in a day the growth of half a century.[4]

In their efforts to communicate the miraculous progress taking place at the heart of El Dorado, image makers at midcentury relied on viewers' familiarity with accounts like Taylor's since, without such information, the scenes of San Francisco they created would have been

largely indistinguishable from pictures of any number of American cities. As it was, because of the fame of the gold rush, artists and photographers were confident that the eyes of the nation were riveted to the western edge of the continent and were scanning constantly for any bit of news. On the other hand, those charged with describing San Francisco to outsiders felt keenly the responsibility of such intense scrutiny and, in their self-consciousness, fell back on highly conventional formats to visualize the city. In attempting to convey the extraordinary quality of events in San Francisco, artists utilized long-distance and bird's-eye views, which had been used by American engravers since the eighteenth century to organize the jumble of streets and edifices that made up Boston, New York, and other eastern cities. The remote perspective allowed image makers to call attention to San Francisco's expanding contours while avoiding the unflattering aspects of unfinished construction, unregulated growth, and, sometimes, a minimum of artistic talent. If such views tended to have a generic, standardized quality, this was precisely the point. The predictable format, with its allusions to the proud metropolises of the Eastern Seaboard, addressed concerns about San Francisco's chaotic rise and the kind of society that made up its population.

Certainly, due to the critical reports of returning argonauts and journalists, Americans in the rest of the country viewed gold-rush San Francisco as a hotbed of vice

Fig. 5. Unidentified artist, Map of San Francisco, California, c. 1853. Lithograph/pictorial letter sheet. California Historical Society, San Francisco.

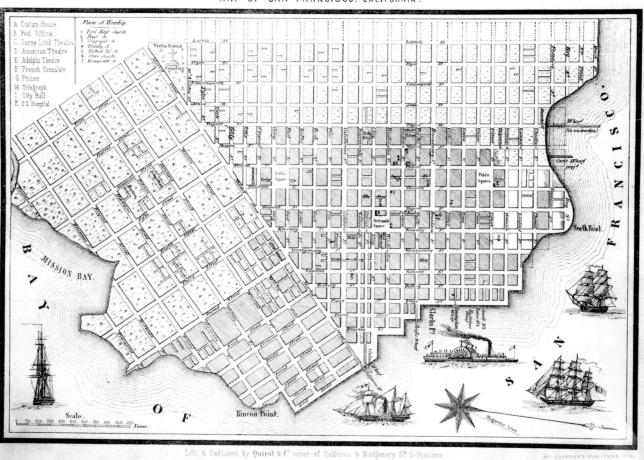

MAP OF SAN-FRANCISCO. CALIFORNIA.

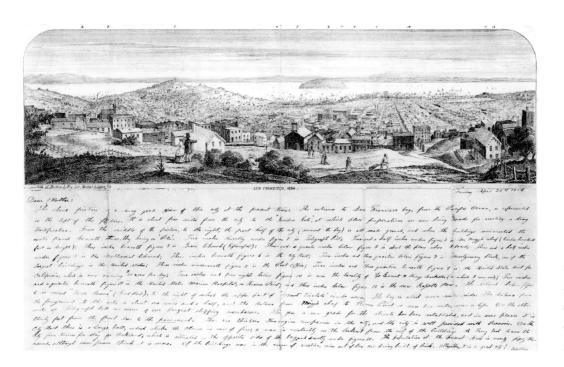

Fig. 6. Unidentified artist, San Francisco, 1854. 1854. Lithograph/pictorial letter sheet, 10 1/2 x 16 1/2 in. California Historical Society, San Francisco.

and crime. "A perpetual carnival reigns," wrote one visitor in the 1850s, who was "sure that no other city contains so many rogues and cutthroats."[5] With a population of twenty-five thousand, gold-rush San Francisco featured nearly one thousand gambling halls and saloons and averaged two murders per day.[6] Furthermore, it was well known that men were not the only ones involved in the general wickedness. A gold seeker described the depths to which one member of the fair sex had fallen in the dens of the Barbary Coast: "Abandoned women visit these places openly," he confided. "I saw one the other evening sitting quietly at the Monte Table, dressed in white pants, blue coat, and cloth cap, curls dangling over her cheeks, cigar in her mouth and a glass of punch at her side. She handled a pile of doubloons with her blue kid gloved hands, and bet most boldly."[7]

Long-distance views allowed promoters to pull back to a safe distance from the appalling profligacy of the Barbary Coast. These images were often published as letter sheets that visitors and settlers sent back to relatives in the East. In this way, conscientious sons writing home to their mothers, fathers, and grandparents were enlisted as the guarantors of the idealized image of San Francisco appearing at the top of the letter sheet. Accompanied by the friendly communication of the writer, such representations were assured a favorable reception in countless American households (figs. 5 and 6). Distant views of San Francisco also appeared in series of lithographs published by Britton and Rey, Currier and Ives, and other publishers, who sold them to subscribers for the reasonable amount of three to five dollars. During the second half of the century, Americans were avid buyers of prints of the nation's cities and proudly displayed this evidence of the nation's progress on the walls of their parlors, shops, and offices. With the image of San Francisco taking its place next to lithographs of Chicago, St. Louis, and Omaha, the issue of the city's strange and not altogether respectable genesis as an offshoot of gold fever in California receded into the background.

In creating appropriate images of the city, developers grappled with the problem that, after the first heady years of the gold rush, hyperbolic claims about the new El

Dorado led easterners to consider any information on California with a high degree of skepticism. In this context, the photograph, which American viewers generally accepted as an indisputable source of visual truth, represented the most effective medium to introduce San Francisco to distrustful audiences. San Francisco became the most photographed city in the United States during the second half of the century, a testament to the irrepressible curiosity about the strange new territory, as well as developers' dogged efforts to advertise local real estate.[8] Railroad companies, merchants, and newspaper editors hurried to take advantage of the national interest focused on the Pacific by supplying a constant flow of photographic images of the city, which were displayed in the galleries of the East and made up into promotional albums for distribution to prospective investors. A typical example of this type of production is the *San Francisco Album* made in 1856 by G. R. Fardon, an English-born photographer who came to the city in 1849. Along with lawyers, carpenters, and undertakers, daguerreotypists like Fardon found that the region offered rich opportunities for hardworking newcomers, even when the easy pickings of placer mining had played themselves out.[9]

 The creation of an entire series of photographic city views was an expensive and unusual undertaking at this time; there were no other published examples for any contemporary American city.[10] The scope of the project required that numerous patrons contribute to cover the costs. The names of various establishments, which are clearly legible in the album, identify these sponsors and clarify the interdependence of image makers and entrepreneurs trying to "make their pile" in California (fig. 7). McColgan and O'Kane Saddles and Harnesses, Mercer Wholesale and Retail Confectioner, and

Fig. 7. G. R. Fardon, Kearny Street, San Francisco, 1856. Albumenized salted-paper print, 6 3/8 x 8 1/16 in. International Museum of Photography, George Eastman House.

Ford Daguerrean Gallery are some of the businesses shown in Fardon's street scenes, interspersed between pictures of the post office, St. Mary's Cathedral, and the Orphans' Asylum. These are the small enterprises that made up the backbone of the Anglo-American community during the 1850s and that achieved a degree of immortality in Fardon's views. On the other hand, the punishment for those who did not ante up for the album is quickly obvious. The billboards announcing the names of their businesses remain indistinct and impossible to read—a curious effect when the lettering was obviously closer to the camera than signs farther away that showed up clear as a bell.

In any case, Fardon did his best to provide his clients with good value for their investment. The *San Francisco Album* allowed sponsors to promote their businesses directly, by providing a specific name for viewers to consider as they looked over the upstanding features of the community at large. To accent the aspects of San Francisco that patrons wanted to emphasize and eliminate items that did not show the city in its best light, Fardon used strategic cropping to produce the desired effect. Cropping was one way to deal with the problem of San Francisco's ramshackle appearance during the 1850s. Many of the buildings had been constructed by transient speculators who did not intend to stay in California, and who consequently were unwilling to invest a great deal of time or money on their lodgings or businesses. In addition, numerous devastating fires, caused in part by haphazard construction and poor municipal planning, had burned large sections of the city during the decade, resulting in a tangle of architectural styles and materials.

Predictably, Fardon's views focused on the fire-resistant masonry buildings that city leaders urged newcomers to build and blocked out nearby structures in wood—as well as the canvas tents, which were a common feature of the city during the 1850s. His photographs of the Custom House and St. Mary's Cathedral extracted the buildings from their murky surroundings, creating, in effect, a sterile field that eliminated outside contamination (figs. 8 and 9). Though a bit of background intrudes at the sides, the images set the viewer close-up and face to face with San Francisco's most pristine architectural specimens. The robust masonry walls and proud facades of the Custom House and the cathedral testify to the blooming health of the newborn metropolis. With

Fig. 8. G. R. Fardon. The Custom House, San Francisco, 1856. Albumenized salted-paper print, 6 3/8 x 8 1/16 in. International Museum of Photography, George Eastman House.

Fig. 9. G. R. Fardon, St. Mary's
Cathedral, San Francisco, 1856.
Albumenized salted-paper print, 6 1/4
x 8 in. International Museum of
Photography, George Eastman House.

Fardon's enthusiastic cropping preventing the eye from wandering farther afield, the idea of municipal stability, order, and continuity prevails. It is only on closer inspection of the minor details of the photographs that the seams of the construction become apparent.

The unpaved dirt that appears abruptly at the bottom of the Custom House steps alerts viewers to basic urban amenities that were absent in San Francisco. In fact, the city's unpaved streets were a much-lamented feature of life on the Pacific, and one with which eastern audiences were widely familiar, thanks to accounts in newspapers and popular magazines. Bayard Taylor described for his readers the abominable mud that residents had to confront each time they left their doors. "One could not walk any distance without getting at least ankle-deep, and although the thermometer rarely sank below 50 degrees, it was impossible to stand for even a short time without a deathlike chill taking hold of the feet," he explained. "The universal custom of wearing the pantaloons inside the boots threatened to restore the knee-breeches of our grandfather's times.... The population seemed to be entirely composed of dismounted hussars."[11]

Frank Marryat, an English journalist who visited California during the gold rush, gave a similar account of the terrible condition of the roads in his popular book of 1855, *Mountains and Molehills*. "Owing to the peculiar soil of the place, the mud was unfathomable," he complained. "The streets were impassable to mules, for there were mudholes large enough to drown them; in those streets which had been connected by means of a pathway of bales of damaged merchandise, it was necessary to exercise great caution in crossing, for one false step would precipitate the unwary passenger into a slough on either side in which he stood a chance of meeting a muddy grave."[12] Marryat includ-

ed a tinted sketch to give readers a better idea of the situation, which showed how belea-
guered San Franciscans coped with the murk (fig. 10). Dressed in the high boots that
Taylor had described, exasperated urbanites pick their way across one of the city's thor-
oughfares, as dogs, discarded crates, shoes, and other debris bob past them. In the mid-
dle of this primordial ooze, it is impossible for residents to retain even the semblance of
dignity. On the left, a bearded fellow with a miserable expression has taken to riding his
mule in a kneeling position to avoid drenching his boots. On the right, an elegantly
dressed gentleman helps a wary lady friend walk over boxes and boards while the view-
er awaits the "one false step" that will plunge her into the quagmire below. Only the pair
of rustics at the center appears unaware of the problem. They engage in a lively con-
versation in the middle of the traffic, without regard for water that swirls around their
legs or commotion that takes place around them. For those who planned to make their
homes permanently in California, then, resigned acceptance seemed to be the only way
to adapt to such conditions.

 Like Marryat's enthusiastic conversationalists, Fardon ignored the messy details of
life in San Francisco and carried out his photographic activities with a single-minded
attention to the business of promotion. His image of St. Mary's Cathedral, like that of
the Custom House, utilized tight cropping to excise undesirable elements, such as the
saloons that had proliferated in every corner of the city. Rescued from its questionable

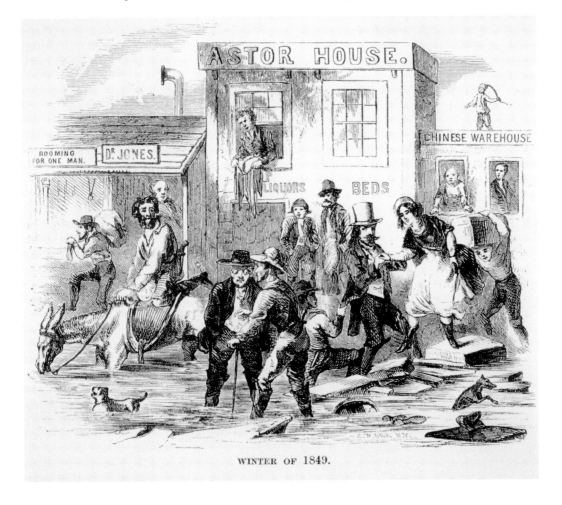

*Fig. 10. Frank Marryat, San Francisco
Street Life. From Marryat, Mountains
and Molehills (1855), facing 163.
Private collection.*

surroundings, St. Mary's floats in the virgin space provided by the limits of the camera lens, leaving the rest of bawdy San Francisco out of sight. With little else to distract the eye, the similarities between St. Mary's and churches like it across the country are allowed to assert themselves. There are the requisite arched Gothic doors and windows, with a suggestion of tracery at their edges. The central tower thrusts upward in a commanding way, though the absence of the clocks which would later be added to the circular compartments at the top gives the structure a forlorn aspect. Nevertheless, the crisply detailed brick construction affirms that the cathedral is all but finished, and that the foundations of righteous living in San Francisco have been laid.

The successful business owners for whom the *San Francisco Album* was produced considered the establishment of a Christian community to be of vital importance to their city. In his widely read history of California, Josiah Royce, a Harvard scholar and native of the state, affirmed that "there was from the first a characteristic American feeling prevalent that churches were a good and sober element in the social order, and that one wanted them to prosper, whether one took a private and personal interest in any of them or not."[13] The construction of a cathedral in San Francisco was thus a crucial undertaking in nurturing the correct social elements. In addition, the fact that St. Mary's parishioners were among "the wealthiest and most aristocratic" in the city made it a potent symbol of the city's prosperity and stability.[14]

Despite the directness of the image, the awkwardness of the cathedral's placement within the composition reveals the effort involved in presenting the building in its ideal aspect. Due to the difficulty of photographing the structure as a single subject, St. Mary's appears somewhat askew, teetering slightly as the surrounding landscape is squeezed out. One can deduce from this problem that there was no grand piazza or commons in front of the church that would have afforded the photographer the space to create a more harmonious view. The urban planning that caused Fardon's photograph of San Francisco's great cathedral to be constrained in such a way provides certain knowledge about the features of the city that are hidden from view and the priorities of those who had established its boundaries. Though the grid pattern of the city is invisible in the image, its effects are clearly pervasive. In 1847 an American engineer, Jasper O'Farrell, surveyed the city and divided the land into lots of 138 3/4 feet square, providing the structure for the area's first land boom.[15] The gridiron plan, the typical scheme for American cities during the nineteenth century, permitted real-estate speculators to maximize the value of their investments by eliminating the diagonal streets that created triangular and other odd-size land parcels. In addition, the idea of communal space used for parks and plazas, which reduced the amount of land available for exchange, did not hold much appeal for O'Farrell and the city builders who supported his design.

The authors of *The Annals of San Francisco*, a chronicle of the city published in 1855, reviewed the results of the gridiron plan. "The eye is wearied, and the imagination quite stupefied, in looking over the numberless square—all *square*—building blocks, and mathematically straight lines of streets, miles long, and every one crossing a host of others at right angles, stretching over sandy hill, chasm and plain, without the least regard to the natural inequalities of the ground," the writers lamented. "Not only is there not only any public park or garden, but there is not even a circus, oval, open terrace, broad avenue, or any ornamental line of street or building, or verdant space of any kind, other than the three or four small squares alluded to; and which every resident knows are by no means verdant, except in patches where stagnant water collects and ditch weeds grow."[16]

For the landowners who hoped to increase the value of their holdings by promoting San Francisco through Fardon's album, the photograph of St. Mary's must have been something of a disappointment, since the image made painfully clear the unhappy consequences of the O'Farrell plan. Pinched by the size of its own small lot and by other structures and streets laid out to optimize the profit-making potential of each square foot, the church rebelled. The photograph showed St. Mary's Cathedral, the focus of the city's spiritual life and a centerpiece of merchant-class dreams of a Pacific Athens, tilting off its axis and refusing to fit completely into the picture. If this was an oblique warning to those who had skimped on the lot size of the Lord's House, however, it surely went unnoticed.

Of the thirty-three photographs in the *San Francisco Album*, Fardon's panoramic views of the city were the most effective at conveying the idea of a thriving metropolis.[17] Sweeping vistas did away with the details of street life which, in the case of San Francisco, tended to undermine the goals of the album's subscribers. The elevated perspective of such photographs placed viewers safely above the mud and substandard construction and revealed a broad expanse of man-made order. One of Fardon's panoramic vistas was taken from the top of Sacramento Street, with the thick line of this major municipal artery leading the eye directly to the busy harbor of San Francisco Bay (fig. 11). Here again, although the names of certain establishments are conspicuously legible, other, indistinct urban details blend into a kind of Morse code of light and dark rooftops and windows flowing down to meet the bay. Three longs and a short, two shorts and a long, the buildings flash out their message of industry to prospective investors. With ships from around the world lining up to take delivery of its products,

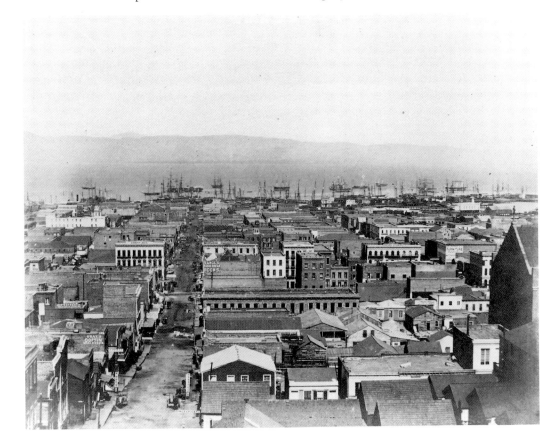

Fig. 11. G. R. Fardon, Sacramento Street, 1856. Albumenized salted-paper print, approx. 6 1/4 x 7 7/8 in. International Museum of Photography, George Eastman House.

and an efficient infrastructure alluded to by the neat geometry of the city plan, San Francisco was revealed as a place where enterprising newcomers could realize their dreams of commercial success.

Of course, Fardon's panoramic cityscape turned away from the series of problems that challenged municipal authorities during the 1850s. From 1849 to 1851, there were six major fires in the city, each of which burned down most of the central commercial district.[18] The photograph also gave no hint of San Francisco's "general lawlessness," a serious defect that the merchant class regularly agonized over in contemporary newspaper editorials, government meetings, and private gatherings. Throughout the decade, business leaders believed that the city was poised on the brink of complete anarchy and that, without their immediate intervention, robberies, murders, public drunkenness, and lewd behavior would soon drive away respectable society. They maintained that the problem was beyond the scope of the local police force, and that civic well-being and a stable business environment depended on property owners taking matters into their own hands. Twice during the 1850s, the merchant class banded together in the largest vigilante movement to be formed in the United States to that time.[19] In 1851 they created the first Vigilance Committee for "the maintenance of the peace and good order of the society, and the preservation of the lives and property of the citizens of San Francisco." After a few hangings, the group was satisfied that they had accomplished their goals and disbanded. In 1856, galvanized by economic hard times and the street-side shooting of the editor of the *Daily Evening Bulletin*, the committee reorganized and once again patroled the streets of the city.

It was not accidental, then, that the date of the creation of the *San Francisco Album*, 1856, coincided with the establishment of the second Vigilance Committee. The photographs were executed during the period when the merchant class was struggling to consolidate its control over a city they considered dangerously out of control. Seeming to shift into an indeterminate future, where the results of the committee's patrols were already visible, Fardon's album showed a San Francisco that was tranquil and well managed, with none of the unsavory characters that made up the city's famously raucous

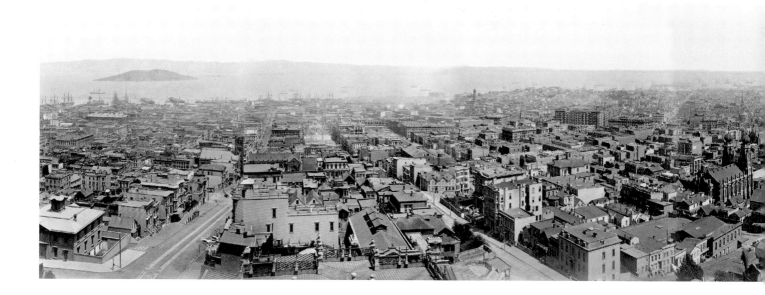

population visible on any of the streets. In fact, it was difficult to make out any kind of resident at all in most of the photographs. Taking no chances, Fardon had somehow managed to empty the streets of all potentially incriminating evidence, allowing viewers to project their own vision onto the vacant thoroughfares and to imaginatively populate the city with their personal interpretation of the ideal citizen.

The *San Francisco Album* was the first of many photographic inventories of San Francisco. From the 1850s throughout the latter part of the century, local photographers, including Robert Vance, Carleton Watkins, and William Shew, vied with one another in the production of imaginative and informative views of the city. Those who were particularly ambitious experimented with multipanel photographs that provided a 360-degree vista. These panoramas, though tedious and time-consuming to create, were an ideal format to communicate the democratic character of the new Pacific metropolis. The camera scanned over the different components of the city with egalitarian impartiality, showing middle-class homes, crowded wharves, and sprawling warehouses without regard for function or status. Under the even gaze of the all-seeing lens, the disparate elements of the community were gathered up into an overarching vision of expansion and progress, twin screws that had propelled the development of the nation since its inception.

One of the most noteworthy panoramas was an eleven-panel work executed by Eadweard Muybridge in 1878. Muybridge's clients included many of San Francisco's most successful residents, and he made every effort to satisfy their desire for innovation. Muybridge was able to take advantage of his relationship with Mark Hopkins, one of the Big Four of the Central Pacific Railroad, to shoot his panorama from one of the towers that made up Hopkins's Transylvania-style mansion at the peak of Nob Hill. From this vantage point, the photographer produced thirteen exposures that made a visual sweep of the harbor and the city's residential and commercial sectors (figs. 12–14). The panorama showed San Francisco as the worthy heir of its eastern predecessors and as the tangible proof that the republican ideals of self-reliance and industry had been successfully transplanted to the Pacific. Furthermore, Muybridge's 360-degree view

Fig. 12–14. Eadweard Muybridge, Panorama of San Francisco, 1878. Thirteen mounted photographs, each 20 3/4 x 16 1/4 in. Stanford University Libraries, Department of Special Collections.

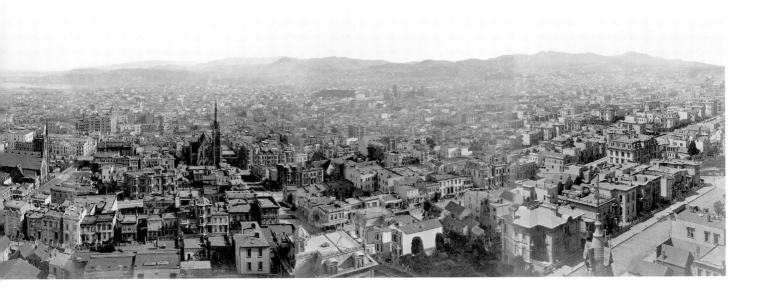

suggested that the prosperity generated by hard work extended to all parts of the metropolis—enveloping residents in a supportive network of commerce and communication.

Of course, on closer inspection, it was clear that some were more equal than others. Where portions of the city a half mile away from Hopkins's tower seemed to speed past in a rapid flow, the structures closer in slowed to a halt, inviting the viewer to take in every detail. This area of heightened visibility was Nob Hill, the elegant neighborhood where Leland Stanford, Collis Huntington, James Crocker, James Flood, and other elite Californians built their residences. The effect of perspective enhanced the already great size of the Nob Hill palaces and dwarfed the city hall, the federal mint, and the colossal Palace Hotel in the distance. In this way, the point of view of the panorama defined the center around which the rest of San Francisco made its orbit, circling the "representative men" who provided the organization and capital through which the mechanism of the metropolis, and in turn, of California at large, was driven.[20]

If Muybridge's photograph revealed worrisome disparities in the social order of San Francisco, it also defined the workings of economic power in ways that Americans would find to be sound. Significantly, the structure of the panorama, with peripheral elements radiating from a central hub, paralleled the much-publicized action of the Corliss double walking beam steam engine, the current technological darling of the nation. The Corliss engine had been introduced to the American public as the central attraction of the Philadelphia Centennial Exposition of 1876, two years before Muybridge made his panorama. Measuring 40 feet high and 56 feet across, the engine was set up in the middle of the 12-acre Machinery Hall at the exposition, where it towered over other displays and and attracted a continuous crowd of visitors (fig. 15). The machine weighed almost 680 tons and was the largest and most powerful engine that had been built to that time. Its cylinders were 44 inches in diameter with a 10-foot stroke and operated next to a flywheel 30 feet in diameter, which weighed 56 tons. Powered by the steam of 20 boilers outside the building, the wheel made 36 revolutions per minute, supplying the 1,400 horsepower needed to drive the 8,000 accessory, or "slave," apparatuses exhibited in the Machinery Hall, including power looms, printing

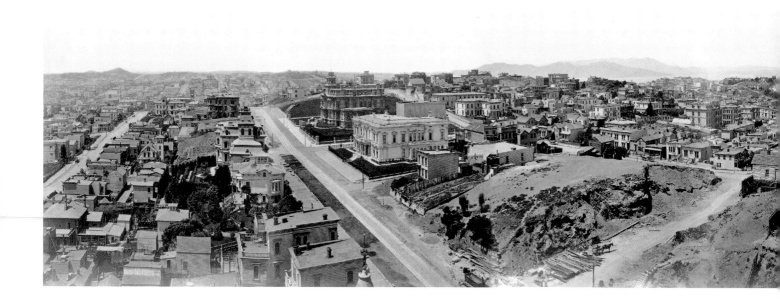

presses, lathes, pumps, tool-making machines, as well as milling and grinding machines.[21] Fairgoers were awed by this technological wonder, remarking on its "vast and almost silent grandeur" and its "unerring intelligence." Across the country, Americans expressed their admiration for the "beneficent Titan" in Philadelphia.[22] The *Atlantic* articulated the prevalent view when it described the machine as a portent of the future greatness of the United States. "Surely here, and not in literature, science, or art is the true evidence of man's creative power," the journal proclaimed. "Here is Prometheus unbound."[23]

Like the Corliss engine, the dynamic of efficiency embodied in Muybridge's photograph centered on a core of successful entrepreneurs, represented by the lavish homes in the foreground, and alluded to the initiative energies that powered accessory enterprises throughout the state. If this system appeared as something less than egalitarian, the higher good of productivity, the "Prometheus unbound," made the trade-off an equitable one—at least in the view of Muybridge's wealthy sponsors. In any case, the photographer himself was just one of many who depended on the trade provided by Hopkins and his neighbors. Muybridge, in turn, supplied his employers with the confirmation of their own authority. Mirroring the action of the Corliss flywheel, the panoramic image of San Francisco revolved around Muybridge's patrons, the "beneficent Titans" who animated the city below from the summit of their Nob Hill Olympus.

By the latter decades of the century, the panoramas and bird's-eye views that newcomers used to keep track of San Francisco's exponential expansion shifted from center stage. They were replaced by works that communicated the cosmopolitan sophistication of the maturing city. San Francisco in the 1870s boasted lavish theaters, a streetcar system, well-stocked libraries, several hospitals, a zoo, and a busy art academy full of

Fig. 15. Unidentified photographer, The Corliss Engine, c. 1876. Engraving. California Museum of Photography, University of California, Riverside.

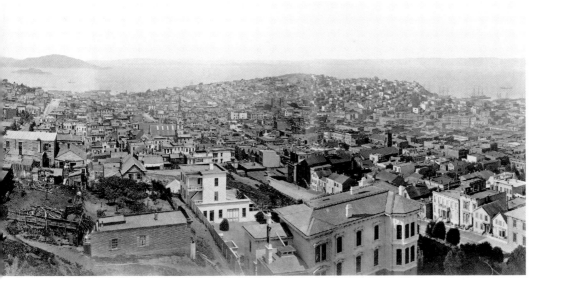

talented hopefuls—all the tangible manifestations of the Comstock silver money that poured into the pockets of local investors during this period. The city's progress encouraged patrons to seek a higher level of refinement in the pictures they bought or subsidized. In this context, with the foundation of San Francisco's municipal assets already communicated in letter sheets, newspaper illustrations, and promotional photographs, image makers began to focus on the city's picturesque features and its international atmosphere. This was the territory of academically trained artists, those who had studied in Paris or Düsseldorf and could tell at a glance the difference between burnt sienna and rusty ocher. Drawn by the new receptivity to the fine arts, artists from New York, Boston, and Europe immigrated to San Francisco, hoping to attract the patronage of a silver baron or a railroad magnate or two.

A painting of San Francisco after dark, *Howard Street, Evening*, executed by Fortunato Arriola in 1865, epitomized the change in attitude toward the city's streets and buildings (fig. 16). The function of the stately edifices that flank Howard Street— the Union Hall, the Howard Methodist Church, the Church of the Advent—is subordinated to the atmospheric effects of the twilight hours. An ethereal mist clings to the sidewalks and vehicles that pass by in the middle of the canvas. Disrupted only by the glimmer of streetlights, the fog gently erases the traces of workday concerns. The windows of shops and offices are closed for the night, and, indeed, the whole city seems to be suspended in a restful slumber. The painting encourages the viewer to dream as well, inviting comparisons with Regent Street, Piccadilly, and cobbled lanes meandering

Fig. 16. Fortunato Arriola, Howard Street, Evening, 1865. Oil on canvas, 18 x 24 in. Collection of Dr. Albert Shumate.

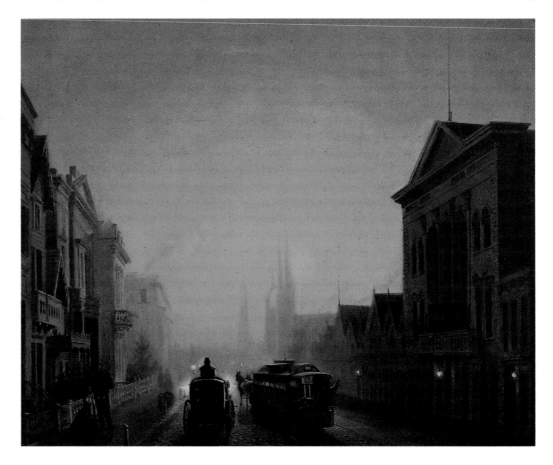

toward the Thames. Here, then, was the new San Francisco as the jewel of empire, awaiting the dawn of another prosperous day.

As part of the promotional work of making favorable comparisons between San Francisco and the major cities of the United States and Europe, images helped to apprise viewers of the ephemeral pleasures enjoyed by those living in or visiting California's largest metropolis. These included pictures of elegant couples entering the Tivoli Opera House, families admiring the menagerie at Woodward's Gardens, and gastronomes tucking into lavish dishes at local restaurants. San Francisco's epicurean delights, in particular—those offered in the "chop houses, coffee-houses, oyster 'grottos,' lunch rooms and restaurants in bewildering abundance in every street lane or alley"—were a source of great local pride and one that residents were eager to advertise to outsiders.[24] The Maison Dorée, Marchand's, and the Poodle Dog were just a few of the establishments extolled in local newspapers and journals as the equals of the finest restaurants in New York or Paris. The level of refinement of San Francisco's cuisine was the subject of a painting of 1874 by Joseph Harrington, *Jules Harder, First Chef of the Palace Hotel*. Chef Harder, his proud muttonchop whiskers hinting at other delectables still to come, holds out for the viewer's consideration a silver tray holding a langoustine in aspic, a crustacean extravaganza he may have perfected during his years at Delmonico's in New York (fig. 17). Set off against Harder's starched and immaculately white jacket, the complex surface of the mold glistens with portent. Eggs and olives swirl past, and a curiously expectant-looking langoustine crowns the creation. The tiny silver Excalibur that skewers the whole affair seems to symbolize Harder's power to vanquish the ennui of

Fig. 17. Joseph Harrington, Jules Harder, First Chef of the Palace Hotel, 1874. Oil on canvas, 36 x 29 in. Collection of the Oakland Museum of California; gift of Mrs. Donald Hewlett and Mr. George Clark in memory of George Casey Clark and Lydia J. Clark.

everyday eating and also served to notify viewers that the dark age of jerked beef and miners' stew was over in San Francisco.

If part of the campaign to promote the idea of San Francisco's maturity included allusions to the city's genteel society, as embodied by Jules Harder's exquisite gelatin composition, another segment was devoted to informing audiences about the city's international population. Though business leaders in the state would have preferred to ignore the issue, the fact that 49.3 percent of those living in the city in 1870 were foreign-born made the subject unavoidable.[25] An article on immigration in the distinguished literary journal *Overland Monthly* confessed to readers that "San Francisco is not an American city."[26] For Americans in the East, San Francisco's ethnic diversity was undoubtedly one of its most characteristic features, and one that raised serious questions about its long-term stability. State boosters would attempt to turn this liability into an asset by showing foreigners as both hardworking and picturesque. Such images addressed both the concerns of prospective immigrants as well as the interests of tourists whose excursions were becoming an increasingly important part of the economy.

In addition to the Hispanic Californians and Native Americans who had originally occupied the area, San Francisco had relatively large numbers of resident Irish, Italians, French, Germans, and Chileans. It was the Chinese, however, who represented both the most rapidly growing foreign population and the group whose culture was considered potentially the most dangerous to the Anglo-American community. Many Americans agreed with H. J. West, author of the xenophobic tract *The Chinese Invasion*, who claimed that immigrant Chinese remained loyal to the emperor and that their numbers in California represented an "advance guard of numberless legions that will, if no check is applied, one day overthrow the United States."[27] The number of Chinese in San Francisco, in fact, rose from 2,719 in 1860 to 12,022 in 1870. By 1880, the figure stood at 21,548, though white San Franciscans had already taken measures to restrict Chinese entry into the country and to limit their access to high-paying jobs and attractive neighborhoods.[28] Unemployed workers and disgruntled business owners banded together in 1862 to found the Anti-Coolie Club, which promoted anti-Chinese sentiment and encouraged discriminatory legislation. Over the next several decades, the organization played a significant role in attacks on individual Chinese and mob violence targeting the Chinese community.[29]

Anglo-Americans in San Francisco were forced to deal differently with the Chinese Question than they had in the goldfields or in the fields of the Central Valley. In the mines, the object of anti-Chinese activity was simply to eliminate Asian rivals for the precious ore and to prohibit them from working in the area. In the agricultural regions of the state, landowners moved the Chinese in at harvest time and moved them out when the job was finished. In San Francisco, however, the Chinese could be neither excluded nor rendered invisible. In 1870 they made up 11.5 percent of the city's population and 13.2 percent of its workforce, providing the essential labor for industries that had traditionally been starved for workers.[30] Consequently, those who promoted San Francisco were compelled to include the Chinese as part of their campaign and demonstrate to outsiders that the relationship between Chinese and Anglo-Americans in San Francisco was harmonious and mutually beneficial.

Pictures disseminated by civic leaders in San Francisco depicted the Chinese as intelligent, able-bodied, hardworking, and capable of providing the reasonably priced labor on which the continual expansion of the city depended. Such images were often

accompanied by narratives explaining that the Chinese, by virtue of living in the United States, would be exposed to the civilizing effects of American society. In 1875 a promotional book described the benefits to whites in terms of the city's development. "We cannot believe otherwise than that the Chinese in California have contributed largely to her prosperity," the author insisted. "There has been no class of people among the inhabitants more busily employed than the Chinese population."[31] In addition, the fact that Chinese in San Francisco were required by law to live in Chinatown and were barred from residing in any other part of the city provided additional reassurance for those newly acquainted with the community.

Lights and Shades in San Francisco, a booster history of San Francisco written by B. E. Lloyd and published in 1876, included several chapters devoted to the city's "Celestial" population. The chapters featured illustrations describing such subjects as the Chinese theater, Chinese religious practices, and the "Representative Chinese" that visitors might encounter on a visit to the Asian quarter (fig. 18). Rather than the slight-bodied, stooped, and squinting coolie of newspaper sketches, the pictures showed full-bodied Chinese whose presence was weighty with dignity. The carefully coiffed matron at the center holds a handkerchief with one hand and an elaborately dressed child with the other. Wearing thick bracelets on both wrists, hooped earrings, and a beaded necklace, she gazes out at the viewer with an equanimity that denotes her elevated status. The refined clothing of the man at the far left, presumably her husband, indicates that he is a successful merchant. He tucks his hands into his sleeves as he turns to address a worker who totes a basket of fish, the commodity that may be the source of the family's prosperity. The tall youth who stands on the right is probably the heir to his parents' lucrative business. In this way, the image communicated to readers the facts that the Chinese not only were strong laborers but also had the skill to initiate and manage enterprises that served the white population.

Significantly, Lloyd did not bother to synchronize his own narrative with the pictures of the representative Chinese that accompanied it. Oblivious to the evidence of Chinese fecundity presented in the illustration, the author dutifully acknowledged readers' fears of the "numberless legions" foretold by authorities on Asian immigration. Lloyd explained that the large majority of Chinese immigrants had not brought their wives or families to California. He remarked that "the persons who are strongly opposed to having the Chinese among us may be content...for according to the natural order of things they will soon become extinct, because of not having the propagating element among them."[32] The laughable contradiction between the words and the image reflects the highly ambivalent attitude of those charged with promoting the

Fig. 18. Unidentified artist, Representative Chinese. From Lloyd, Lights and Shades in San Francisco (1876), facing 218. Private collection.

REPRESENTATIVE CHINESE.

virtues of the Chinese population. Another author revealed the crux of the problem more openly: "Those who have mingled with 'celestials' have commonly felt before long an uncontrollable sort of loathing against them."[33] Inevitably, as racial hatred and the desire to market the city to outsiders became uncomfortable bedfellows, contradictions of this sort were a common feature of the promotional campaign. Only the anti-coolie groups, however, could afford to express their animosities openly (fig. 19).

By the 1880s and 1890s, Chinatown had become one of the most popular genre subjects for image makers in San Francisco. The passage of the Chinese Exclusion Act by Congress in 1882, which prohibited the immigration of Chinese to the United States, may have played a role in the growing popularity of the theme. Certainly, the Exclusion Act, which was ratified at the insistence of the legislature's California members, helped to imbue otherwise unremarkable representations of Chinatown with an attractive ephemeral quality and convinced buyers that the supply of such pictures had been limited, in effect, by federal decree. One of the most noteworthy artists to specialize in Chinese subjects was Theodore Wores, a former student of Frank Duveneck, who painted scenes of Chinatown that focused on costume, flowers, food, and the colorful bric-a-brac sold by local vendors (figs. 20 and 21). Wores included a wide range of Chinese society in his studies, from wealthy merchants and elderly scholars to fishermen and

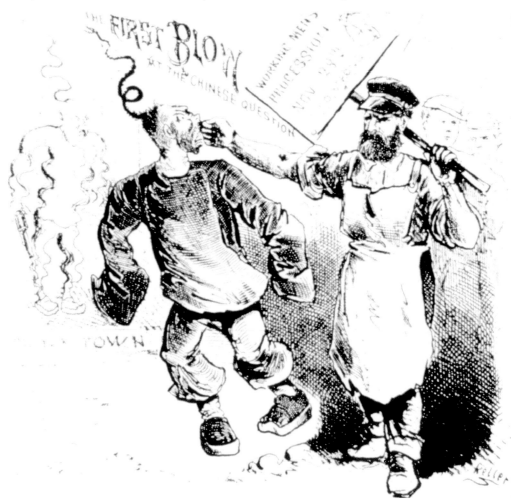

Fig. 19. R. Reller, The First Blow. From
The San Francisco Illustrated Wasp
(December 8, 1877): 1.

Fig. 20. (left) Theodore Wores, New Year's Day in San Francisco's Chinatown, 1881. Oil on canvas, 29 x 22 in. Collection of Dr. A. Jess Shenson.

Fig. 21. (below) Theodore Wores, San Francisco Chinese Maiden, c. 1881–82. Oil on board, approx. 16 x 12 in. Collection of Dr. A. Jess Shenson.

itinerant peddlers, providing viewers with an introduction to the Asian microcosm which lay at their doorstep in San Francisco. Wores's high level of expertise and his attention to sensual detail—the stiffness of thickly embroidered silk brocades and the moist, taut surface of freshly caught fish—demonstrated that Chinatown subjects could be considered a worthy topic for serious artists and an excellent choice for connoisseurs with a taste for chinoiserie.

In the final decade of the century, Chinatown also became a popular venue for photographers hoping to capture picturesque curiosities. These works were often sold as stereographs that were disseminated around the country as part of the packages of "California Views" sold in photographers' salons or distributed free of charge by the makers of consumer products. Many of these showed elaborately costumed and formally posed Chinese, presenting them as typical residents of the Asian community. Others showed the businesses where hardworking Chinese made their livings, including restaurants where the daring could sample exotic delicacies like bird's-nest soup and fried shark fin (figs. 22 and 23).

Chinatown also provided the opportunity for

photographers to carve out a special niche for themselves. Arnold Genthe, for example—one of the city's most popular photographers at the turn of the century—established a nationwide reputation with his Chinatown portraits. A selection of these works was offered as a collection in a successful book published in 1908, *Pictures of Old Chinatown.* Predictably, the emphasis in these photographs was decidedly on the "old."

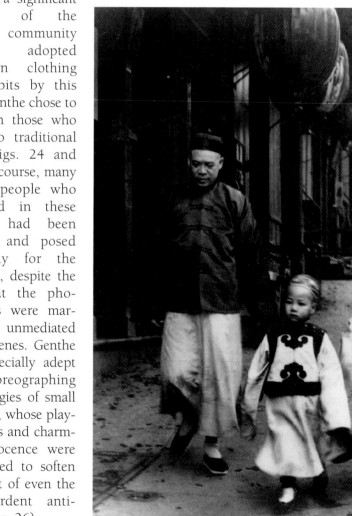

Though a significant portion of the Chinese community had adopted American clothing and habits by this time, Genthe chose to focus on those who clung to traditional ways (figs. 24 and 25). Of course, many of the people who appeared in these images had been dressed and posed especially for the occasion, despite the fact that the photographs were marketed as unmediated street scenes. Genthe was especially adept at choreographing the energies of small children, whose playful antics and charming innocence were guaranteed to soften the heart of even the most ardent anticoolie (fig. 26).

Fig. 22. (above, left) Isaiah Taber, Chinese Woman, c. 1880. Stereograph, approx. 3 x 5 in. Collection of Peter E. Palmquist.

Fig. 23. (above, right) Unidentified photographer, Chinese Restaurant, c. 1880. Stereograph, approx. 3 x 5 in. Collection of Peter E. Palmquist.

Fig. 24. (right) Arnold Genthe, Untitled (man and two children), 1900. Gelatin silver print, approx. 8 5/8 x 11 7/8 in. Fine Arts Museums of San Francisco, Achenbach Foundation for Graphic Arts, California Palace of the Legion of Honor purchase.

By the end of the century, civic leaders and the image makers they sponsored had honed the business of promoting San Francisco to a fine art. It was at this point that a great disaster struck the city. On April 18, 1906, a large earthquake, followed by a devastating fire, destroyed a major portion of the city.[34] The quake began at 5:13 in morning, as the stopped clock on the Ferry Building would show, and lasted for over a minute. The shock is estimated to have had a force of 8.25 on the Richter scale, which describes 8.0 as the level at which an earthquake causes severe damage to property and loss of life.[35] Along the San Andreas fault, the source

Fig. 25. (left) Arnold Genthe, New Chinatown Series: The Balloon Peddler, c. 1900. Gelatin silver print, 8 15/16 x 11 7/8 in. Fine Arts Museums of San Francisco, Achenbach Foundation for Graphic Arts, California Palace of the Legion of Honor purchase.

Fig. 26. (below) Arnold Genthe, Pigtail Parade, c. 1900. Gelatin silver print, 9 x 12 in. Fine Arts Museums of San Francisco, Achenbach Foundation for Graphic Arts, California Palace of the Legion of Honor purchase.

of the quake, the earth shifted horizontally an average of ten feet, severely affecting an area some 180 miles long and 40 miles wide.[36]

San Francisco residents' descriptions of the quake were published in newspapers across the country. Fred J. Hewitt, a reporter for the *San Francisco Examiner*, described his experience:

> It is impossible to judge the length of that shock. To me it seemed an eternity. I was thrown...on my back and the pavement pulsated like a living thing. Around me the huge buildings, looming up were terrible because of the queer dance they were performing, wobbled and veered.... The streetbeds heaved in frightful fashion. The earth rocked and then came the blow that wrecked San Francisco from the bay shore to the Ocean Beach and from the Golden Gate to the end of the peninsula.... Each and every person I saw was temporarily insane. Laughing idiots commented on the fun they were having. Terror marked other faces. Strong men bellowed like babies in their furor. No one knew which way to turn, when on all sides destruction stared them in the very eye.[37]

In the first minutes of the disaster, the dome and most of the roof of San Francisco City Hall collapsed. South of Market Street, in one of the city's most densely populated areas, almost all of the two- and three-story structures were severely damaged. Shortly afterward, the first plumes of smoke from a growing fire became visible over the city.[38] Caused by overturned stoves, fallen chimneys, and ruptured gas mains, the blaze began as fifty separate fires spread out over the city. These soon merged into one great conflagration that burned for three days and two nights, consuming almost the entire downtown business and industrial sections. Author Jack London, who watched the scene from across the bay, reported that "the smoke of San Francisco's burning was a lurid tower visible a hundred miles away. And for three days and nights this lurid tower swayed in the sky, reddening the sun, darkening the sky and filling the land with smoke."[39] Ultimately, 512 blocks, covering an area of 4.7 square miles, were leveled. 28,188 buildings were destroyed and, in the central portion of the city, not more than six structures were left habitable.[40] Though contemporary sources estimated the loss of life in the disaster to be about 450, more recent research indicates that the figure was closer to 2,500 and that property valued at $1 billion was destroyed.[41]

All in all, it was a bad week for the San Francisco Chamber of Commerce. Still, in planning a strategy to deal with the calamity, city and state authorities were able to utilize all the promotional skills that they had acquired in over half a century of marketing the Golden State to outsiders. In addition, San Francisco residents had dealt with earthquakes and fires in the past and drew on this experience to cope with the present disaster. During the 1850s, San Francisco suffered a series of six great fires and acquired a reputation around the country as a place that was continually going up in smoke. In almost every case, civic leaders insisted the fires had a salubrious effect on the evolution of the city. San Franciscans were conscious of the notorious image their city had in the minds of the eastern public, and the numerous fires helped them promote the idea of penitence and cleansing. Moreover, since loss of life was generally light, landowners were free to focus on the beneficial effects to property. They pointed out the improved construction that generally followed the disasters and the enhanced level of civic organization that resulted from the formation of fire brigades and agencies appointed to

enforce compliance with upgraded building codes, trash removal, and occupancy standards. Writing in the 1880s, the state historian Hubert Bancroft expressed the attitude toward the fires that had been prevalent since the 1850s: "One bitter fruit of the improvident haste of the city-builders was early forthcoming in a series of disastrous conflagrations, which stamped San Francisco as one of the most combustible of cities, the houses being as inflammable as the temper of the inhabitants," he reported. "Street preachers proclaimed the visitation to be a divine vengeance upon the godless revellers and gamblers of this second Sodom…[but] thus purified by misfortune, and by the weeding out of rookeries and much filth, the city rose more beautiful than ever from its ashes."[42]

In addition to having a constructive effect on local real estate, fires were a problem with which Americans across the nation had firsthand experience. Lexington and Pittsburgh endured numerous serious blazes during the early part of the century and, in 1835, New York City was the site of a large fire. Chicago burned repeatedly and, in 1871, was almost completely razed by the most destructive fire in the nation's history to that time.

Earthquakes, on the other hand, appeared to be a uniquely Californian phenomenon and were perceived by those in the East as yet another example of the Golden State's worrisome strangeness. Traditionally, local authorities, unable to find a parallel in American history that might help to put the geological disturbances in a positive perspective, responded by attempting to make the issue disappear. In 1860 a state history reported incorrectly that "no sizeable earthquake has ever been recorded north of the 35th parallel," or north of San Luis Obispo.[43] Describing a severe quake that had taken place in 1865, Bancroft dismissed it with the comment that it had "merely cracked a few weak walls."[44]

Others were less confident, however, including Mark Twain, whose account of the earthquake of 1865 was published in the *Golden Era* and subsequently in other journals around the country. The author supplemented his report on the tremor with an "Earthquake Almanac," which provided anxious California readers with a forecast of the various natural phenomena that could be expected to manifest themselves over the weeks following "The Great Quake of '65":

> Oct. 23: Mild, balmy earthquakes. Oct. 24: Shaky. Oct. 25: Occasional shakes, followed by light showers of bricks and plastering. N.B.—Stand from under. Oct. 26: Considerable atmospheric foolishness. About this time expect more earthquakes, but do not look out for them, on account of the bricks…Nov. 2: Spasmodic but exhilarating earthquakes, accompanied by occasional showers of rain, churches and things. Nov. 3: Make your will. Nov. 4: Sell out. Nov. 5: Select your "last words." Those of John Quincy Adams will do, with the addition of a syllable, thus: "This is the last of earthquakes." Nov. 6: Prepare to shed this mortal coil. Nov. 7: Shed. Nov. 8: The sun will rise as usual, perhaps; but if he does he will be staggered some to find nothing but a large round hole eight thousand miles in diameter in the place where he saw this world serenely spinning the day before.[45]

The frightening peculiarity of an earthquake, at which Twain had poked fun some forty years earlier in his "Almanac," led those who had invested heavily in California real estate to decide that, for publicity purposes, the earthquake of 1906 should be treated

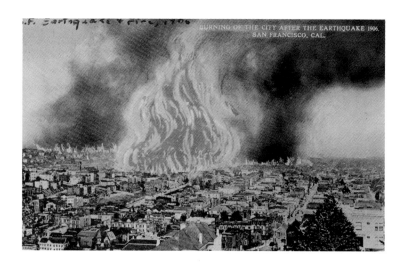

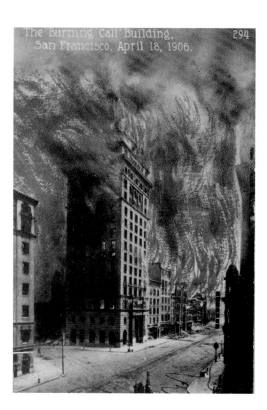

Fig. 27. (left top) Unidentified photographer, Burning of the City after the Earthquake, 1906, 1906. Postcard, approx. 3 x 5 in. San Francisco History Room, San Francisco Public Library.

as a minor occurrence and the fire blamed for most of the destruction in San Francisco. In their handling of the news on the fire, business leaders looked to Chicago as their model. The Great Chicago Fire of 1871 immolated the entire downtown portion of the city, representing almost $200 million in property damage. Close to three hundred people were killed and one hundred thousand were left homeless. Still, only one year after the fire, the Chicago *Lakeside Monthly* cheerfully reported that land values had risen so dramatically that what earlier had seemed "horrible" had ultimately proved to be "wonderful." The paper asked its

readers, "Was not the Great Fire a Blessing in disguise?"[46] Chicago responded with a resounding affirmative through the great Columbian Exposition of 1893, which replaced memories of the disaster with a dream city of white palaces and technological wonders. Awed by the marvels of the fair, Americans around the country applauded the new Chicago and its exposition as the embodiment of the nation's strength of character and its glorious transition into the twentiethcentury.

With the inspiration of Chicago ever present, civic authorities and business leaders in San Francisco set out to regain the carefully constructed public image of the city that had been lost. In this context, the first priority was to affirm that the fire

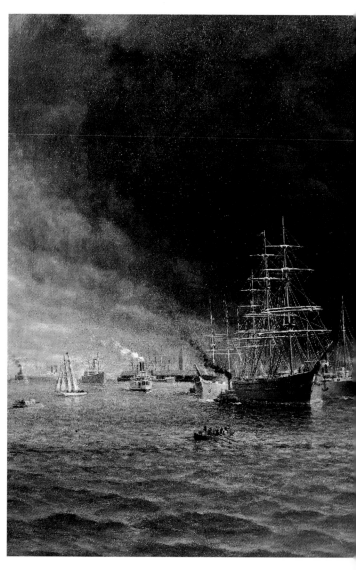

had caused the terrible damage to the city. Photographic postcards of San Francisco burning were a small but important tool in this campaign. With the photographic medium vouching for the truthfulness of pictures, the postcards included numerous additions that directed viewers' perception of the disaster. Studio alterations allowed smoldering earthquake rubble to be transformed into buildings consumed by flames, with red and yellow tinting added for dramatic effect. Such postcards, which were available at a reasonable price in shops throughout the city, quickly made their way to households across the country as San Franciscans rushed to tell grandparents, aunts, and uncles in the East they had survived. Curiously, the problem of blending such reassurances with the apocalyptic vision of horror on the reverse did not seem to affect the postcards' marketability (figs. 27 and 28).

San Francisco residents' valor in confronting the conflagration, an idea effectively implied by the melding of message and image in postcards of the city, was also the subject of a large painting by William Coulter: *San Francisco Burning, April 18, 1906.* The

Fig. 28. (left bottom) Unidentified photographer, The Burning "Call" Building, 1906. Postcard, approx. 3 x 5 in. San Francisco History Room, San Francisco Public Library.

Fig. 29. William A. Coulter, San Francisco Burning, April 18, 1906, 1907. Oil on canvas, 60 x 120 in. Collection of Thomas M. Siebel.

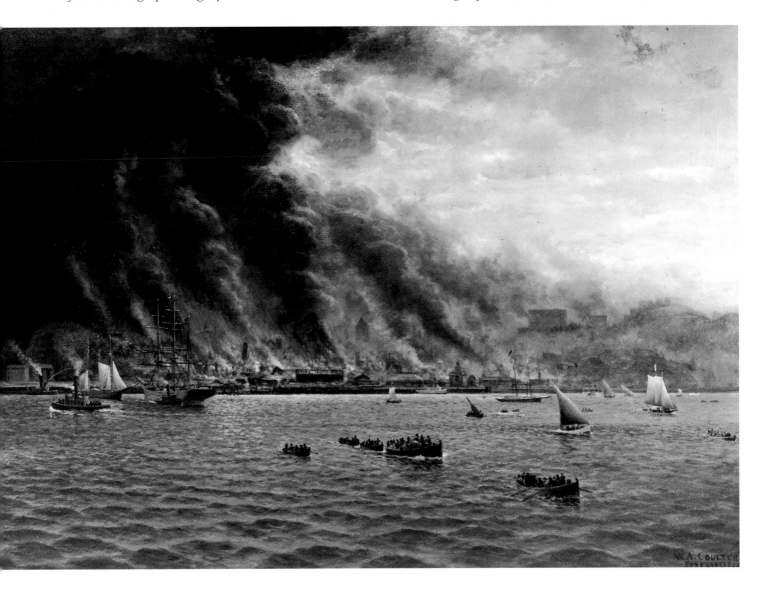

painting represented the catastrophe from a vantage point on the opposite side of the bay, conveniently distant from the evidence of earthquake-caused damage (fig. 29). San Francisco appears as a flaming band on the horizon, with the abundance of water around it a cruel counterpart to the great expanse of the fire. The harbor is flecked with different kinds of vessels—feluccas, pleasure yachts, schooners, tugboats, and dories—and contemporary audiences would have recognized the ships as the flotilla that rescued over thirty thousand people from the blaze. This operation, in which victims were ferried from the city docks to Sausalito, was celebrated in contemporary newspapers as the largest maritime rescue effort in the history of the United States.[47] The generous size of the painting, which measured five by ten feet, made it a suitable format for telling the tale of the heroes on the bay. In the setting of the great canvas, the rescue operation took on the aspect of the glorious naval battles of history—the Punic Wars, the defeat of the Spanish Armada, the Battle of Trafalgar. In addition, public recollection of the recent Spanish-American War of 1898, Teddy Roosevelt's "splendid little war" in which the United States claimed a new role as a world power, encouraged associations between the disaster in San Francisco and the triumphs that took place in the waters of the Caribbean and the Pacific.

Images not only called attention to the fire and the valiant response of city residents; they also were utilized to create a sense of detachment from the suffering by promoting an aestheticized interpretation of the ruins of San Francisco. During the previous years, local artists and photographers had perfected their technique in the portrayal of ruined buildings through representations of the dilapidated California missions. The practices utilized to imbue the old churches with an aura of mystery and romance—the unfocused lens, chiaroscuro lighting, and an impressionistic brushstroke—proved to be highly effective in interpreting the blasted landscape of San Francisco (figs. 30 and 31). Moreover, the fin-de-siècle melancholy that pervaded much art of the period made it easy to maneuver pictures of post-earthquake San Francisco into an already established genre of contemplative and introspective works.

An album of photographs and poetry published by Louis Stellmann in 1910, entitled *The Vanished Ruin Era: San Francisco's Classic Artistry of Ruin*, demonstrates how the city's wrecked buildings became the object of "artistic" reflections in

Fig. 30. (above, top) Theodore Wores, Ruins of City Hall after the Great Earthquake and Fire, 1908. Oil on canvas, 12 x 9 in. Iris & B. Gerald Cantor Center for Visual Arts at Stanford University; gift of Drs. Ben and A. Jess Shenson Collection.

Fig. 31. (previous page, bottom)
Arnold Genthe, Untitled (church arch,
probably old St. Mary's), c. 1906.
Photograph, 13 1/4 x 13 in. Fine Arts
Museums of San Francisco, Achenbach
Foundation for Graphic Arts.

Fig. 32. (previous page, right) Louis
Stellmann, The Vanished Ruin Era.
From The Vanished Ruin Era (1910),
cover. Private collection.

Fig. 33. (left) Louis Stellmann,
Strawberry Hill Conservatory. From
The Vanished Ruin Era (1910), 10.
Private collection.

Fig. 34. (below) Maynard Dixon, San
Francisco. From Sunset (June–July
1906): cover.

the years following the disaster. The book included a selection of photographs of the charred remains of the downtown area, set onto dusky brown paper that hinted at the torments of the "fire-ravished" city. In introducing these images, the author actually lamented the disappearance of the ruins of 1906, reminding readers that the tragedy had created "memories beautiful as well as awesome." Stellmann expounded on this idea with more than a hint of pyromaniacal enthusiasm: "Among [the photographs] are the pictures of that modern Acropolis which the Fire God created, that ephemeral and vanished ruin era which in its weird, flame-wrought transformation, made things of beauty out of hovels," he explained, "which carved shapes of classic dignity out of structural atrocities; which lent a touch of magical, if spurious, age-refinement to the fire-ravished areas, akin to the decadent and time-hallowed grandeur of Athens and Rome"[48] (figs. 32 and 33).

Stellmann's album supplied the sort of souvenir that disappointed tourists who came to San Francisco a few years after the disaster could take home with them as a consolation. Assured by information released by the state government and the railroad that it was safe to travel there, sightseers from across the country flocked to see the evidence of the disaster. The reconstruction of the city had

been so rapid, however, that visitors were denied the enjoyment of seeing with their own eyes the devastation that had been described endlessly in contemporary newspapers. Aside from a few unimpressive remnants, San Francisco had been almost completely rebuilt within a few years of the catastrophe, leaving only books like *The Vanished Ruin Era* for the enjoyment of curious spectators.

The cover of *Sunset* magazine for June and July 1906 represented the plan for the new metropolis initially espoused by the Southern Pacific Railroad—the publisher of the journal—and other powerful business interests. Embraced by an angel that materializes from the smoke of the conflagration, a new San Francisco, with great temples and neo-classical arcades, appears in the heavens (fig. 34). The image alludes to the ambitious proposal of Daniel Burnham, the architect of the Columbian Exposition in Chicago, for the reconstruction of San Francisco. Burnham's plan addressed the providential opportunity provided by the disaster to make important changes in the city's layout, replacing the grid plan with wide, curving boulevards better suited to the hilly terrain and creating a system of parks and plazas, the lack of which residents had lamented since the 1850s. As the details of the plan were laid out, however, and it was revealed that the property of many of the city's wealthiest residents, including that of M. H. de Young, publisher of the *San Francisco Chronicle*, would have to be condemned to make room for the changes, enthusiasm for the project shifted to vehement opposition. "The crying need of San Francisco today is not more parks and boulevards," the *Chronicle* told its readers. "It is business."[49] Consequently, unable to withstand the increasingly powerful opposition led by the paper, Burnham's visionary program was scrapped in favor of a more practical one. During the three years that followed the earthquake and fire, the city was hastily rebuilt, with no significant changes to its original grid pattern and with the frequently marginal quality of the new construction a concession to the exigencies of business.

Haunted, perhaps, by the golden opportunity that had eluded them, the Merchants' Association, the San Francisco Chamber of Commerce, the State Board of Trade, and the Manufacturers and Producers Association turned to another kind of city plan, one that would beautify San Francisco—at least temporarily—and refill its coffers at the same time. The projected metropolis would not be a city of bricks and marble but an ephemeral city of lathe frame and plaster construction, a micropolis of wonders and amusements—the "Jewel City" of the Panama-Pacific International Exposition of 1915

Fig. 35. Unidentified photographer, Panama-Pacific Exposition, 1915, 1915. Photograph, 8 x 46 5/8 in. San Francisco History Room, San Francisco Public Library.

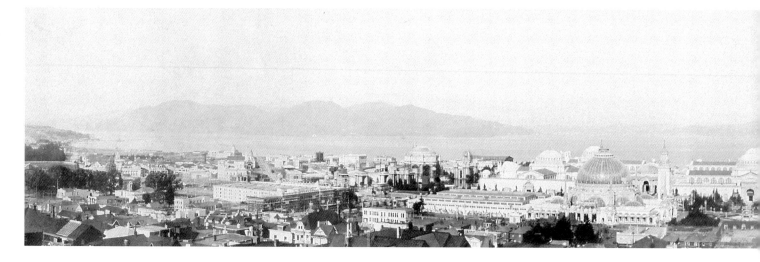

(fig. 35). An exposition was, of course, the final part of the equation through which San Francisco identified itself with Chicago. Planners hoped that a great fair celebrating the rebirth of the city, like the Columbian Exposition of 1893, would focus the attention of the nation on San Francisco's amazing resurgence and galvanize its commerce.

However, when the exposition board of governors committed themselves to the considerable expense of hosting an international exposition, it was clear that such a fair represented more than just the chance to show off the resuscitated San Francisco. The Panama-Pacific Exposition would allow all the promotional skills gained in the campaigns of earlier years to be called into play by publicizing, not only San Francisco's attractions, but the wonders of the Golden State in general. In return for an outlay of some $25 million, directors expected to receive "$50 million of judicious advertising...the gain in colonization...the number of new homes on the land, the added impetus to building."[50]

To achieve the highest order of magnificence in the exposition display, hundreds of specialists in painting, architecture, sculpture, music, woodworking, light display, choreography, landscaping, and costume were called to contribute their expertise. McKim, Mead and White, Bernard Maybeck, Ernest Coxhead, and other noteworthy architects worked on the layout of the fair and the features of individual structures. Jules Guérin, the celebrated French artist, created a jewel-toned color scheme for the buildings (fig. 36). Arthur and Lucia Mathews, Childe Hassam, and Frank Brangwyn contributed the murals that decorated the walls. The works of Daniel Chester French, Auguste Rodin, Gertrude Vanderbilt Whitney, Stirling Calder, and other sculptors graced the walkways and courtyards. Camille Saint-Saëns directed the exposition orchestra and composed a piece in honor of the state, which he titled *Hail California*. The synchronization of the myriad talents of these many contributors resulted in a multimedia extravaganza that many fairgoers would remember for the rest of their lives. The author William Saroyan, who visited the exposition as a child, described it as a fairyland of "shining, almost imaginary buildings full of unbelievable works of sculpture, paintings, weaving, basketmaking, products of agriculture, and all kinds of mechanical inventions...a place that couldn't possibly be real."[51]

Incorporated into the individual exhibits that made up the fair were reminders of all the promotional strategies that developers had used over the years to advertise the state. The California State Building, which covered more than five acres and cost over

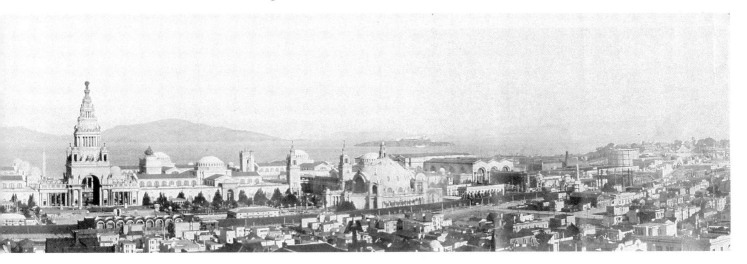

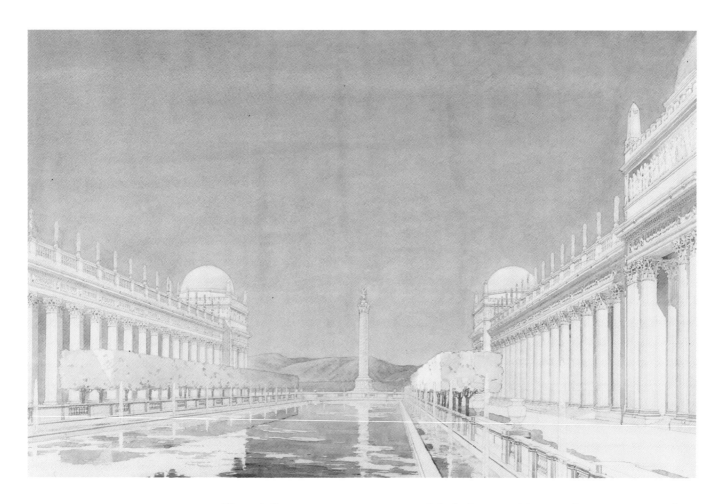

Fig. 36. Jules Guerin, Court Leading to the Column of Progress, 1912. Pencil and watercolor on paper, 37 x 50 in. San Francisco History Room, San Francisco Public Library.

two million dollars to construct, was modeled after an old Spanish mission, complete with multiple bell towers and a statue of Junípero Serra looking down from a niche on the facade. Paths nearby were covered with sand brought from the beaches next to the old *pueblo* of Monterey. The Southern Pacific Building duplicated famous excursion spots along the railroad route, allowing visitors to walk through dioramas of Yosemite, Lake Tahoe, and the Big Tree groves. In the Palace of Horticulture, Luther Burbank, the "wizard" of hybridization, stood by displays of potatoes and plums and passed out free packets of seeds for improved varieties of vegetables. In the Joy Zone of the exposition, fairgoers could mingle with rough-and-ready argonauts outfitted in red flannel shirts and denim pants and eat a meal from a tin plate in a forty-niners' camp.

In the middle of the central island of the fair, flanked by palaces, courtyards, and the great expanse of the bay, was the crowning glory of the exhibition: the 432-foot Tower of Jewels (fig. 37). Taller than the Arc de Triomphe in Paris, the structure was littered with golden statuary and topped with a radiant sphere that glowed after dark. This imposing ziggurat was hung with over 102,000 "Novagems," faceted and colored Bohemian glass jewels backed with mirrors and suspended from thin wires that allowed them to twist and spin in the constant breeze from the bay. The shimmering effect of the glass was enhanced by strategic lighting that swept the exposition at night. W. D'Arcy Ryan of General Electric, "the Alladin of the 1915 City Luminous," had devised a bat-

tery of forty-eight searchlights, which he called the "Scintillator" to create aurora-like colors in the sky above the exposition and to magnify the presence of the Tower of Jewels (fig. 38). One of the special effects that could be produced through Ryan's illumination was known as the Burning of the Tower, which symbolized the burning of San Francisco in 1906. Frank Morton Todd, the official historian of the fair, described the spectacle as a gorgeous display of colors sweeping through the air: "Concealed ruby lights, and pans of red fire behind the colonnades on the different galleries, seemed to turn the whole gigantic structure into a pyramid of incandescent metal, glowing toward white heat and about to melt," he wrote. "From the great vaulted base to the top of the sphere, it had the unstable effulgence of a charge in a furnace, and yet it did not melt, however much you expected it to."[52]

Fig. 37. Unidentified photographer, The Tower of Jewels. From Macomber, The Jewel City in Natural Colors (1915). Private collection.

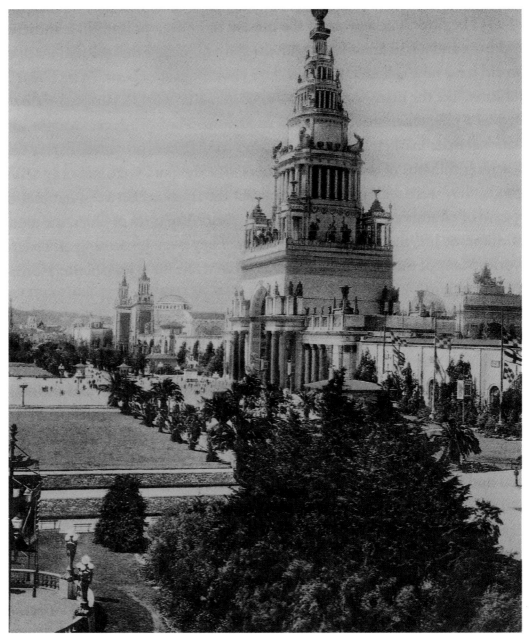

Through the visual magic of the exposition, the "lurid tower" of flame that Jack London had described in 1906 was transformed into the Tower of Jewels which, like the former, could be seen for miles around the bay. This scintillating spectacle replaced the horror of ten years earlier with a pyrotechnical simulation that took its place at the fair alongside the grand canvases at the Palace of Fine Arts, the technological wonders in the Machinery Hall, and the thrilling rides in the amusement zone. The idea of treasure and material abundance conveyed by the tower, with its golden decorations and gem-laden surface, also returned in a fitting way to the themes that

Fig. 38. Unidentified photographer, Night View of the Tower of Jewels. From Macomber, The Jewel City in Natural Colors (1915). Private collection.

had characterized representations of California since the arrival of the first Europeans four hundred years earlier. Like the auriferous wonders of Queen Calafia's realm sought by Spanish explorers, the precious nuggets that lone prospectors from across the country hoped to find, and bonanza harvests of wheat and oranges in the Central Valley, the Tower of Jewels renewed the promise of a golden California and brought that vision forward into the new century.

EPILOGUE

Despite the optimistic predictions of local boosters, the illustrious economic future of California was by no means apparent at the close of the nineteenth century. State population continued to increase at a modest rate during this period, and, though the economy was relatively stable, its measured growth continued to frustrate ambitious citizens. For Californians accustomed to the delight of gold-rush strikes, windfall profits in the wheat business, and the "sudden, monstrous growth" of urban areas, the lackluster performance of California commerce was a great disappointment. Still, though immigration and economic growth did not occur as speedily as nineteenth-century business leaders would have liked, the rapidly increasing number of new residents and the exponential rise in the state's productive capacity during the twentieth century proved that the promotional campaigns sponsored by early merchants, railroad owners, financiers, and real-estate speculators ultimately succeeded in establishing the Golden State as a land of infinite possibilities in the mind of the American public. The problem was simply that the change in attitude did not occur quickly enough. With their lavish investments in strategic sectors of the economy and their dissemination of alluring images of the state, nineteenth-century promoters had, in effect, planted a seed in the rich California soil. Though the resulting fruit did not mature until the middle of the next century, it ultimately attained the gargantuan proportions typical of California products. During the 1960s, California became the most populous state in the nation and was ranked first in

terms of agricultural and industrial production. At present, the state economy, if considered on a worldwide basis, stands twelfth in the value of international trade and sixth in gross national product. In addition, more than five hundred thousand newcomers come to settle in California each year. Nevertheless, the state's early developers did not, for the most part, survive to see their dreams of an overflowing California cornucopia come true. The full measure of the tremendous bounty generated by their efforts would be harvested by other entrepreneurs and other companies in another time.

NOTES

INTRODUCTION

1. *Ca-li-for-ni-ay*, music and lyrics by Jerome Kern, from the film *Can't Help Singing*, 1944.

2. "The Endangered Dream," *Time*, November 18 1991, 42.

CHAPTER ONE

1. Quoted in Arda M. Haenszel, "Visual Knowledge of California to 1700," *California Historical Quarterly* 36 (September 1957): 229-230.

2. Quoted in Dora Beale Polk, *The Island of California: A History of the Myth* (Spokane, Wash.: Clark, 1991), 124-125. Polk's book is a thorough investigation of early maps representing California as an island. Another excellent study of the history of an insular California is John Leighly, *California as an Island* (San Francisco: Book Club of California, 1972).

3. For more information on the Strait of Anián as it related to the island of California, see W. Michael Mathes, "Apocryphal Tales of the Island of California and the Straits of Anián," *California History* 62 (Spring 1983): 53.

4. Quoted in Polk, *The Island of California*, 291.

5. On Malaspina's voyage to California, see two books by Donald C. Cutter, *Malaspina in California* (San Francisco: John Howell Co., 1960); and *California in 1792: A Spanish Naval Visit* (Norman: University of Oklahoma Press, 1990).

6. David J. Weber's book, *The Spanish Frontier in North America* (New Haven, Conn.: Yale University Press, 1992), is an excellent history of the colonial structure in New Spain. On the *encomienda* system, see Lesley B. Simpson, *The Encomienda in New Spain: The Beginning of Spanish Mexico,* 2d ed. (Berkeley and Los Angeles: University of California Press, 1950).

7. Quoted in James J. Rawls, ed., *New Directions in California History: A Book of Readings* (New York: McGraw-Hill, 1988), 36.

8. On the Black Legend, see David J. Weber, "Scarce More than Apes: Historical Roots of Anglo-American Stereotypes of Mexicans," in David J. Weber, ed., *New Spain's Far Northern Frontier: Essays on Spain in the American West, 1540-1821,* ed. Weber (Dallas: Second Southern Methodist University Press, 1989); Phillip Wayne Powell, *Tree of Hate: Propaganda and Prejudices Affecting United States Relations with the Hispanic World* (New York: Basic Books, 1971); and Charles Gibson, ed., *The Black Legend: Anti-Spanish Attitudes in the Old World and the New* (New York: Harper and Row, 1971).

9. Quoted in James J. Rawls, *Indians of California: The Changing Image* (Norman: University of Oklahoma Press, 1984), 23.

10. For a description of California Indian populations and their environment at the time of Spanish settlement, see Rawls, *Indians of California,* 6-13.

11. On the ideology of Manifest Destiny, see Albert K. Weinberg, *Manifest Destiny: A Study of Nationalist Expansion in American History* (Chicago: University of Chicago Press, 1963); and Frederick Merck, *Manifest Destiny and Mission in American History: A Reinterpretation* (New York: Knopf, 1963).

12. Quoted in David Brion Davis, ed., *Antebellum American Culture: An Interpretive Anthology* (Lexington, Mass.: D. C. Heath and Co., 1979), 458.

13. Quoted in Lawrence Ferlinghetti and Nancy J. Peters, *Literary San Francisco: A Pictorial History from Its Beginnings to the Present Day* (San Francisco: City Lights Books, 1980), 14.

14. Robert Lucid, "*Two Years before the Mast* as Propaganda," *American Quarterly* 12 (Fall 1960): 392.

15. Richard Henry Dana, *Two Years before the Mast* (1840; rpt., London: Folio, 1986), 140.

16. For a history of the Californios, see Leonard Pitt, *The Decline of the Californios: A Social History of the Spanish-Speaking Californians, 1846-1890* (Berkeley and Los Angeles: University of California Press, 1966).

17. On the racial aspect of American expansionism, see Reginald Horsman, *Race and Manifest Destiny: The Origins of American Racial Anglo-Saxonism* (Cambridge, Mass.: Harvard University Press, 1981).

18. John F. Kasson discusses the role of technological advances in nineteenth-century American culture in his book, *Civilizing the Machine: Technology and Republican Values in America, 1776-1900* (New York: Penguin Books, 1976).

19. Quoted in Davis, *Antebellum American Culture,* 364.

20. Edwin Bryant, *What I Saw in California* (New York: Appleton Co., 1848; rpt., Lincoln: University of Nebraska Press, 1985), 308.

21. Alfred Robinson, *Life in California during a Residence of Several Years in That*

Territory (1846; rpt., San Francisco: William Doxey, 1891), 99.

22. Quoted in Pitt, *The Decline of the Californios*, 16.

23. Quoted in Dana, *Two Years before the Mast*, 61-62.

24. Quoted in Kevin Starr, *Americans and the California Dream, 1850-1915* (New York: Oxford University Press, 1973), 20. Starr's book is an intriguing study of the roots of the "California Dream" in literature and myth and is the most comprehensive social history of the state up to the time of the Panama-Pacific Exposition in 1915.

CHAPTER TWO

1. Quoted in Richard B. Rice, William A. Bullough, and Richard Orsi, *The Elusive Eden: A New History of California* (New York: Knopf, 1988), 181.

2. This figure is in contemporary dollars and has not been adjusted to reflect the worth of the gold today. For statistics on the value of gold production in California through the 1870s, see Rodman W. Paul, *California Gold: The Beginnings of Mining in the Far West* (Cambridge, Mass.: Harvard University Press, 1947), 345-346.

3. Quoted in Joseph Henry Jackson, ed., *Gold Rush Album* (New York: Charles Scribner's Sons, 1949), 11.

4. Quoted in J. S. Holliday, *The World Rushed In: The California Gold Rush Experience* (New York: Simon and Schuster, 1981), 40.

5. Quoted in B. Dutka, "New York Discovers Gold: How the New York Press Fanned the Flames of Gold Mania," *California History* 73 (Fall 1984): 315.

6. Hubert Howe Bancroft, *History of California*, vol. 6, *1848-1859* (San Francisco: History Press, 1888; rpt., Santa Barbara: Wallace Hebberd, 1970), 117.

7. Quoted in Holliday, *The World Rushed In*, 51.

8. Quoted in Walton Bean and James J. Rawls, *California: An Interpretive History*, 5th ed. (New York: McGraw-Hill, 1988), 85.

9. Quoted in Bancroft, *History of California*, 119.

10. Quoted in Dutka, "New York Discovers Gold," 314.

11. Quoted in Kevin Starr, *Americans and the California Dream, 1850-1915* (New York: Oxford University Press, 1973), 66.

12. Quoted in Bancroft, *History of California*, 123.

13. Paul, *California Gold*, 57.

14. Quoted in William H. Goetzmann, "The Mountain Man as Jacksonian Man," *American Quarterly* 15 (Fall 1963): 412.

15. Quoted in Starr, *Americans and the California Dream*, 62.

16. Quoted in Alan Trachtenberg, *Reading American Photographs: Images as History, Mathew Brady to Walker Evans* (New York: Hill and Wang, 1989), 15.

17. J. D. Borthwick, *Three Years in California* (1857; rpt., Oakland: Biobooks, 1948), 166, 41.

18. Frank Marryat, *Mountains and Molehills; or, Recollections of a Burnt Journal* (1855; rpt., Stanford: Stanford University Press, 1952), 281.

19. During the 1850s, California became one of the five or six states in the nation having the highest proportion of urban populations. This was attributable to the fact that a large proportion of early settlers were employed in businesses that supplied miners with goods and services, activities that were based in towns and cities. The nature of agriculture in the state, which was concentrated in large "bonanza" ranches rather than in single-family operations, also played an important role in encouraging

urban settlement. For more information on this subject, see Warren S. Thompson, *Growth and Changes in California's Population* (Los Angeles: Haynes, 1955), 9-19.

20. Quoted in Starr, *Americans and the California Dream,* 56.

21. Bancroft, *History of California,* vol. 6, *1848-1859,* 226.

22. H. J. West, *The Chinese Invasion* (1873), 5. Quoted in Robert F. Heizer and Alan J. Almquist, *The Other Californians: Prejudice and Discrimination under Spain, Mexico, and the United States to 1920* (Berkeley and Los Angeles: University of California Press, 1971), 157.

23. Marryat, *Mountains and Molehills,* 295; and Borthwick, *Three Years in California,* 219.

24. Andrew Rolle, *California: A History,* 4th ed. (Arlington Heights, Va.: Harlan Press, 1987), 177.

25. Walter Colton, *Three Years in California* (1850; rpt., Oakland: Biobooks, 1948), 140.

26. David Brion Davis, ed., *Antebellum American Culture: An Interpretive Anthology* (Lexington, Mass.: D. C. Heath and Co., 1979), 454.

27. Quoted in Daniel J. Boorstin, *The Americans: The National Experience* (New York: Random House, 1965), 376.

28. Marvin Lewis, *The Mining Frontier: Contemporary Accounts from the American West in the Nineteenth Century* (Norman: University of Oklahoma Press, 1967), 38.

29. William Taylor, *California Life Illustrated* (New York: Carleton and Porter, 1858), 279.

30. Frank Soulé, John H. Gihon, and James Nisbet, *The Annals of San Francisco* (San Francisco: Appleton Co., 1855), 586-587.

31. Oscar Lewis, *Bret Harte's Tales of the Gold Rush* (Chicago: University of Chicago Press, 1944), ix.

32. Bret Harte, "The Luck of Roaring Camp," in Lewis, *Bret Harte's Tales of the Gold Rush,* 7.

33. Charles Howard Shinn, *Mining Camps: A Study in American Frontier Government* (New York: Scribner's Co., 1885), 134-135.

34. Ralph K. Andrist, *The California Gold Rush* (New York: American Press, 1961), 142.

35. Shinn, *Mining Camps,* 144.

36. William Wreden, *Early California Trade Catalogues,* no. 8 (San Francisco: Book Club, 1968).

CHAPTER THREE

1. Quoted in Oscar T. Shuck, ed., *The California Scrap Book: A Repository of Useful Information and Select Readings* (San Francisco: H. H. Bancroft and Co., 1869), 104.

2. Quoted in Gary Scharnhorst, *Bret Harte's California: Letters to the "Springfield Republican" and "Christian Register," 1866-1867* (Albuquerque: University of New Mexico Press, 1990), 112.

3. Quoted in Franklin Walker, *San Francisco's Literary Frontier* (New York: Knopf, 1939), 245.

4. Quoted in Henry Nash Smith, *Virgin Land: The American West as Symbol and Myth* (Cambridge, Mass.: Harvard University Press, 1950), 142.

5. Quoted in Ivan Benson, *Mark Twain's Westering Years* (Palo Alto, Calif., 1938),

211-212.

6. Walton Bean and James J. Rawls, *California: An Interpretive History*, 5th ed. (New York: McGraw-Hill, 1988), 168.

7. Quoted in Richard J. Orsi, "Selling the Golden State: A Study of Boosterism in Nineteenth-Century California" (Ph.D. diss., University of Wisconsin, 1973), 10. Orsi's dissertation deals with the immigration campaigns sponsored by railroad companies and other businesses in California. The author's meticulous research provides a wealth of details about promotional activities in the state during the second half of the nineteenth century that have supplied the factual grounding for many of the ideas expressed in this book.

8. A comprehensive history of agriculture in California is Donald J. Pisani, *From the Family Farm to Agribusiness: The Irrigation Crusade in California and the West, 1850-1931* (Berkeley and Los Angeles: University of California Press, 1984). Pisani discusses the process through which California's farms were transformed into "factories in the fields" during the latter part of the century.

9. Quoted in Rodman W. Paul, *The Far West and the Great Plains in Transition* (Cambridge, Mass.: Harvard University Press, 1988), 20.

10. Ibid., 228.

11. Richard Steven Street, "Dr. Glenn, 'Wheat King,'" in *The Breadbasket of the World: California's Great Wheat-Growing Era, 1860-1890*, vol. 2 (San Francisco: Book Club, 1984).

12. Frank Norris, *The Octopus* (New York: Doubleday, 1901), 16.

13. Quoted in Shuck, *California Scrap Book*, 117.

14. Quoted in Scharnhorst, *Bret Harte's California*, 58.

15. Janice T. Driesbach, *Bountiful Harvest: Nineteenth-Century California Still-Life Painting* (Sacramento: Crocker Art Museum, 1991), 35.

16. Benjamin P. Avery, "Art Beginnings on the Pacific," *Overland Monthly* 1 (July 1868): 28-29.

17. My comments on still-life paintings are informed by Norman Bryson's ideas as set forth in *Looking at the Overlooked: Four Essays on Still-Life Painting* (Cambridge, Mass.: Harvard University Press, 1990).

18. Quoted in Jeanne Van Nostrand, *The First Hundred Years of Painting in California, 1775-1875* (San Francisco: John Howell Books, 1980), 61.

19. For further discussion of these ideas, see William H. Truettner, "The Art of History: American Exploration and Discovery Scenes, 1840-1860," *American Art Journal* 14 (Winter 1982): 4-31.

20. Ann Bermingham gives a fuller explanation of these ideas in her book *Landscape and Ideology: The English Rustic Tradition, 1740-1860* (Berkeley and Los Angeles: University of California Press, 1986).

21. Mark Twain, *Roughing It* (Hartford, Conn.: American Publishing Co., 1872), 416-417.

22. H. H. Bancroft, *Leland Stanford* (San Francisco: History Press, 1891), 125.

23. For a history of Stanford's business dealings, see Oscar Lewis, *The Big Four: The Story of Huntington, Stanford, Hopkins, and Crocker, and the Building of the Central Pacific* (Chicago: University of Chicago Press, 1938).

24. Neil Larry Schumsky, "Tar Flat and Nob Hill: A Social History of Industrial San Francisco during the 1870s" (Ph.D. diss., University of California, Berkeley, 1966), 225.

25. Quoted in James J. Rawls, "The California Dream," *The Commonwealth* (January 27, 1992): 52.

26. "Best and truest" was a phrase used by David Starr Jordan to describe Stanford University's student body at the turn of the century. Quoted in Kevin Starr, *Americans and the California Dream, 1850-1915* (New York: Oxford University Press, 1973), 344.

27. Charles Nordhoff, *Northern California, Oregon, and the Sandwich Islands* (1874; rpt., Berkeley: Ten Speed Press, 1974), 143.

28. Lansford W. Hastings, *Emigrant's Guide to Oregon and California* (Cincinnati: Conclin Company, 1845), 132.

29. Robert F. Heizer and Alan J. Almquist, *The Other Californians: Prejudice and Discrimination under Spain, Mexico, and the United States to 1920* (Berkeley and Los Angeles: University of California Press, 1971), 40-41.

30. California Indians were called "diggers" by Anglo-American settlers because it was thought they obtained their food by digging for roots and insects instead of hunting for game as the Plains Indians did.

31. For more information on labor unrest and the response of corporations in America in the nineteenth century, see Robert H. Wiebe, *The Search for Order, 1877-1920* (New York: Hill and Wang, 1967); and Alan Trachtenberg, *The Incorporation of America: Culture and Society in the Gilded Age* (New York: Hill and Wang, 1982).

32. Albert L. Hurtado, *Indian Survival on the California Frontier* (New Haven, Conn.: Yale University Press, 1988), 117.

33. Jessie Frémont was the daughter of Senator Thomas Hart Benton of Missouri, the champion of westward expansion, who introduced his daughter to her future husband, Lieutenant Charles Frémont, "The Great Pathfinder" and early California explorer. Mrs. Frémont was the toast of California society during the 1850s and 1860s. When Mrs. Frémont went to call on her friends, she traveled in a carriage with a pair of Indian retainers dressed in the Spanish costume of Old California riding on horseback in front of her. For more information on Frémont, see Starr, *Americans and the California Dream*, 98-100 and 365-370.

34. Quoted in James B. Rawls, *Indians of California: The Changing Image* (Norman: University of Oklahoma Press, 1984), 115.

35. Benjamin C. Truman, *Semi-Tropical California* (San Francisco: Bancroft Co., 1874), 29.

36. Ibid., 33.

37. For a brief account of the Southern Pacific's promotion of Southern California, see Alfred Runte, "Promoting the Golden West: Advertising and the Railroad," *California History* 70 (Spring 1991): 62-75.

38. Orsi, "Selling the Golden State," 336-337.

39. Ibid., 443.

40. On the moral dimensions of horticulture in nineteenth-century American culture, see Tamara Platkins Thornton, *Cultivating Gentlemen: The Meaning of Country Life among the Boston Elite, 1785-1860* (New Haven, Conn.: Yale University Press, 1989).

41. I thank Caroline Gordon for her ideas on social "hybridization."

42. Quoted in Peter Palmquist, *Carleton E. Watkins: Photographer of the American West* (Albuquerque: University of New Mexico Press, 1983), 76.

43. Charles Nordhoff, *California for Health, Pleasure, and Residence* (New York: Harper, 1882), 98.

44. Quoted in John Baur, *Health Seekers of Southern California* (San Marino: Huntington Library, 1959), 117.

45. A history of orange-crate art that features vivid color reproductions of many different labels is John Salkin and Laurie Gordon, *Orange-Crate Art* (New York: Warner, 1976).

46. Baur, *Health Seekers of Southern California*, 117.

47. Orsi, "Selling the Golden State," 180.

48. Ibid., 522.

49. Ibid., 191-193.

50. Quoted in Starr, *Americans and the California Dream*, 418.

51. Hinton Rowan Helper, *The Land of Gold, Reality versus Fiction* (1855; rpt., New York: Bobbs Co., 1948), 156-157.

CHAPTER FOUR

1. Quoted in David Robertson, *Yosemite as We Saw It: A Centennial Collection of Early Writings and Art* (Yosemite: Wilderness Press, 1990), 35.

2. These ideas were based on Edmund Burke's *Philosophical Inquiry into the Origin of Our Idea of the Sublime and the Beautiful* of 1757; Immanuel Kant's *Observations on the Feeling of the Beautiful and the Sublime*, 1763; and William Gilpin's *Remarks on Forest Scenery and Other Forest Views*, 1792, among other sources.

3. Charles Nordhoff, *California for Health, Pleasure, and Residence* (New York: Harper, 1882), 18.

4. Anne Farrar Hyde, *An American Vision: Far Western Landscape and National Culture* (New York: New York University Press, 1990), 120. Hyde's important study of tourism in the West during the nineteenth century emphasizes railroad excursions and the development of resort hotels. Another excellent work on western tourism is Earl S. Pomeroy, *In Search of the Golden West: The Tourist in Western America* (Lincoln: University of Nebraska Press, 1957).

5. Frederick E. Schearer, ed., *The Pacific Tourist* (1884; rpt., New York: Crown Publishers, 1970), 1.

6. Hyde, *An American Vision*, 108.

7. Pomeroy, *In Search of the Golden West*, 8.

8. Ibid., 10.

9. Richard Reinhardt, *Out West on the Overland Train: An Across-the-Continent Excursion with "Leslie's Illustrated Magazine" in 1877* (Palo Alto: American Press, 1967), 7.

10. For an account of Huntington's role in the building of the transcontinental railroad, see Oscar Lewis, *The Big Four: The Story of Huntington, Stanford, Hopkins, and Crocker, and the Building of the Central Pacific* (New York: Knopf, 1938).

11. See George R. Stewart, *Ordeal by Hunger: The Story of the Donner Party* (New York: Holt Press, 1936), for a full account of the immigrant group's misadventure.

12. Quoted in Reinhardt, *Out West on the Overland Train*, 162.

13. "Two California Landscapes," *Overland Monthly* (March 1873): 286, quoted in Nancy K. Anderson, "Albert Bierstadt: The Path to California, 1830-1874" (Ph.D. diss., University of Delaware, 1985), 236.

14. Numerous publications have studied the theme of the railroad in the wilderness landscape. These include Susan Danly and Leo Marx, eds., *The Railroad in American Art: Representations of Technological Change* (Cambridge, Mass.: MIT Press,

1988); and David Lubin, "A Backward Look at Forward Motion," *American Quarterly* 41 (September 1989): 549-557.

15. For a more detailed discussion of the attractions of Lake George and its role as a locus of artistic production, see William Chapman White, *Adirondack Country* (New York: Duell Press, 1954); and Frederic F. van de Water, *Lake Champlain and Lake George* (New York: Bobbs Press, 1946).

16. Quoted in David Strauss, "Towards a Consumer Culture: 'Adirondack' Murray and the Wilderness Vacation," *American Quarterly* 39 (Summer 1987): 276.

17. Ibid., 275.

18. Peter J. Schmidt, *Back to Nature: The Arcadian Myth in Urban America* (Baltimore: Johns Hopkins University Press, 1969), 7.

19. Thomas Starr King, *A Vacation among the Sierras: Yosemite in 1860* (1861; rpt., San Francisco: Book Club, 1962), xviii.

20. Ibid., 44.

21. Ibid., xxi.

22. Samuel Bowles, *Across the Continent: A Summer's Journey to the Rocky Mountains, the Mormons, and the Pacific States* (1865; rpt.; Washington, D.C.: Readex Microprint, 1966), 223.

23. Quoted in Elizabeth McKinsey, *Niagara Falls: Icon of the American Sublime* (New York: Cambridge University Press, 1985), 268.

24. The most extensive study of Watkins's photographs is Peter E. Palmquist, *Carleton E. Watkins: Photographer of the American West* (Albuquerque: University of New Mexico Press, 1983).

25. Quoted in ibid., 19.

26. Anderson, "Albert Bierstadt: The Path to California," 222.

27. Ibid.

28. Gordon Hendricks, *Albert Bierstadt: The Painter of the American West* (New York: Abrams, 1988), 116.

29. Quoted in Anderson, "Albert Bierstadt: The Path to California," 222.

30. Ibid., 232.

31. Hyde, *An American Vision*, 80.

32. Quoted in Hendricks, *Albert Bierstadt,* 115.

33. Quoted in Anderson, "Albert Bierstadt: The Path to California," 87.

34. Quoted in George Wharton James, *Lake Tahoe: Lake of the Sky* (1915; rpt., Las Vegas: Nevada Publications, 1992), 15.

35. For more information on fishing at Lake Tahoe during the nineteenth century, see E. B. Scott, *The Saga of Lake Tahoe* (Lake Tahoe: Sierra Tahoe Publishing, 1957), 443-448.

36. Shearer, ed., *The Pacific Tourist*, 274.

37. Quoted in *California Sketches: Mark Twain and Bret Harte* (New York: Dover, 1991), 36.

38. Quoted in Malcolm Margolin, ed., *Monterey in 1786: Life in a California Mission, The Journals of Jean-François de La Pérouse* (Berkeley: Heyday Books, 1989), 55.

39. Marjorie Arkelian, *Thomas Hill: The Grand View* (Oakland: The Oakland Museum, 1980), 14.

40. Quoted in Richard N. Masteller, "Western Views in Eastern Parlors: The Contribution of the Stereograph Photographer to the Conquest of the West," *Prospects* 6

(1981): 55.

41. Ibid., 58.

42. Horace Greeley, *An Overland Journey from New York to San Francisco in the Summer of 1859* (New York, 1861), 264.

43. Quoted in Shirley Sargeant, *Yosemite: The First One Hundred Years, 1890-1990* (Santa Barbara: Sequoia, 1988), 10.

44. Dennis G. Kruska, *Sierra Nevada Big Trees: History of the Exhibitions, 1850-1903* (Los Angeles: Dawson's Books, 1985), 33-35.

45. The others who accompanied Emerson to Philosophers' Camp included W. J. Stillman, art critic for the *Crayon*, Louis Agassiz, the Harvard geologist, and the poet James R. Lowell. Henry Longfellow and Henry Thoreau were also invited on the excursion but declined to come.

46. Among many others in the 1850s, 1860s and 1870s, the photographers William H. Jackson and Carleton Watkins and the artists Sanford Gifford and Thomas Moran joined government-sponsored surveys.

47. For more information about the role of surveys in the development of the West, see Alan Trachtenberg's chapter "Naming the View," in *Reading American Photographs: Images as History, Mathew Brady to Walker Evans* (New York: Hill and Wang, 1989); William H. Goetzmann, *Exploration and Empire: The Explorer and the Scientist in the Winning of the American West* (New York: Norton, 1966); Peter Bacon Hales, *William Henry Jackson and the Transformation of the American Landscape* (Philadelphia: Temple University Press, 1988); and Joni Louise Kinsey, *Thomas Moran and the Surveying of the American West* (Washington, D.C.: Smithsonian Institution Press, 1992).

48. *The Annals of the Bohemian Club*, vol. 3 (San Francisco: Hicks-Judd, 1895), 92.

49. Muir has been the subject of numerous studies, including Holway R. Jones, *John Muir and the Sierra Club: The Battle for Yosemite* (San Francisco: Sierra Club Books, 1965); and Michael P. Cohen, *The Pathless Way: John Muir and the American Wilderness* (Madison: University of Wisconsin Press, 1984).

50. Quoted in Michael P. Cohen, *The History of the Sierra Club, 1892-1970* (San Francisco: Sierra Club Books, 1988), 9.

51. Quoted in Kevin Starr, *Americans and the California Dream, 1850-1915* (New York: Oxford University Press, 1973), 186.

52. Quoted in Margaret Sanborn, *Yosemite: Its Wonders, Its Discovery, and Its People* (Yosemite: Yosemite Association, 1989), 207.

53. Albert F. Moritz, *America the Picturesque in Nineteenth-Century Engravings* (New York: New Trend, 1983), 35.

54. Quoted in David Robertson, *Yosemite as We Saw It: A Centennial Collection of Early Writings and Art* (Yosemite: Wilderness Press, 1990), 30.

55. *The Yosemite Tourist* (Yosemite, 1903), 3.

56. In his book *The Magisterial Gaze: Manifest Destiny and American Landscape Painting* (Washington, D.C.: Smithsonian Institution Press, 1991), Albert Boime discusses the cultural meanings of the "view from above." Examining the paintings of Cole, Church, and others in this context, the author explains how this convention was used during the nineteenth century to bring new territories under symbolic control. Boime's ideas provide a useful paradigm for understanding pictures of Glacier Point, as well as other panoramic California views.

57. For more information about this nineteenth-century geological debate, see

Michael L. Smith, *Pacific Visions: California Scientists and the Environment, 1850-1915* (New Haven, Conn.: Yale University Press, 1987), 50ff.

58. Quoted in Peter J. Blodgett, "Visiting the 'Realm of Wonder': Yosemite and the Business of Tourism, 1855-1916," *California History 69* (Summer 1990): 122.

59. Olive Logan, "Does It Pay to Visit Yosemite?" *Galaxy Magazine* (October 1870): 107.

60. Quoted in Sanborne, *Yosemite*, 86.

61. Quoted in Carl Parcher Russell, *One Hundred Years in Yosemite* (Berkeley and Los Angeles: University of California Press, 1947), 108-109.

62. Stanford Demars, *The Tourist in Yosemite, 1855-1985* (Salt Lake City: University of Utah Press, 1991), 68.

CHAPTER FIVE

1. Quoted in Leonard Pitt, *The Decline of the Californios: A Social History of the Spanish-Speaking Californians, 1846-1890* (Berkeley and Los Angeles: University of California Press, 1966), 16.

2. Richard Henry Dana, *Two Years before the Mast* (1840; rpt., London: Folio, 1986), 140.

3. For more information on this subject, see Richard Peterson, "Anti-Mexican Nativism in California, 1848-1853: A Study in Cultural Conflict," *Southern California Quarterly* 62 (Winter 1980): 309-328; and Leonard Pitt, "Greasers in the Diggings," in Roger Daniels and Spencer C. Olin, Jr., eds., *Racism in California: A Reader in the History of Oppression* (New York: Macmillan Company, 1972), 194-195.

4. Quoted in Earl S. Pomeroy, *In Search of the Golden West: The Tourist in Western America* (Lincoln: University of Nebraska Press, 1957), 35.

5. Ibid., 33.

6. Quoted in Kevin Starr, *Americans and the California Dream, 1848-1915* (New York: Oxford University Press, 1973), 379.

7. On the subject of antimodernism in the late nineteenth-century, see T. J. Jackson Lears, *No Place of Grace: Antimodernism and the Transformation of American Culture, 1880-1920* (Chicago: University of Chicago Press, 1981).

8. Quoted in Alan Trachtenberg, ed., *Democratic Vistas, 1800-1880* (New York: George Braziller, 1970), 238-247.

9. Quoted in Starr, *Americans and the California Dream*, 418-419.

10. Frank Marryat, *Mountains and Molehills; or, Recollections of a Burnt Journal* (1855; rpt., Stanford: Stanford University Press, 1952), 66.

11. Mark Twain, *Roughing It* (Hartford, Conn.: American Press, 1872), 178.

12. Quoted in Joseph Henry Jackson, introduction to John Rollins Ridge, *The Life and Adventures of Joaquin Murieta, the Celebrated California Bandit* (1854; rpt., Norman: University of Okalahoma Press, 1955), xxvi.

13. Quoted in Anne Farrer Hyde, *An American Vision: Far Western Landscape and National Culture* (New York: New York University Press, 1990), 165.

14. In his excellent study of anti-Hispanic attitudes in America, Raymund Paredes writes: "Racialists regarded mixed-breeds as impulsive, unstable, and prone to insanity. The Mexicans, as the most conspicuous products of mass-miscegenation, inevitably were assigned these qualities." See Paredes, "The Origins of Anti-Mexican Sentiment in the United States," *New Scholar* 6 (1977): 155-167. For a further discussion of this sub-

ject, see William Stanton, *The Leopard's Spots: Scientific Attitudes towards Race in America, 1815-1859* (Chicago: University of Chicago Press, 1960), 43-44, 66-68, 158-159, 160, 190-191.

15. Quoted in Moreland L. Stevens, *Charles Christian Nahl: Artist of the Gold Rush, 1818-1878* (Sacramento: E. B. Crocker Art Gallery, 1976), 84.

16. *Before the Gringo Came* was the title of a book written by Gertrude Atherton in 1894.

17. Helen Hunt Jackson, *Ramona* (1881; rpt., New York: Avon Company, 1970), 15.

18. After graduating from Harvard, Charles Lummis (1859-1928) walked from Ohio to California, recording his experience for the readers of the *Los Angeles Times*. Shortly afterward, he became the paper's city editor. From 1895 to 1903 Lummis edited *Land of Sunshine*, a journal devoted to publicizing the natural beauties and culture of California and the Southwest. Lummis was instrumental in encouraging the idea of an alternative and improved moral and intellectual culture in the southwestern part of the United States. The articles he included in *Land of Sunshine*, by authors such as Mary Austin, Edwin Markham, and Joaquin Miller, as well as his own writings, called attention to the region's Spanish heritage. In addition to founding the Landmarks Club, which worked to restore the missions and other historic buildings, Lummis established the Southwest Museum in Los Angeles in 1914 and started an important collection of Southwest material in the Los Angeles Public Library, which he headed from 1905 to 1910.

19. James M. Hansen, *Alexander Harmer, 1856-1925* (Santa Barbara: James M. Hansen, 1982), n.p.

20. Idah M. Strobridge, "One Day at Pacheco's," *Land of Sunshine 4* (July 1899): 101.

21. An excellent article on the "mission myth" is James J. Rawls, "The California Mission as Symbol and Myth," *California History 71* (Fall 1992), 342-361. Rawls discusses the significance of the enormous popularity of *Ramona* and interprets the images of ruined missions that Anglo-Americans found so appealing in the context of the ideologies of modernism.

22. Quoted in Kevin Starr, *Inventing the Dream: California through the Progressive Era* (New York: Oxford University Press, 1985), 85.

23. I discovered this image in Rawls, "The California Mission as Symbol and Myth," 357.

CHAPTER SIX

1. Quoted in Lawrence Ferlinghetti and Nancy J. Peters, *Literary San Francisco: A Pictorial History from Its Beginnings to the Present Day* (San Francisco: City Lights Books, 1980), 60.

2. Quoted in Thomas Bender, *Towards an Urban Vision: Ideas and Institutions in Nineteenth-Century America* (Baltimore: Johns Hopkins University Press, 1975), 7. Bender's book is an important study of the emerging urban culture in America during the nineteenth century. He discusses the ideas of Charles Loring Brace and Frederick Law Olmsted, and their role in the development of an "urban vision" of the ideal city during this period.

3. Ibid., xv.

4. Bayard Taylor, *El Dorado; or, Adventures in the Path of Empire* (1850; rpt.; New York: Knopf, 1949), 226.

5. Quoted in Tom Cole, *A Short History of San Francisco* (San Francisco: Don't Call It Frisco Press, 1981), 37.

6. Arthur Chandler, *Old Tales of San Francisco*, 2d ed. (Dubuque, Iowa: Kendall-Hunt Company, 1987), 73.

7. Quoted in Roger W. Lotchin, *San Francisco, 1846-1856, from Hamlet to City* (New York: Oxford University Press, 1974), 303.

8. Robert A. Sobieszek, *San Francisco in the 1850s: Thirty-three Photographic Views by G. R. Fardon* (New York: Dover, 1977), viii.

9. An informative history of the merchant class in San Francisco is Peter R. Decker, *Fortunes and Failures: White-Collar Mobility in Nineteenth-Century San Francisco* (Cambridge, Mass.: Harvard University Press, 1978). Decker provides an account of the motives that drew merchant pioneers to the Pacific and describes how a community that was centered on the activities of these newcomers emerged in San Francisco during the middle of the century. An engaging study that has directed my interpretation of photographs of San Francisco, including the works of Fardon and Muybridge, is Peter Bacon Hales, *Silver Cities: The Photography of American Urbanization, 1839-1915* (Philadelphia: Temple University Press, 1984).

10. Sobieszek, *San Francisco in the 1850s*, viii.

11. Taylor, *El Dorado*, 229-230.

12. Frank Marryat, *Mountains and Molehills; or, Recollections of a Burnt Journal* (1855; rpt., Stanford: Stanford University Press, 1952), 151-152.

13. Josiah Royce, *California, from the Conquest in 1846 to the Second Vigilance Committee in San Francisco: A Study of American Character* (1886; rpt., New York: Knopf, 1948), 316.

14. B. E. Lloyd, *Lights and Shades in San Francisco* (San Francisco: Bancroft, 1876), 497.

15. John W. Reps, *Cities of the American West: A History of Frontier Urban Planning* (Princeton, N.J.: Princeton University Press, 1979), 157. Reps' study provides a wealth of reproductions of contemporary maps and urban images, for those interested in the visual culture of the period. Another noteworthy book by the same author is *Cities on Stone: Nineteenth-Century Lithographic Images of the Urban West* (Fort Worth: Amon Carter Museum, 1979).

16. Frank Soulé, John H. Gihon, and James Nisbet, *The Annals of San Francisco* (New York: Appleton Company, 1855), 160-161.

17. Though it takes New York as its subject, a brief analysis of the panoramic photograph and its relation to middle-class notions about the characteristics of the ideal city is Hans Bergmann, "Panoramas of New York, 1845-1860," *Prospects* 10 (1985): 119-135.

18. John Alan Lawrence, "Behind the Palaces: The Working Class and the Labor Movement in San Francisco, 1877-1901" (Ph.D. diss., University of California, Berkeley, 1979), 16-17.

19. Robert M. Senkewicz, *Vigilantes in Gold Rush San Francisco* (Stanford: Stanford University Press, 1985), 29.

20. On the social geography of San Francisco, see Decker, "A Social Geography of the Urban Landscape," 196-230; and "A View Toward the Nob," 231-260.

21. Howard Mumford Jones, *The Age of Energy* (New York: Viking Press, 1970), 142.

22. Alan Trachtenberg, *The Incorporation of America: Culture and Society in the Gilded Age* (New York: Hill and Wang, 1982), 47.

23. Quoted in John A. Kouwenhoven, *Made in America: The Arts in Modern Civilization* (Garden City, N.Y.: Doubleday, 1948), 30.

24. Lloyd, *Lights and Shades*, 62.

25. Lawrence, "Behind the Palaces," 10.

26. Charles Howard Shinn, "Poverty and Charity in San Francisco," *Overland Monthly* 33 (1894): 14.

27. Quoted in Robert F. Heizer and Alan J. Almquist, *The Other Californians: Prejudice and Discrimination under Spain, Mexico, and the United States to 1920* (Berkeley and Los Angeles: University of California Press, 1971), 157.

28. Sucheng Chan, "Chinese Livelihood," in *New Directions in California History: A Book of Readings*, ed. James J. Rawls (New York: McGraw-Hill, 1988), 180-182.

29. A number of studies deal with the conflict between Anglo-Americans and Chinese in nineteenth-century California. For additional information on this subject, see Elmer Sandmeyer, *The Anti-Chinese Movement in California* (Urbana: University of Illinois Press, 1939); and Alexander Saxton, *The Indispensible Enemy: Labor and the Anti-Chinese Movement in California* (Berkeley and Los Angeles: University of California Press, 1971).

30. Chan, "Chinese Livelihood," 180-182.

31. Lloyd, *Lights and Shades*, 213-214.

32. Ibid., 235.

33. Soulé, Gihon, and Nisbet, *The Annals of San Francisco,* 379-387.

34. Margaret Hindle and Robert Hazen, *Keepers of the Flame: The Role of Fire in American Culture, 1775-1925* (Princeton, N.J.: Princeton University Press, 1992), discuss the frequency of fires in American cities and the type of coverage that was provided by local newspapers. They describe the problem as a daily occurrence in urban areas across the country.

35. Laverne Mau Dicker, "The San Francisco Earthquake and Fire," *California History* 59 (Spring 1980): 34.

36. Oscar Lewis, *San Francisco: From Mission to Metropolis* (Berkeley: Howell-North Press, 1966), 185.

37. Quoted in Gladys Hansen and Emmet Condon, *Denial of Disaster: The Untold Story and Photographs of the San Francisco Earthquake and Fire of 1906* (San Francisco: Cameron Press, 1989), 34-35.

38. Mel Scott, *The San Francisco Bay Area: A Metropolis in Perspective,* 2d ed. (Berkeley and Los Angeles: University of California Press, 1985), 107.

39. Quoted in Hindle and Hazen, 75.

40. Lawrence Kinnaird, *History of the Greater San Francisco Bay Region,* vol. 2 (New York: Lewis Historical Press, 1966), 132.

41. Walton Bean and James J. Rawls, *California: An Interpretive History,* 5th ed. (New York: McGraw-Hill, 1988), 241.

42. Hubert H. Bancroft, *History of California,* vol. 7, *1860-1890* (San Francisco: History Company, 1890), 207.

43. Hansen and Condon, *Denial of Disaster*, 7.

44. Bancroft, *History of California,* vol. 7, 684.

45. Quoted in Bernard Taper, *Mark Twain's San Francisco* (New York: McGraw-Hill, 1963), 124-128.

46. William Cronon, *Nature's Metropolis: Chicago and the Great West* (New York: Norton, 1991), 245-246.

47. Hansen and Condon, *Denial of Disaster*, 62.

48. Louis J. Stellmann, *The Vanished Ruin Era: San Francisco's Classic Artistry of Ruin Depicted in Picture and Song* (San Francisco: Paul Elder, 1910), vii-viii.

49. Scott, *The San Francisco Bay Area*, 115.

50. Quoted in Burton Benedict, *The Anthropology of World's Fairs: San Francisco's Panama-Pacific International Exposition of 1915* (Berkeley: Scholar Press, 1983), 88.

51. Quoted in Donna Ewald and Peter Clute, *San Francisco Invites the World: The Panama-Pacific International Exposition of 1915* (San Francisco: Chronicle Books, 1991), 9.

52. Quoted in Gray A. Brechin, "Sailing to Byzantium: The Architecture of the Panama-Pacific Exposition," *California History* 62 (Summer 1983), 112.

SELECTED BIBLIOGRAPHY

Anderson, John. "Emerson and California." *California Historical Society Quarterly* 33 (September 1954): 241-248.

Anderson, Nancy K. "Albert Bierstadt: The Path to California, 1830-1874." Ph.D. diss.,University of Delaware, 1985.

Andrist, Ralph K. *The California Gold Rush*. New York: American Press, 1961.

Arkelian, Marjorie. *The Kahn Collection of Nineteenth-Century Paintings by Artists in California*. Oakland: The Oakland Museum, 1975.

————.*William Hahn, Genre Painter*. Oakland: The Oakland Museum, 1976.

————. *Thomas Hill: The Grand View*. Oakland: The Oakland Museum, 1980.

Atherton, Gertrude. *Before the Gringo Came*. New York: Selwin, 1894.

————. *The Splendid, Idle Forties*. New York: Macmillan, 1902.

Avery, Benjamin P. "Summering in the Sierra." *Overland Monthly* 12 (February 1874): 79-83.

Baird, Joseph. *From Frontier to Fire: California Painting from 1816 to 1906*. Davis: University of California, Art Department, 1964.

————. *California's Pictorial Letter Sheets, 1849-1869*. San Francisco: Magee Co., 1967.

————. *Catalogue of Original Paintings, Drawings, and Watercolors in the Robert B. Honeyman, Jr., Collection*. Berkeley and Los Angeles: University of California Press, 1968.

Baker, Elna. *An Island Called California*. Berkeley and Los Angeles: University of California Press, 1972.

Bancroft, Hubert H. *California Pastoral, 1769-1848*. San Francisco: The History Company, 1888.

————. *History of California*. 7 vols. San Francisco: History Press, 1888-90. Rpt. Santa Barbara: Wallace Hebberd, 1970.

————. *Leland Stanford*. San Francisco: History Press, 1891.

Bannister, Robert C. *Social Darwinism: Science and Myth in Anglo-American Thought*. Philadelphia: Temple University Press, 1979.

Barth, Gunther. *Instant Cities: Urbanization and the Rise of San Francisco and Denver*. Albuquerque: University of New Mexico Press, 1988.

Barthes, Roland. *Mythologies*. 1950. Trans. Annette Lavers. New York: Noonday Press, 1990.

Baur, John. "Los Angeles County in the Health Rush, 1870-1900." *California Historical Quarterly* 31 (March 1952): 13-31.

————. *Health Seekers of Southern California*. San Marino: Huntington Library, 1959.

Bean, Walton, and James J. Rawls. *California: An Interpretive History*. 5th ed. New York: McGraw-Hill, 1988.

Beebe, Lucius, and Charles Cleeg. *San Francisco's Golden Era*. Berkeley: Howell-North Press, 1960.

Bender, Thomas. *Towards an Urban Vision: Ideas and Institutions in Nineteenth-Century America*. Baltimore: Johns Hopkins University Press, 1975.

Benedict, Burton, ed. *The Anthropology of World's Fairs: San Francisco's Panama-Pacific International Exposition of 1915*. Berkeley: Scholar Press, 1983.

Benson, Ivan, *Mark Twain's Westering Years*. Palo Alto, Calif., 1938.

Berger, John. *Ways of Seeing*. New York: Penguin Books, 1972.

Bergmann, Hans. "Panoramas of New York, 1845-1860." *Prospects* 10 (1985): 119-135.

Bermingham, Ann. *Landscape and Ideology: The English Rustic Tradition, 1740-1860*. Berkeley and Los Angeles: University of California Press, 1986.

Blodgett, Peter J. "Visiting the 'Realm of Wonder': Yosemite and the Business of Tourism, 1855-1916." *California History* 69 (Summer 1990): 118-133.

Boime, Albert. *The Magisterial Gaze: Manifest Destiny and American Landscape Painting*. Washington, D.C.: Smithsonian Institution Press, 1991.

Book Club of California. *Resorts of California*. San Francisco: Book Club, 1957.

————. *Breadbasket of the World: California's Wheat-Growing Era*. San Francisco: Book Club, 1974.

Boorstin, Daniel J. *The Americans: The National Experience*. New York: Random House, 1965.

————. *The Americans: The Democratic Experience*. New York: Random House, 1973.

Booth, Larry, Richard Olmstead, and Richard Pourade. "Portrait of a Boom Town: San Diego in the 1880s." *California Historical Quarterly* 50 (December 1971): 363-394.

Borthwick, J. D. *Three Years in California*. 1857. Rpt. Oakland: Biobooks, 1948.

Boston, Museum of Fine Arts. *Art and Commerce: American Prints of the Nineteenth Century*. Charlottesville: University Press of Virginia, 1975.

Bowles, Samuel. *Across the Continent: A Summer's Journey to the Rocky Mountains, the Mormons, and the Pacific States*. 1865. Rpt. Washington, D.C.: Readex Microprint, 1966.

Brechin, Gray A. "Sailing to Byzantium: The Architecture of the Panama-Pacific Exposition." *California History* 62 (Summer 1983): 106-121.

Bredeson, R. "Landscape Description in American Travel Literature." *American Quarterly* 20 (Spring 1968): 86-94.

Brewer, William H. *Up and Down California*. 1864. Rpt. Berkeley and Los Angeles: University of California Press, 1966.

Bryant, Edwin. *What I Saw in California*. New York: Appleton Co., 1848. Rpt. Lincoln: University of Nebraska Press, 1985.

Bryson, Norman. *Looking at the Overlooked: Four Essays on Still-Life Painting*. Cambridge, Mass.: Harvard University Press, 1990.

Burbank, Luther. *The Training of the Human Plant*. New York: Houghton Co., 1904.

———. *The Harvest of the Years*. New York: Riverside Co., 1931.

Burchell, Robert. "The Faded Dream: Inequality in Northern California in the 1860s and 1870s." *Journal of American Studies* 23 (1989): 215-234.

Burns, Sarah. *Pastoral Inventions: Rural Life in Nineteenth-Century American Art and Culture*. Philadelphia: Temple University Press, 1989.

California World's Fair Commission. *California at the World's Columbian Exhibition*. Sacramento: State Printing Co., 1893.

Caughey, John W. *Gold Is the Cornerstone*. Berkeley and Los Angeles: University of California Press, 1948.

Chan, Sucheng. *This Bittersweet Soil: The Chinese in California Agriculture, 1860-1910*. Berkeley and Los Angeles: University of California Press, 1986.

Chandler, Arthur. *Old Tales of San Francisco*. 2d ed. Dubuque, Iowa: Kendall-Hunt Company, 1987.

Chu, G. "Chinatowns in the Delta: The Chinese in the Sacramento-San Joaquin Delta, 1870-1960." *California Historical Quarterly* 49 (March 1970): 21-37.

Clappe, Louise Amelia Knapp Smith. *The Shirley Letters from the California Mines, 1851-1852*. New York: Knopf, 1949.

Clark, George. *Leland Stanford*. Stanford: Stanford University Press, 1931.

Clark, H. "Their Pride, Their Manners, and Their Voices: Sources of the Traditional Portrait of Early Californians." *California Historical Quarterly* 53 (Spring 1974): 71-82.

Clemente, William M. "Savage, Pastoral, Civilized: An Ecological Typology of American Frontier Heroes." *Journal of Popular Culture* 8 (Fall 1974): 254-266.

Cohen, Michael P. *The Pathless Way: John Muir and the American Wilderness*. Madison: University of Wisconsin Press, 1984.

———. *The History of the Sierra Club, 1892-1970*. San Francisco: Sierra Club Books, 1988.

Cole, Tom. *A Short History of San Francisco*. San Francisco: Don't Call It Frisco Press, 1981.

Collier, John, and Malcolm Collier. *Visual Anthropology*. Albuquerque: University of New Mexico Press, 1990.

Colton, Walter. *Three Years in California*. 1850. Rpt. Oakland: Biobooks, 1948.

Cooper, Erwin. *Aqueduct Empire: A Guide to Water in California, Its Turbulent History, and Its Management Today*. Glendale, Calif.: Clarke Co., 1968.

Crofutt, George A. *Crofutt's New Overland Tourist and Pacific Coast Guide*. Chicago: Overland Press, 1879.

Cronon, William, and Jay Gitlin. *Under an Open Sky: Rethinking America's Western Past.* New York: Viking Press, 1992.

Curtis, J. "New Chicago of the Far West: Land Speculation in Alviso, California, 1890-1891." *California History* 61 (Spring 1982): 36-45.

Cutter, Donald C. *Malaspina in California.* San Francisco: John Howell Co., 1960.

———. *California in 1792: A Spanish Naval Visit.* Norman: University of Oklahoma Press, 1990.

Dana, Richard Henry. *Two Years before the Mast.* 1840. Rpt. London: Folio, 1986.

Daniel, Cletus. *Bitter Harvest: A History of California Farmworkers, 1870-1941.* New York: Macmillan, 1981.

Daniels, Roger, and Spencer C. Olin, Jr., eds. *Racism in California: A Reader in the History of Oppression.* New York: Macmillan Company, 1972.

Danly, Susan, and Leo Marx, eds. *The Railroad in American Art: Representations of Technological Change.* Cambridge, Mass.: MIT Press, 1988.

Davis, David Brion, ed. *Antebellum American Culture: An Interpretive Anthology.* Lexington, Mass.: D. C. Heath and Co., 1979.

Davis, William Hawley. "Emerson the Lecturer in California." *California Historical Society Quarterly* 20 (March 1941): 1-11.

Davis, William Heath. *Seventy-five Years in California.* 1889. Rpt. San Francisco: John Howell Books, 1967.

Decker, Peter R. *Fortunes and Failures: White-Collar Mobility in Nineteenth-Century San Francisco.* Cambridge, Mass.: Harvard University Press, 1978.

Delano, Alonzo. *Pen Knife Sketches; or, Chips Off the Old Block.* 1853. Rpt. San Francisco: Grabhorn, 1934

———. *Old Block's Sketch Book; or, Tales of California Life.* 1856. Rpt.Santa Ana, Calif.: Fine Arts Press, 1947.

Del Castillo, Richard Griswold. "The Del Valle Family and the Fantasy Heritage." *California History* 59 (Spring 1980): 2-15 .

Demars, Stanford. *The Tourist in Yosemite, 1855-1985.* Salt Lake City: University of Utah Press, 1991.

Dicker, Laverne Mau. "The San Francisco Earthquake and Fire." *California History* 59 (Spring 1980): 34-65.

Driesbach, Janice. *Bountiful Harvest: Nineteenth-Century California Still-Life Painting.* Sacramento: Crocker Art Museum, 1991.

———. "Landmarks of Early California Painting: The Crocker Art Museum Exhibition." *California History* 71 (Spring 1992): 24-32.

Duhaut-Cilly, August Bernard. "Duhaut-Cilly's Account of California in the Years 1827-1828." *California Historical Society Quarterly* 8 (December 1929): 214-242.

Dumke, Glenn. *The Boom of the Eighties in Southern California.* San Marino: Huntington Library, 1944.

Dutka, B. "New York Discovers Gold: How the New York Press Fanned the Flames of Gold Mania." *California History* 73 (Fall 1984): 313-319.

Earle, Edward H., ed. *Points of View: The Stereograph in America—a Cultural History.* Rochester, N.Y.: Visual Studies Workshop, 1979.

Ewald, Donna, and Peter Clute. *San Francisco Invites the World: The Panama-Pacific International Exposition of 1915.* San Francisco: Chronicle Books, 1991.

Eyring, Rose. "The Portrayal of the Gold Rush in Period Imaginative Literature." Ph.D.

diss., University of California, Berkeley, 1944.

Fender, Stephen. *Plotting the Golden West: American Literature and the Rhetoric of the California Trail.* Cambridge, Mass.: Harvard University Press, 1981.

Ferlinghetti, Lawrence, and Nancy J. Peters. *Literary San Francisco: A Pictorial History from Its Beginnings to the Present Day.* San Francisco: City Lights Books, 1980.

Fletcher, Robert, ed. *The Annals of the Bohemian Club, 1872-1906.* San Francisco: Hicks, 1930.

Frankenstein, Alfred. *William Sidney Mount.* New York: Abrams, 1975.

Friedricks, William B. *Henry Huntington and the Creation of Southern California.* Columbus: Ohio State University Press, 1992.

Gates, Paul. *California Ranchos and Farms, 1848-1862.* Madison: University of Wisconsin Press, 1967.

————. "Carpetbaggers Join the Rush for California Land." *California Historical Quarterly* 66 (Summer 1977): 98-127.

Geertz, Clifford. *The Interpretation of Cultures.* New York: Basic Books, 1973.

————. *Local Knowledge.* New York: Basic Books, 1983.

Genthe, Arnold, and Will Irwin. *Pictures of Old Chinatown.* New York: Moffat Yard and Co., 1909.

Gibson, Charles, ed. *The Black Legend: Anti-Spanish Attitudes in the Old World and the New.* New York: Harper and Row, 1971.

Goetzmann, William H. "The Mountain Man as Jacksonian Man." *American Quarterly* 15 (Fall 1963): 202-215.

————. *Exploration and Empire: The Explorer and the Scientist in the Winning of the American West.* New York: Norton, 1966.

Goetzmann, William H., and William N. Goetzmann. *The West of the Imagination.* New York: Norton, 1986.

Graebner, Norman A. "The Mexican War: A Study in Causation." *Pacific Historical Review* 49 (August 1980): 405-426.

Greeley, Horace. *An Overland Journey from New York to San Francisco in the Summer of 1859.* New York, 1861.

Greenblatt, Stephen. *Marvelous Possessions: The Wonder of the New World.* Chicago: University of Chicago Press, 1991.

Greever, W. *The Bonanza West: The Story of the Western Mining Rushes, 1848-1900.* Norman: University of Oklahoma Press, 1963.

Haas, Robert Bartlett. "Eadweard Muybridge's Yosemite Valley Photographs, 1867-1872." *California Historical Society Quarterly* 42 (March 1963): 5-26.

Haenszel, Arda M. "Visual Knowledge of California to 1700." *California Historical Quarterly* 36 (September 1957): 213-240.

Hahn, Stephen, and Jonathan Prude, eds. *The Countryside in the Age of Capitalist Transformation: Essays on the Social History of Rural America.* Chapel Hill: University of North Carolina Press, 1985.

Hales, Peter Bacon. *Silver Cities: The Photography of American Urbanization, 1839-1915.* Philadelphia: Temple University Press, 1984.

————. *William Henry Jackson and the Transformation of the American Landscape.* Philadelphia: Temple University Press, 1988.

Hansen, Gladys, and Emmet Condon. *Denial of Disaster: The Untold Story and Photographs of the San Francisco Earthquake and Fire of 1906.* San Francisco:

Cameron Press, 1989.

Hansen, James. *Alexander Harmer, 1856-1925.* Santa Barbara: James M. Hansen, 1982.

Harris, David, and Eric Sandweiss. *Eadweard Muybridge and the Photographic Panorama of San Francisco, 1850-1880.* Cambridge, Mass.: MIT Press, 1993.

Harrison, Alfred. *William Keith: The Saint Mary's College Collection.* Moraga, Calif.: Hearst Art Gallery, 1988.

———. "Bierstadt and the Emerging San Francisco Art World of the 1860s and 1870s." *California History* 71 (Spring 1992): 74-87.

———. "The Tradition of Donner Lake Paintings." *California History* 71 (Spring 1992): 83-87.

Hart, James D. *American Images of Spanish California.* Berkeley and Los Angeles: University of California Press, 1960.

Harte, Bret. *Outcroppings: Being Selections of California Verse.* San Francisco, 1860.

———. *Bret Harte's Writings.* Cambridge, Mass.: Riverside Co., 1875.

Hastings, Lansford W. *Emigrant's Guide to Oregon and California.* Cincinnati: Conclin Company, 1845.

Hawgood, John A. "The Pattern of Yankee Infiltration in Mexican Alta California, 1812-1846." *Pacific Historical Review* 27 (February 1958): 27-38.

Hazen, Margaret Hindle, and Robert Hazen. *Keepers of the Flame: The Role of Fire in American Culture, 1775-1925.* Princeton, N.J.: Princeton University Press, 1992.

Heizer, Robert F., and Alan J. Almquist. *The Other Californians: Prejudice and Discrimination under Spain, Mexico, and the United States to 1920.* Berkeley and Los Angeles: University of California Press, 1971.

Helper, Hinton Rowan. *The Land of Gold, Reality versus Fiction.* 1855. Rpt. New York: Bobbs Co., 1948.

Hendricks, Gordon. "The Domes of Yosemite." *American Art Journal* 3 (Fall 1971): 23-31.

———. *Albert Bierstadt: The Painter of the American West.* New York: Abrams, 1988.

Hine, Robert V. *California's Utopian Colonies.* Berkeley: University of California Press, 1953.

———. *California Utopianism.* San Francisco: Bord and Fraser Co., 1981.

Hittell, Theodore H. *The Resources of California.* San Francisco: Alta California, 1863.

———. *History of San Francisco, 1885-1897.* San Francisco: Bancroft, 1878.

Holliday, J. S. "The Gold Rush in Myth and Reality." Ph.D. diss., University of California, Berkeley, 1959.

———. *The World Rushed In: The California Gold Rush Experience.* New York: Simon and Schuster, 1981.

Honour, Hugh. *The New Golden Land: European Images of America from the Discoveries to the Present Time.* New York: Pantheon Books, 1975.

Horsman, Reginald. *Race and Manifest Destiny: The Origins of American Racial Anglo-Saxonism.* Cambridge, Mass.: Harvard University Press, 1981.

Howard, Robert West. *The Great Iron Trail: The Story of the First Transcontinental Railroad.* New York: McGraw-Hill, 1962.

Howell, John, *California Sketches: Mark Twain and Bret Harte.* New York: Dover, 1991.

Hughs, Ednan M. *Artists in California, 1786-1940.* San Francisco: Hughs Co., 1986.

Hurtado, Albert L. "Ranchos, Goldmines, and Rancherias: A Socioeconomic History of Indians and Whites in Northern California." Ph.D. diss., University of California,

Santa Barbara, 1981.

————. *Indian Survival on the California Frontier*. New Haven, Conn.: Yale University Press, 1988.

Hutchings, James M. *In the Heart of the Sierras*. Oakland: Pacific Books, 1888.

Hutchinson, W. H. "The Southern Pacific: Myth and Reality." *California Historical Quarterly* 48 (December 1969): 325-334.

Huth, Hans. "Yosemite: The Story of an Idea." *Sierra Club Bulletin* 33 (1948): 47-78.

————. *Nature and the American: Three Centuries of Changing Attitudes*. Berkeley and Los Angeles: University of California Press, 1957.

Hyde, Anne Farrer. "Temples and Playgrounds: The Sierra Club in the Wilderness, 1901-1922." *California History* 59 (September 1987): 154-169.

————. *An American Vision: Far Western Landscape and National Culture*. New York: New York University Press, 1990.

————. "From Stagecoach to Packard Twin Six: Yosemite and the Changing Face of Tourism, 1880-1930." *California History* 46 (Summer 1990): 208-220.

Issel, William, and Robert W. Cherney. *San Francisco, 1865-1932: Politics, Power, and Urban Development*. Berkeley and Los Angeles: University of California Press, 1986.

Jackson, Helen Hunt. *Ramona*. 1881. Rpt. New York, Avon Company, 1970.

Jackson, Joseph Henry, ed. *Gold Rush Album*. New York: Charles Scribner's Sons, 1949.

James, George Wharton. *Through Ramona's Country*. Boston: Little, Brown and Co., 1913.

————. *Lake Tahoe: Lake of the Sky*. 1915. Rpt. Las Vegas: Nevada Publications, 1992.

Jameson, Frederic. *The Political Unconscious: Narrative as a Socially Symbolic Act*. Ithaca: Cornell University Press, 1981.

Johns, Elizabeth. *American Genre Painting: The Politics of Everyday Life*. New Haven, Conn.: Yale University Press, 1991.

Jones, Holway R. *John Muir and the Sierra Club: The Battle for Yosemite*. San Francisco: Sierra Club Books, 1965.

Jones, Howard Mumford. *The Age of Energy*. New York: Viking Press, 1970.

Kasson, John F. *Civilizing the Machine: Technology and Republican Values in America, 1776-1900*. New York: Penguin Books, 1976.

King, Thomas Starr. *A Vacation among the Sierras: Yosemite in 1860*. 1861. Rpt. San Francisco: Book Club, 1962.

Kinnaird, Lawrence. *History of the Greater San Francisco Bay Region*. Vol. 2. New York: Lewis Historical Press, 1966.

Kinsey, Joni Louise. *Thomas Moran and the Surveying of the American West*. Washington, D.C.: Smithsonian Insitution Press, 1992.

Kirk, Anthony. "In a Golden Land So Far: The Rise of Art in Early California." *California History* 61 (Spring 1992): 2-23.

Kouwenhoven, John A. *Made in America: The Arts in Modern Civilization*. Garden City, N.Y.: Doubleday, 1948.

Kowalewski, Michael. "Imagining the California Gold Rush: The Visual and Verbal Legacy." *California History* 61 (Spring 1992): 60-73.

Kruska, Dennis G. *Sierra Nevada Big Trees: History of the Exhibitions, 1850-1903*. Los Angeles: Dawson's Books, 1985.

Kurutz, Gary F. *Benjamin C. Truman: A California Booster and Bon Vivant*. San Francisco: Book Club, 1984.

Larsen, Laurence. *The Urban West at the End of the Frontier*. Lawrence, Kans.: Regents,

1978.

Lavender, David. *The Great Persuader: Collis P. Huntington*. New York: Doubleday, 1969.
———. *Nothing Seemed Impossible: William C. Ralston and Early San Francisco*. Palo Alto: American West, 1975.

Lawrence, John Alan. "Behind the Palaces: The Working Class and the Labor Movement in San Francisco, 1877-1901." Ph.D. diss., University of California, Berkeley, 1979.

Lears, T. J. Jackson. *No Place of Grace: Antimodernism and the Transformation of American Culture, 1880-1920*. Chicago: University of Chicago Press, 1981.

Leighly, John. *California as an Island*. San Francisco: Book Club of California, 1972.

Levy, Jo Ann. *They Saw the Elephant: Women in the California Gold Rush*. Hamden, Conn.: Shoe String Press, 1990.

Leslie, M. Florence. *California: A Pleasure Trip from Gotham to the Golden Gate*. New York: G. W. Carleton, 1877.

Lewis, Marvin. *The Mining Frontier: Contemporary Accounts from the American West in the Nineteenth Century*. Norman: University of Oklahoma Press, 1967.

Lewis, Oscar. *The Big Four: The Story of Huntington, Stanford, Hopkins, and Crocker, and the Building of the Central Pacific*. Chicago: University of Chicago Press, 1938.
———. *Bret Harte's Tales of the Gold Rush*. Chicago: University of Chicago Press, 1944.
———. *The Silver Kings*. New York: Knopf, 1947.
———. *Bay Window Bohemia*. Garden City, N.Y. : Doubleday Co. 1956.
———. *San Francisco: From Mission to Metropolis*. Berkeley: Howell-North Press, 1966.

Lewis, Ruth R. "Kaweah, an Experiment in Cooperative Colonization." *Pacific Historical Review* 17 (November 1948): 429-442.

Light, Ivan. "From Vice District to Tourist Attraction: The Moral Career of American Chinatowns, 1880-1949." *Pacific Historical Review* 43 (August 1974): 367-394.

Limerick, Patricia. *The Legacy of Conquest: The Unbroken Past of the American West*. New York: Norton, 1987.

Lloyd, B. E. *Lights and Shades in San Francisco*. San Francisco: Bancroft, 1876.

Loeffler, Jane. "Landscape as Legend: Carleton Watkins in Kern County, California." *Landscape Journal* 11 (Spring 1992): 1-21.

Loomis, Reverend A. W. "The Old East in the New West." *Overland Monthly* 1 (1868): 360-367.

Lotchin, Roger W. *San Francisco, 1846-1856, from Hamlet to City*. New York: Oxford University Press, 1974.

Lubin, David. "A Backward Look at Forward Motion." *American Quarterly* 41 (September 1989): 549-557.

Lucid, Robert. "*Two Years before the Mast* as Propaganda." *American Quarterly* 12 (Fall 1960): 392-403.

McAffee, Ward. *California's Railroad Era, 1850-1911*. San Marino: Golden West, 1973.

McClelland, Gordon T., and Jay T. Last. *California Orange Box Labels: An Illustrated History*. Santa Ana: Hilllcrest Press, 1995.

McDermott, J. "Gold Rush Movies." *California Historical Quarterly* 33 (March 1954): 29-38.

McGraw, Donald. "A Tree that Crossed a Continent." *California History* 61 (Summer 1982): 120-139.

McKinsey, Elizabeth. *Niagara Falls: Icon of the American Sublime*. New York: Cambridge University Press, 1985.

————. "American Wanderlust." *American Quarterly* 43 (December 1991): 681-687.

Magliari, Michael. "Populism, Steamboats, and the *Octopus*: Transportation Rates and the Monopoly in California's Wheat Regions, 1890-1896." *Pacific Historical Review* 58 (November 1989): 449-470.

Mahood, Ruth. *Photographer of the Southwest: Adam Clark Vroman, 1856-1916.* San Francisco: Ward Ritchie Press, 1961.

————. *A Gallery of California: Mission Paintings by Edward Deakin.* Los Angeles: Los Angeles County Museum, 1966.

Mann, Ralph. *After the Gold Rush: Society in Grass Valley and Nevada City, California, 1849-1870.* Stanford: Stanford University Press, 1982.

Marcus, Alan, and Howard Segal. *Technology in America.* New York: Harcourt, 1989.

Margolin, Malcolm, ed. *Monterey in 1786: Life in a California Mission. The Journals of Jean-François de La Pérouse.* Berkeley: Heyday Books, 1989.

Marryat, Frank. *Mountains and Molehills; or, Recollections of a Burnt Journal.* 1855. Rpt. Stanford: Stanford University Press, 1952.

Marzio, Peter. *The Democratic Art: Pictures for a Nineteenth-Century America.* Boston: Godine, 1979.

Marx, Leo. *The Machine in the Garden: Technology and the Pastoral Ideal in America.* New York: Oxford University Press, 1964.

Masteller, Richard N. "Western Views in Eastern Parlors: The Contribution of the Stereograph Photographer to the Conquest of the West." *Prospects* 6 (1981): 55-72.

Mathes, W. Michael. "Apocryphal Tales of the Island of California and the Straits of Anián." *California History* 62 (Spring 1983): 52-59.

Mathes, Valerie. *Helen Hunt Jackson and Her Indian Reform Legacy.* Austin: University of Texas Press, 1990.

Merck, Frederick. *Manifest Destiny and Mission in American History: A Reinterpretation.* New York: Knopf, 1963.

Merlo, Catherine. *Heritage of Gold: The First One Hundred Years of Sunkist Growers, Inc., 1893-1993.* Riverside, Calif.: Sunkist Growers, Inc., 1993.

Meyers, Kenneth. *The Catskills: Painters, Writers, and Tourists in the Mountains.* Yonkers, N.Y.: Hudson River Museum, 1987.

Miller, Dwight. *Artists around Keith and Hill (1850-1900).* Stanford: Stanford University Department of Art, 1979.

Mitchell, Lee Clark. *Witnesses to a Vanishing America: The Nineteenth-Century Response.* Princeton, N.J.: Princeton University Press, 1981.

Mogen, David, Mark Busby, and Paul Bryant. *The Frontier Experience and the American Dream.* College Station: Texas A. and M. University Press, 1989.

Moritz, Albert F. *America the Picturesque in Nineteenth-Century Engravings.* New York: New Trend, 1983.

Moses, V. "Machine in the Garden: A Citrus Monopoly in Riverside, 1900-1936." *California History* 61 (Spring 1982): 26-35 .

Muir, John. *The Rambles of a Botanist.* 1873. Rpt. Los Angeles: Dawson's Books, 1974.

————, ed. *Picturesque California.* New York: Dewing Co., 1888.

Naef, Weston J., and James N. Wood. *Era of Exploration: The Rise of Landscape Photography in the American West.* Buffalo, N.Y.: Albright-Knox Art Gallery; New York: The Metropolitan Museum of New York, 1975.

Nash, Roderick. *Wilderness and the American Mind.* New Haven, Conn.: Yale University

Press, 1967.

———. "The American Invention of National Parks." *American Quarterly* 22 (Fall 1970): 726-735.

Neuerberg, Norman, ed. *Henry Chapman Ford: An Artist Records the California Missions.* San Francisco: Book Club of California, 1989.

Neuhaus, Eugen. *William Keith: The Man and the Artist.* Berkeley and Los Angeles: University of California Press, 1938.

Nordhoff, Charles. *Northern California, Oregon, and the Sandwich Islands.* 1874. Rpt. Berkeley: Ten Speed Press, 1974.

———. *California for Health, Pleasure, and Residence.* New York: Harper, 1882.

North, Douglas C. *The Economic Growth of the United States, 1790-1860.* New York: Norton, 1966.

Ogden, Adele. "Alfred Robinson: New England Merchant in Mexican California." *California Historical Society Quarterly* 23 (June 1944): 193-218.

Ogden, Kate Nearpass. "Sublime Vistas and Scenic Backdrops: Nineteenth-Century Painters and Photographers at Yosemite." *California History* 69 (Summer 1990): 134-153.

———. "God's Great Plow and the Scripture of Nature: Art and Geology at Yosemite." *California History* 71 (Spring 1992): 88-109.

Olmstead, Roger R. *Scenes of Wonder and Curiosity from "Hutchings' California Magazine."* Berkeley: Howell Books, 1962.

Orsi, Richard, J. "Selling the Golden State: A Study of Boosterism in Nineteenth-Century California." Ph.D. diss., University of Wisconsin, 1973.

———. "The *Octopus* Reconsidered: The Southern Pacific and Agricultural Modernization in California, 1865-1915." *California Historical Quarterly* 54 (Fall 1975): 197-220.

———. "Railroads and the Arid Far West: The Southern Pacific Company as a Pioneer Water Developer." *California History* 70 (Spring 1991): 46-61.

Osborne, Carol. *Museum Builders of the West: The Stanfords as Patrons and Collectors of Art, 1870-1906.* Stanford: Stanford University Press, 1986.

Palmquist, Peter. "The California Indian in Three-Dimensional Photography." *Journal of California and Great Basin Anthropology* 1 (Summer 1979): 89-116.

———. *Carlton E. Watkins: Photographer of the American West.* Albuquerque: University of New Mexico Press, 1983.

———. "Silver Plates among the Gold Fields: The Photographers of Siskiyou County, 1850-1906." *California History* 65 (June 1986): 114-125.

———. *Carlton E. Watkins: Photographs, 1861-1874.* San Francisco: Bedford Press, 1989.

———. "Carleton Watkins: A Biography—Shadow Catching in El Dorado, 1849-1856." *Daguerrian Annual* 1 (1990): 167-186.

Paredes, Raymund. "The Origins of Anti-Mexican Sentiment in the United States." *New Scholar* 6 (1977): 155-167.

Paul, Rodman W. *California Gold: The Beginnings of Mining in the Far West.* Cambridge, Mass.: Harvard University Press, 1947.

———. *Mining Frontiers of the Far West, 1848-1880.* New York: Holt, 1963.

———. "The Beginnings of Agriculture in California." *California Historical Quarterly* 52 (Spring 1973): 47-63.

———. *The Far West and the Great Plains in Transition.* Cambridge, Mass.: Harvard

University Press, 1988.

Peters, Harry T. *California on Stone*. Garden City, N.Y.: Doubleday, Doran and Co., 1935.

Peterson, Richard. *The Bonanza Kings: The Social Origins and Business Behavior of Western Mining Entrepeneurs, 1870-1900*. Lincoln: University of Nebraska Press, 1971.

———. "Anti-Mexican Nativism in California, 1848-1853: A Study in Cultural Conflict." *Southern California Quarterly* 62 (Winter 1980): 309-328.

Pisani, Donald J. "Why Shouldn't California Have the Largest Aqueduct in the World? Alexis Schmidt's Lake Tahoe Scheme." *California Historical Quarterly* 53 (Winter 1974): 347-361.

———. *From the Family Farm to Agribusiness: The Irrigation Crusade in California and the West, 1850-1931*. Berkeley and Los Angeles: University of California Press, 1984.

Pitt, Leonard. *The Decline of the Californios: A Social History of the Spanish-Speaking Californians, 1846-1890*. Berkeley and Los Angeles: University of California Press, 1966.

Polledri, Paolo. *Visionary San Francisco*. Munich: Prestel, 1990.

Polk, Dora Beale. *The Island of California: A History of the Myth*. Spokane, Wash.: Clark, 1991.

Pomeroy, Earl S. *In Search of the Golden West: The Tourist in Western America*. Lincoln: University of Nebraska Press, 1957.

———. *The Pacific Slope*. New York: Knopf, 1966.

Powell, Phillip Wayne. *Tree of Hate: Propaganda and Prejudices Affecting United States Relations with the Hispanic World*. New York: Basic Books, 1971.

Pred, Allan R. *Urban Growth and the Circulation of Information: The United States' System of Cities*. Cambridge, Mass.: Harvard University Press, 1973.

Prescott, Gerald. "Farm Gentry vs. the Grangers: Conflict in Rural America." *California Historical Quarterly* 61 (Winter 1977-78): 328-345.

Prown, Jules, ed. *Discovered Lands, Invented Pasts: Transforming Visions of the American West*. New Haven, Conn.: Yale University Press, 1992.

Rawls, James J. *Indians of California: The Changing Image*. Norman: University of Oklahoma Press, 1984.

———. *New Directions in California History: A Book of Readings*. New York: McGraw-Hill, 1988.

———. "The California Dream." *The Commonwealth* (January 27, 1992): 50-56.

———. "The California Mission as Symbol and Myth." *California History* 71 (Fall 1992): 342-361.

Reinhardt, Richard. "Southern California as Witnessed by Mrs. Frank Leslie." *California Historical Quarterly* 52 (Spring 1973): 64-79.

———. *Out West on the Overland Train: An Across-the-Continent Excursion with "Leslie's Illustrated Magazine" in 1877*. Palo Alto: American Press, 1967.

Reps, John W. *Cities of the American West: A History of Frontier Urban Planning*. Princeton, N.J.: Princeton University Press, 1979.

———. *Cities on Stone: Nineteenth-Century Lithographic Images of the Urban West*. Fort Worth: Amon Carter Museum, 1979.

Rice, Richard, William A. Bullough, and Richard Orsi. *The Elusive Eden: A New History of California*. New York: Knopf, 1988.

Ridge, John Rollins. *The Life and Adventures of Joaquin Murieta, the Celebrated California Bandit*. 1854. Rpt. Norman: University of Oklahoma Press, 1955.

Robertson, David. *West of Eden: A History of the Art and Literature of Yosemite.* Yosemite, Calif.: Wilderness Press, 1984.

———. *Yosemite as We Saw It: A Centennial Collection of Early Writings and Art.* Yosemite: Wilderness Press, 1990.

Robinson, Henry. *Life in California during a Residence of Several Years in That Territory.* 1846. Rpt. San Francisco: William Doxey, 1891.

Robinson, Henry. "The City at the Golden Gate." *Overland Monthly* 10 (1873): 62-66.

Robinson, William W. *Land in California.* Berkeley and Los Angeles: University of California Press, 1948.

Rolle, Andrew. *California: A History.* 4th ed. Arlington Heights, Va.: Harlan Press, 1987.

Rosenthal, Bernard. *City of Nature: Journeys to Nature in the Age of American Romanticism.* Newark, Del.: Associated University Presses, 1980.

Royce, Josiah. *California, from the Conquest in 1846 to the Second Vigilance Committee in San Francisco: A Study of American Character.* 1886. Rpt. New York: Knopf, 1948.

Runte, Alfred. *National Parks: The American Experience.* Lincoln: University of Nebraska Press, 1979.

———. "Promoting the Golden West: Advertising and the Railroad." *California History* 70 (Spring 1991): 62-75.

Russell, Carl Parcher. *One Hundred Years in Yosemite.* Berkeley and Los Angeles: University of California Press, 1947.

Ryan, Arthur J. "San Francisco as a Cyanosure of the Eyes of America and the World." *Overland Monthly* 48 (1906): 413-426.

Said, Edward. *Orientalism.* New York: Vintage Books, 1979.

Salkin, John, and Laurie Gordon. *Orange Crate Art.* New York: Warner, 1976.

———. "Orange Crate Art in the Golden State." *California History* 61 (Spring 1977): 52-71.

Sanborn, Margaret. *Yosemite: Its Discovery, Its Wonders, and Its People.* Yosemite: Yosemite Association, 1989.

Sandmeyer, Elmer. *The Anti-Chinese Movement in California.* Urbana: University of Illinois Press, 1939.

Santa Barbara Museum. *101 Years of California Photography.* Niwot: University of Colorado Press, 1990.

Sargeant, Shirley. *Yosemite's Historic Wawona.* Yosemite: Flying Spur Press, 1979.

———. *Yosemite: The First One Hundred Years, 1890-1990.* Santa Barbara: Sequoia, 1988.

Saxton, Alexander. *The Indispensible Enemy: Labor and the Anti-Chinese Movement in California.* Berkeley and Los Angeles: University of California Press, 1971.

Scharnhorst, Gary. *Bret Harte's California: Letters to the "Springfield Republican" and "Christian Register," 1866-1867.* Albuquerque: University of New Mexico Press, 1990.

Schearer, Frederick E., ed. *The Pacific Tourist.* 1884. Rpt. New York: Crown Publishers, 1970.

Schmidt, Peter J. *Back to Nature: The Arcadian Myth in Urban America.* Baltimore: Johns Hopkins Univesity Press, 1969.

Schumsky, Neil Larry. "Tar Flat and Nob Hill: A Social History of Industrial San Francisco during the 1870s." Ph.D. diss., University of California, Berkeley, 1966.

Schwartz, Ellen. *San Francisco Nineteenth-Century Art Exhibition Catalogues: A Descriptive Checklist and Index.* Davis, Calif.: privately published, 1981.

Scott, E. B. *The Saga of Lake Tahoe*. Lake Tahoe: Sierra Tahoe Publishing, 1957.

Scott, Mel. *The San Francisco Bay Area: A Metropolis in Perspective*. 2d ed. Berkeley and Los Angeles: University of California Press, 1985.

Sears, John F. *Sacred Places: American Tourist Attractions in the Nineteenth Century*. New York: Oxford University Press, 1989.

Senkewicz, Robert M. *Vigilantes in Gold Rush San Francisco*. Stanford: Stanford University Press, 1985.

Servin, Manuel P., ed. *An Awakening Minority: The Mexican Americans*. Beverly Hills: Glencoe Press, 1970.

————. "California's Hispanic Heritage: A View into the Spanish Myth." *Journal of San Diego History* 19 (Winter 1973): 1-9.

Shinn, Charles Howard. *Mining Camps: A Study in American Frontier Government*. New York: Scribner's Co., 1885.

————. "Poverty and Charity in San Francisco." *Overland Monthly* 33 (1894): 12-15.

Shuck, Oscar T., ed. *The California Scrap Book: A Repository of Useful Information and Select Readings*. San Francisco: H. H. Bancroft and Co., 1869.

Sienkiewicz, H. "The Chinese in California." *California Historical Quarterly* 34 (December 1955): 301-316.

Silver, J. "Farming Facts for California Immigrants." *Overland Monthly* 1 (1868): 176-183 .

Simpson, Lesley B. *The Encomienda in New Spain: The Beginning ofSpanish Mexico*. 2d ed. Berkeley and Los Angeles: University of California Press, 1950.

Smith, Henry Nash. *Virgin Land: The American West as Symbol and Myth*. Cambridge, Mass.: Harvard University Press, 1950.

Smith, Michael L. *Pacific Visions: California Scientists and the Environment, 1850-1915*. New Haven, Conn.: Yale University Press, 1987.

Sobieszek, Robert A. *San Francisco in the 1850s: Thirty-three Photographic Views by G. R. Fardon*. New York: Dover, 1977.

Soltow, Lee. *Men and Wealth in the United States, 1850-1870*. New Haven, Conn.: Yale University Press, 1975.

Soulé, Frank, John H. Gihon, and James Nisbet. *The Annals of San Francisco*. San Francisco: Appleton Company, 1855.

Stanton, William. *The Leopard's Spots: Scientific Attitude towards Race in America, 1815-1859*. Chicago: University of Chicago Press, 1960.

Starr, Kevin. *Americans and the California Dream, 1850-1915*. New York: Oxford University Press, 1973.

————. *Inventing the Dream: California through the Progressive Era*. New York: Oxford University Press, 1985.

————. *Material Dreams: Southern California through the 1920s*. New York: Oxford University Press, 1990.

Stellmann, Louis J. *The Vanished Ruin Era: San Francisco's Classic Artistry of Ruin Depicted in Picture and Song*. San Francisco: Paul Elder, 1910.

Stevens, Moreland L. *Charles Christian Nahl: Artist of the Gold Rush, 1818-1878*. Sacramento: E. B. Crocker Art Gallery, 1976.

Stewart, George R. *Bret Harte: Argonaut and Exile*. Boston: Houghton, 1931.

————. *Ordeal by Hunger: The Story of the Donner Party*. New York: Holt Press, 1936.

Stratton, R. B. *The Captivity of the Oatman Girls*. San Francisco: Whitton, 1857.

Strauss, David. "Toward a Consumer Culture: 'Adirondack' Murray and the Wilderness Vacation." *American Quarterly* 39 (Summer 1987): 270-286.

Street, Richard Steven. "Dr. Glenn, Wheat King." *The Breadbasket of the World: California's Great Wheat-Growing Era, 1860-1890.* San Francisco: Book Club, 1984.

Strobridge, Ida. "One Day at Pacheco's." *Land of Sunshine* 4 (July 1899): 101.

Taft, Robert. *Artists and Illustrators of the Old West, 1850-1900.* Princeton, N.J.: Princeton University Press, 1982.

Taper, Bernard. *Mark Twain's San Francisco.* New York: McGraw-Hill, 1963.

Taylor, Bayard. *El Dorado; or, Adventures in the Path of Empire.* 1850. Rpt. New York: Knopf, 1949.

Taylor, William. *California Life Illustrated.* New York: Carleton and Porter, 1858.

Thomas, Gordon, and Max Morgan Witts. *The San Francisco Earthquake.* New York: Stein Co., 1971.

Thomson, Kenneth. "Climatotherapy in California." *California Historical Quarterly* 50 (June 1971): 111-130.

Thompson, Warren S. *Growth and Changes in California's Population.* Los Angeles: Haynes, 1955.

Thornton, Tamara Plakins. *Cultivating Gentlemen: The Meaning of Country Life among the Boston Elite, 1785-1860.* New Haven, Conn.: Yale University Press, 1989.

Trachtenberg, Alan. *The Incorporation of America: Culture and Society in the Gilded Age.* New York: Hill and Wang, 1982.

————. "The American West Comes Out of the Closet—Partially." *American Quarterly* 37 (Summer 1985): 305-310.

————. *Reading American Photographs: Images as History, Mathew Brady to Walker Evans.* New York: Hill and Wang, 1989.

Truettner, William H. "The Art of History: American Exploration and Discovery Scenes, 1840-1860." *American Art Journal* 14 (Winter 1982): 4-31.

————, ed. *The West as America: Reinterpreting Images of the Frontier.* Washington, D.C.: Smithsonian Institution Press, 1991.

Truman, Benjamin C. *Semi-Tropical California.* San Francisco: Bancroft Co., 1874.

————. *Tourist's Illustrated Guide to the Celebrated Summer and Winter Resorts of California.* San Francisco: Bancroft Co., 1884.

Twain, Mark. *Roughing It.* Hartford, Conn.: American Publishing Co., 1872.

Van Nostrand, Jeanne. "Thomas Ayres: Artist and Argonaut of California." *California Historical Quarterly* 20 (September 1941): 275-279.

————. *San Francisco, 1806-1906.* San Francisco: Book Club, 1975.

————. *The First Hundred Years of Painting in California, 1775-1875.* San Francisco: John Howell Books, 1980.

————. *Vischer's Drawings of California Missions.* San Francisco: Book Club, 1982.

Van Nostrand, Jeanne, and Edith M. Coulter. *California Pictorial, 1786-1859.* Berkeley and Los Angeles: University of California Press, 1948.

Wade, Richard C. *The Urban Frontier.* Chicago: University of Chicago Press, 1959.

Walker, Franklin. *San Francisco's Literary Frontier.* New York: Knopf, 1939.

Watkins T. H., and R. R. Olmstead. *Mirror of the Dream: An Illustrated History of San Francisco.* San Francisco: Scrimshaw Press, 1976.

Weber, David. J. *Foreigners in Their Native Land: Historical Roots of the Mexican Americans.* Albuquerque: University of New Mexico Press, 1973.

———— *New Spain's Far Northern Frontier: Essays on Spain in the American West, 1540-1821.* Dallas: Second Southern Methodist University Press, 1989.

———— *The Spanish Frontier in North America.* New Haven, Conn.: Yale University Press, 1992.

Weinberg, Albert K. *Manifest Destiny: A Study of Nationalist Expansionism in American History.* Chicago: University of Chicago Press, 1963.

Weitze, Katherine J. *California's Mission Revival.* Los Angeles: Hennessey and Ingalls, Inc., 1984.

White, Edward G. *The Eastern Establishment and the Western Experience: The West of Frederic Remington, Theodore Roosevelt, and Owen Wister.* New Haven, Conn.: Yale University Press, 1968.

White, Richard. *"It's Your Misfortune and None of My Own": A New History of the American West.* Norman: University of Oklahoma Press, 1991.

Wiebe, Robert H. *The Search for Order, 1877-1920.* New York: Hill and Wang, 1967.

Wierzbicki, Felix Paul. *California as It Is and as It May Be; or, a Guide to the Gold Region.* 1849. Rpt. New York: Franklin, 1970.

Williams, John. *A Great and Shining Road: The Epic Story of the Transcontinental Railroad.* New York: Times, 1988.

Williams, Raymond. *The Sociology of Culture.* New York: Schocken, 1982.

Wilson, James Russell. *San Francisco's Horror of Fire and Earthquake.* San Francisco: Memorial Co., 1906.

Wilson, Raymond. "The First Art Scool in the West: The San Francisco Art Association's California School of Design." *American Art Journal* 14 (Winter 1982): 42-55.

————. "Painters of California's Silver Era." *American Art Journal* 16 (Autumn 1984): 71-92.

Woodward, David, ed. *Art and Cartography: Six Historical Essays.* Chicago: University of Chicago Press, 1987.

Worster, Donald. *Rivers of Empire: Water, Aridity, and the Growth of the American West.* New York: Pantheon Books, 1985.

Wreden, William. *Early California Trade Catalogues.* San Francisco: Book Club, 1968.

Zimmerman, T. "Paradise Promoted: Boosterism and the Los Angeles Chamber of Commerce." *California History* 64 (Winter 1985): 22-33.

INDEX

Note: Page numbers in italics
indicate illustrations.

Abe Edgington (horse), 81, 82
abundance, theme of: to encour-
 age settlers, 64–70, 73–77,
 87–88, 90–93; to justify
 colonialism, 9–11, 19–22;
 as a myth, 3–4, 5
Across the Continent (Bowles),
 108–109
Act: Chinese Exclusion (1882),
 184; for the Government
 and Protection of Indians
 (1850), 83
*Adventures in the Wilderness; or,
 Camp Life in the Adirondacks*
 (Murray), 106, 107
advertising: Californian images
 in, 119–20, *121*, 158–62;
 in paintings, 76–77; in
 photographs, 170–71, *170*,
 175; by Southern Pacific
 Railroad, 119–20, *121*
Agassiz, Louis, 209 *n.* 45
agriculture, in California, 67, 70,
 87–88, 90–91; and commer-
 cial development, 62–63;
 mechanization of, 70, 71–73,
 81; as speculation, 70

Alarcón, Hernando de, 6
album, souvenir, 154, 192–93
*Album Californiano: Colección de
 tipos observados* (Ferran and
 Baturone), 45–46
Alexander, William, engraving
 by, *18*
Alta. See *Daily Alta California*
*American Nervousness: Its Causes
 and Consequences* (Beard),
 137
American River, discovery of
 gold in, 27–28
Amerique Septentrionale (Sanson)
 (*map*), 6
Annals of San Francisco, The
 (Soulè, Gihon, and Nisbet),
 53, 83–84, 85, 174; illus-
 trations from, *84*
Anonymous: "A Large Pear," *72*,
 73; A Pioneer Embossed
 Washout Closet (brochure),
 59, *59*; *Automobile Passing
 through the Wawona Tree in
 the Mariposa Grove* (photo-
 graph), *120*; "Boarding the
 Train at Grand Central

Depot, New York City," *103*;
 *Burning of the City after the
 Earthquake, 1906* (post-
 card), *190*; "California: The
 Home of the Big Tree," *121*;
 "California Products," 73,
 73; *California, The
 Cornucopia of the World*
 (poster), 87, *87*; *Camping
 Chores* (photograph), *127*;
 Celestial Empire in California
 (letter sheet), 46–47, *47*;
 Charles Lummis (photo-
 graph), *150*; *Chinese
 Restaurant* (stereograph),
 186; *Digger Indian–Washer
 Woman* (stereograph), *118*;
 Elim Grove (photograph),
 124, *124–25*; *George W.
 Northrup* (daguerreotype),
 40; *Glacier Point, 7201 FT*
 (silver gelatin print), *132*;
 *Gold! Gold! Gold! Mr.
 Hexikiah Jerolomans
 Departure for California*
 (lithograph), 31, *31*;
 Harvester-Schmeiser